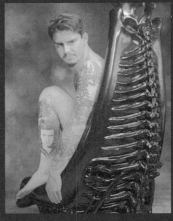

*Paul Ivanko, artist/tattooist*
*Photo: © 1996 Susumu Sato*

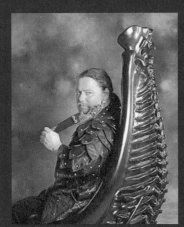

*André Lassen, artist/sculptor*
*Photo: © 1996 Susumu Sato*

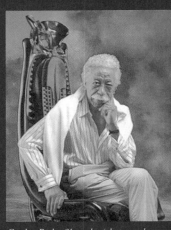

*Gordon Parks, filmmaker/photographer*
*Photo: © 1996 Susumu Sato*

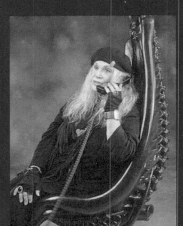

*Sylvia Miles, actress; 2-time Academy*
*Oscar nominee. Photo: © 1996 S. Sato*

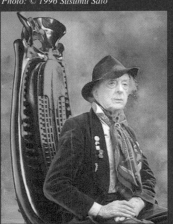

*Quentin Crisp, author/actor*
*Photo: © 1996 Susumu Sato*

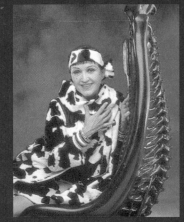

*Christine Spengler, photographer*
*Photo: © 1996 Susumu Sato*

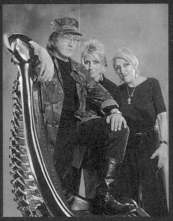

*Mikhail, Rebecca & Dorothee Chemiakin,*
*artist family. Photo: © 1996 Susumu Sato*

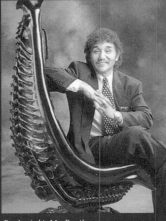

*Rocky Aoki, Mr. Benihana*
*Photo: © 1996 Susumu Sato*

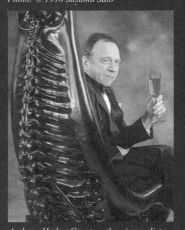

*Anthony Haden-Guest, author, journalist,*
*caricaturist. Photo: © 1996 Susumu Sato*

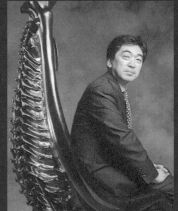

*Masaki Nakata, Opera Artistic Director, Na-*
*tional Theatre Tokyo. Photo: © 1996 S. Sato*

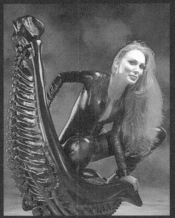

*Julie Lamb (Freckle), rock musician*
*Photo: © 1996 Susumu Sato*

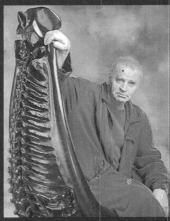

*Janusz Głowacki, playwright*
*Photo: © 1996 Susumu Sato*

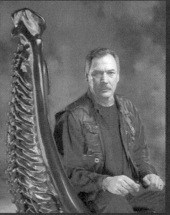

*Yuri Gorbachev, painter*
*Photo: © 1996 Susumu Sato*

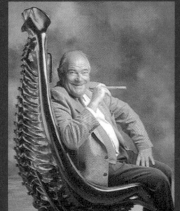

*Michel Roux, modern-day Medici*
*Photo: © 1996 Susumu Sato*

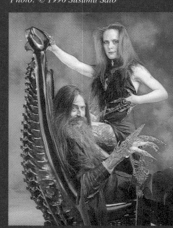

*Axel, jeweler and bloodpainter, with*
*Bebe Bullet, artist, soulmate and muse*
*Photo: © 1996 Susumu Sato*

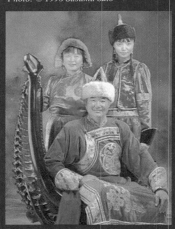

*Vladen Pantaev, composer, wife Tatiana,*
*theatre director and daughter Irina, super-*
*model. Photo: © 1996 S. Sato*

www HR Giger com

To stay informed about upcoming TASCHEN titles, please request our magazine at www.taschen.com/magazine or write to TASCHEN America, 6671 Sunset Boulevard, Suite 1508, USA-Los Angeles, CA 90028, contact-us@taschen.com, Fax: +1-323-463.4442. We will be happy to send you a free copy of our magazine which is filled with information about all of our books.

Layout: H.R. Giger and Sandra Beretta
Graphic design: Sandra Beretta, Atelier Giger, Zurich
Text: H.R. Giger, Carl Laszlo, Alfred Ogi, Michel Thévoz
Text edited by: Leslie Barany
Biography and bibliography list management: Matthias Belz and Leslie Barany
Translated by: Sandra Hathaway
Transcription of manuscript: Mia Bonzanigo, Sascha Serfoezoe
Editorial coordination: Anne Gerlinger, Cologne
Production: Ute Wachendorf, Cologne
Cover design: Sense/Net, Andy Disl and Birgit Reber, Cologne

Printed in South Korea
ISBN 978–3–8228–3316–2

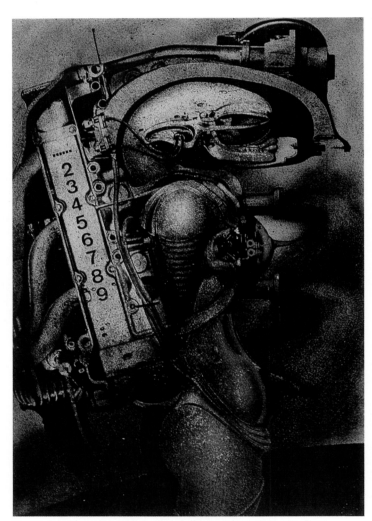

*No. 138, Biomechanoid 70, 1970, Four–color silkscreen, edition of 125, 100 x 70 cm*

Photos: Susumu Sato, Kelly Ann Brill, Louis Stalder, Willy Spiller, Roy Volkmann, Roland Gretler, H.R. Giger, Leslie Barany, Robin Perine, Steve Bonge, Dana Frank, Ira Cohen, Axel Linge, Chris Stein, Elihu Blotnick, Chris Lamb, Amy Ardrey, Sandra Beretta, Charly Bieler, Fred Engelberg Knecht, Margret Ann Wilde, Roland Königshofer, Sascha Serfoezoe, Roman Güttinger, Anne Garde, Candid Lang, Michèle Zerbini, Zumbrunn, Eric T. Michelson, Jürg Kummer, Peter de Jong, Brigitte von Känel, Serge Höltschi, Joost Dankelman, Schmid, Michael Lichter, N. Chard, Reto Dohner, Toini Lindroos, Panja Jürgens, Patrick M. Haley, Matthias Belz, Wolfgang Holz, Burkhard Pagels, Carmen Scheifele Giger

H.R. Giger's Representatives:
Agent USA: Leslie Barany, Barany Artists, ARh+ Editions, 226 East 27th Street, #3D, New York, NY 10016, Tel. (212) 684-2225, les@BaranyArtists.com
France: Bijan Aalam, bijanaalam@aol.com
All other countries: Office H.R. Giger, hrgiger@datacomm.ch, Museum HR Giger, Château St. Germain, CH-1663 Gruyères, info@hrgigermuseum.com

U.S.A. Publisher: James R. Cowan, Morpheus International, 125 East Reno Avenue, # 17, Las Vegas, NV 89119, Tel. (702) 233-3339, curator@morpheusgallery.com

H.R. Giger International Fan Club: Thomas Riehm, President, Rudolfplatz 6, D–38118 Braunschweig, Germany

Luxury edition of this book with zinc-plate lithographs, 3 colors, signed and numbered. Printing: Walo Steiner, ASP 84 x 60 cm, folded and bound into the book.
Edition A: 1–23/300 litho and signed holograph by Urs Fries from Hoppla I, 69 x 20 cm, B: 24–300/300, litho signed and numbered.

## DEDICATED TO
Melly Giger-Meier

### SPECIAL THANKS TO
Sandra Beretta, Maria del Carmen Scheifele de Vega and Carmen Scheifele Giger, Mia Bonzanigo, Bijan Aalam, Leslie Barany, Alf Bättig and Cécile and KoKo, Ronald Brandt, Thomas Riehm, Matthias Belz and Marco Witzig, Asy Betamona, Sandra Hathaway, James R. Cowan, Anne Gerlinger, Stanislav Grof and GTT, Moni and Kurt Egger, Frank Holler, Wolfgang Holz, Daniel Krenger, Ingrid Lehner and Manuela Allaman, Franz and Pia Marti, Patrick Müller, Museum HR Giger Crew!, Urs Senn, Fränzi Steiger and Crew, Stephan Stucki, Urs Tremp and Mirjam and Armando Bertozzi, Mona Uhl, Catya Rusch, Joseph Klein, Firma Faserplast, Michael Geringer, Andy Schedler, Brigitte von Känel, Conny de Fries, Robert Christoph Jr., Harry Omura, Jean-Pierre Vaufrey, Joël Morand, Hans C. Bodmer, F. Alain Gegauf, Marco Wüst, Daniel Rieser, Stahl & Traum, Urs Grob, Andy Stutz, Ball & Sohn, Ernst Ammann, Firma Spengler, Josef Gruber, Yilmaz Mehmet, Hansjörg Mattmüller, Alfred Ogi, Michel Thévoz, Eveline and Boris Nicolaj Bühler, Tania Tkatchuk, Roman Güttinger, Sascha Serfoezoe, Uldry & Sohn, André Margraitner, Ralf Kühne, Benedikt Taschen, Burkhard Riemschneider, Michael Konze, Ute Wachendorf, Pro Litteris, Pro Helvetia, The Guardian, Interview, Prof. Ernst Fuchs, Turi Werkner, Martin Schwarz, Günter Brus, Ralf Abati, François Burland, Walter Wegmüller, Claude Sandoz, Franz Ringel, Dado, Pier Geering, Michel Desimon, Jürg Attinger, Fred Engelberg Knecht, Gottfried Helnwein, Marcel Reuschmann, Jean-Marie Poumeyrol, S. Clay Wilson, Thomas Ott, Charles Voegele, Karl Bieler, Ruedi Hoffmann, Dr. Baul Tobler, Tobias Hauser, Panja Jürgens, Sybille Ruppert, Silvio R. Baviera, Jello Biafra, Natasha Henstridge, Ignaz Roellin, Thomas Domenig, Iris Suter-Giger, Marlyse Huber, Marco Poleni, Peter Rothenbühler, Dr. Harald Szeemann, Walo Steiner, André Lassen, Mengia, Carl Laszlo, Roland Königshofer, Annie Sprinkle, Joe Coleman, Debbie Harry, Chris Stein, Mr. Lüpken, Mr. Moeller, Rolf Müller, Fabian Wicki, PanVison, Dr. Prof. Herbert Franke, Martin Walz, Ralf König, Ralph S. Dietrich, Harald Reichebner, Elite Entertainment Group, Etienne Chatton, Paul Walter, Susumu Sato, Rebecca Segerstrom, Karen Golightly, Kelly Ann Brill, Roy Volkmann, Louis Stalder, Willy Spiller, Roland Gretler, Robin Perine, Steve Bonge, Dana Frank, Ira Cohen, Axel Linge, Elihu Blotnick, Chris Lamb, Amy Ardrey, Charly Bieler, Margret Ann Wilde, Anne Garde, Candid Lang, Michèle Zerbini, Zumbrunn, Eric T. Michelson, Jürg Kummer, Peter de Jong, Serge Höltschi, Schmid, Michael Lichter, N. Chard, Reto Dohner, Toini Lindroos, Alexander Gallery/NYC, Mary Anthony Galleries/NYC, Dr. Bryan Bajakian, Patrick Rochon, Dr. Prof. Barbara Gawryziak

# www HR Giger com

**TASCHEN**

## My Passions

When Mr. Taschen offered me the opportunity to do a book about my many interests, I was delighted, because books have always given me the greatest pleasure. I have always been happy to receive a book, be it an art book or a novel. I am always interested in the person behind it. I always compare the authors of books or movies to my life: how long did they live?

*Mengia, a friend from Giger's youth, 1961*

In what year did they achieve success? Under what sign were they born? When did they create their main body of work? What did they die from? What were their passions? And so I've reached my topic.

In the final analysis, the multimedia skills so little appreciated by collectors keep one from repeating oneself. I may repeat myself thematically, but, once I have finished something, I do not take it up again. That's what makes it so difficult for me to complete interrupted works years later, because, by then, my interests may have

*Walter Wegmüller: Head and Foot Wheelcake, 1969. Plastic, diameter 28 cm*

changed completely and I can no longer connect with the past. Most people believe that artists – among whom I count myself – can only be really good in one genre. In my case, this would be my work with the spraygun. And yet, these pictures were more like preparations for three-dimensional work. The airbrush, as it is commonly referred to, is undergoing a renaissance right now. When I started working with it around 1972, few artists were using it. Later, I discovered the army of American illustrators. They use templates made from photos to create a copy as accurate as possible. I have never considered myself part of this group. I work freehand with the airbrush, the way one sketches, usually with diluted watercolor on paper.

Years ago, I used a toothbrush to laboriously spray watercolor onto a paper surface through a sieve, and then

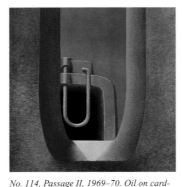

*No. 114, Passage II, 1969–70. Oil on cardboard, 54 x 64 cm (detail)*

scraped parts of it away with a razor blade. This is how the pictures between 1966 and 1969 were created. I used the razorblade to lighten dark parts and then the rapidograph to work on the small details. In 1969, I tried my hand at oil. I never mastered this medium very well, and only a few pieces were created. I believed that life was too short to capture all my ideas and fantasies in oil! Then I discovered the airbrush through my painter friend Hugo

Schuhmacher. He had studied retouching and believed one needed five years to master this instrument. I simply went out

*A Gift for Ernst Nebel, 1974. Acrylic on paper, 22.9 x 31.5 cm (detail)*

and bought the same brand, and started off.

I had just moved into my new house and the big empty walls had to be covered. For many nights, I worked only with diluted watercolor on paper. Then I glued these widths of paper onto 12 mm panels of plywood, whose backs I covered with the same paper to maintain the tension. The largest panels I could squeeze into the studio measured 240 x 140 cm. The walls were covered vertically with three screwed-together panels. Horizontally, two panels were enough. This is how the large-format temple pictures, which measure either 240 x 420 cm or 240 x 280 cm, were created. The *Aleph Temple* (page 61), the first piece created solely with diluted watercolor, still shows some insecurities, but

*N.Y.C., 1975. Duotone litho, 100 signed and numbered, deluxe edition for the catalog of the Sydow Zirkwitz exhibit, Frankfurt, 24 x 24 cm*

the *Spell Temple* (page 116) or the *Passages Temple* (page 130), especially, can be counted among my major pieces, which I don't expect to surpass anymore. The best paintings with the most varied themes were created between 1972 and 1975. Then my longtime companion Li died, and after that, I painted only smaller pieces.

I really caught fire when the movie "Alien" was made. I needed about two months to create its decor and costumes. This film experience, for which I even got an Oscar, awakened my interest in the third dimension and the fourth dimension, which is called time or move-

*The Airbrush, 1985. Watercolor on paper, 70 x 50 cm*

ment. Since then, I've done many more airbrush paintings, almost all of which are collected in the books "Necronomicon 1 and 2", "N.Y.C." and "Biomechanics".

Around 1990, I created my last airbrush paintings, and I textured the surfaces using templates and strong colors. With the advent of the fax machine, I stopped airbrushing and turned instead to drawing on pages in the DIN-A4 format, which were often joined together to create larger pages. My education as an interior designer was of much help to me in drafting my designs and ideas for the U.S. and England in different sizes. I used mostly rapidograph, pencils or pens. Since the fax does not allow for good shading, I had to use cross-

hatching. I also began to use the scraping technique from the '60s. Presently, however, paper is coated with polyesters that render it scrape-resistant.

After 20 years of airbrushing, I have switched to sketches in which I give all of the necessary specifications for my designs. Now everybody wants airbrush paintings from me, but I collect them myself, and am buying back all my old pieces so that I can have exhibits without constantly resorting to loans. The airbrush wave from the U.S. has hit Europe, and now there are airbrush competitions everywhere. In misguided homage, people copy

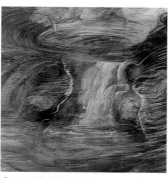

*Cataract II, 1989. Pastel crayons and acrylic on paper, 70 x 100 cm (detail)*

me and steal from me. Since the advent of CD-ROMs, computer users are able to steal "long-distance". They have become unstoppable. My paintings have also been used as the basis for tattoos and sprayed onto motorcycles and cars. Meanwhile, my own passion for airbrushing seems to have died, for the time being. I have never been one for trends. It's more likely that I've created them.

At the time of my writing this text, I am happily working on a garden train which was inspired by my contribution of a model train to the movie *Species*. It is said that one becomes more of a child as one gets older, and it seems to be true in my case. The dimensions have grown somewhat, however. A large room is no longer an adequate play-

ground; now I need 2,000 square meters of garden and parts of the house. A shortage of funds and the narrow-mind-

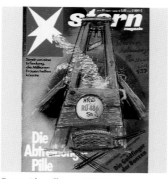

*Stern with guillotine, 1989. Markers on an issue of "Stern", 29.4 cm x 22.4 cm*

edness of cleaning ladies stopped me from expanding earlier. I no longer tolerate such restrictions. The more famous I get, the more I am tolerated, albeit with some head-shaking. I cannot even feel pity for the husbands whose wives say that such pictures will not come into their homes. Women are usually the ones who decorate the home, which is why most homes are boring and stodgy. Not even "Playboy" centerfolds are allowed, else the woman immediately senses competition. The male may procreate only with the wife, and is not even allowed to get inspiration from another woman's photograph. This would be an insult. The excuse is always the same: "I take care of the entire household. He sits in the office all day, and then in front of the TV the entire evening." Original

*New Year's Wishes to Taschen, duck à l'orange. Markers on an issue of "Stern", 29.4 x 22.4 cm*

artwork shouldn't be sold to people like that. It would only be dirtied by smoke and serve to display wealth and taste to guests. For that, there are reproductions and books. The bourgeois should be honest about his disinterest. He shouldn't buy paintings as an investment. In all likelihood, he'll buy the wrong ones. Only true passion matters. That's why artists are the best collectors. There are some who think artists other than themselves are good. I, for example, have a tidy collection of pieces which I've almost always bought in galleries (pages 102–113). It rarely occurs that two artists find each other's work great and trade pieces. My desire to make presents of originals has vanished completely since my former manager sold off his last twelve birthday presents. People like that deserve framed posters. These days, hardly anyone can differentiate a laser copy from

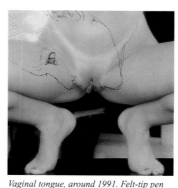

*Vaginal tongue, around 1991. Felt-tip pen on an issue of "Penthouse", 22 x 19.8 cm*

an original, anyway.

When I think about it, I should really live faster and consume more at my age; otherwise I won't even get through my inheritance! That would be a shame.

The 90s are the era of crazy sects and holy murderers. Ernst Fuchs, whom I value highly both as a painter and human being, said that the apocalypse had already begun and would be reversed in 1999 (6661 backwards) with the fall of Sa-

tan. The cleansing should occur in the next four years. I wonder if I shouldn't start my own sect, one that will watch over my train....

*H. R. Giger*

*Carmen Scheifele. Photo: Ed Willard*

*Satan 1, book cover for "Opus Diaboli", by K. Deschner, Uraneus Publishing 1995*

# Childhood Memories

When I was five years old, I had everything under control! At least as far as the Storchengasse was concerned. I sat on my raised kiddy seat at the semi-circular table in the bay window (see picture) and could see everything from the post office to the bend in the road where the model school stood and the Planetastrasse rose steeply to the plaza. I made music by singing loudly and hitting the wall rhythmically with the wiry flyswatter. Mostly, though, I modeled clay. My mother bought me different kinds of modeling clay and I recreated entire carnival bands from Basel, fashioning their drumsticks from matches. I was my mother's favorite, and she helped me with everything, something my strict father didn't think quite necessary. The house in the Storchengasse was dark. The bay window was the only place that got a little sun. The pharmacy on the ground floor, which was run by my father, was part of my playground. Also, the passageway which led, somewhat crookedly, to the little courtyard in the back. This was the location of my ghost train, which I operated until I was twelve. To create it, I needed only to cover the one window that opened on the courtyard, and presto! It was dark, and ready to allow my imagination free reign.

At this time I was convinced I would become an architect of castles and fortresses when I grew up. I was also fascinated by the brick-carrying trucks of the Wiesental. There, a group of men worked on clay in a network of rails which were perpendicular to each other and connected by little swiveling frames. The direction of these rails was changed according to where the majority of work was going to be done. I constantly drew castles, trains and ghost

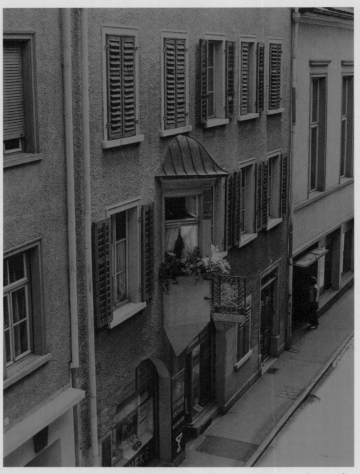

*The house of H. R. G.'s parents at Storchengasse 17, in Chur, 1945: pharmacy on the ground floor, apartment with bay window on the second floor, Black Room on the third floor*

*H. R. G.'s kindergarten Marienheim, Chur. Today it is the site of the Kantonalbank.*

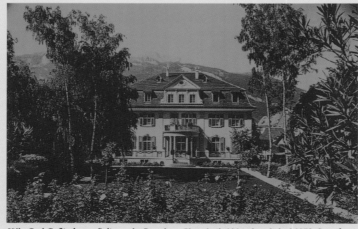

*Villa Carl Caflisch-von-Salis on the Postplatz, Chur; built 1914, demolished 1972. Seen from the Postplaz; Domenig Sr. built on top of the entire plaza.*

trains. Every one of my school compositions dealt with one of these topics. I took these things seriously then, as I do now, as I plan a museum in a castle, complete with an integrated castle railroad!

Back to my youth. From the plaza in front of the post office, where the fountain was, a path led through a cast iron gate to the park of the Villa Caflisch, which was planted with huge trees. The place reminded me of the castle in *Beauty and the Beast*. There was a huge, empty swimming pool overgrown with moss, and the uncovered brook that fed the mill rushed through the property, adding to the air of mystery. When I was in first grade, this park had an irresistible attraction for me, especially since a girl who went to school with me lived in the villa. I liked her a lot and often lay in wait for her in the park. I didn't really know what attracted me to her. It had to have been some sort of sexual urge that I had not yet pinpointed. The only clear fantasy I had was to romantically free her from the clutches of the enemy, a commonplace in my books about Indians. But I was incredibly shy, and since I was the only boy in a class with seven girls, I was afraid to make the wrong move. When we took a field trip to the Fürstenwald in the sixth grade, the girls wanted me to participate in games which I considered embarrass-

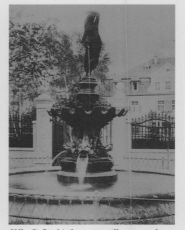

*Villa Caflisch's fountain, still preserved, today stands amidst stores.*

6

ing. I avoided it by telling them I would not play any game that involved kissing. I was attracted to these girls but didn't know how to act around them. In addition, their girlish giggling made me nervous and afraid.

Before I entered puberty I collected weapons like a madman, although I limited myself to revolvers. The "Gölischmid", the goldsmith, an old man who was considered crazy and to whom I delivered things from the pharmacy, showed me how to repair a variety of handguns. I learned how to solder, how to install new springs, and how to temper metal. Everything not needed at home ended up in Gölischmid's house, which was packed with all kinds of weapons I had gotten by trading. I could have armed at least twenty people by the time I was ten. My father trusted me. He thought I was practicing for military service and would become a lieutenant as he had been. He would also have liked to see me become a pharmacist, but thank God I was too disinterested, too lazy, and otherwise altogether unsuited for a university career.

In high school I often sat next to an ambitious, uptight little boy with a too-large head who never let me look at his dictations. Especially during examinations, when I had sore need of a mental crutch next to me every now and then. This priggish classmate took immense care to hide his secrets from me. In a Swiss Television program forty years later, presenting my *Baphomet Tarot*, this same "model citizen", Georg Schmid (who by now had worked his way up to Deputy of Sects, and is paid by the government), had the temerity to say about my *Mirror Image*, which represented the card *The Magician*: "The man who painted this is suicidal and puts other people in the same dan-

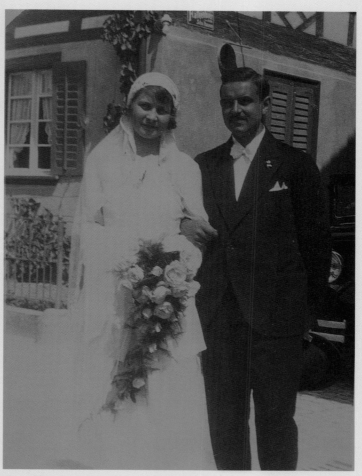

The wedding of Melly Giger-Meier and Hans-Richard Giger, in front of the Restaurant Adler in Mammern, circa 1934

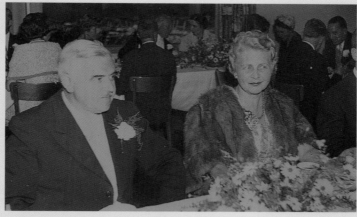

H. R. G.'s father Hans-Richard Giger and mother Melly Giger-Meier, circa 1955

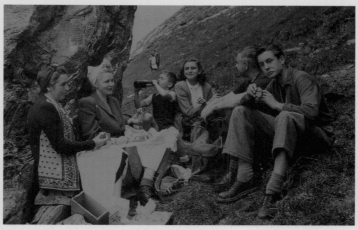

From left to right: Mrs. Salzborn, H.R.G.'s mother, H.R.G., H.R.G.'s sister Iris, H.R.G.'s father and Mr. Salzborn, Jr., circa 1945

ger. This person is in sore need of God's community." He was under the delusion that the subject was a headless person. This idiot was making a reference to my girlfriend, who had died 17 years earlier. It would have been better for Schmid to have let me profit from his knowledge in school rather than to make ignorant remarks about my work now. He might have been able to stop my artistic career – and I would now be a pharmacist.

I described my schooldays in "H. R. Giger's Arh+". I think I was 14 the first time I kissed a girl. From then on, I was indifferent to weapons, trains and ghost trains. I began to learn how to play soprano sax and piano. But I didn't use sheet music, and stopped playing at the age of 20. The first time I slept with a girl I was 21. After that I was obsessed. I had already tried to lure a girl into bed after my kissing experience, but the ladies played coy. To quell my constant excitement, I masturbated during class. I usually sat in the back on the left and hoped no one could see what I was doing. Nobody seemed to, although a girl that sat on the far right might have seen me. She seemed as distracted as I was and always wore a disdainful expression. Later, at the School of Applied Arts in Zurich, I made love to various school companions during the breaks in the stairways, behind stage scenery, in the cellar and on the carpenter's bench, where my father almost caught me once when he visited the school. My only interest was eroticism, and I couldn't connect it with school. Maybe with the toilets. They smelled of forbidden sex and often appeared in my dreams as a result.

My interest in art was awakened by the collector and publisher Carl Laszlo, who lived in Basel and whose magazine

"Panderma" was a revelation to me. He liked handwritten letters and a certain kind of art that I had not seen before. I showed him a few photos that I had made in Vienna in the old Lobau – photos similar to those of Lucien Clergue, who was also published in "Panderma" and used the element of water to set the scene for his female nudes. Laszlo greeted me and led me to a bed, as all chairs were covered with books. At his house, for the first time, I saw the works of Schröder, Sonnenstern and Oelze, who seemed extremely mysterious to me. From the bed, Laszlo showed me books, about Arman's assemblies for example. I was delighted, but at the same time I sensed that the man wanted something from me. I didn't notice that Laszlo followed me after this visit. When I arrived, excited, at the gallery, where I was taking part in a group exhibit, and told of my suspicions about Laszlo, he suddenly appeared behind me. I froze! He looked at the exhibit and said everything should be burned. Although my work pleased him more than the others', he thought that even I should throw everything into the fire. I understood, because I had read his SIW-publication "Vacation on the Waldsee", in which he described his five years in a concentration camp. He was one of the few not exterminated.

For me, Carl Laszlo was the most important connoisseur of art. He knew ten years in advance what would become fashionable and wrote some essays which I count among the best I have ever read. Later, when he participated in the art fair in Basel, he published a magazine called "Radar", which was full of work by prominent New Yorkers from the circle around William Burroughs. There were some very good articles in this magazine. I

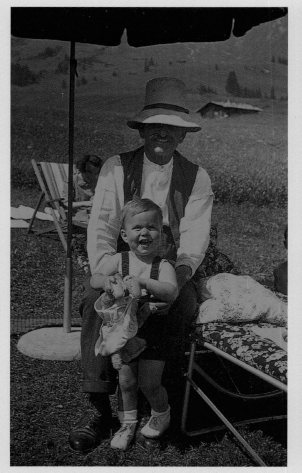

*Uncle Kaspar Schröpfer and H.R.G. in Flims, 1943*

*H.R.G. with a modified army revolver, Flims, circa 1953*

*H.R.G. mountain climbing in Flims, 1956*

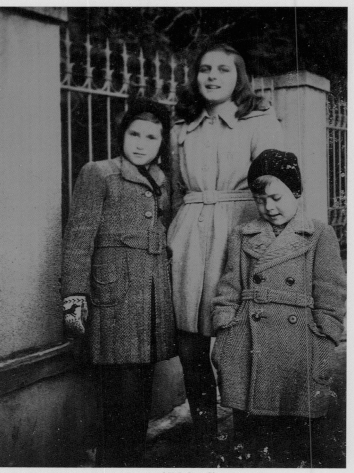

*with double-barrelled shotgun with a pistol handle, c. 1953*

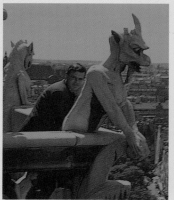

*H.R.G., Paris, Notre Dame, circa 1960*

*Dorli Goldner, H.R.G.'s sister Iris Giger and H.R.G. in Chur, circa 1945*

personally never did business with Laszlo. Answering my question as to what I was best suited for, he said: creator of films or graveyard sculptures for rich Americans. Laszlo, whose whole house, including the ceiling, was virtually plastered with paintings, said that paintings were not important, that film was the medium of this century.

The following text is from "Panderma 4":

*Man is nothing*

*Man is in himself nothing, merely an infinitely small part of the infinite. His world is not the world; his destiny as well as his reason are less than a drop in the bucket. Men are nothing, as persons nothing, as families nothing, as a class nothing, as a people nothing, as humanity nothing. Autonomous independent man is a soap-bubble which every day comes nearer to being burst. Man's proper estate is ennui; nothing results from man, nothing begins with him, nothing can be built upon him – he himself lacks a firm basis.*

*What is finite and transient has relevance only in relation to what is infinite and eternal. Man can make nothing of himself, if he draws only on his own forces, for he is himself nothing and has at his disposal only the illusion of his person and his forces. He can claim no power for himself, for, being meaningless, he has no right of possession over living beings or things. Led astray by humanism and blinded by the belief that man is the centre of the universe, he fails to recognize his true place in the order of things. He forgets the basis of his existence, and therefore he must perish.*

*The anthropomorphic world, the reign of mankind, is near its end. The idolization of man and his resultant despotism, the glorification of the picture he*

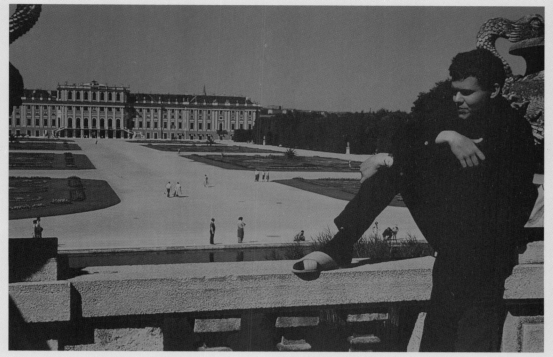

H.R.G. at Schönbrunn Castle, Vienna, circa 1960

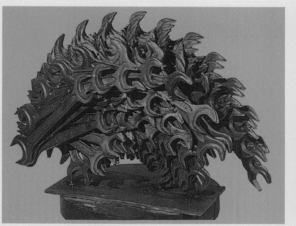

Arman: "Stregosaurus Wrencheus", 1978. 56 x 83 x 30 cm

Basilio Schmid (died 1995) with H.R.G. glasses, 1966

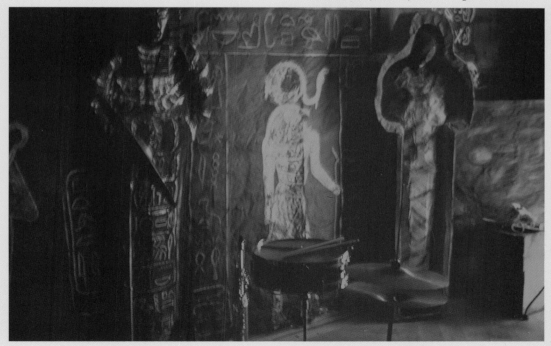

H.R.G.'s Black Room, Egyptian burial chamber, on the third floor of his parents' house at Storchengasse 17, Chur, 1958

presents of himself and his environment, the "art for art's sake" and art through artistry— all that is past. Humanistic autonomy and surrealistic automatism can escape complete destruction only through radical evaluation. As this world comes to an end, man loses his artificially central position. After autonomous man has proven to be a bankrupt conception, he will be forced to recognize that he cannot be identified with the illusory image which he has wantonly created of himself.

Only when he renounces his immeasurable vanity and realizes that he is only an infinitely small part of the infinite, will man find his definitive place. Then the era of ennui, of alienation, the era in which the objective and the human have dominated, will be succeded by an era in which the essence of things and their correspondence are sought. Man's grandeur, with its consequences – his disintegration and his enslavement – means decline. His liberation from the ballast of the unbefitting claims made on him, and with that, his entry into a world governed by eternal order, is at hand.

Carl Laszlo, 1959

Another man who became very important to me was my teacher Mattmüller at the Zurich School of Applied Arts. I once described his classes in a book ("F+F Zürich, das offene Kunststudium" [the open study of Art], Benteli Verlag Bern, 191, p. 238):

Cleaning up my studio I found a letter from Hansjörg Mattmüller, who asked me to send him a photo of myself for a book. The letter is only three weeks old, perhaps it's not too late. When I spoke with Mattmüller on the phone, I mentioned that I had always wanted to write something about him.

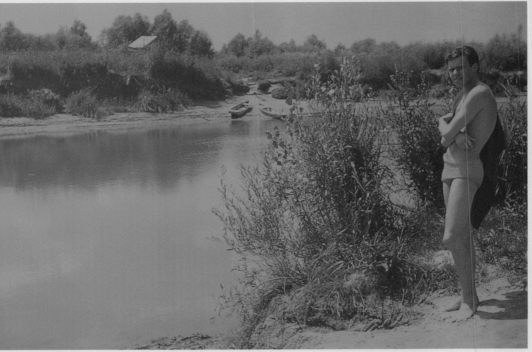

H.R.G. on the old Donau, Lobau by Vienna, circa 1960

On the old Donau, Lobau by Vienna, 1962. Photo: H.R.G.

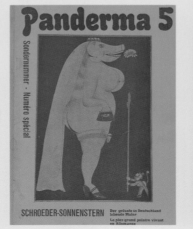

Panderma 5, 1962

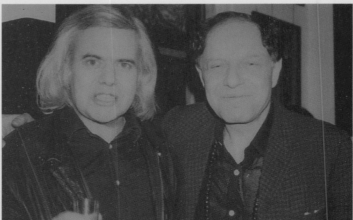

H.R.G. and Carl Laszlo, 1981. Photo: Fredy Knecht

He consented, but added: no praise!

In 1962, after a three-year internship drawing blueprints, and after finishing basic training, I came to the Zurich School of Applied Arts from Chur, and took a foundation class with Hansjörg Mattmüller. He was the homeroom teacher. After his third class with us – an event everyone always looked forward to – the skepticism of even the most vehement opponents vanished. Boys and girls loved him equally. He had given up his own painting, and encouraged every one of us individually by highlighting aspects of every student's personality, and drawing parallels with similar examples from art history. At the beginning of class older students made sure that potential pests behaved properly. Then, suddenly, always a little late, he made his entrance. It was as if the classroom had been custom-made for him, since it had no desk and the front part looked like a stage. With a "Hello, everybody!", a glowing face, and a few dancelike movements, he stood in front of us. He was always in motion when talking to us. He underscored his statements – all in the Bernese dialect – with the appropriate movements, squatting, pirouetting, falling backwards as if drunk and regaining his balance at the last moment.

Each theory class was dedicated to a separate artist, whom we had known only by name, and by some of their "boring" pieces – Albers, Piet Mondrian, etc. He showed us reproductions of their work and then asked for our opinion. At that time, the word "artist" was a curse word, and so we went at the pieces before us until they were leveled to the ground. Then Mattmüller handed out colored paper and invited us to try to do better. "You seem to know what to do", he would say, and disappear into the cigarette smoke of the teacher's lounge to recover. The smarter ones among us slowly realized how someone can either create excitement or spread boredom. Mattmüller gave every student the feeling he or she was special, and endorsed all kinds of mischief. If you had personal problems, you knew he could be counted on to help, even if you weren't necessarily right. He also organized trips into the contemporary art world, be it to the Biennale in Venice, the experimental film festival in Knokke or a working week in Guarda. His field trips were always interesting and there was nothing he didn't know. Old, serious art was approached with a lot of humor, without putting it down. He was a man of Happenings. He would have invented them if Kaprow or Oldenburg hadn't beaten him to it. He was great at organizing and delegating. He sparkled with happiness in the planning phases and whetted everyone's appetite for the upcoming ecstasy. Unfortunately, as happened with Dali's experiments, we rarely experienced it. A student's thoughtless words would destroy the whole thing. Then the glowing Mattmüller would fall into a deep depression and lock himself in. We would go home with hanging heads, burdened with a heavy conscience for not being sensitive enough to appreciate Mattmüller's experiments. It took some time for us to realize that there was nothing better than the anticipation. By then the year with Mattmüller was over and the next three years of classes were desolate and empty.

My main teacher for design and decoration at the Zurich School of Applied Arts was Willi Guhl, who, unfortunately, often simply lacked the time to teach us. About my skeletal furniture, he said: "Giger, you always make sick stuff that looks like a cow's neck!" Fortunately,

Students from the foundation class at the School of Applied Arts, Zurich. Rieterpark, Zurich, 1962. Second from the right: Hansjörg Mattmüller, first from the left: H. R. G.

in spite of his predictions, I never reached the plump-udder phase. His prophecy that I would end up working in one of the Swiss department stores, Globus or Jelmoli, has also, as of yet, not come true.

When I was around 20, a suicide wave broke out in Chur. Several younger acquaintances of mine died within a short time. One of them hung himself in the forest, another shot himself, the next stuck his head in the oven, and so on. One of my important friends was Markus Schmidt, who was a year older and the son of a strange priest. Schmidt was the one who originally told me about "Panderma", who played music from Brecht's "Threepenny Opera" and "Mahagoni" for me, and who encouraged me to paint. He became a guitar player in the political rock group "Floh de Cologne" (Flea of Cologne), for which I later designed posters and one album cover. After the first poster, "Force man out", the following article appeared in a daily German newspaper:

*For two days, there was a flea circus in Wuppertal – literally. It was "Floh de Cologne", a cabaret group from Cologne, and once again Friedrich Engels, the city's great unloved son, was proven right: In his time, he called the large industrial city in the mountains "Muckertal" (valley of hypocrites). Students from the newspaper "Junge Presse Wuppertal" (Young Press of Wuppertal) wanted to bring the group – which is not exactly renowned for its delicacy – to Wuppertal.*

*They had been planning their "Week of the Student Newspaper" for months, had invited radio and television and gotten permission from the principal of the Gymnasium Sedanstrasse (Sedanstrasse High School) to present a cabaret in the school's*

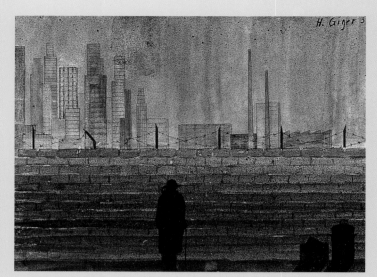

*Dream of New York, 1958. Poster paint and ink on paper, 20.5 x 28.1 cm*

*View from H.R.G.'s room at Alpina high school in Davos, 1958. Poster paint on paper, 24.8 x 34.7 cm*

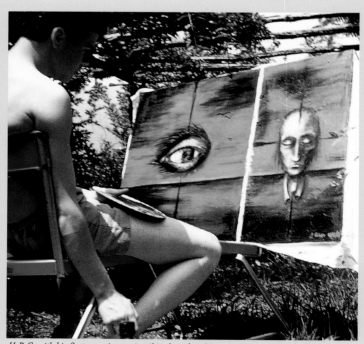

*H.R.G. with his first experiments in oil in the arbor, Morcote, Tessin, circa 1961*

*auditorium. Then he rescinded permission, on the grounds that the performance might contain obscenities.*

*Then the students secured the Yellow Room of City Hall, but the next day, the city withdrew its permission, on the grounds that the performance might contain obscenities. Or, as it was officially put: "There were no guarantees that only students above 18 years of age – the only ones to whom the Junge Presse, to be on the safe side, has sold its tickets, would be allowed to enter the hall. Refusing to engage in a fight with the morals patrol, the students finally rented a private hall.*

*Headmaster Tonn, the principal of the Sedanstrasse Gymnasium, had not anticipated having to deal with any obscenities. When "Floh de Cologne" sent him a poster, Headmaster Schorer (61), who was replacing the by-now ill Headmaster Tonn, couldn't find anything obscene either. Without another thought, he allowed the poster to be hung. Teachers and students walked past the poster and noticed nothing. Even the nuns from the St. Anna School had to learn from the newspaper that there was something amiss with the poster on the bulletin board.*

*Nothing happened until math teacher Hybel remembered having seen the portrayed object somewhere before. Yes, indeed, the central object bore a marked resemblance to an erect penis. Worse was the title: "Force man out." And the IUD below.*

*Teacher Hybel shamefacedly shared his discovery with his boss, who quickly assured him that he would not tolerate the newly identified organ on the wall. Schorer acted quickly. He had endless deliberations with teachers, parents and the students from "Junger Presse".*

His main concern: Would the show be as provocative as the poster? The students could not promise it wouldn't be. Now the outrage escalated. Parents feared for their children's morals. Thirty teachers – they couldn't get any more together on such short notice – decided unanimously: "This goes beyond permissible limits. We cannot tolerate something like this in our assembly hall." Schorer: "A show like this threatens our morals. I want to keep my school clean." Angelika Jung, from the executive committee of "Junge Presse", then asked the Real Estate Office if the Yellow Room of City Hall was available. The response: "So far no one has asked for it. We will pencil you in. If the Press and Advertising Office gives its authorization, you can go ahead." The Press and Advertising Office said yes, but things came to pass differently.

Deputy Finke, head of City Hall, read about the events at the Gymnasium Sedanstrasse in the newspaper the next morning. With sure instinct he sensed danger and called his colleague, social department head Platte, whom even his friends in the SPD (Social Democratic Party) consider a 19th century man with a Victorian sense of morality.

Both of them decided to hold a roundtable discussion on morals with Mayor Stelly, but he – politically skilled as always – was nowhere to be found. They had to make do with Deputy Mayor Schmeissing.

To find out what it was all about, Platte sent the city's Youth Administrator Schwung to the "Haus der Jugend" (House of Youth). Another poster was rumored to be hanging there. The Youth Administrator brought back the penis poster.

Seven hours before the show was supposed to start, the stu-

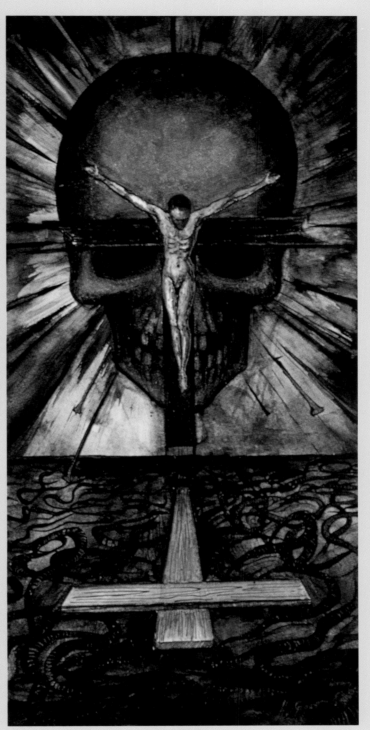

*Untitled, 1962. Poster paint and ink on paper, 19.9 x 9.8 cm*

*On the old Donau, Lobau by Vienna, 1962. Photo: H.R.G.*

dents knew only that they had to pay "Floh de Cologne" 600 DM for the gig. But they had no hall. The chairman had to improvise and rented a private auditorium. All this happened within a few hours. The show finally started one hour late.

There was one small consolation for the students: Four additional tickets were sold. In addition to Headmaster Schörr ("Now I'm interested in seeing what this is all about") and the criminal investigation department, an employee of the Youth Office took his seat in the hall. He was observed frantically writing down every relevant word coming from the stage.

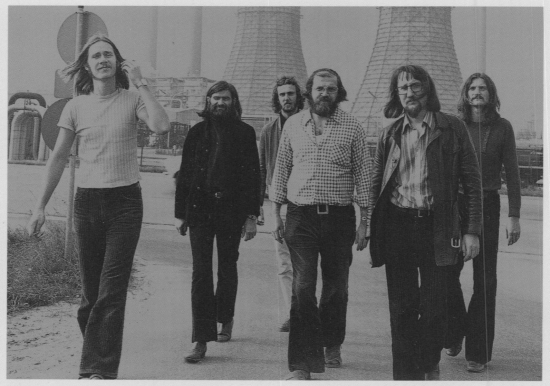

*The group "Floh de Cologne", with H.R.G.'s friend Markus Schmidt (second from left), called Filius, banjo player and lyricist, circa 1968*
*Photo: Margret Ann Wilde*

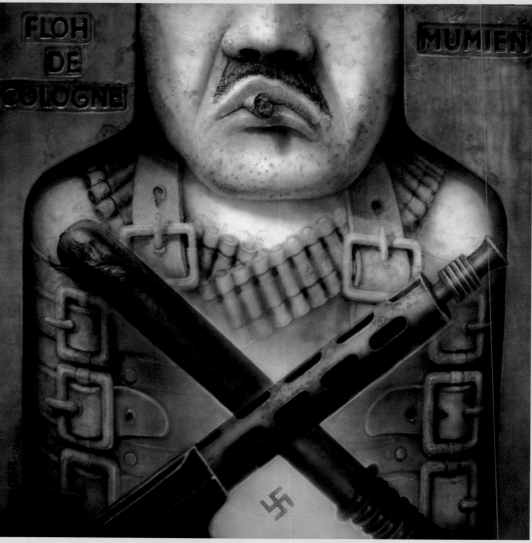

*Pages 16 and 17:*
*No. 463, New York City XIII, 1980, and No.*
*478, New York City XXVIII (Cross Oppo-*
*site), 1981. Acrylic and ink on paper,*
*100 x 70 cm*

*No. 253, Mummies, album cover for "Floh de Cologne", 1974. Acrylic and ink on paper, 68 x 68 cm*

*No. 86, poster for "Floh de Cologne". Silkscreen, 65 x 46 cm, 1967*

*No. 97, poster for "Floh de Cologne". Offset print b/w, dimensions unknown, circa 1968*

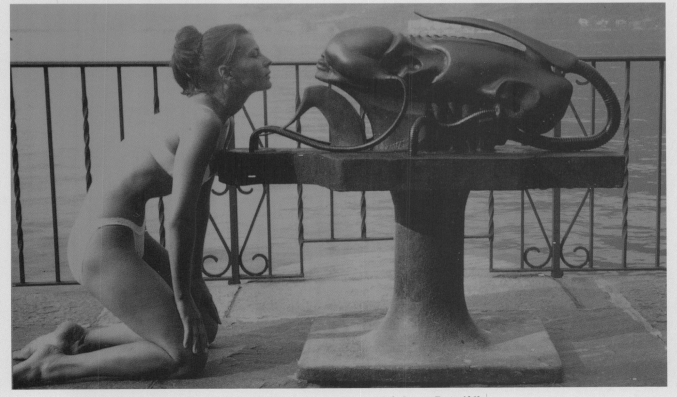

*Li with unfinished "Biomechanoid" sculpture, No. 106. Polyester, 102 x 52 x 120 cm, in Pojana on Lake Lugano, Tessin, 1969*

## Early Drawings

Anyone making a prediction about my future from the drawing shown below would never have believed that painting and drawing would become my life. At the time this drawing was done, I was a student at the sec-

*Self-portrait, 1954. Pencil and colored pencil on paper, 14.3 x 10.4 cm*

ond Gymnasium of the Canton School in Chur and was mainly interested in jazz. My art teacher Nigg sent me this self-portrait.

My father was against art. He called it a breadless profession. My father's negative attitude and my all-too-perfect sister, who excelled in all school subjects, challenged me to prove that I wasn't as worthless as bad students are usually thought to be.

I always drew and modeled in clay. My mother believed in me and showered me with painting utensils and modeling clay. At Christmastime, however, she made a present for my "Götti" (godfather) in my place. For me, it was always highly embarrassing to be

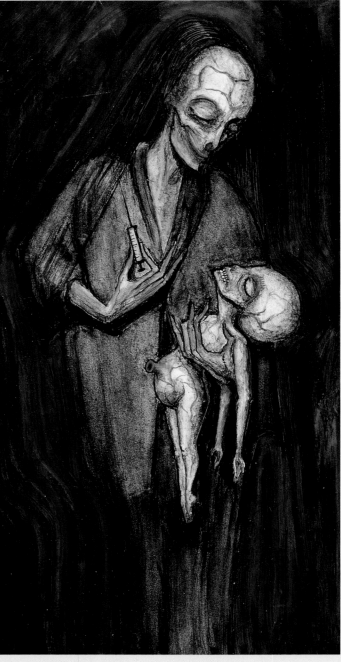

*Mother with child, 1962. Acrylic and ink on paper, 18.7 x 9.9 cm*

complimented for something I hadn't made. Admittedly, Mama's porcelain paintings of cartoon-like characters copied from Globi books were more attractive than my ghost train drawings or my painted clay miniatures of Basel carnival bands. For a time, I also made masks, which I affixed to paintings to form reliefs. I also made swords from files and made brass knuckles from lead using the lost wax method. Later, inspired by Markus Schmidt, I created posters and album covers for "Floh de Cologne". These were followed by illustrations for the magazines "Clou", "Schoengeist" and "Fallbeil". But the music of Miles Davis, John Coltrane and Erik Dolphi was still my primary passion. When I was 20, I painted my first oil paintings, inspired by Dalí, Oelze, Schröder-Sonnenstern and Bellmer...

*H.R. Giger*

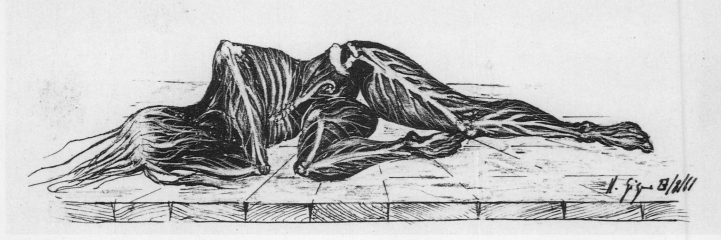

*Untitled, 1961. Ink on transcop, 10.6 x 17.7 cm*

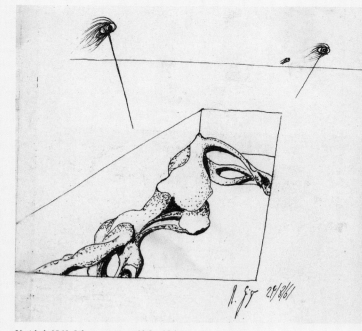

Untitled, 1961. Ink on transcop, 13.8 x 11.9 cm

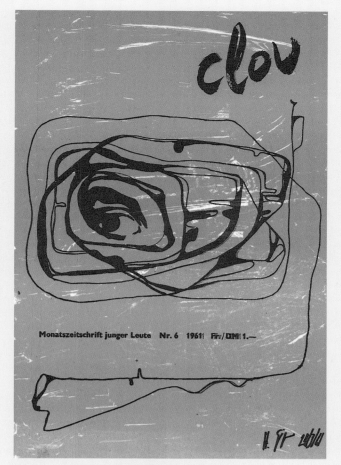

Monatszeitschrift junger Leute   Nr. 6   1961   Fr./DM 1.—

Cover for the monthly magazine "Clou" No. 6, 1961. 21.2 x 14.6 cm

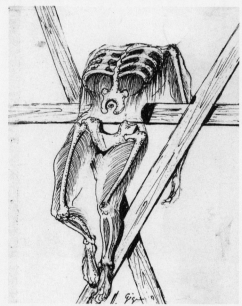

Untitled, 1961. Ink on transcop, 11.8 x 9.2 cm

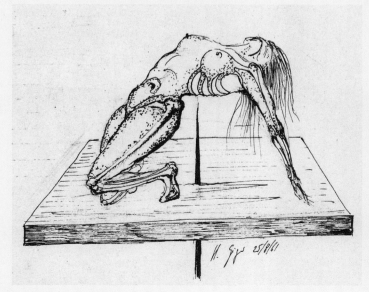

Untitled, 1961. Ink on transcop, 13.8 x 17 cm

Cover for the monthly magazine "Clou" Nos. 1/2, 1961. 21.3 x 14.2 cm

*Untitled, 1961. Ink on transcop, 29.7 x 21 cm*

*Untitled, 1961. Ink on transcop, 21 x 29.7 cm*

*Untitled, 1961. Ink on transcop, 21 x 29.7 cm*

*Untitled, 1964. Etching with aquatint on paper, 2nd condition, 37.7 x 26.6 cm*

*Birth Machine, Version I, 1964. Ink on transcop, 29.7 x 21 cm*

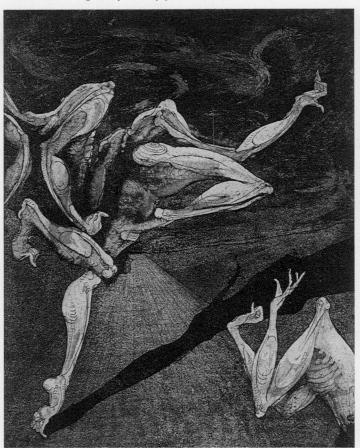

*Untitled, 1965. Etching with aquatint (2 colors) on paper, 37.7 x 26.6 cm*

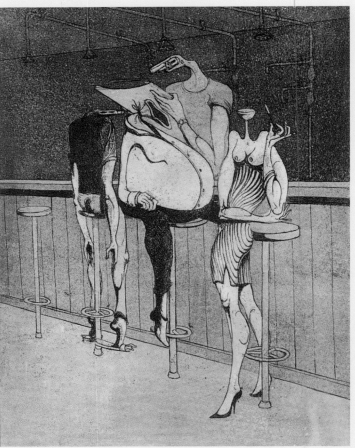

*A Feast for the Psychiatrist, 1964. Etching with aquatint on paper, 3rd condition, 37.7 x 26.6 cm*

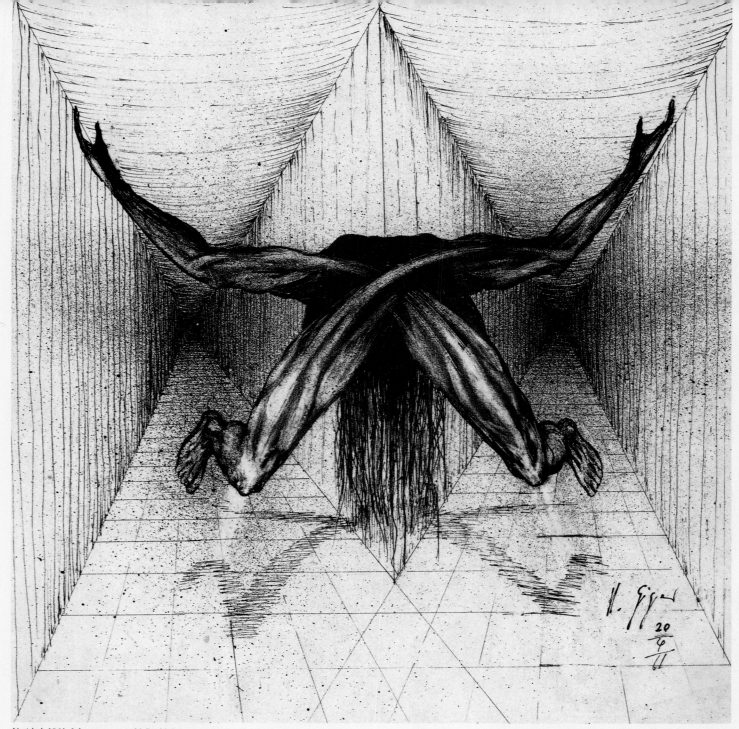

*Untitled, 1961. Ink on transcop, 20.7 x 20.5 cm*

*Untitled, 1961. Ink on transcop, 14.3 x 29.8 cm*

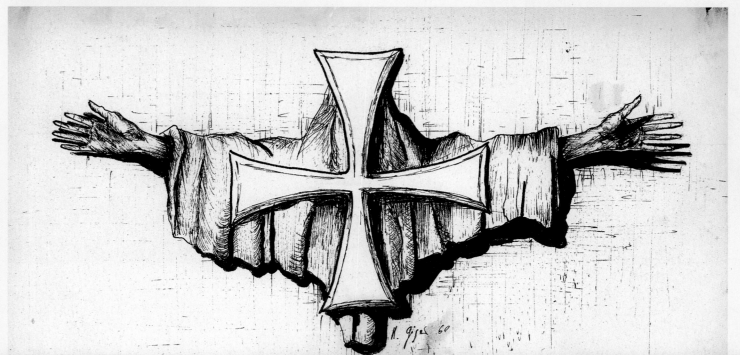

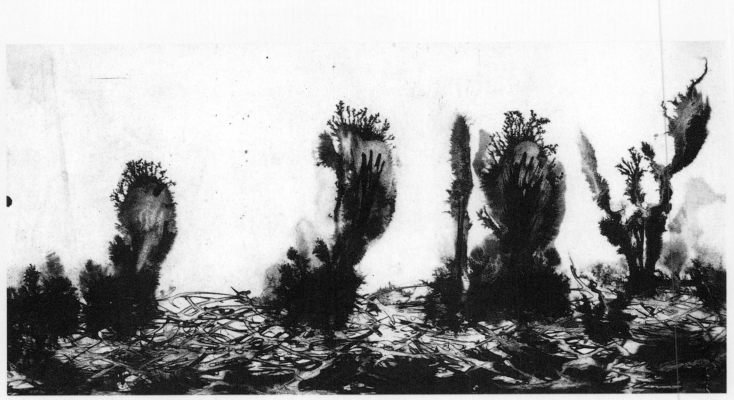

*Untitled, 1961. Ink on transcop, 14.2 x 28.8 cm*

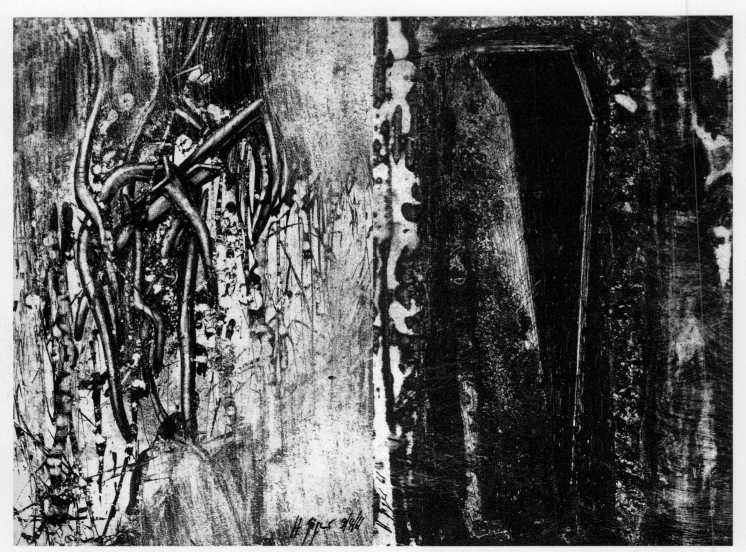

*Untitled, 1961. Ink on transcop, 21 x 29 cm*

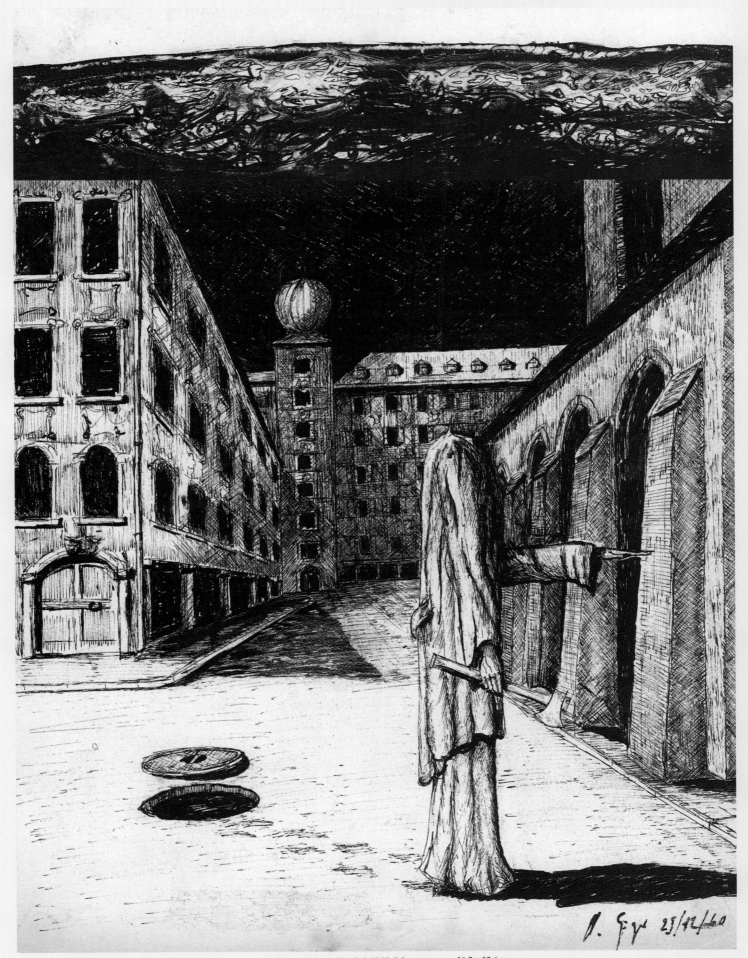

*Consisting of two works. Top: Untitled, 1961. Ink on transcop, 13.3 x 29 cm. Bottom: Untitled, 1960. Ink on transcop, 29.7 x 27.6 cm*

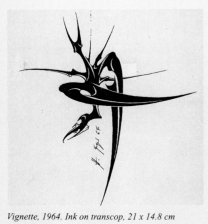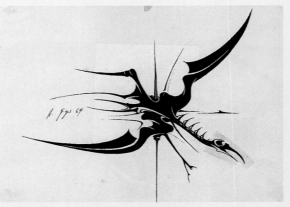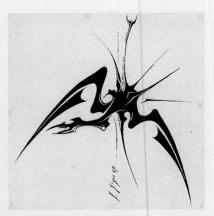

*Vignette, 1964. Ink on transcop, 21 x 14.8 cm*     *Vignette, 1964. Ink on transcop, 14.8 x 20.9 cm*     *Vignette, 1964. Ink on transcop, 15 x 15 cm*

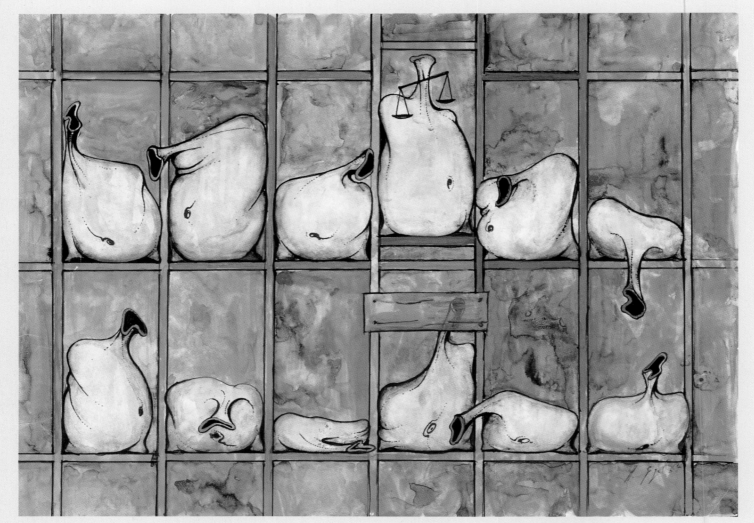

*Stage Set for the Just, 1964. Poster paint on paper, 20.8 x 29.7 cm*

*Vignette, 1964. Ink on transcop, 3.9 x 3.3 cm*

*Self-portrait, 1962. Ink on transcop, 15.3 x 20 cm*

*No. 4 of the series "Stockings", 1960.*
*Ink on paper, 29.7 x 21 cm*

*No. 6 of the series "Stockings", 1960.*
*Ink on paper, 29.7 x 21 cm*

*No. 2 of the series "Stockings", 1960.*
*Ink on paper, 29.7 x 21 cm*

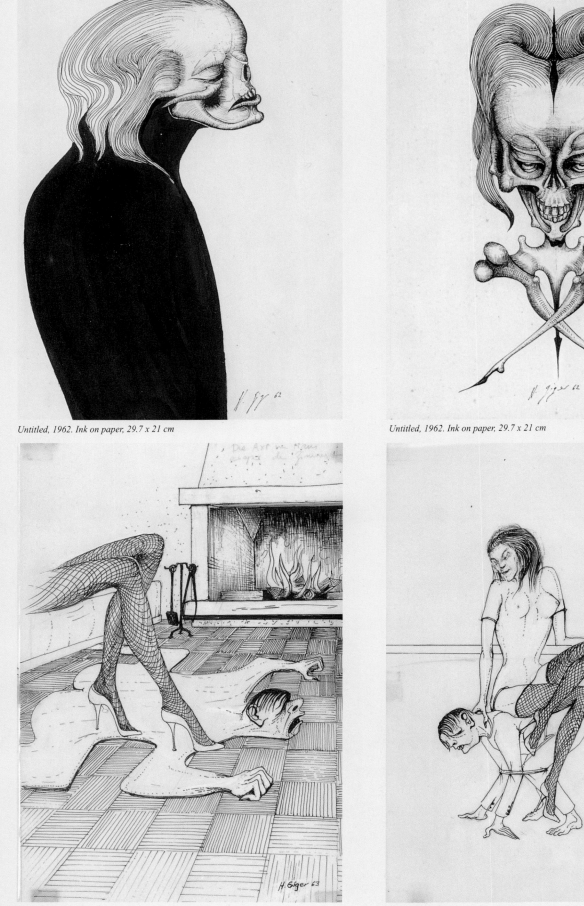

Untitled, 1962. Ink on paper, 29.7 x 21 cm

Untitled, 1962. Ink on paper, 29.7 x 21 cm

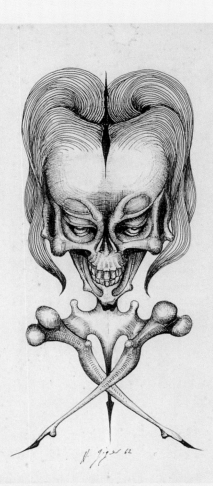

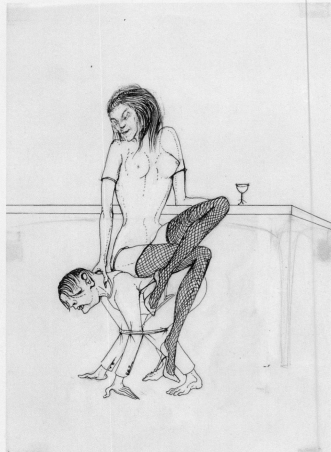

From the series "Stockings", 1963. Ink on transcop, 21 x 14.8 cm

From the series "Stockings", 1963. Ink on transcop, 21 x 14.8 cm

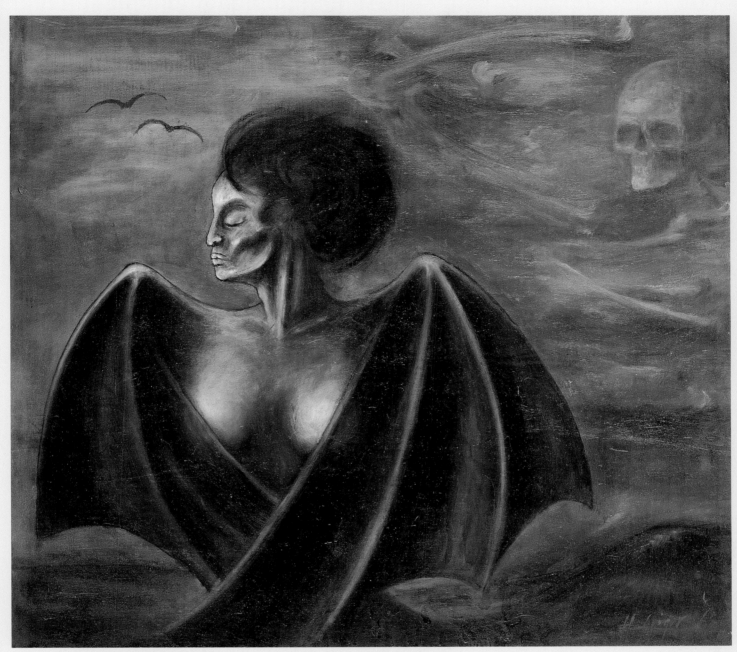

*No. 20, 1962. Oil on wood, dimensions unknown*

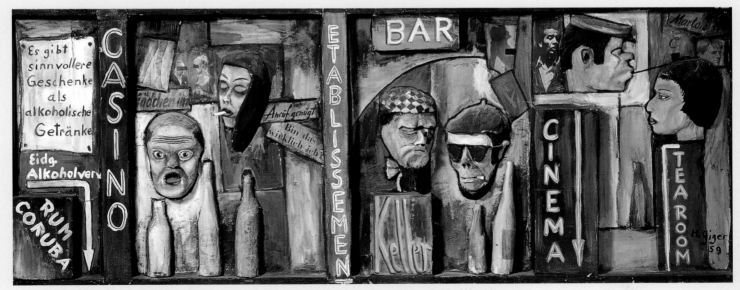

*Advertisement for Headache Remedies, Better Gifts than Alcoholic Beverages Exist, 1959. Acrylic on paper mach, 85 x 223 x 4.5 cm*

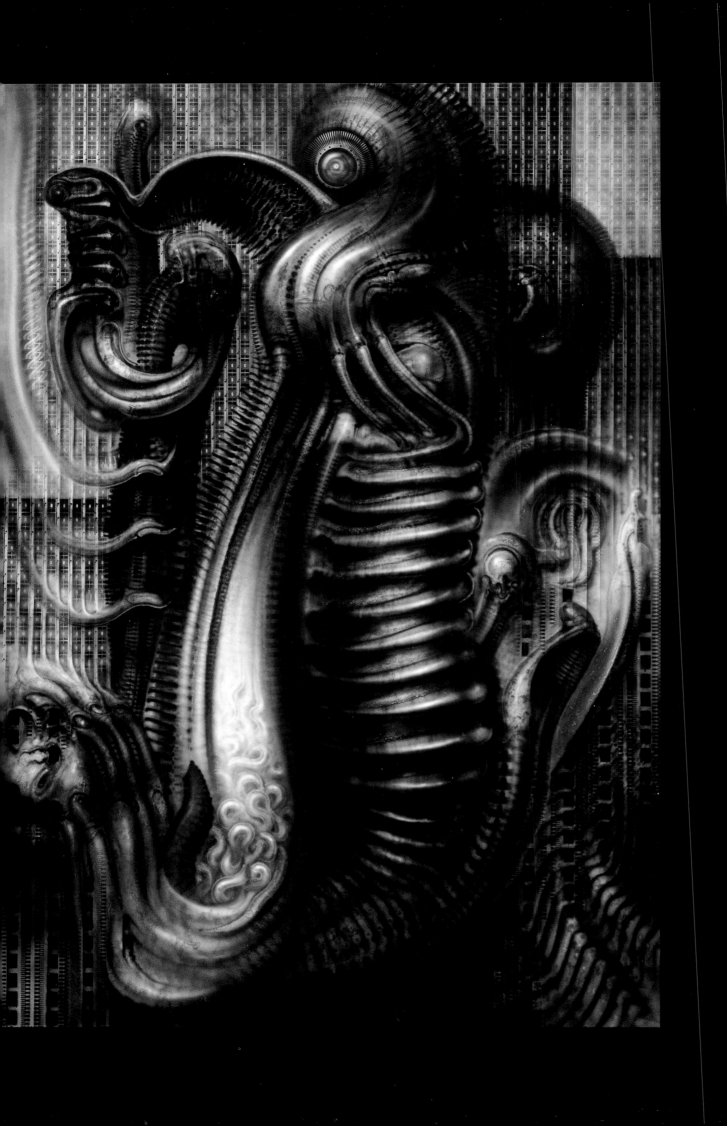

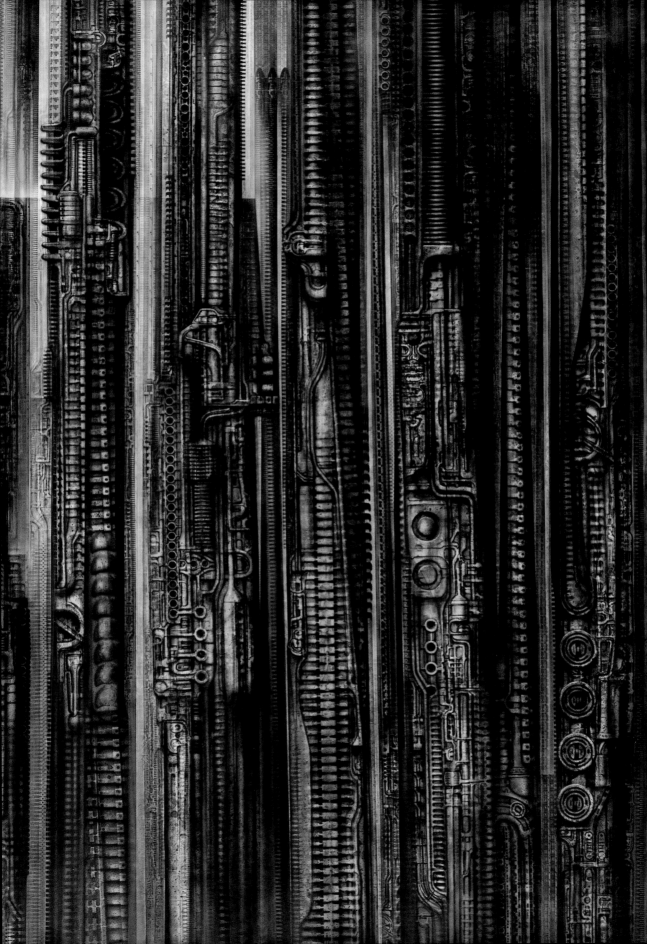

## A Feast for
## the Psychiatrist

This cycle of ink drawings on Transcop in DIN A4 format was created after some months of writing down my dreams and trying to analyze them according to the theories of Sigmund Freud. I discovered that the hours before going to bed were the decisive influence so I tried to affect my dreams by engaging in certain actions before retiring! I was pleased that my work confirmed Freud's theory; I also believed that any psychiatrist would interpret my dream drawings in the same manner and tell me what I wanted to hear, or already knew. My belief that any psychiatrist would understand my solid symbolism was the reason I titled the cycle: "A Feast (or a Gold Mine) for the Psychiatrist."

*H.R. Giger*

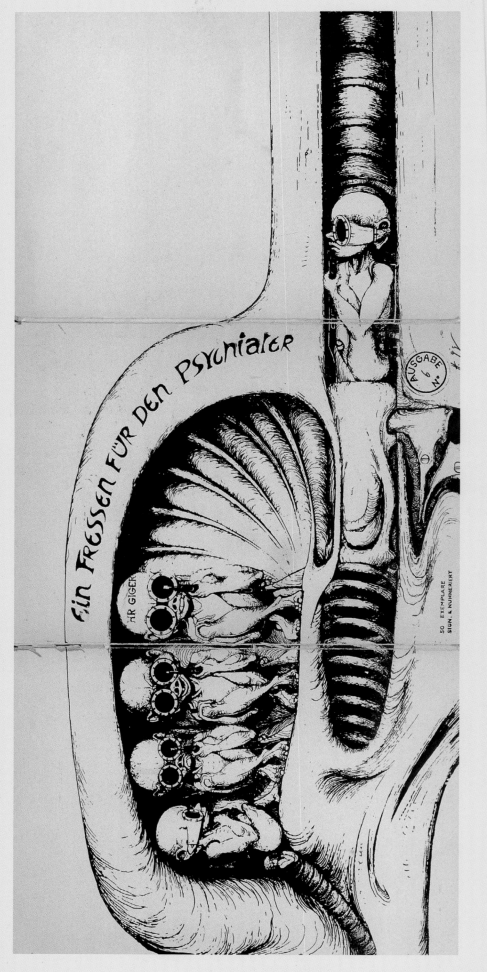

*Cardboard portfolio "A Feast for the Psychiatrist", cover: Birth Machine, 1966. Silkscreen, 93.2 x 43.9 cm, portfolio signed and numbered, edition of 50, contents of the portfolio: 12 DIN A4 Plandruck drawings, 42 x 31 cm (approx. 15 copies printed). Printing: H.R.G./Lichtpausanstalt Zürich*

*Page 30:*
*No. 455, New York City V (Embryo Growth), 1980. Acrylic and ink on paper, 100 x 70 cm*
*Page 31:*
*No. 475, New York City XXV, 1981. Acrylic and ink on paper, 200 x 140 cm*

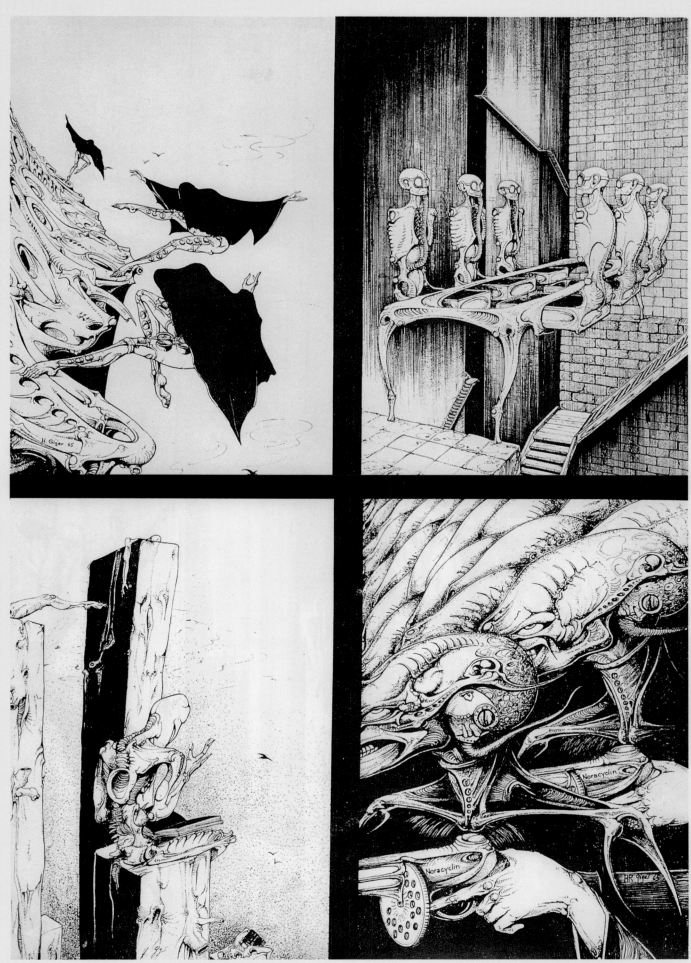

*4 of 12 prints in the cardboard portfolio "A Feast for the Psychiatrist", 1966. Drawings DIN A4 Plandruck, 42 x 31 cm (approx. 15 copies printed). Printing: H.R.G./Lichtpausanstalt Zürich, portfolio signed and numbered, in an edition of 50*
*Top left: No. 36, At the Abyss; top right: No. 43, Shaft No. 5; bottom left: No. 33, Waiting for Godot; bottom right: No. 40, Noracyclin (contraceptive pill)*

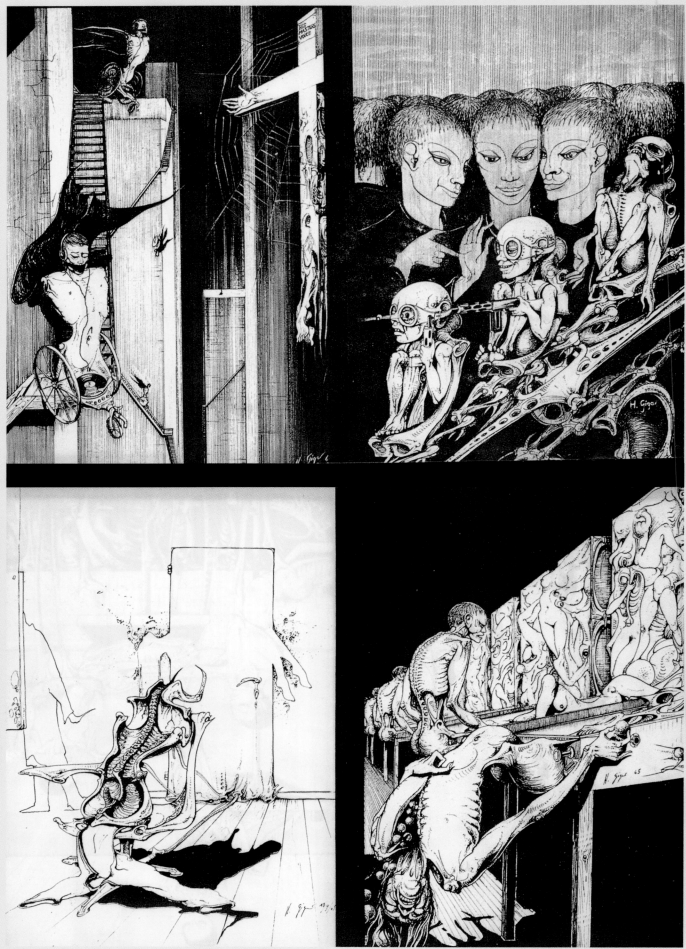

*4 of 12 prints in the cardboard portfolio "A Feast for the Psychiatrist", 1966. Drawings DIN A4, Plandruck, 42 x 31 cm (approx. 15 copies printed). Printing: H.R.G./Lichtpausanstalt Zürich, portfolio signed and numbered, in an edition of 50*
*Top left: No. 38, His Master's Voice; top right: No. 30, Supermarket; bottom left: No. 32, At the Doctor's; bottom right: No. 23, Tilt*

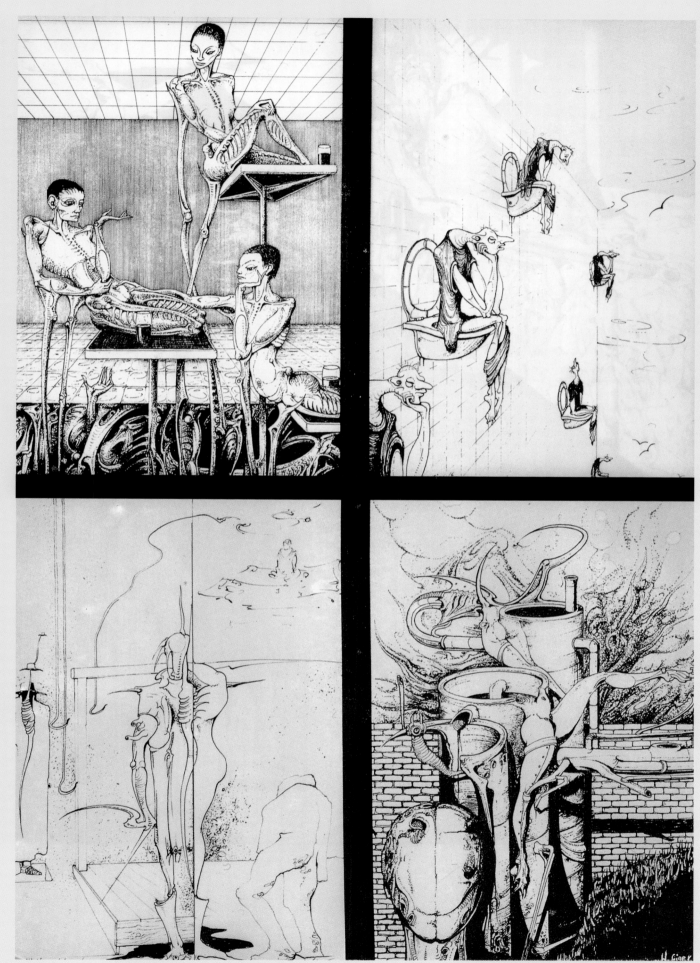

*4 of 12 prints in the cardboard portfolio "A Feast for the Psychiatrist". 1966. Drawings DIN A4, Plandruck, 42 x 31 cm (approx. 15 copies printed). Printing: H.R.G./Lichtpaus-anstalt Zürich, portfolio signed and numbered, in an edition of 50*
*Top right: No. 29, The Top Ten Thousand; top right: No. 28, Waiting for Godot; bottom left: No. 31, Christmas for the Psychiatrist; bottom right: No. 41, Sewage Treatment Plant*

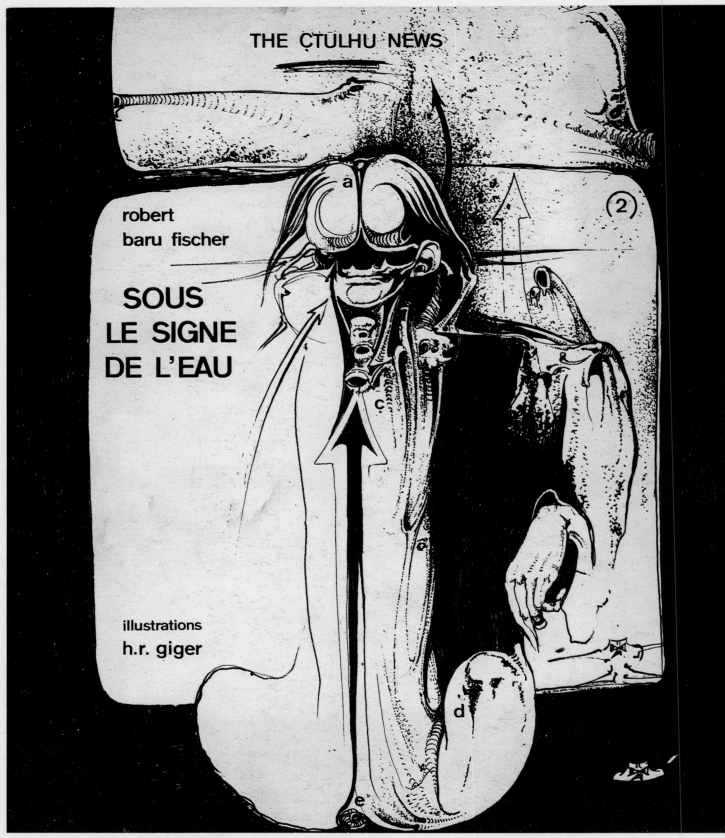

Illustration for "Cthulhu News 2", No. 44, The Cthulhu (cover), 1966. Ink on transcop, 23.8 x 20.7 cm

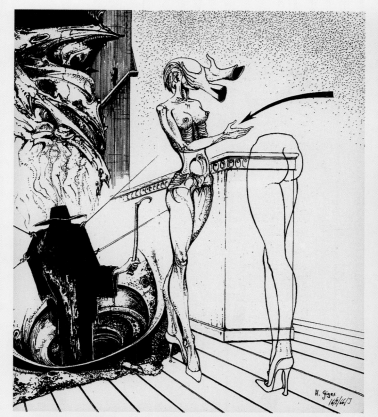

*Illustration for "Cthulhu News 2", No. 45, Phantôme de l'opera (Hommage à G. Leroux), 1966. Ink on transcop, 23.8 x 20.7 cm*

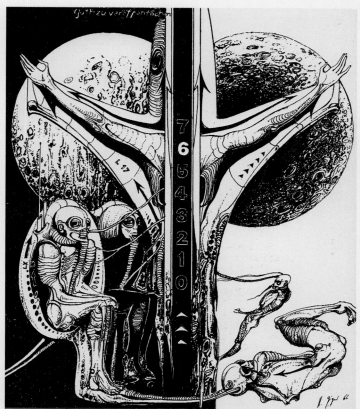

*Illustration for "Cthulhu News 2", No. 46, The Attempt to Announce a New God, 1966. Ink on transcop, 23.8 x 20.7 cm*

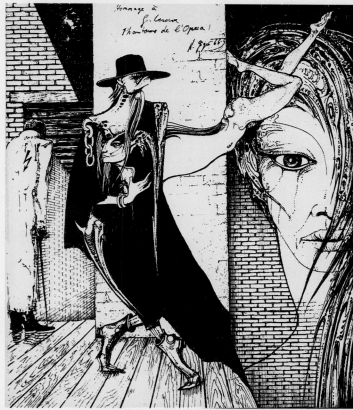

*Illustration for "Cthulhu News 2", No. 47, Phantôme de l'opera (Hommage à G. Leroux), 1966. Ink on transcop, 23.8 x 20.7 cm*

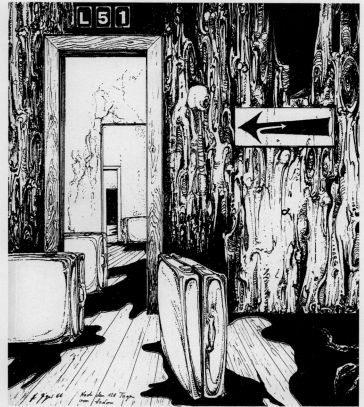

*Illustration for "Cthulhu News 2", No. 48, After the 120 Days of Sodom, 1966. Ink on transcop, 23.8 x 20.7 cm*

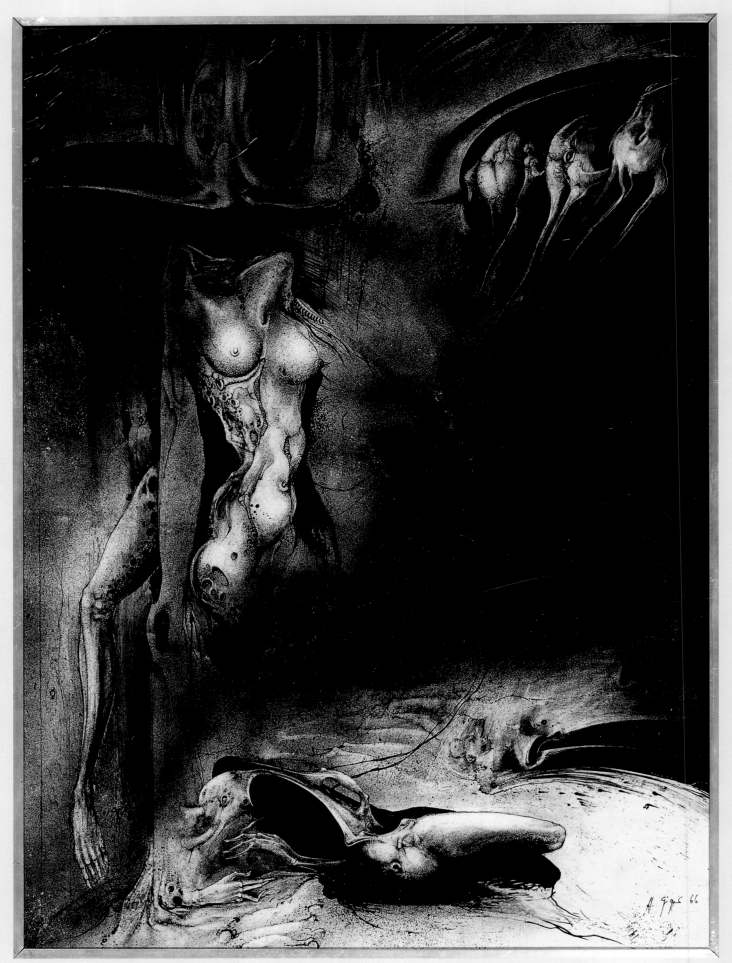

*No. 68, Organic Matter III, 1966. Ink on transcop on paper/wood, 80 x 63 cm*

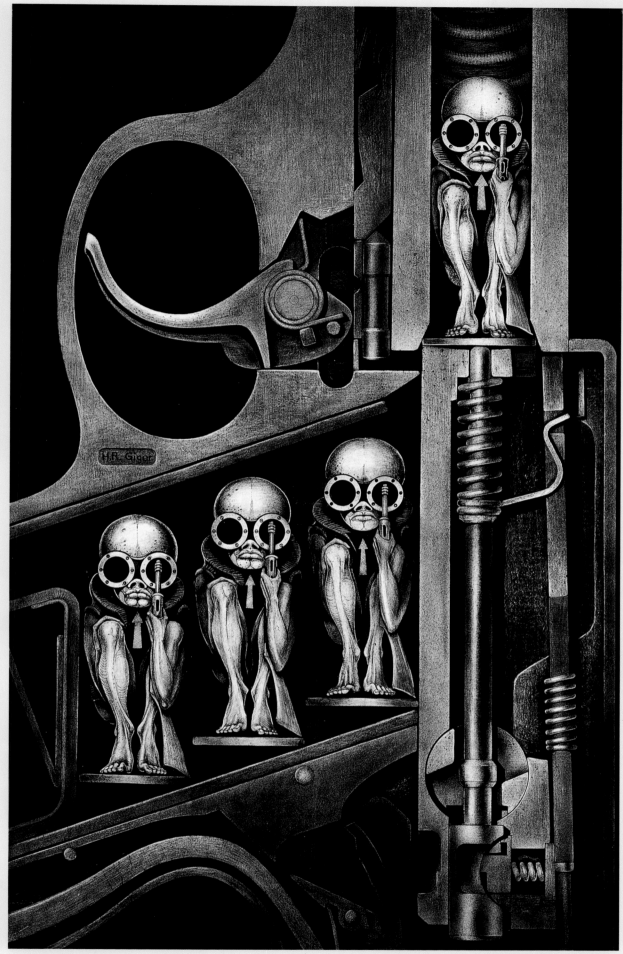

*No. 85, Birth Machine, 1967. Ink on transcop on paper/wood, 170 x 110 cm*

## Early Experiments in Oil

Anyone who tries his hand at art sooner or later is confronted with the prospect of painting in oil. For me, personally, oil painting is just too slow. Also, since I never received instruction in the subject, I never developed the right technique. Nevertheless I created some acceptable works, all of them hanging in state museums or banks. Between 1969 and 1971, I utilized a self-taught method, wherein I thinned the paints with benzene to achieve certain desired effects (see page 43).

Some years prior, around 1960/61, I created the first pieces, which have – with few exceptions – all disappeared in Chur. Gulf Juvalta, an old school friend, who used the paintings in a play around 1962, later told me that the paintings wound up in the attic of the City Hall with the other theater props, and were probably thrown out when it was renovated. That is why only black and white photographs of these predominantly red attempts, painted in the surrealistic style, remain, along with the Dracula Painting (page 29) and a few pieces in poster paint.

*H. R. Giger*

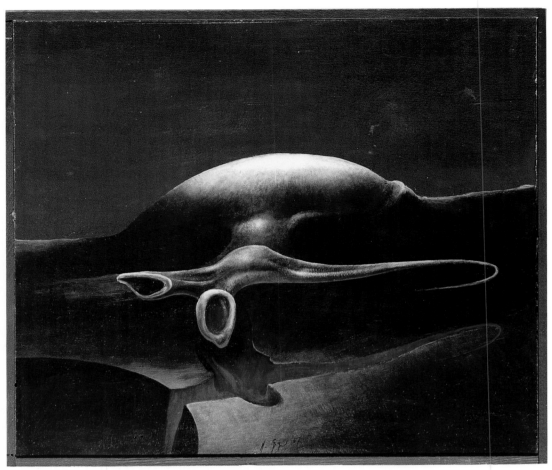

*No. 82, Landscape, 1967. Oil on cardboard, 46 x 53 cm*

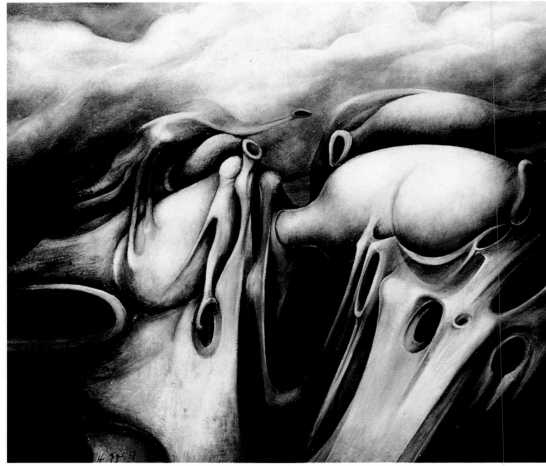

*No. 84, Landscape, 1967. Oil on cardboard, 46 x 54 cm*

40

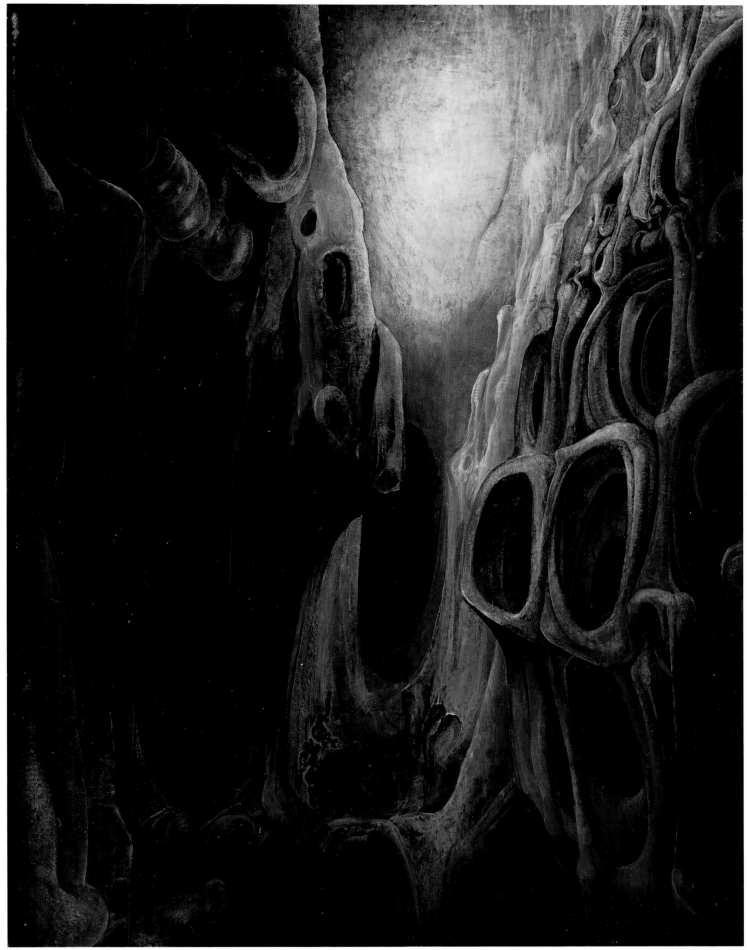

*No. 115, Landscape, 1967–69. Oil on cardboard, 41 x 32 cm*

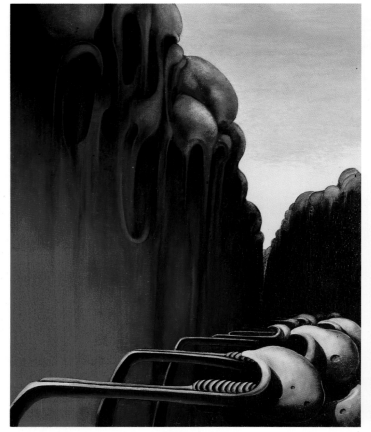

*No. 80, Landscape, 1967–69. Oil on cardboard, 46 x 38 cm*

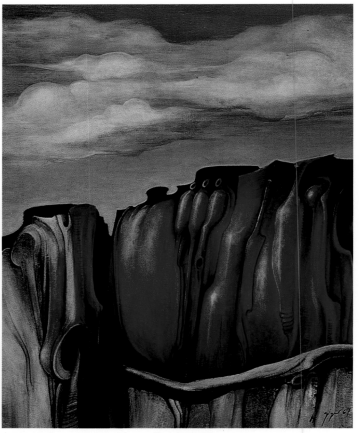

*No. 81, Landscape, 1967–69. Oil on cardboard, 46 x 38 cm*

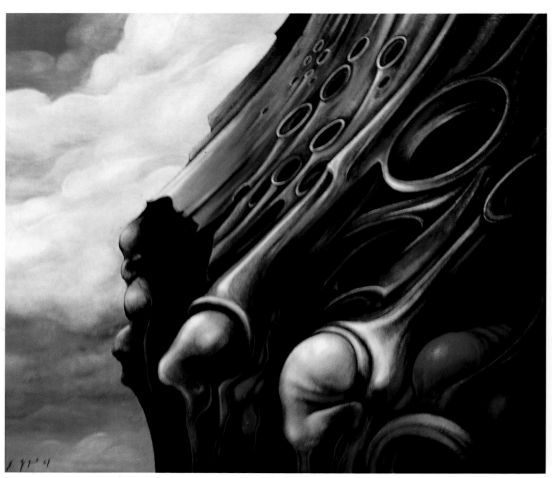

*No. 83, Landscape, 1967. Oil on cardboard, 46 x 54 cm*

*Page 43:
No. 114, Head III,
1969. Oil on
cardboard,
54 x 46 cm (detail)*

*Pages 44 and 45:
No. 466, New York
City XVI (Baseraker),
1980, and No. 461,
New York City XI
(Exotic), 1980. Acrylic
and ink on paper,
100 x 70 cm*

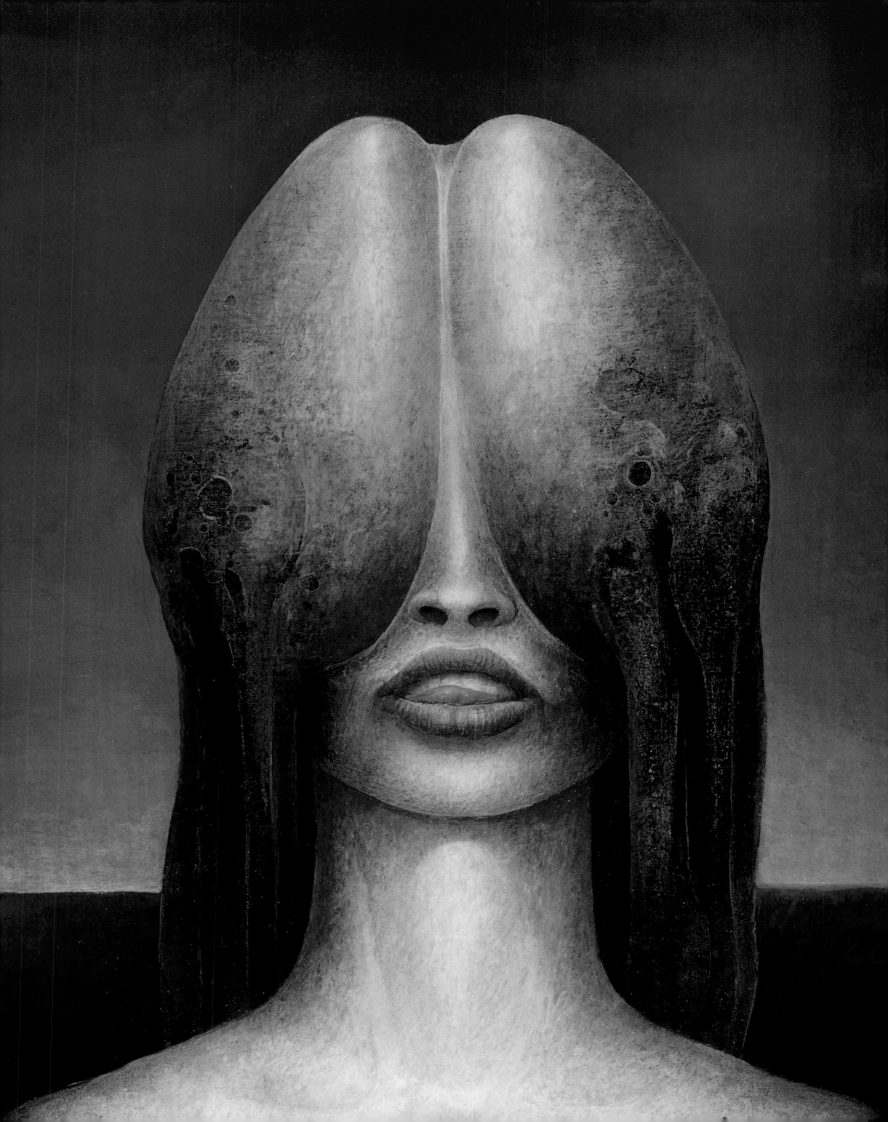

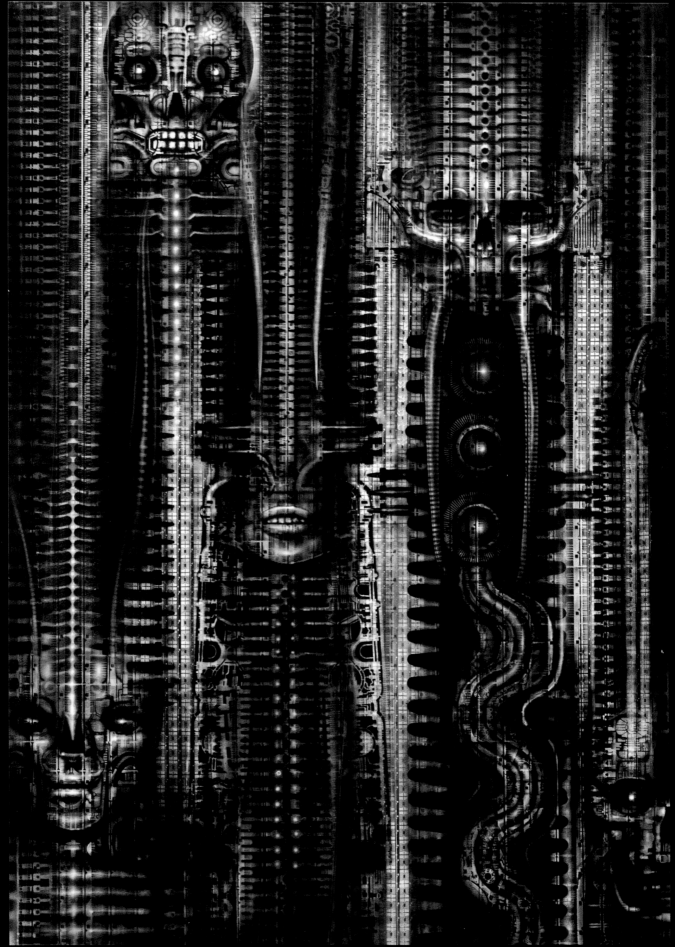

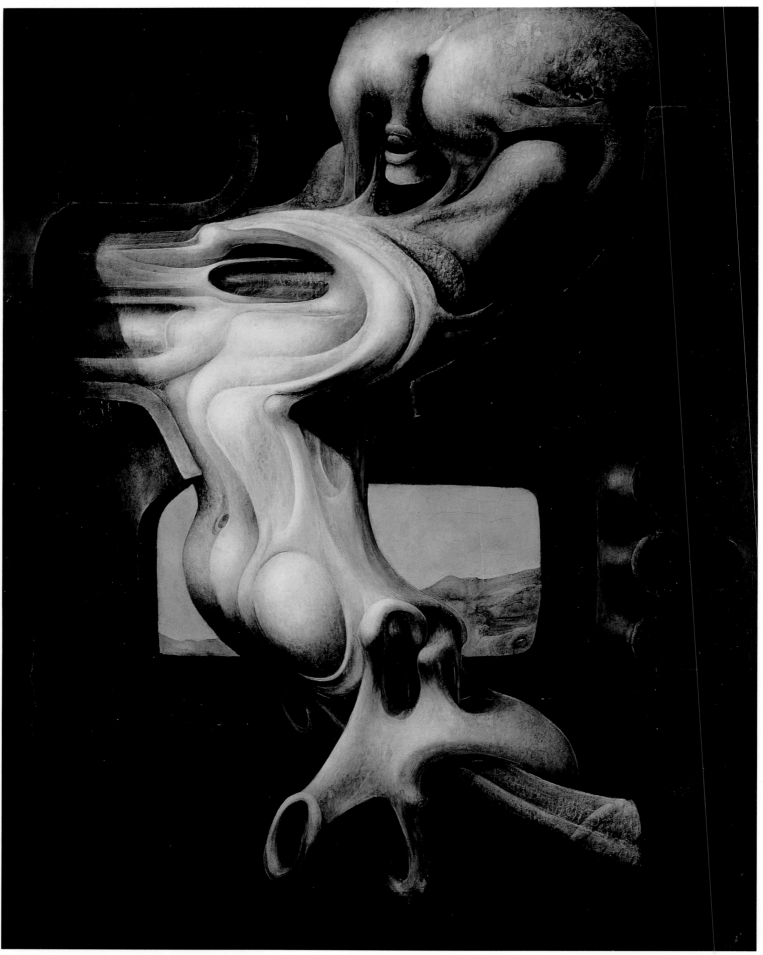

*No. 93, Hommage to S. Beckett I, 1968. Oil on wood, 100 x 80 cm*

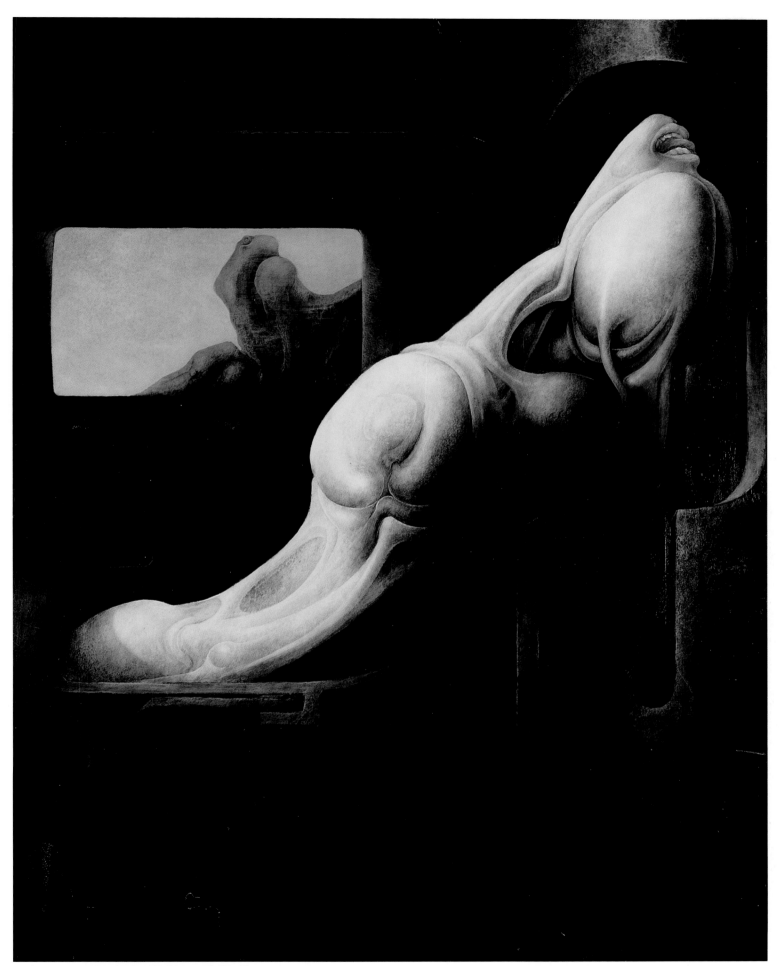

*No. 94, Hommage to S. Beckett II, 1968. Oil on wood, 100 x 80 cm*

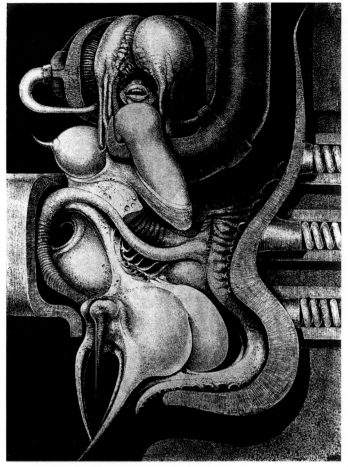

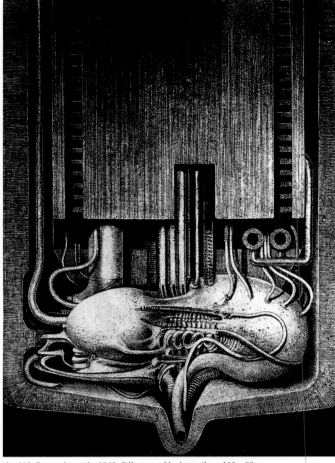

*No. 100, Biomechanoids, 1969. Silkscreen, black on silver, 100 x 80 cm*

*No. 103, Biomechanoids, 1969. Silkscreen, black on silver, 100 x 80 cm*

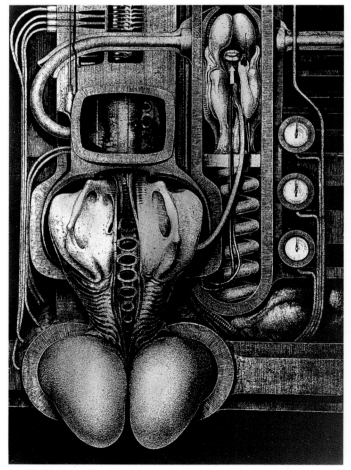

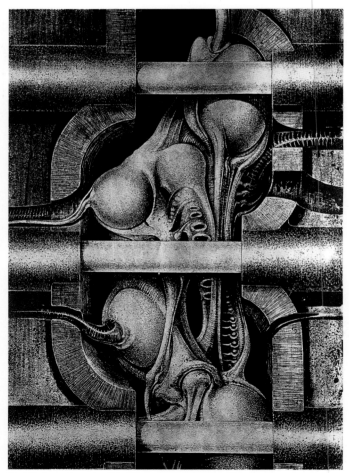

*No. 104, Biomechanoids, 1969. Silkscreen, black on silver, 100 x 80 cm*
*Nos. 98–105: Portfolio of eight silkscreens, black on silver, edition 100 + XX,*
*signed, Edition Bischofsberger, Zurich*

*No. 105, Biomechanoids, 1969. Silkscreen, black on silver, 100 x 80 cm*

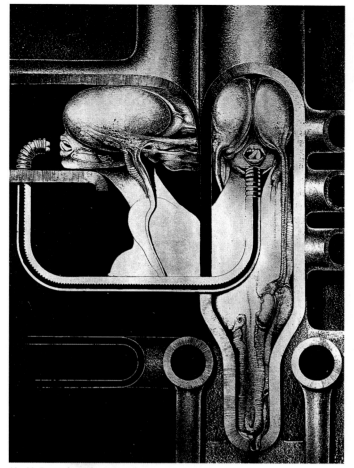

*No. 98, Biomechanoids, 1969. Silkscreen, black on silver, 100 x 80 cm*

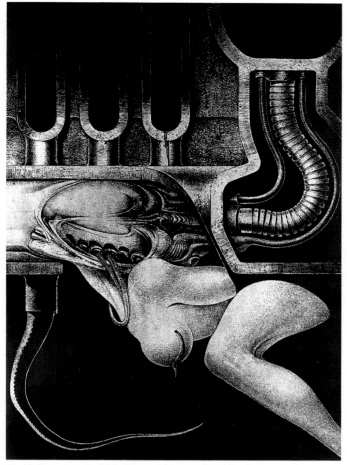

*No. 99, Biomechanoids, 1969. Silkscreen, black on silver, 100 x 80 cm*

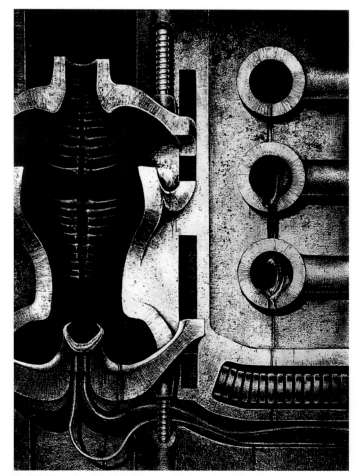

*No. 102, Biomechanoids, 1969. Silkscreen, black on silver, 100 x 80 cm*

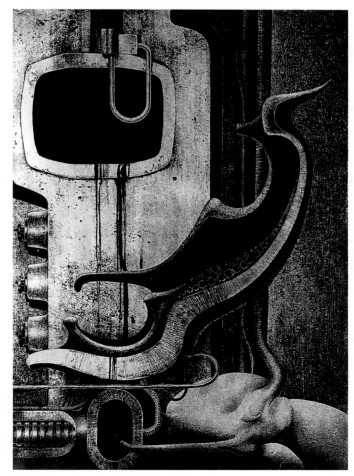

*No. 101, Biomechanoids, 1969. Silkscreen, black on silver, 100 x 80 cm*

## Leslie Barany

One of my closest American friends is my agent Leslie Barany. Leslie is the kind of agent one dreams about: he is loyal to the bone. He knows how I function and understands my needs as an artist. Over the years, he has become a close and trusted confidant. I can't imagine how it would be without him and our daily conversations. Due to the time difference and because he works late evenings, as I do, he is always there for me, even in the middle of the night.

Leslie is friend, helper, editor, art director, photographer, legal advisor, troubleshooter, champion, and art collector, all in one person. He is one of the most precise and correct people I know, and he is also painfully honest.

When journalists contact him looking to do an article about me, he is generous with his time and his energy. He provides so much assistance, information and material, that the final result often becomes a much longer cover feature story, which benefits everyone involved. As my dedicated advocate, he defends me so zealously that I almost have to apologize. He does it all with heart.

He moves among many worlds and, as a result, has introduced my work to a unique mix of creative people over the years. Some of them are shown in these pages as part of a project he has organized, photos of prominent personalities in my Harkonnen Chair.

He is now working on a book entitled "H. R. Giger Under Your Skin". Collectors of Giger-tattoos with good-quality color transparencies are asked to send them to Leslie Barany Communications in New York.

*H. R. Giger*

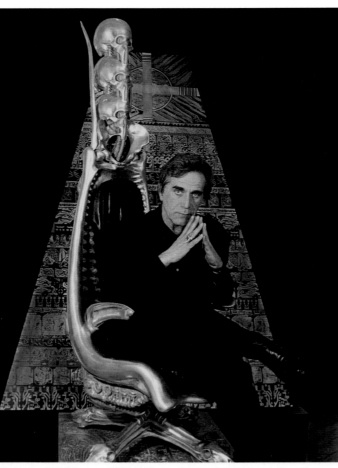

*Leslie Barany, H.R.G.'s agent, (ARh+ Publications) in H.R.G.'s Harkonnen Capo Chair, In background: "Ra" sculpture, 1987, by Theo Kamecke. Photo: © 1995, Amy Ardrey*

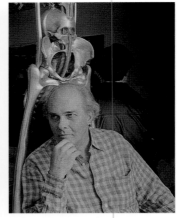

*Theo Kamecke, sculptor/filmmaker, N.Y.C. Photo: © 1995, Chris Lamb*

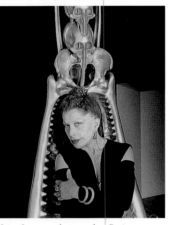

*Irina Ionesco, photographer, Paris Photo: © 1995, Chris Lamb*

*Neke Carson, artist, N.Y.C. Photo: © 1995, Chris Lamb*

*Mark Kostabi, artist, N.Y.C. Photo: © 1995, Chris Lamb*

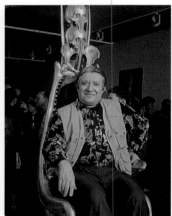

*Valery Oisteanu, poet, N.Y.C. Photo: © 1995, Chris Lamb*

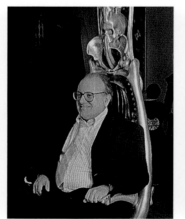

*Debbie Ullman, art director, International Tattoo Art, N.Y.C. Photo: © 1995, Chris Lamb*

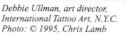

*Edgar David Grana, composer, N.Y.C. Photo: © 1995, Chris Lamb*

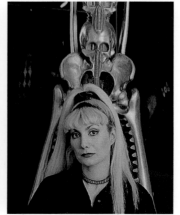

*Marjan Moghaddam, artist, N.Y.C. Photo: © 1995, Chris Lamb*

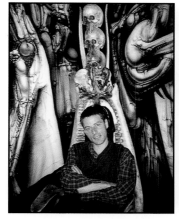

Burkhard Riemschneider, editor, Benedikt
Taschen Verlag. Photo: 1996, H.R. Giger

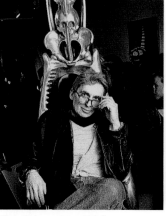

Joe Coleman, artist, N.Y.C.
Photo: © 1995, Chris Lamb

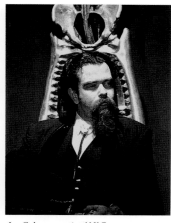

Chris Stein, musician, N.Y.C.
Photo: © 1995, Chris Lamb

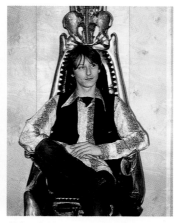

Hubert Röhling, owner of an aluminium
Capo Chair. Photo: © 1996, Königshofer

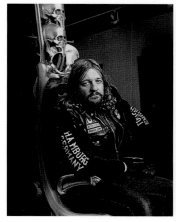

Steve Bonge, photographer/Hells Angel,
N.Y.C. Photo: © 1995, Chris Lamb

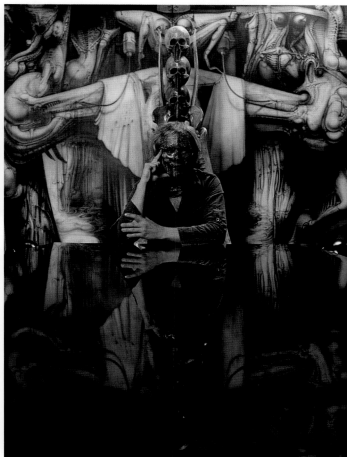

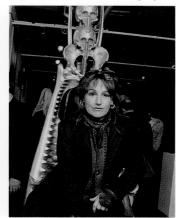

Andrea Elston, tattooist, N.Y.C.
Photo: © 1995, Chris Lamb

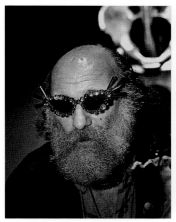

Ira Cohen, poet/photographer (Living
Theatre), N.Y.C. Photo: © 1993, E. Blotnick

H.R. Giger, Zurich, in the original Harkonnen Capo Chair (made of plaster, bones and a
Bertoia chair). Photo: © 1983, Zumbrunn

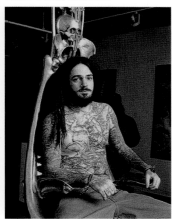

Rick Healy, "the living Giger museum",
N.Y.C. Photo: © 1995, Chris Lamb

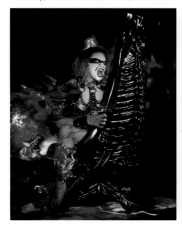

Danyelle, as "Slymenstra Hyman" of Gwar,
Richmond, Virginia
Photo: © 1994, Robin Perine

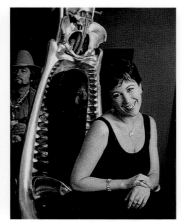

Annie Sprinkle, sex guru, performance
artist, N.Y.C. Photo: © 1995, Chris Lamb

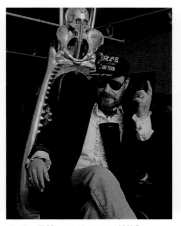

Spider Webb, artist/tattooist, N.Y.C.
Photo: © 1995, Chris Lamb

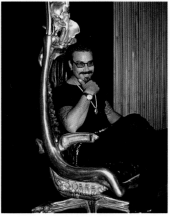

Jonathan Shaw, tattooist, N.Y.C.
Photo: © 1995, Steve Bonge

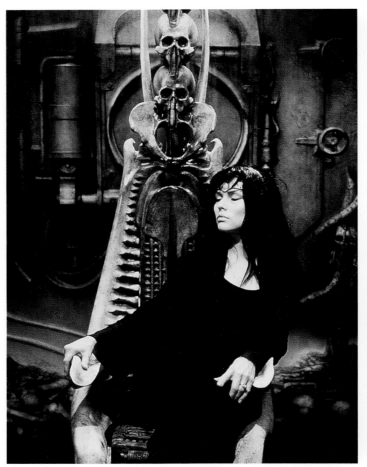

*Debbie Harry (Blondie), musician, during the production of the rock video "Koo Koo" in Switzerland. Photo: © 1981, Chris Stein*

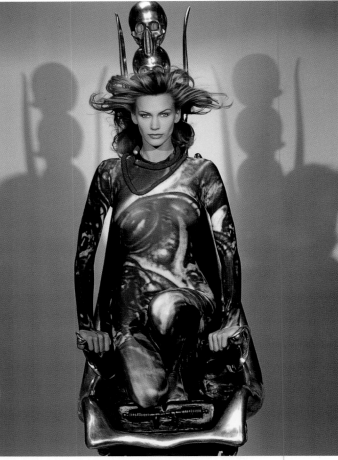

*Natasha Henstridge, actress, the extraterrestrial role of "Sil" in "Species" (1995 MGM), N.Y.C. Photo: © 1995, Roy Volkmann, art director: Leslie Barany*

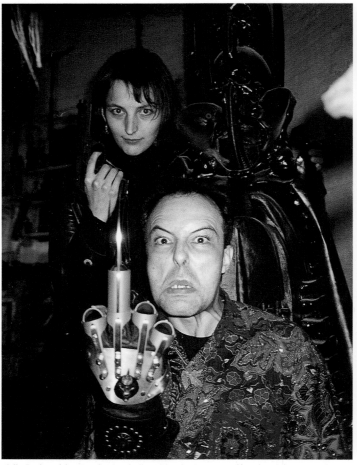

*Jello Biafra, of the "Dead Kennedys", and Sandra Beretta, in Chris Stein's home, N.Y.C. (H.R.G. poster in the DK-LP titled "Frankenchrist"). Photo: © 1993, Leslie Barany*

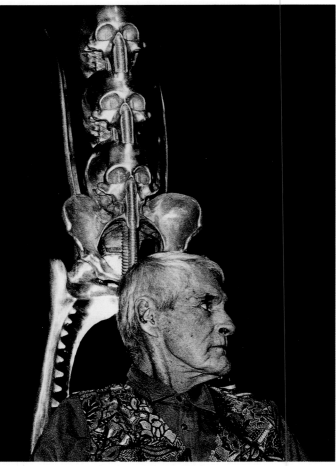

*Timothy Leary, writer, Harvard professor, LSD guru, N.Y.C. Photo: © 1993, Ira Cohen*

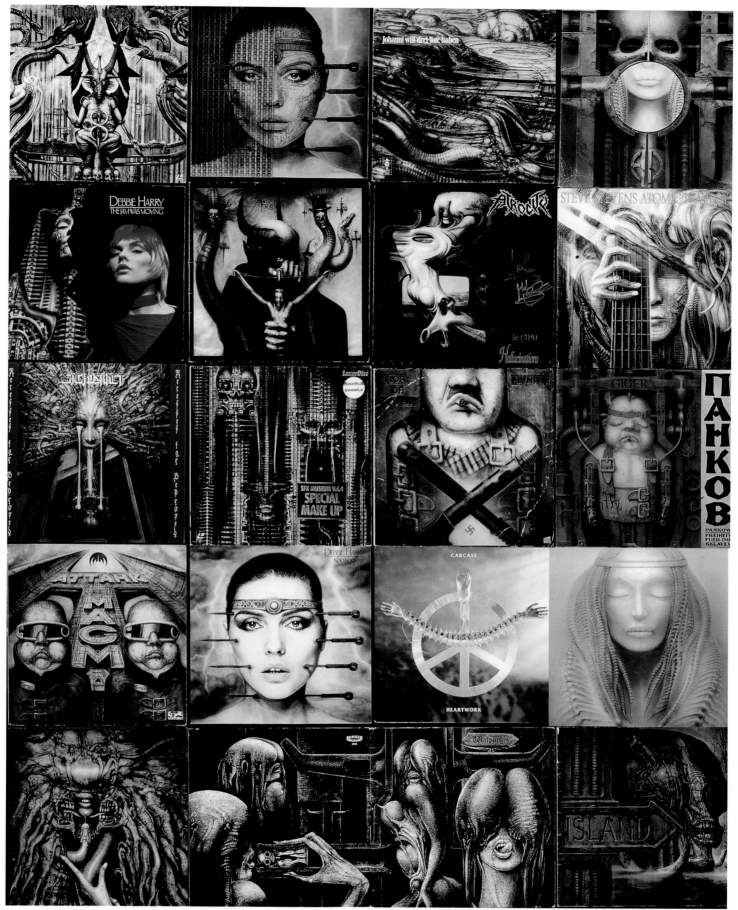

1st row, l-to-r: 1. Necronomicon by H.R.G. and J.J. Wittmer, 1975; 2. Debbie Harry: Koo Koo, inside cover; 3. Oser, Weber, Bürder: Johanni Wants Three Dead, 1980; 4. Emerson, Lake and Palmer: Brain Salad Surgery, 1973

2nd row, l-to-r: 1. Debbie Harry: The Jam Was Moving, 1981; 2. Celtic Frost: To Mega Therion, 1985; 3. Atrocity: Hallucinations, 1990; 4. Steve Stevens: Atomic Playboys, 1989

3rd row, l-to-r: 1. Sacrosanct: Recesses for the Depraved, 1991; 2. SFX-Museum, Vol. 4, laserdisc, 1981; 3. Floh de Cologne: Mummies, 1974; 4. pankow: Freedom for the Slaves, 1987

4th row, l-to-r: 1. Magma: Attahk, 1978; 2. Debbie Harry: Koo Koo, 1981; 3. Carcass: Heartwork, 1993; 4. Emerson, Lake and Palmer: Brain Salad Surgery, 1973, inside cover

5th row, l-to-r: Danzig III: How the Gods Kill, 1992; 2. Walpurgis, 1969, back and front cover (first album-cover ever designed by H.R.G.); 3. Island: pictures, 1977

The covers of Debbie Harry: Koo Koo, 1981, and Emerson, Lake and Palmer: Brain Salad Surgery, 1973, were chosen as two of the top 100 best covers of the century by Rolling Stone Magazine

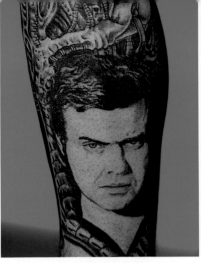
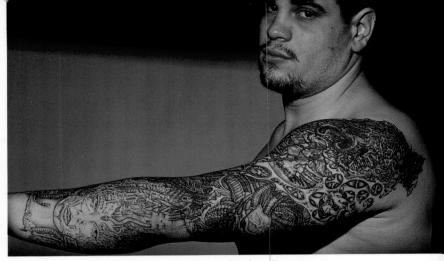

# Tattoos

Tattooing is an underground art. I started paying attention to it only when I was shown images of my old paintings (mostly the airbrushed ones) on people's arms, legs, backs or other parts of their bodies. I was truly astonished when, at a tattoo convention near New York, Paul Ivanko pulled up his pant leg to reveal my portrait on his calf. Since then, I look through all the tattoo magazines to find new variations, which Leslie Barany in New York is collecting for the forthcoming book, "H. R. Giger Under Your Skin". My favorite science-fiction writer, William Gibson, the author of such books as "Necromancer" and "Mona Lisa Overdrive", immortalized my works as blueprints for tattoo artists in his novel "Virtual Light", in a conversation in a tattoo shop in the future: "'Lowell... he's got a Giger.' 'Giger'? 'This painter. Like nineteenth-century or something. Real classical. Biomech.'" It seems that the word "bio-mechanical", a term I coined to describe many of my paintings, in tattooing has come to represent a futuristic style in which the body is shown as transparent, revealing that we are all robots under the skin. I admire and respect the people who wear these tattoos. They are the sincerest fans of my work because they collect for pleasure, not for profit. As living bearers of my work, almost like exhibits in an open-air museum, they are not locked away in safes as so often happens with valuable art. Not yet, at least.

*H. R. Giger*

*Paul Ivanko, tattoo by Elio España, East Side Inc., N.Y.C. Photo: © 1995, Kelly Brill*

*Richard Rosa, tattoo by Bob Murdock, Rainbow Body Art, Waterbury, Connecticut Photo: © 1996, Kelly Brill*

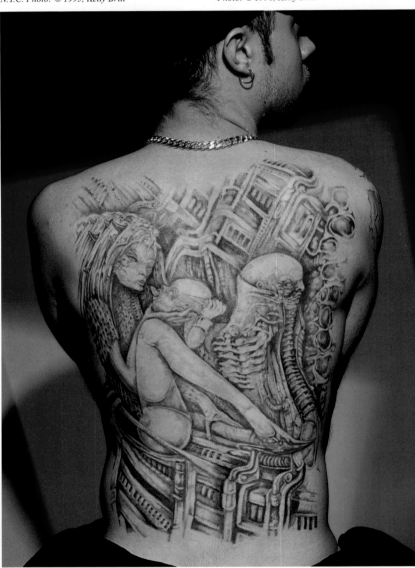

*Anthony Schiavo, tattoo by Andrea Elston, East Side Inc., N.Y.C. Photo: © 1996, Kelly Brill*

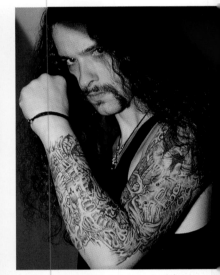

*Jack Paul (Mortal Remains), tattoo by Mike Maney, N.Y.C. Photo: © 1996, Kelly Brill*

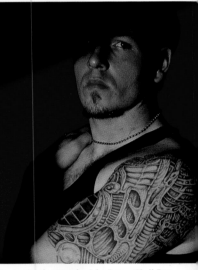

*Bennet Smith, tattoo by John Peters, Skull Duggery Tattoo, N.Y.C. Photo: © 1996, Kelly Brill*

*Bottom left:*
*August King III, tattoo by Bob Murdock, Rainbow Body Art, Waterbury, CT. Photo: © 1996, Kelly Brill*

*Bottom right:*
*Scott Smith, tattoo by Walt Fogarty, Electric Circus Tattoo, Mattydale, N.Y. Photo: © 1996, Kelly Brill*

*Page 55:*
*Mark Fillerbrown, tattoo by Anil Gupta, Inkline, N.Y.C. Photo: © 1995, Panja Jürgens*

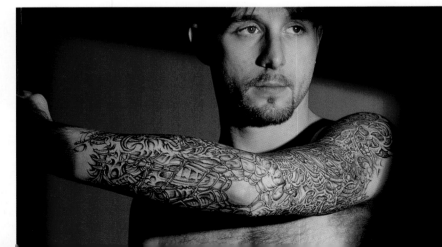

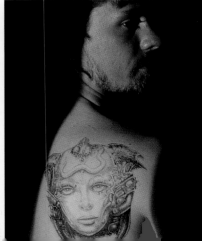

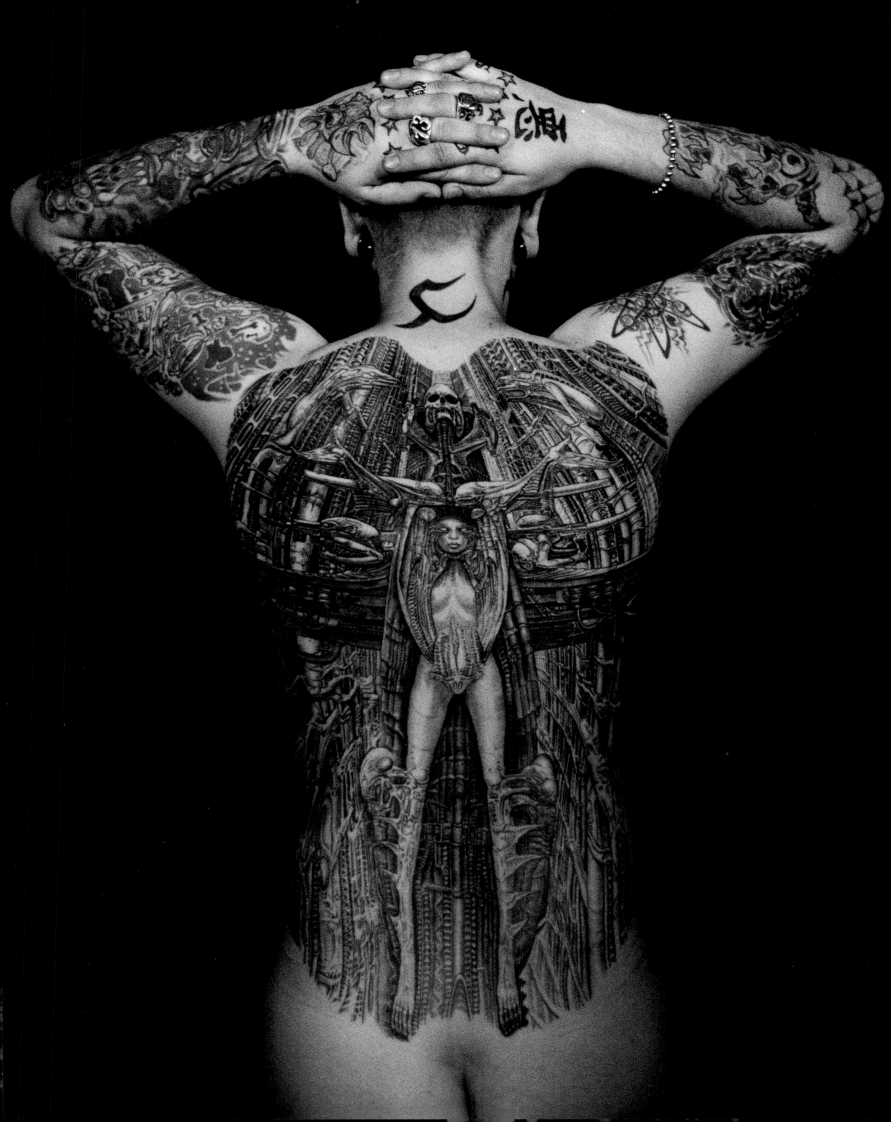

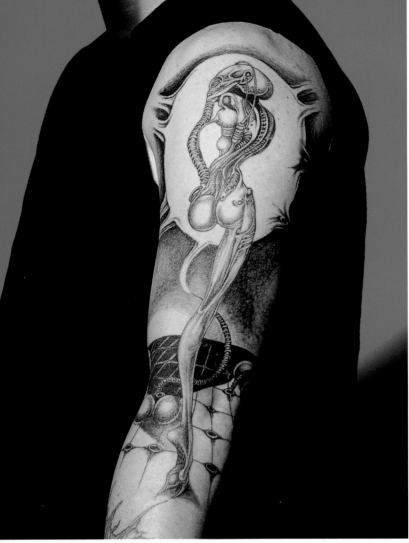

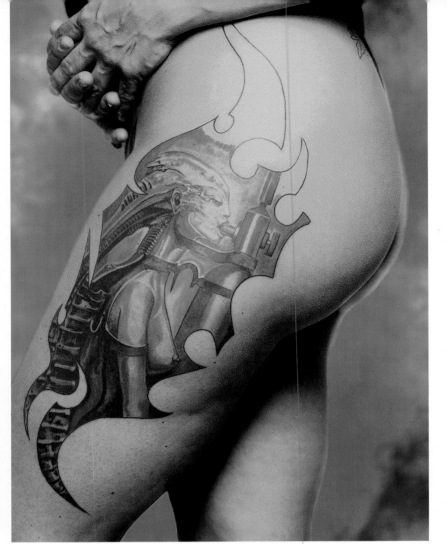

Top: Josef Becvar
Tattoo by Ronda Hoelzer, N.Y.C.
Photo: © 1996, Kelly Brill

Bottom: Andrea Elston
Tattoo by Bernie Luther, Vienna
Photo: © 1994, Robin Perine

Top: Andrea Elston
Tattoo by Tin-Tin, Paris
Photo: © 1994, Robin Perine

Bottom: Joe Donahue, tattoo by Walt Fogart
Electric Circus Tattoo, Mattydale, N.Y.C.
Photo: © 1996, Kelly Brill

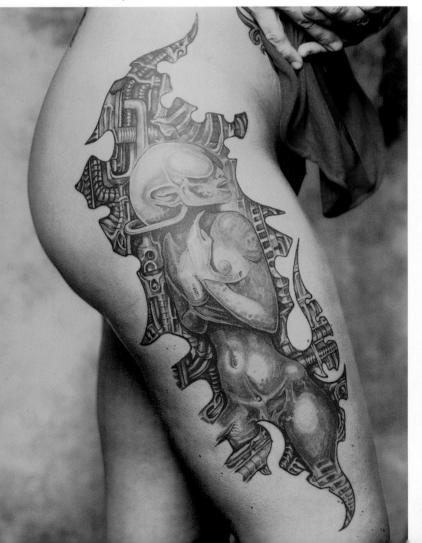

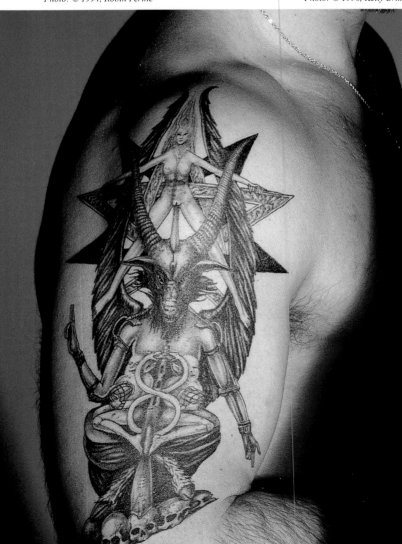

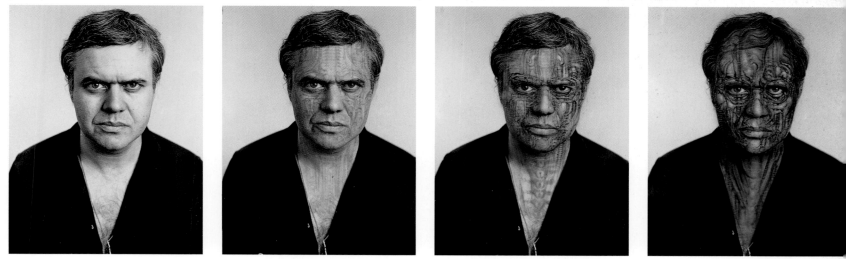

*From left to right: No. 476b, No. 477b, No. 478b and No. 479b, H. R. Giger self-portraits, for the film "H. R. Giger's Dream Quest" by Robert Kopuit, 1981. Acrylic on photo paper, approx. 45 x 35 cm. Photos: Joost Dankelman. Originals appropriated by Joost Dankelman, Heemstede, Netherlands. Private viewings may be coordinated by contacting the proper authorities.*

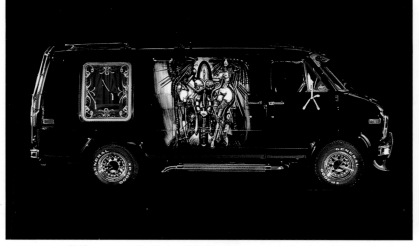
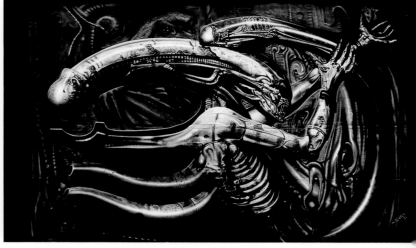

*GMC van, owner: Cox Kocher, H. R. Giger images executed by Martin Günther, Moto Senn, 1992. Photos: Schmid, Frick, (l-to-r) 1. side view of the van, Work No. 341: Witches' Dance; 2. Detail, Work No. 303, Necronom IV. Below: details (from l-to-r): 1. Rear view, spare tire holder 1, Work No. 557: Future Kill I; 2. Side view: Work No. 341, Witches' Dance; 3. Spare tire holder 2, Work No. 428, Deification XI*

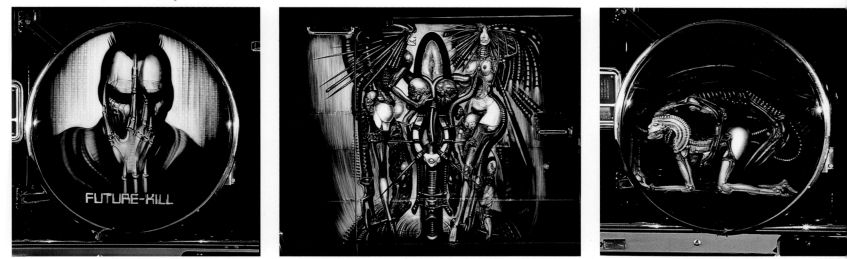

*New Jersey chiropractor Dr. Bryan Bajakian's passion and labor of love, the mutant Harley Davidson 1990 Fat Boy, "Not Of This World". A four-year project inspired by the art of H. R. Giger, with molding and casting in stainless steel by Bryan Bajakian, and paintings by Kram. Photos: © 1995 Michael Lichter, (from l-to-r): 1. Detail, 2. Side view, 3. Detail*

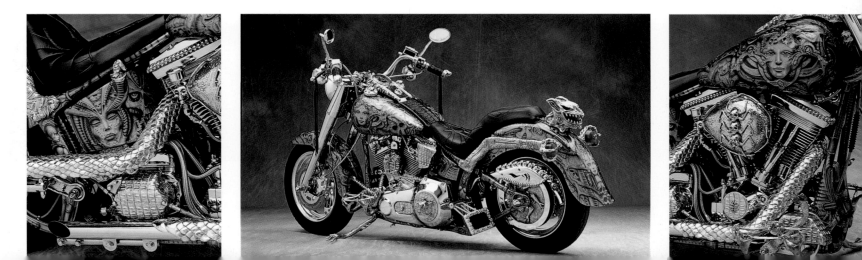

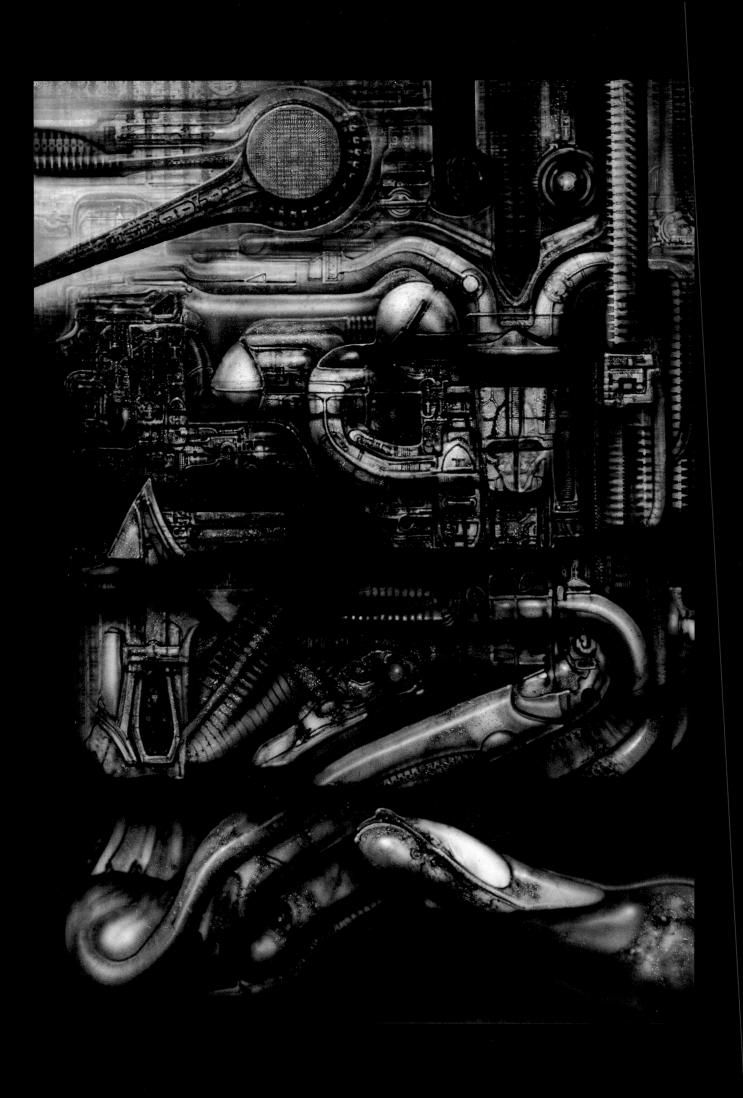

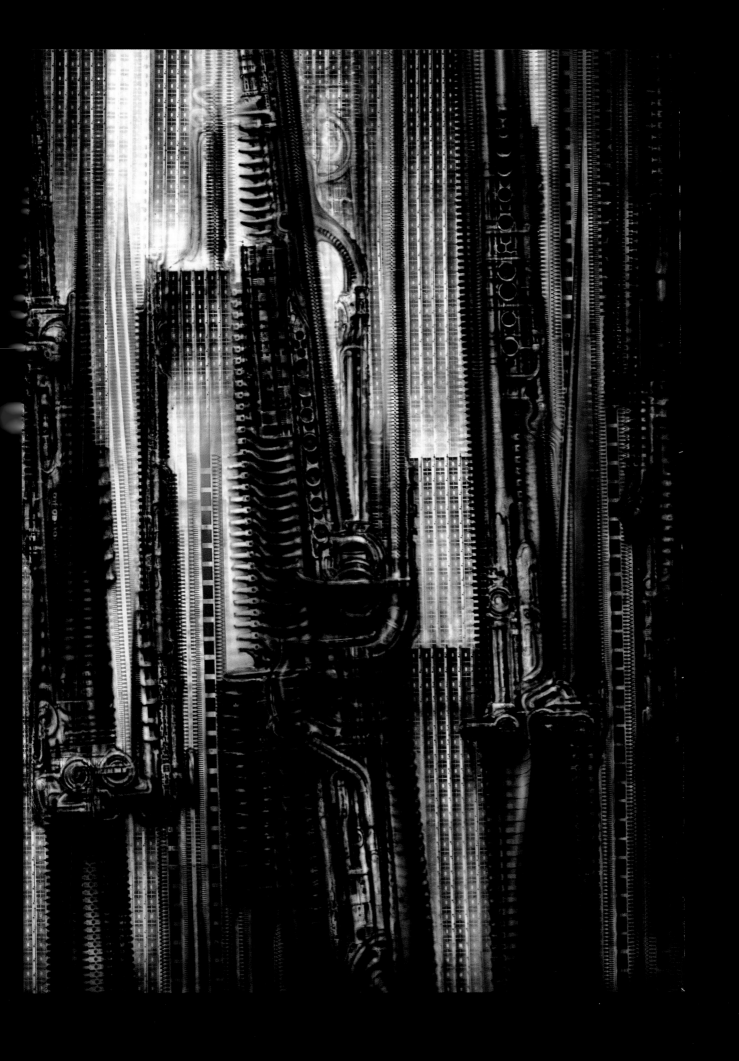

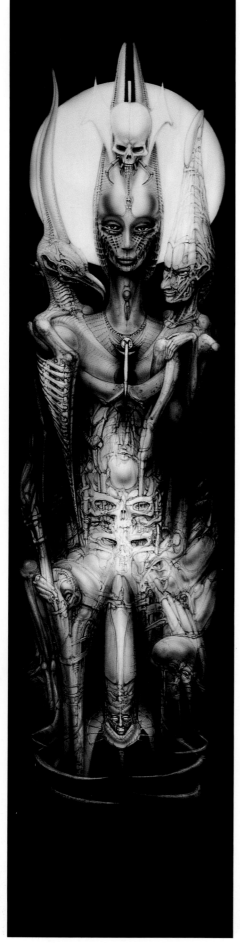

*No. 212, Front in Entrance Hall, 1973. Ink on paper/wood,
230 x 55 cm*

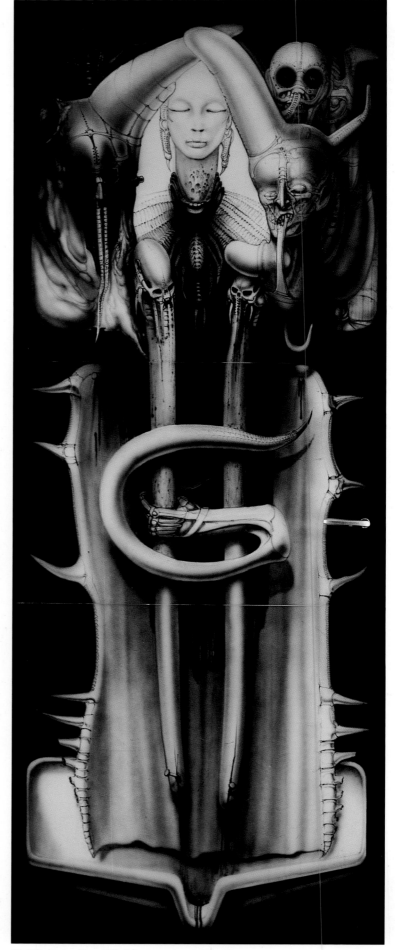

*No. 213, Kitchen Door, 1973. Ink on paper/wood, 200 x 79 cm*

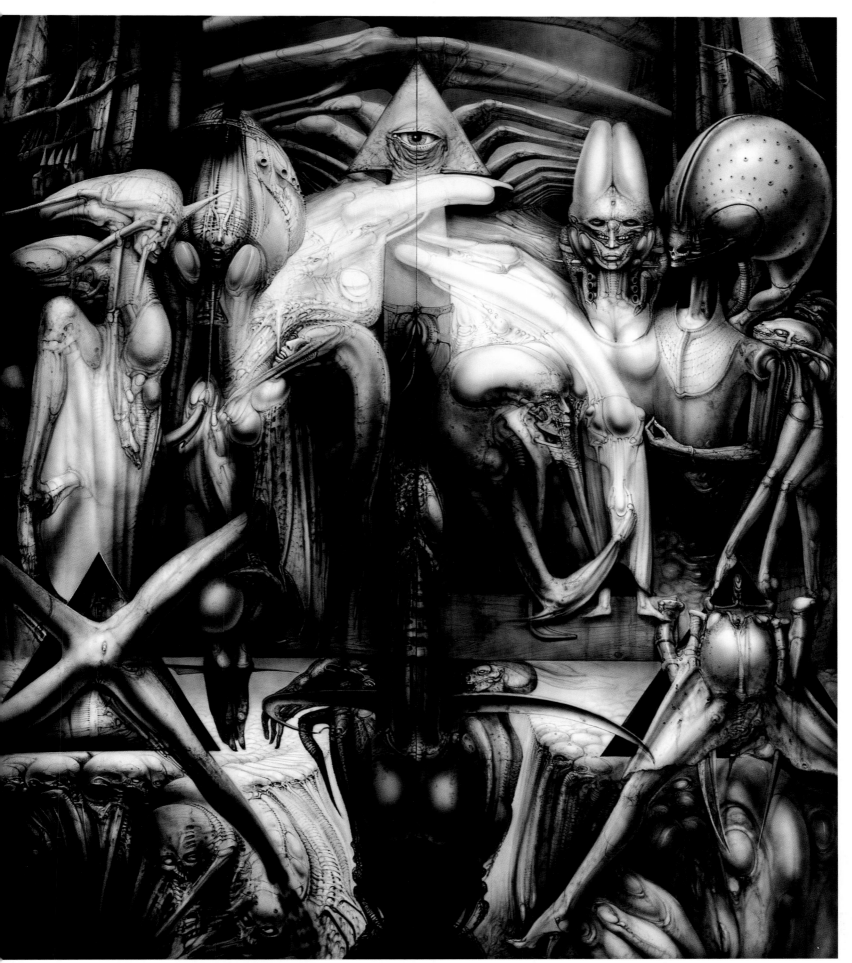

*No. 210, Aleph, 1972–73. Ink on paper/wood, 240 x 216 cm*
*Pages 58 and 59: No. 464, New York City XIV (Factory), 1981, and No. 454, New York City IV (Spike), 1980. Acrylic and ink on paper, 100 x 70 cm*

61

## Expanded Drawings

My day, night and dream diaries, as well as my sketchbooks, which in part were created as far back as 20 years ago, served as my inspiration for these newly created works.

The new four-color copy machine gave me the chance to put various sketches from my books into a standard format. These color copies provided a good starting point for reworking and reinterpreting earlier ideas. Since I spend the greater part of the day in bed anyway and it is difficult to work with an airbrush in that position, it was my method to make as many as ten copies of the sketches and then rework them by drawing, an ideal way of working. This technique is not new.

In the '50s, Arnulf Rainer, whom I admire very much, had reworked his photo portraits by drawing to intensify expressions. Possibly, my "overdrawings" are extensions of earlier ideas into new creations. This way of working started a kind of unstoppable chain reaction, so that I recopied the results of my changes over and over and reworked them again. In comparing the original sketches to the final results, we can speak of expanded drawings.

*H. R. Giger*

# Der Oscar-Preisträger kehrt in den Zürcher Untergrund zurück
### Eine Ausstellung von H. R. Giger im Zürcher Art-Magazin

■ VON CONRADIN WOLF

H. R. Giger bemüht sich seit fünfundzwanzig Jahren erfolgreich, die Schlafzimmer der Welt in Folterkammern zu verwandeln. 'Als apokalyptischer Reiter durchstreift er das Atomzeitalter. Zartbesaitete Teenies und hartgesottene Rocker lassen sich genauso locken und schrekken von seinen gruselig-phantastischen Bildwelten. Heute zählen vor allem die Anhänger von New Age und Esoterik zu seiner Fan-Gemeinde.

### Vorbeigeschmuggelt

Geboren wurde Hansruedi Giger 1940 in Chur. Zu malen und zu zeichnen begann der gelernte Innenarchitekt und Designer Mitte der sechziger Jahre. Nach Erfolgen in der Zürcher Kunstszene trat er mit der Spritzpistole in der Hand den Siegeszug um den Erdball an. Von der Neuen Welt bis Fernost hat H. R. Giger seine Fans mit metallenen Penissen, kopulierenden Embryos, schwarzen Messen und abstrusen Wahnwelten beglückt. Giger gelang es mit erstaunlicher Konsequenz immer wieder, den Sittenaposteln ein Schnippchen zu schlagen, unter dem Etikett der hohen Kunst seine sexuellen Phantasmagorien an den Grenzwächtern der Moral vorbeizuschmuggeln.

Aus den USA ist H. R. Giger mit dem Oscar für visuelle Effekte im Film «Alien» zurückgekommen. Der Erfolg mit Filmausstattungen, Plattenhüllen, Postern, Grafik und Schickeria-Bardekorationen ist an Giger freilich nicht spurlos vorübergegangen, hat ihn eher noch ängstlicher, zurückhaltender gemacht. Jetzt ist der Oscar-Preisträger wieder zu seinen Anfängen zurückgekehrt. In der Zürcher «Untergrundgalerie» Art-Magazin zeigt er überarbeitete Xeroxkopien aus seinen Tag-und-Nacht-Skizzenbüchern, die sein ursprüngliches zeichnerisches Talent erkennen und wiederaufleben lassen. Giger bearbeitet die Kopien mit Öl, Wachs, Neocolor, Lithokreide und Graphit.

### Die immergleichen Themen

Die Themen sind freilich dieselben geblieben. Schreckensvögel, Frauenkörper auf der Guillotine, mechanische Todesboten und grinsende Embryos bevölkern die Blätter. Ein Tischfussball mit Penissen und Vagina als Tor zählt zu den schröcklichsten Kreationen. Die Phallokratie ist dermassen übersteigert und die sexuellen Obsessionen sind so weit ausformuliert, dass sie ins Gegenteil, ins Belanglose kippen.

Nicht nur der Schlaf der Vernunft, sondern auch die Angst gebiert halt Ungeheuer. So besehen ist die Schau im Art-Magazin ehrlich, denn Giger hascht weniger nach Effekten als manche Betrachter der Werke glauben möchten. Er ist selbst ein Gefangener seiner psychedelischen Wahnwelten, einer, der sich nur mit makabrer Ironie und dem Umstülpen seiner visionären Innenwelt retten kann. Als künstlerischer Prophet hat H. R. Giger seinem Lieblingsmotiv, dem Penis, immerhin bereits vor Jahren ein Präservativ übergestülpt. (Bis 4. Juni.)

H. R. Giger: Tagebuchüberzeichnungen auf Xerox-Kopien.　　　(Bild Pressedienst)

*Article in the "Tagesanzeiger Zürich", on the occasion of the "Expanded Drawings" exhibit in the Galerie Art Magazin, Zurich, May 1988*

*Gallery owner Rolf Müller*
*Photo: Jean-Jacques Ruchti*

*"Expanded Drawings" Exhibit at the Galerie Art Magazin, Zurich, 1988*

*Renovation of the Galerie Art Magazin new rooms*

62

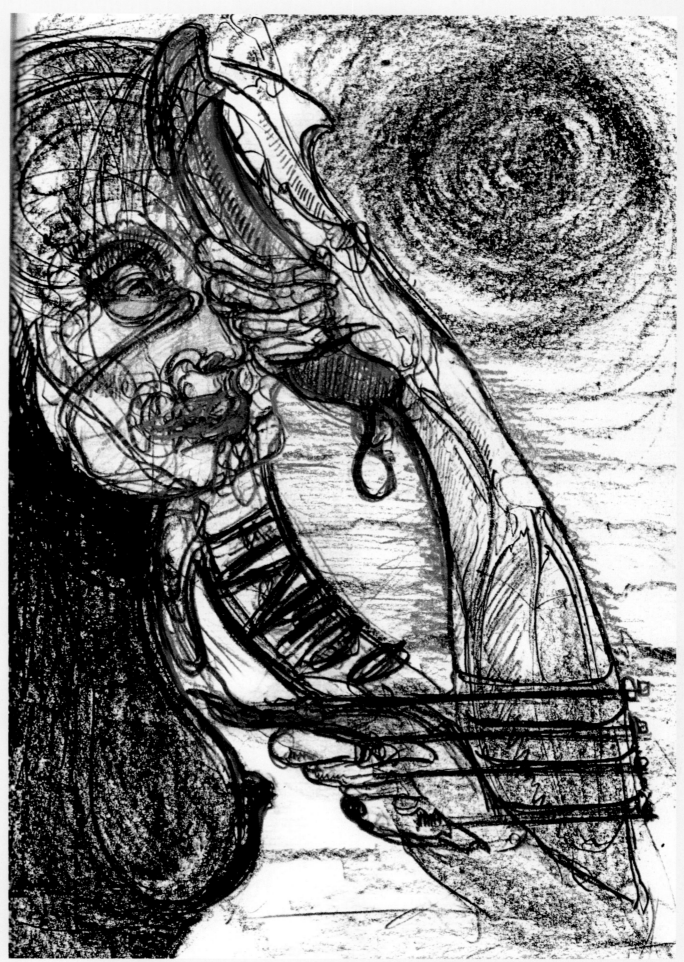

*No. 68, Expanded Drawings, 1988. Diary overdrawings with wax sticks, oil sticks, Neocolor, lithographic chalk and graphite pencil on black-and-white and color Xerox copies, 42 x 29.7 cm*

*No. 61, Expanded Drawings, 1988. Diary overdrawings with wax sticks, oil sticks, Neocolor, lithographic chalk and graphite pencil on black-and-white and color Xerox copies, 42 x 29.7 cm*

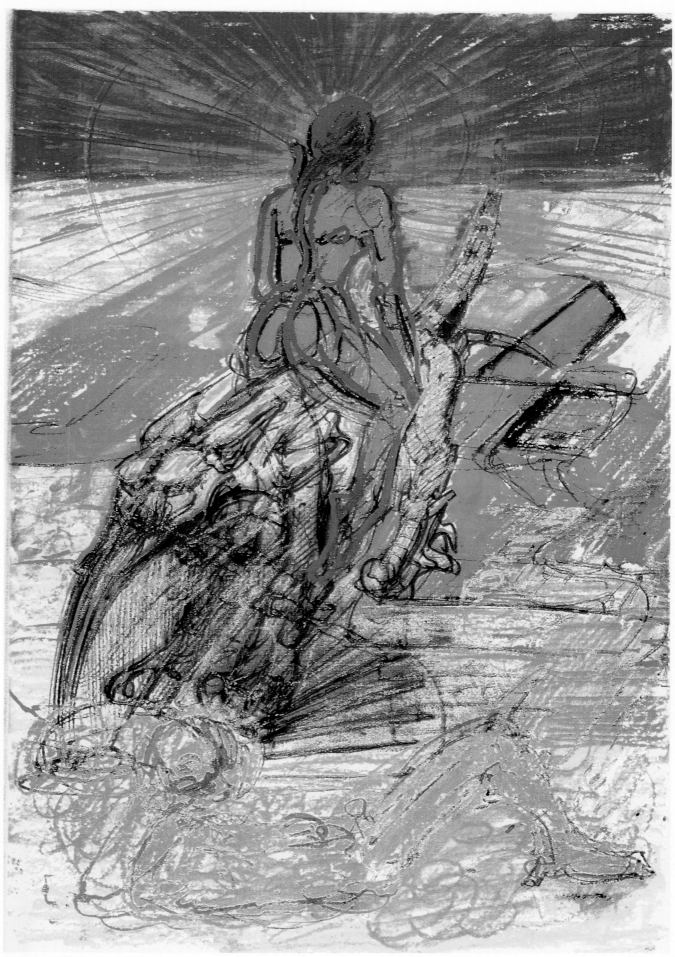

*No. 78, Expanded Drawings, 1988. Diary overdrawings with wax sticks, oil sticks, Neocolor, lithographic chalk and graphite pencil on black-and-white and color Xerox copies, 42 x 29.7 cm*

*No. 35, Expanded Drawings, 1988. Diary overdrawings with wax sticks, oil sticks, Neocolor, lithographic chalk and graphite pencil on black-and-white and color Xerox copies, 42 x 29.7 cm*

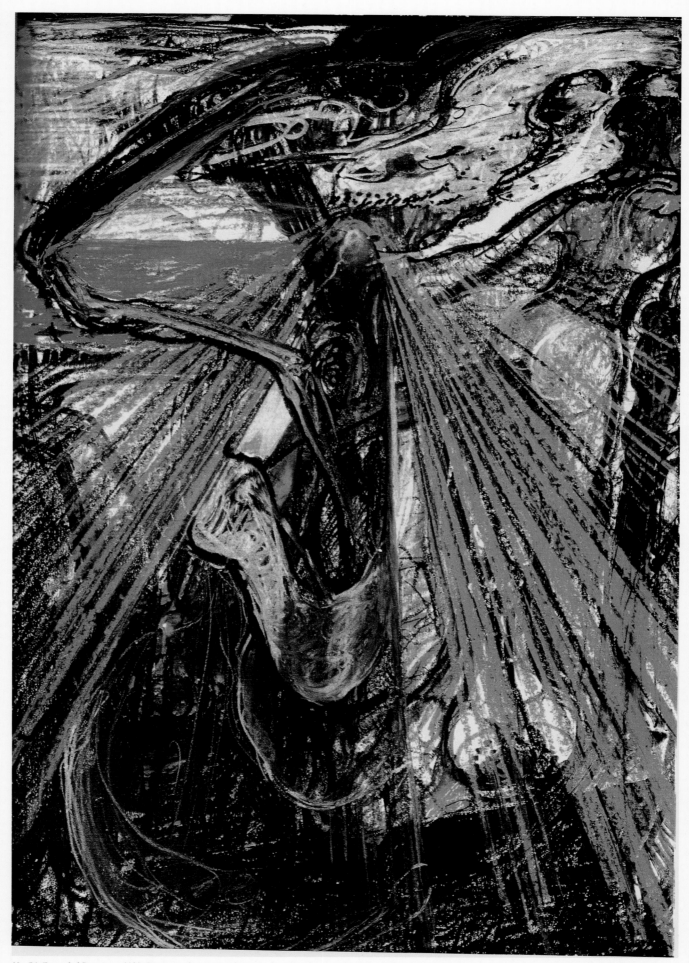

*No. 76, Expanded Drawings, 1988. Diary overdrawings with wax sticks, oil sticks, Neocolor, lithographic chalk and graphite pencil on black-and-white and color Xerox copies, 42 x 29.7 cm*

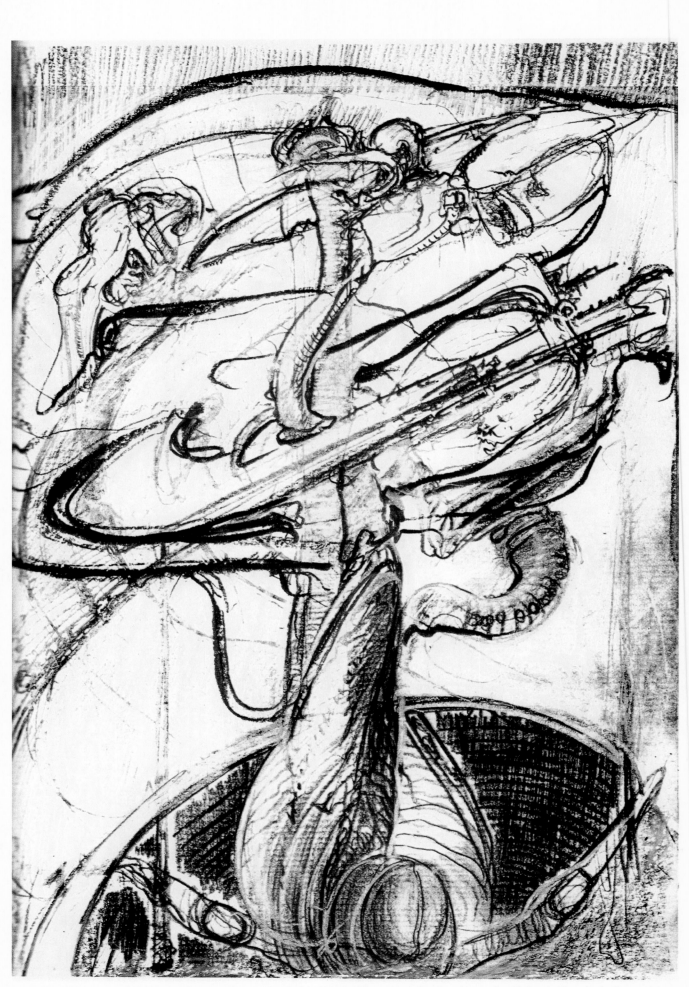

*No. 52, Expanded Drawings, 1988. Diary overdrawings with wax sticks, oil sticks, Neocolor, lithographic chalk and graphite pencil on black-and-white and color Xerox copies, 42 x 29.7 cm*

*No. 31, Expanded Drawings, 1988. Diary overdrawings with wax sticks, oil sticks, Neocolor, lithographic chalk and graphite pencil on black-and-white and color Xerox copies, 42 x 29.7 cm*

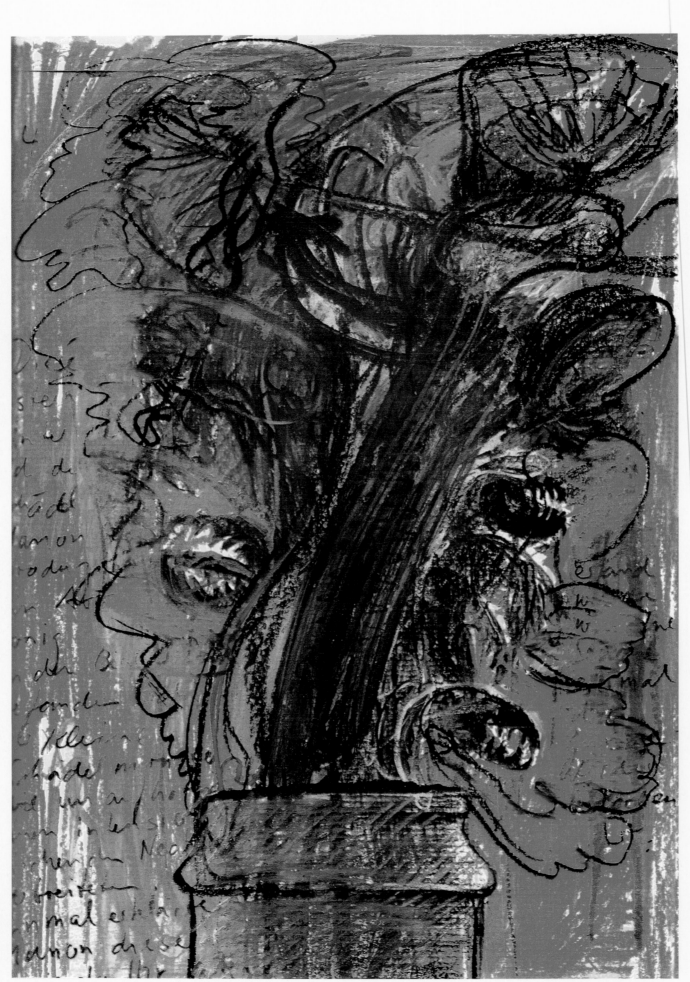

*No. 62, Expanded Drawings, 1988. Diary overdrawings with wax sticks, oil sticks, Neocolor, lithographic chalk and graphite pencil on black-and-white and color Xerox copies,*
*42 x 29.7 cm*

*No. 64, Expanded Drawings, 1988. Diary overdrawings with wax sticks, oil sticks, Neocolor, lithographic chalk and graphite pencil on black-and-white and color Xerox copies, 42 x 29.7 cm*
*Pages 72 and 73: No. 445, "Biomechanical Interior", 1980, and No. 469, New York City XIX (Cathedral), 1981. Acrylic and ink on paper, 100 x 70 cm*

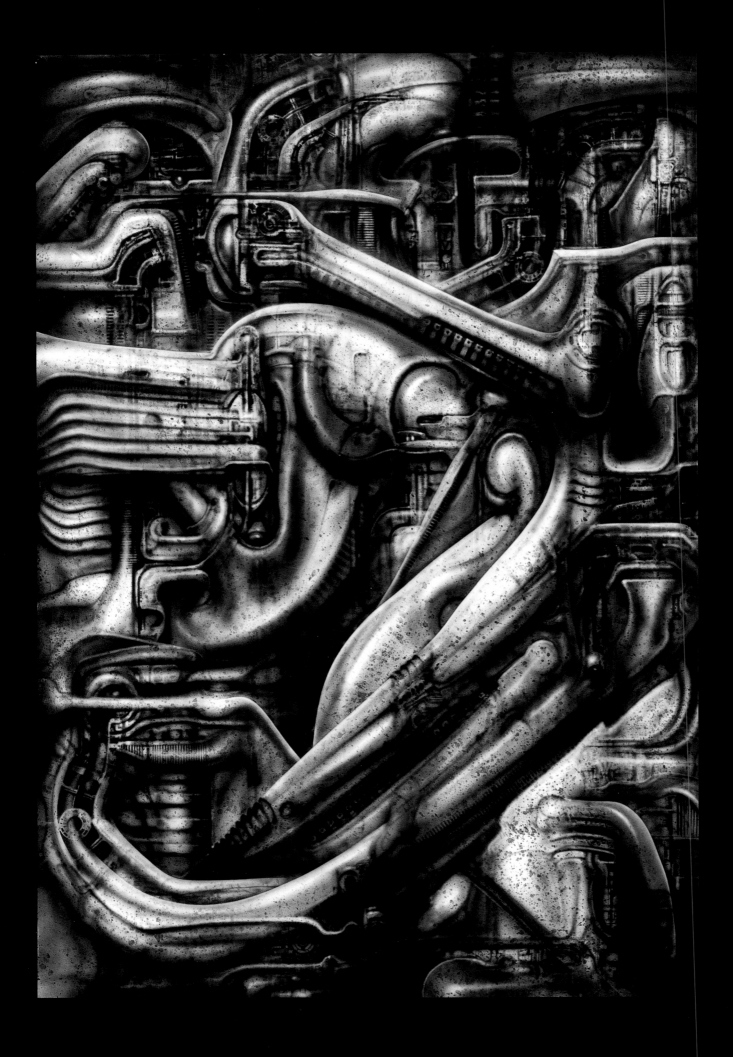

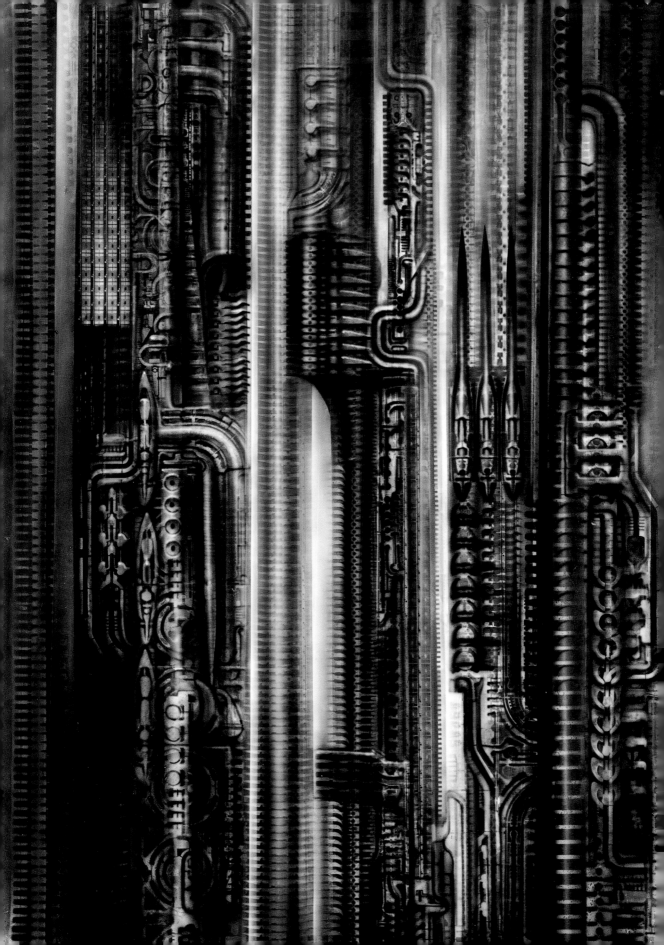

## The Furniture

All graphic designers want to make art, as do furniture designers. Who's stopping them? The critics? What's the difference between an artist's chair and a designer's chair? Isn't it that the artist's chair has been released from its original function by a few artistic tricks? Give it a slanted seat and you've got a chair that's impractical for sitting! Since our homes are getting smaller and we have no room for sculptures, which take up a lot of space, we try to make usable works of art. After all, the burial objects of the ancient Egyptians (especially those of Tutankhamen) are considered art, although they were eminently practical. In short, long live the Viennese workshops!

At the School of Applied Art in Zurich I learned the trades of interior and industrial design. After graduation, I worked with Andreas Christen for Knoll International for about one and a half years before becoming an free-lance artist. Once in his lifetime, every designer designs a chair – especially if he's had an applied art teacher like Willi Guhl. During my first-year design course, I began to experiment with polyester and fiberglass in the school's cellar, much to the dismay of some sensitive noses. During my last year of study, my class worked together on a model of the passage underneath the Zurich train station for our dissertation. In my personal continuation of this theme, I designed a space for weary travelers: resting chambers and bathrooms (with showers and sinks) in one

*Page 75:*
*Interior Decoration, 1991. Table: No. 701, glass and metal, 114 x 73.5 x 73.5 cm, four chairs, No. 700, polyester and aluminum, 53 x 60 x 106 cm, and floor plates (Biomechanical Matrix), No. 703, aluminum, 93.5 x 77.5 x 0.8 cm, furniture produced by Erwin Ammann, Ignaz Röllin, Spengler AG (Josef Gruber).*
*Photo: © Louis Stalder*

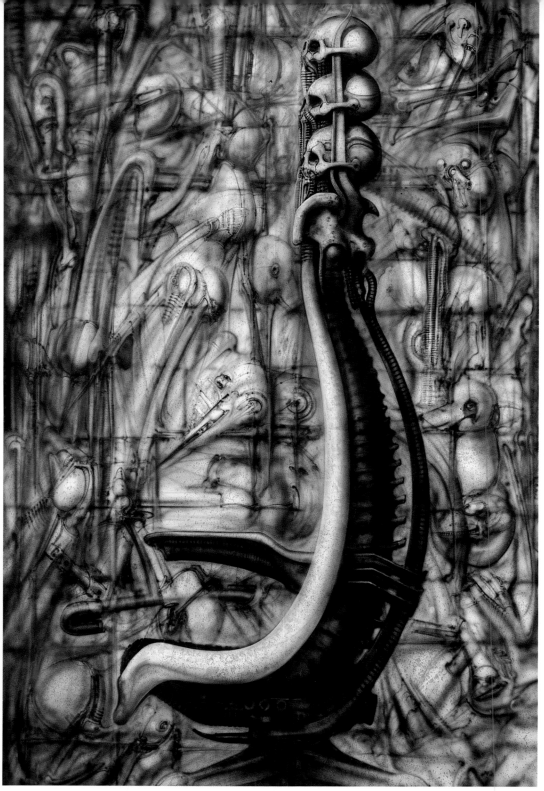

*No. 448, Harkonnen Chair design, 1980. Acrylic and ink on paper, 215 x 140 cm*

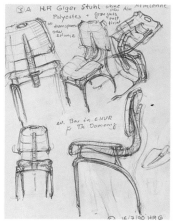

*No. 3a, Chair without armrests, 1990. Pencil on paper, 27.9 x 20.5 cm*

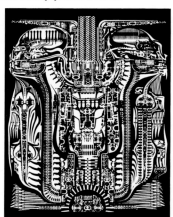

*Floor plate design (Biomechanical Matrix), 1982. 93.5 x 77.5 cm*

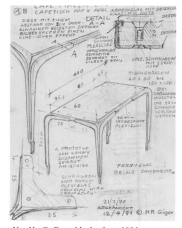

*No. 1b, Coffee table for four, 1991. Pencil on paper, 26.8 x 21 cm*

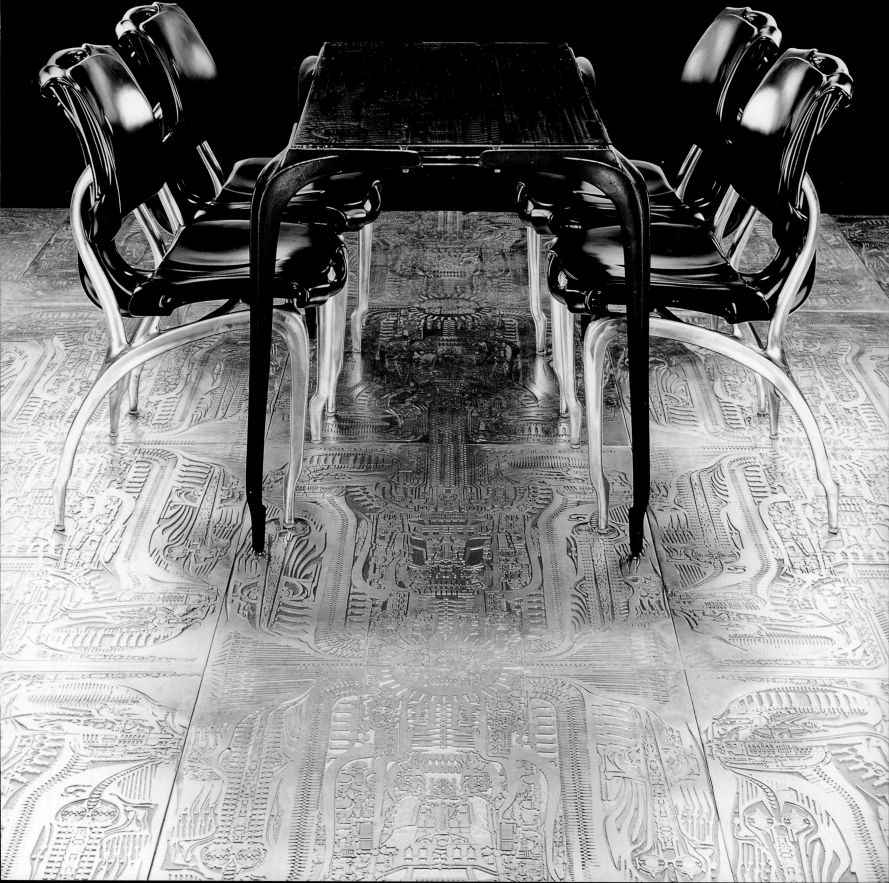

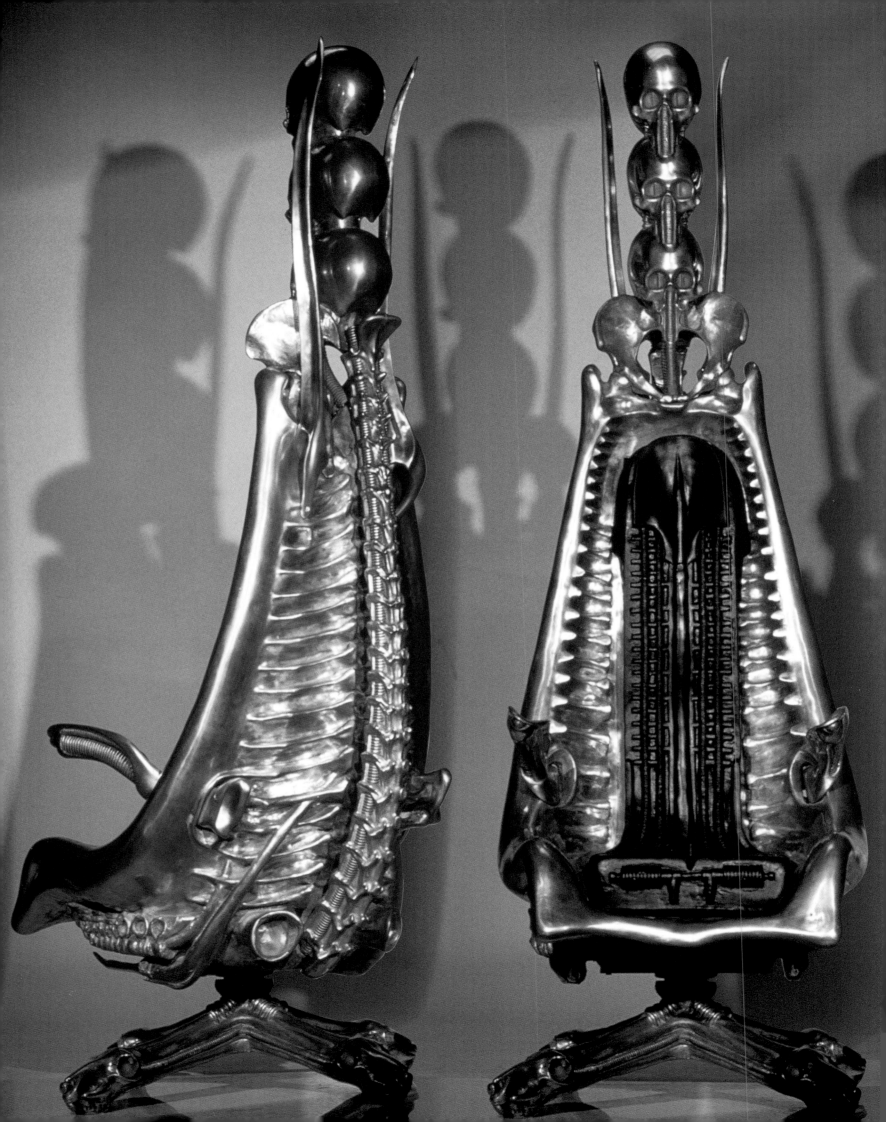

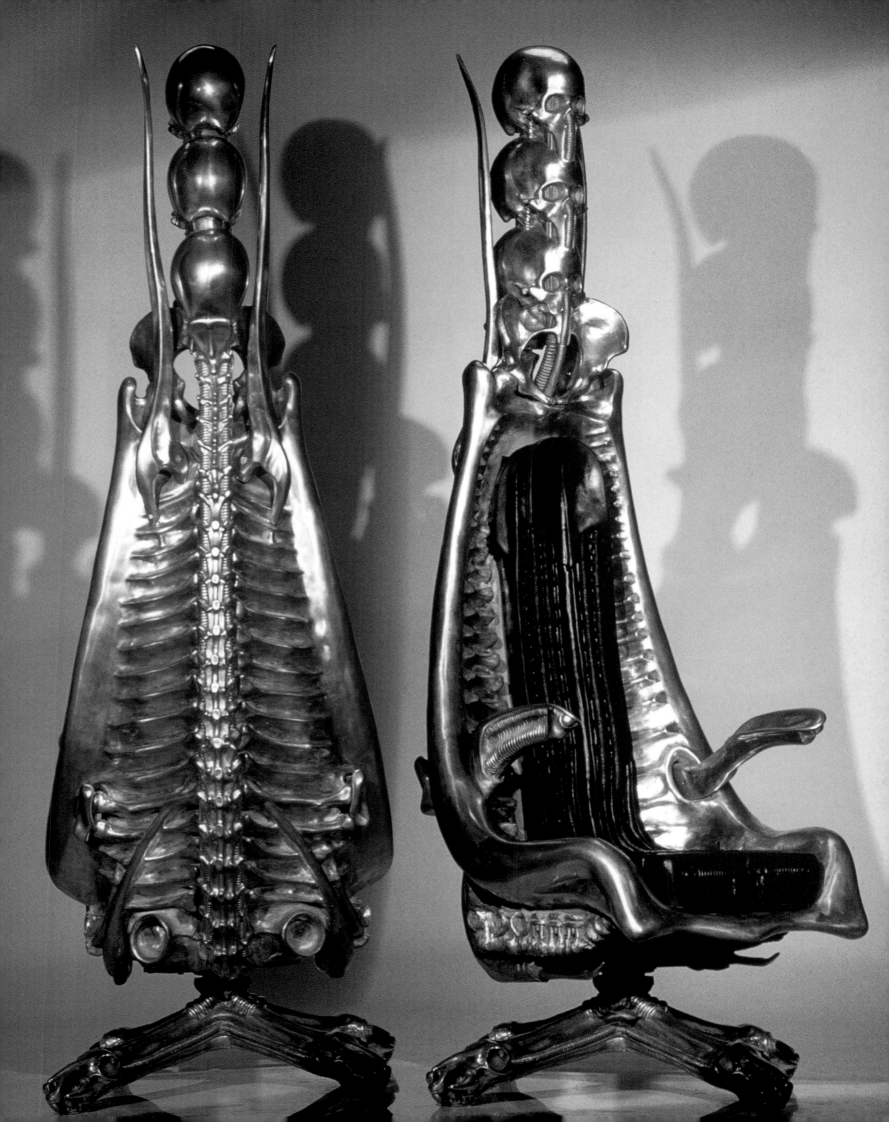

unit made of polyester, in a 1-to-5 scale. My sense of form was always greeted thusly by my main teacher Guhl: "Giger, don't make such sick shapes which look like cows' necks!" What can I say? Even then I had a predilection for organic art nouveau shapes á la Hector Guimard, reminiscent of twisted bone constructions. I don't like plump, inflated Botero-shapes. They strike me as sick. I graduated nevertheless, and my father got what he wanted!

While I was at Shepperton Studios on my honeymoon with my then-wife Mia, I designed the movie *Alien*, which brought me an Oscar. Conny de Fries asked if he could model something from a two-dimensional plan in one of my books (e.g., *Necronomicon I*). I planned the Harkonnen furniture for the movie *Dune*, which I took on with Ridley Scott. Unfortunately, the film was not realized by us. But I had already incorporated the furniture in the contract and was possessed by the idea of actually realizing it, come what may! Conny de Fries and I established a studio for furniture making, in which Dino Zerbini, Bettina Roost and Bruno Reithaar also participated. The first piece we created, which was the most complicated and remains the best, was the *Harkonnen Capo Chair*, with three skulls stacked on top of each other. In the expanded program, it was also available as the regular *Harkonnen Chair* with a built-in spine. Additionally there was a large table whose legs consisted of compact skull shapes. Using no screws, these legs are simply hooked onto the table-top to support it.

*Pages 76–77:*
*No. 443, Harkonnen Capo Chair, 1993. Aluminum, metal and foam rubber, 180 x 100 x 65 cm, Photos: © Roy Volkmann, Leslie Barany Communications/N.Y.C.*

*Page 79:*
*Chair, 1991, No. 700. Polyester and aluminium, 53 x 60 x 126 cm Photo: © L. Stadler*

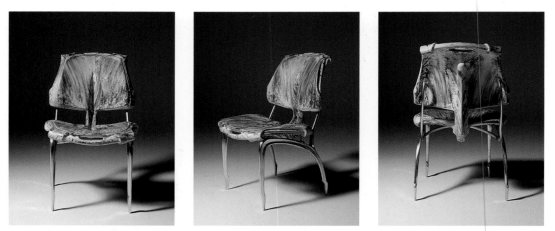

*Chair, No. 700b, Unique, 1991–96. Polyester and aluminum, signed, front, 3/4 and rear view, 53 x 60 x 126 cm, produced by Erwin Amman, Spengler AG (Josef Gruber)*

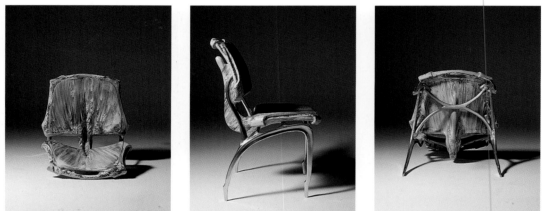

*Chair, No. 700b, Unique, 1991–96. Polyester and aluminum, signed, top, side and bottom view, 53 x 60 x 126 cm*

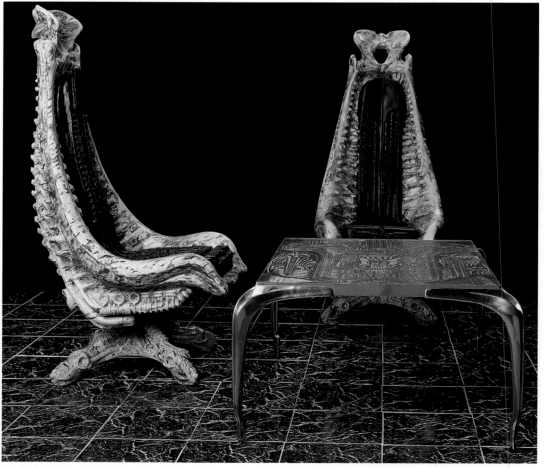

*Two Harkonnen Chairs, No. 443d, 1996. Polyester and foam rubber, 135 x 100 x 65 cm, and small table, No. 701b, 1990–91 Aluminum, 108 x 102 x 45 cm, produced by Erwin Amman, Spengler AG (Josef Gruber), all photos on this page: © 1996, Louis Stalder*

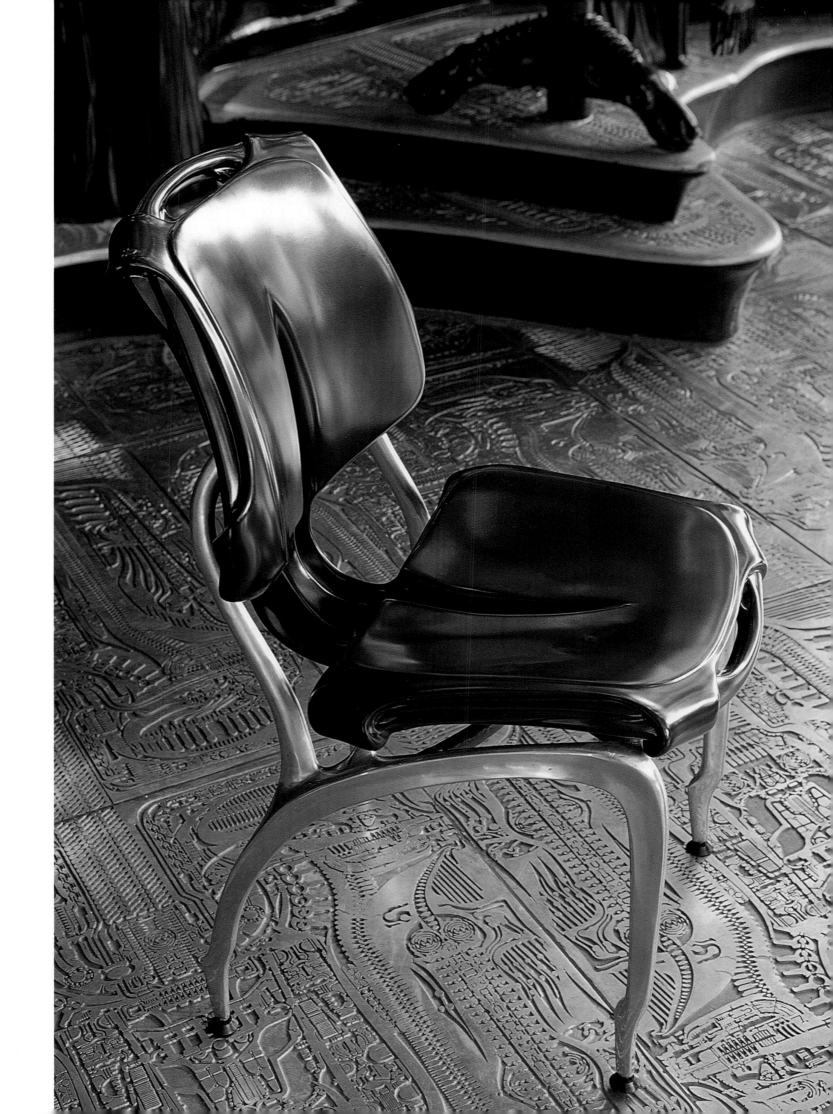

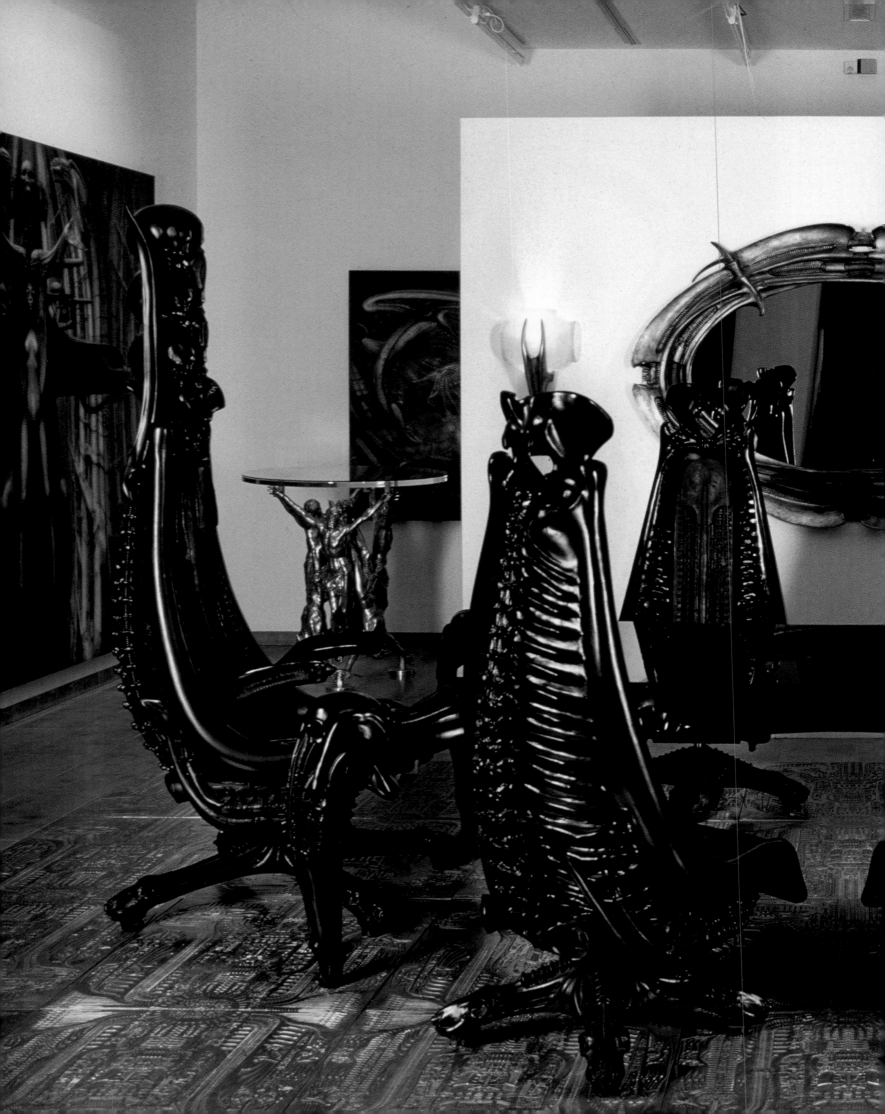

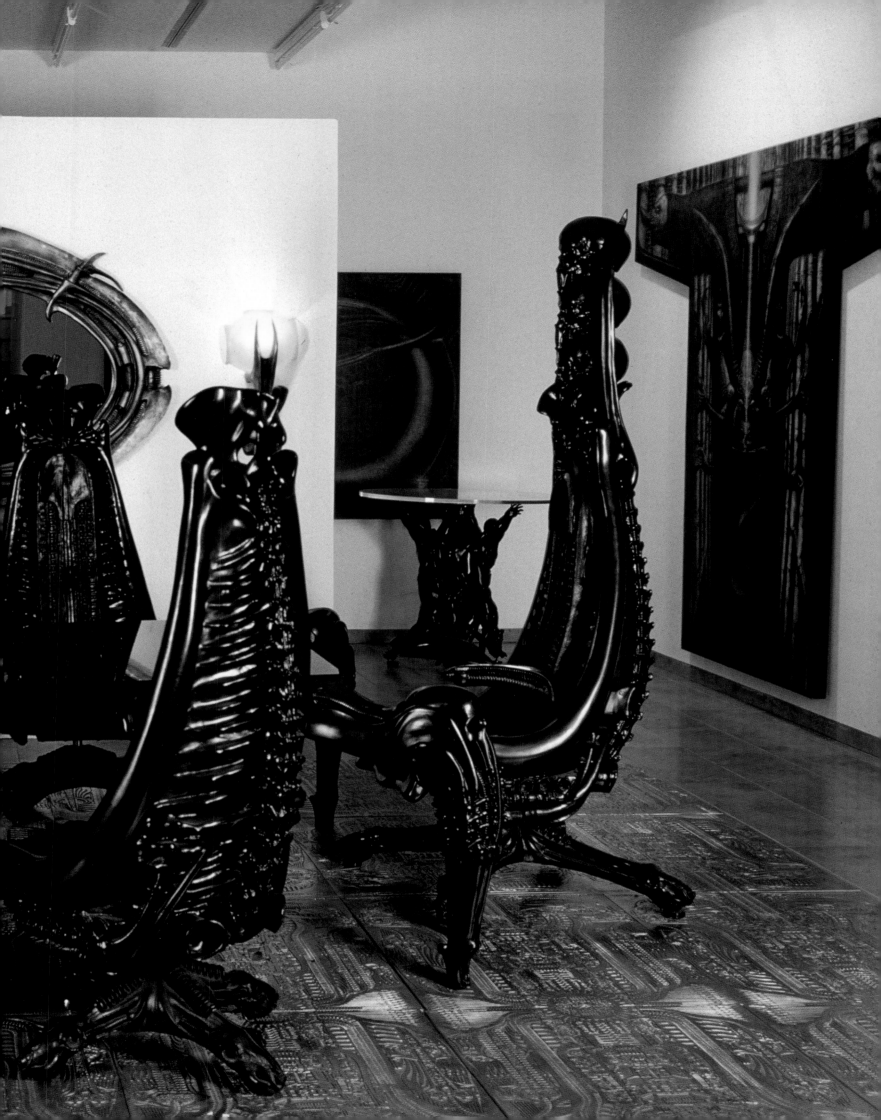

The studio ultimately became the Atelier de Fries, which I financed with my painting. The whole furniture production ended up costing me 250,000 Swiss Francs, but we sold just about nothing. The unique hand-made pieces were too expensive for the average person and not artsy enough for art collectors. For them, if it's functional, it isn't art.

One manifestation of this furniture is the Giger-Bar in Chur. To make the realization of the bar possible, I turned down any compensation for my work and also allowed the builder, Thomas Domenig, to utilize my molds to cast more furniture for the bar. Even with these concessions, the bar cost more than enough. At least my furniture has finally found a public resting place.

I doubt that I will ever create something for mass production, since the limitations of the process would necessitate too many compromises on my part. Thus my furniture remains a very elitist affair for the wealthy.

*H. R. Giger*

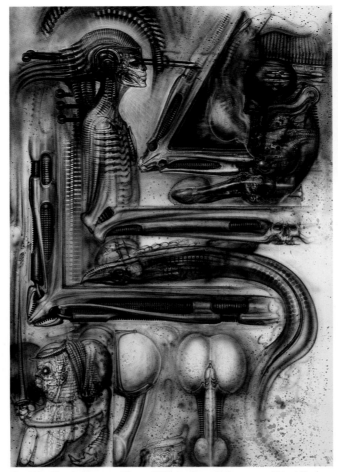

*No. 450a, Plan for Frame and Lamp, 1980. Acrylic and ink on paper, 215 x 140 cm*

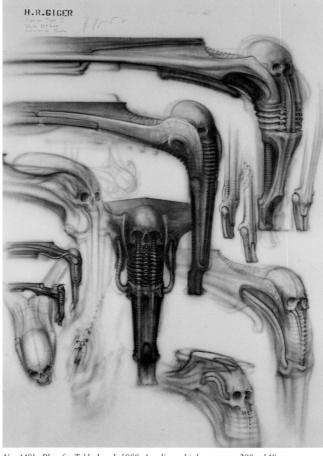

*No. 449b, Plan for Table Leg I, 1980. Acrylic and ink on paper, 200 x 140 cm*

*No. 450b, Triangular Mirror, produced by FormArt, 1983. Polyester and glass, 140 x 123 x 7 cm*

*Original candleholder made of six Christ figures for "The Second Celebration of the Four", 1976, bronze, 27 x 23 x 20 cm*

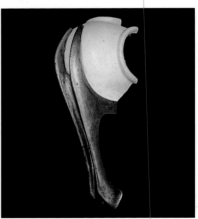

*No. 450e, Lamp, produced by FormArt, 1992. Polyester, metal and glass, 40 x 61, x 40 cm*

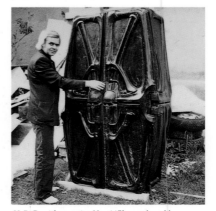

*H. R.G. with armoire No. 447b, produced by Atelier de Fries, 1982/83. Polyester, metal and glass, 180 x 100 x 65 cm*

*Pages 80–81:*
*Harkonnen Table, No. 449d,*
*two Harkonnen Capo Chairs, No. 443a, and*
*four Harkonnen Chairs, No. 443b, 1982.*
*On exhibit at the Silvio R. Baviera Museum*
*1992, Zwinglistrasse 10, Zurich, polyester,*
*metal, glass and foam rubber.*
*Photo: © Louis Stalder*

*Page 83:*
*Christ Table made of six Christ figures,*
*1992. Aluminum, plexiglass and glass,*
*94 x 105 cm. Photo: © H. R.G.*

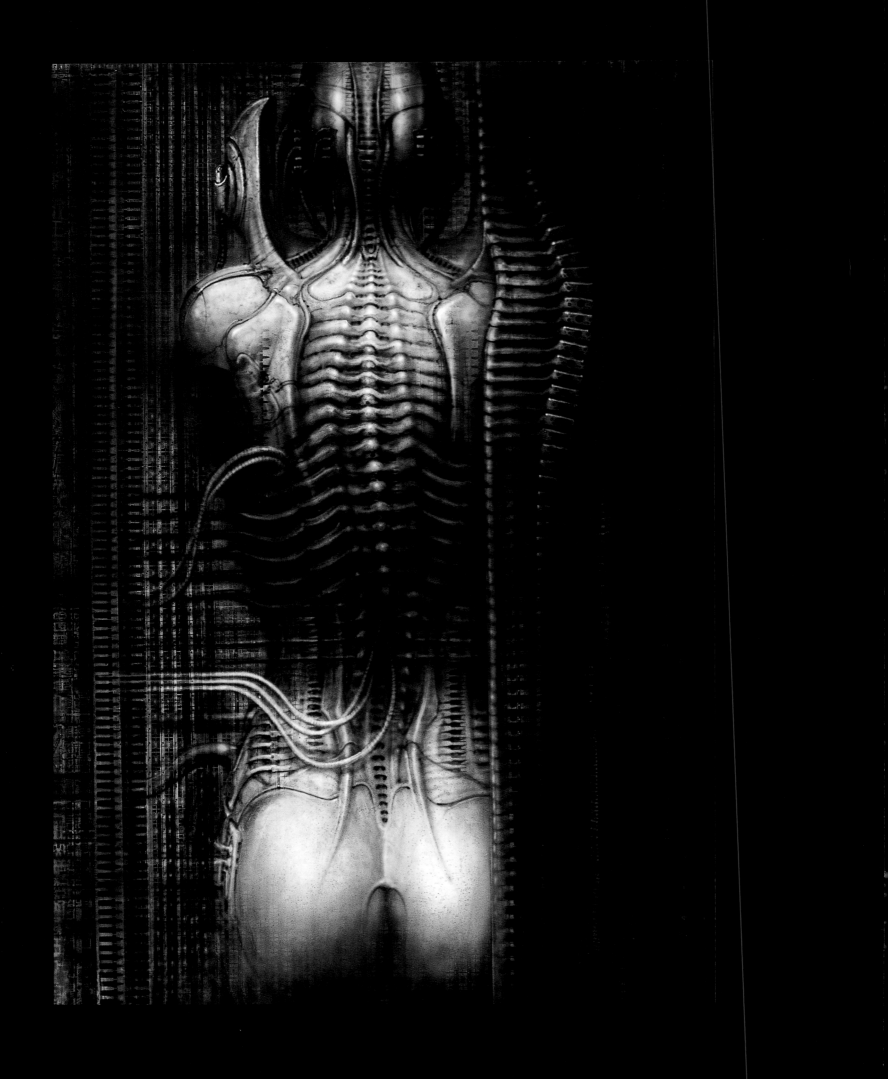

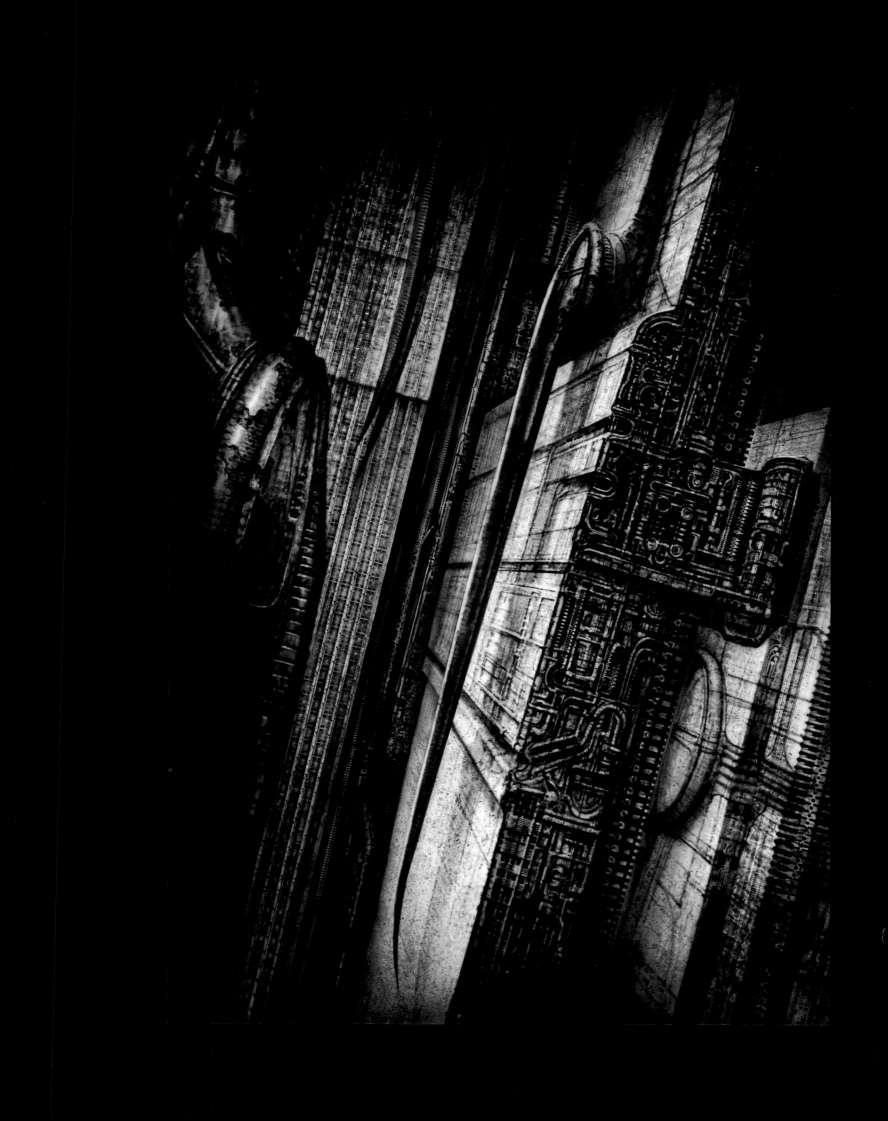

## Giger-Bar in Tokyo

The Giger-Bar was actually created against my will. While I was in Tokyo, I was asked to make a wish on stage during a press conference. Spontaneously, I wished for a bar, which was then brought into being even more spontaneously!

For this bar, I had developed the concept of tables-for-two in open elevator cars in the manner of gliding elevators that would travel up and down the four-story establishment, perpetually in motion. I hadn't taken into consideration the Japanese fire marshals. I had already been driven to the brink of madness by the building codes requiring flexible structures to ensure that buildings withstand earthquake shocks. When they nixed the elevator idea and prescribed fixed cabins hanging like balconies with wire mesh on the atrium side, I threw in the towel. Only Conny de Fries and my former agent persevered. Thus this bar, with its huge entrance area, inside which spiral stairs open to the atrium, came into being.

It seems the bar was tailor-made for the underworld, which is not what I had intended. A friend who visited the place about five years after it opened told me it had fallen into the hands of the Yakuza. He went on to report that he was alone in the bar until 11 o'clock, when it began to fill with the type of unsavory characters who might have installed a roulette table in the atrium. My friend chose to take his leave.

In all likelihood, the bar no longer exists, since a murder occurred there. Insiders know that a bar in Tokyo rarely survives more than five years!

*H. R. Giger*

*Right:*
*News item about the Giger-Bar, Tokyo*

*Pages 84 and 85:*
*No. 456, New York City VI (Torso), 1980,*
*and No. 458, New York City VIII, 1980.*
*Acrylic and ink on paper, 100 x 70 cm*

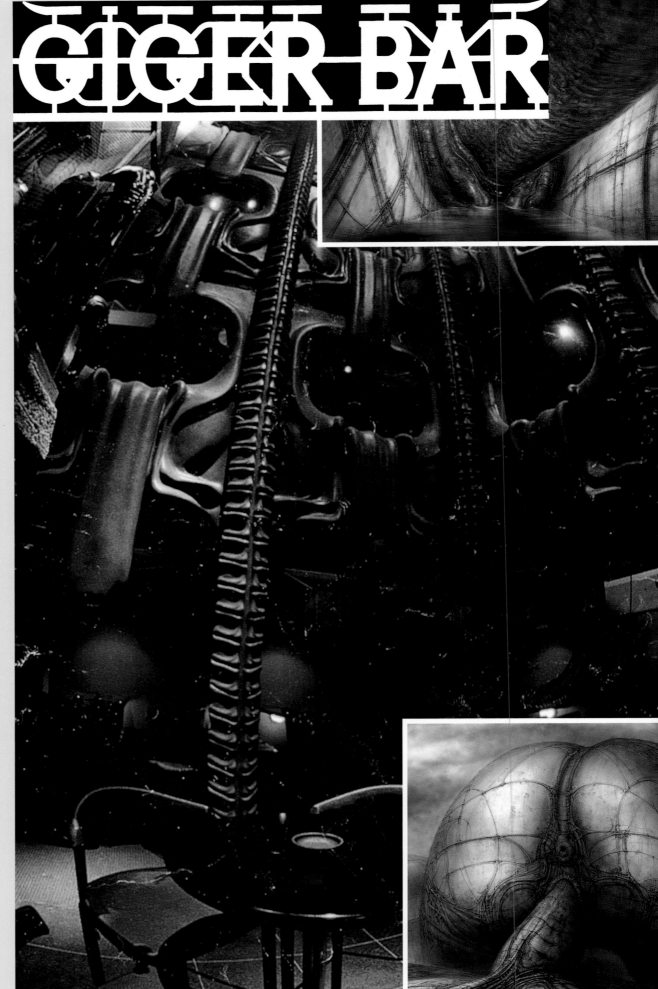

# GIGER BAR

骨を模した柱が目を引く㊨ドライアイスの煙と紫に着色した
フラワーが雰囲気を盛り上げる「エイリアンズ・エッグ」と

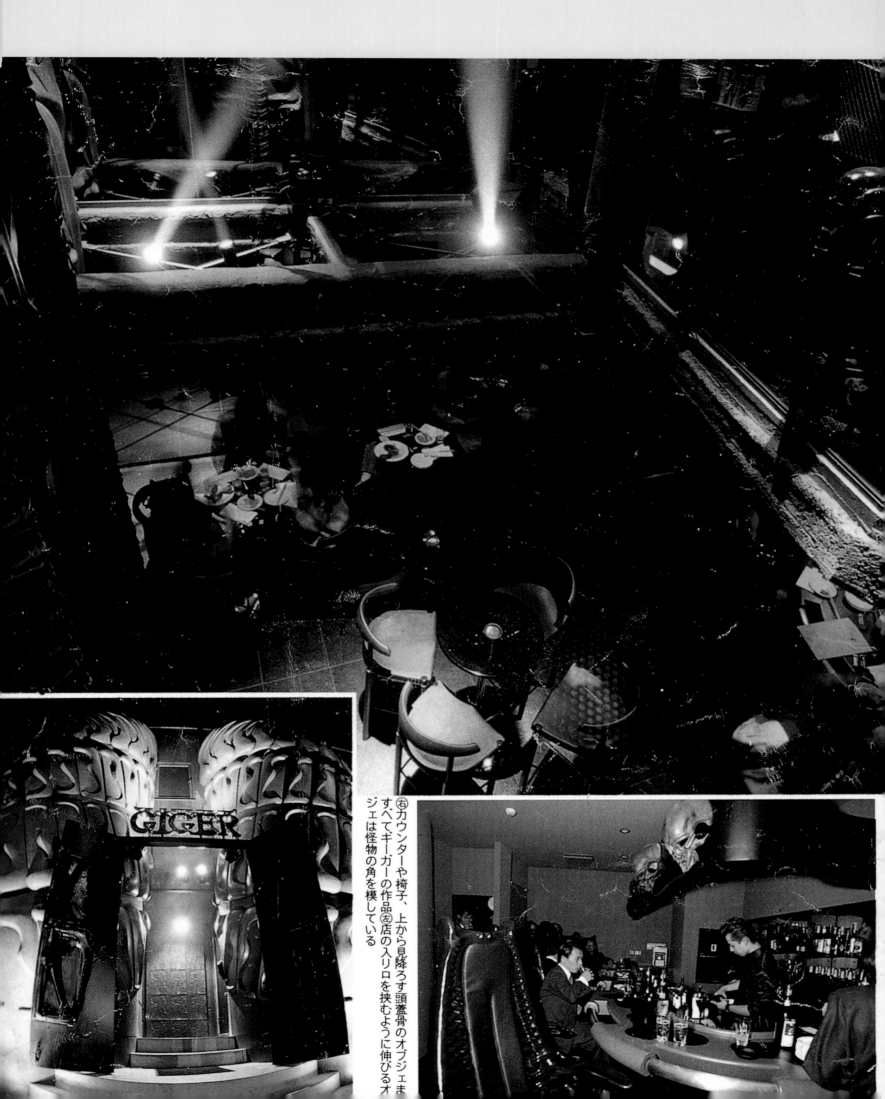

カウンターや椅子、上から見降ろす頭蓋骨のオブジェますべてギーガーの作品②店の入リ口を挟むように伸びるオジェは怪物の角を模している

GIGER

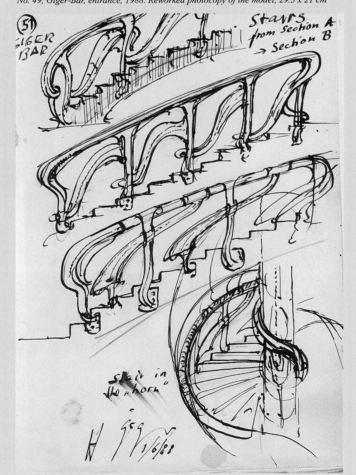

No. 49, Giger-Bar, entrance, 1988. Reworked photocopy of the model, 29.5 x 21 cm

Model of the Giger-Bar entrance, now being used as a decoration in H.R.G.'s garden

No. 51, Giger-Bar, detail sketch: Staircase, 1988. Felt-tip pen on paper, 29.5 x 21 cm

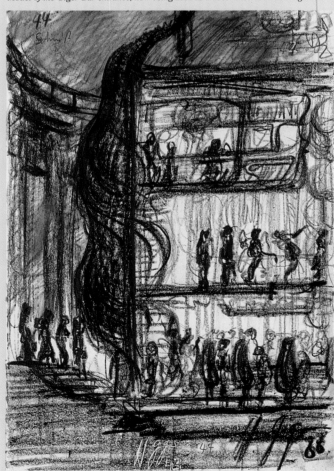

No. 44, Giger-Bar, Tokyo, sketch: cross-section, 1988. Neocolor on paper, 29.5 x 21 cm

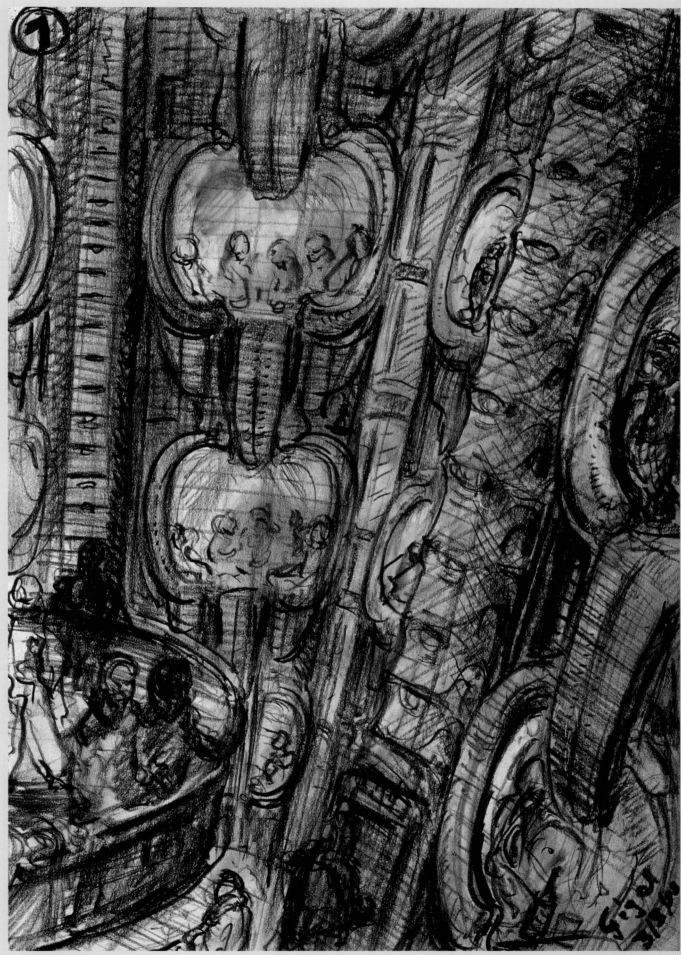

*No. 1, Giger-Bar, Tokyo, detail sketch: Interior of the bar, 1988. Neocolor on paper, 29.5 x 21 cm*

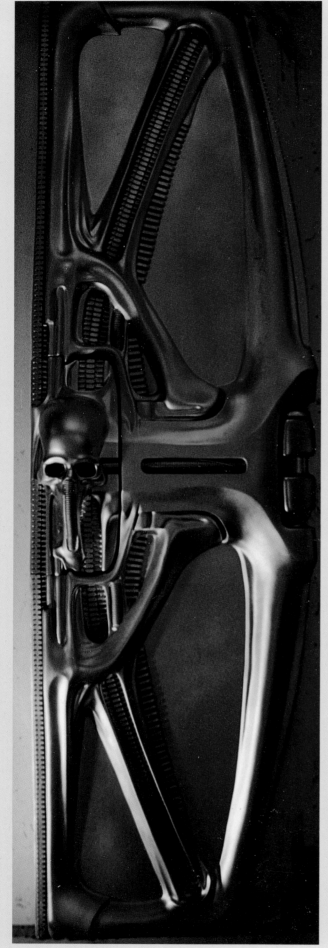

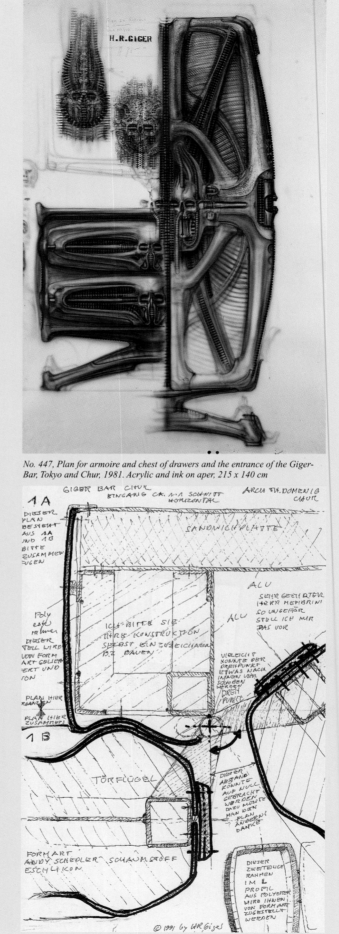

No. 447, Plan for armoire and chest of drawers and the entrance of the Giger-Bar, Tokyo and Chur, 1981. Acrylic and ink on aper, 215 x 140 cm

*Giger-Bar, Chur, door leaf, 1991. Polyester, 250 x 75 x 39 cm*
*Page 91: H.R.G. in the entrance of the Giger-Bar, Chur, 1992. Photo: Willy Spiller*

*Giger-Bar, Chur, door construction blueprint, 1991. Ink and felt-tip pen on paper, 41.5 x 29 cm*

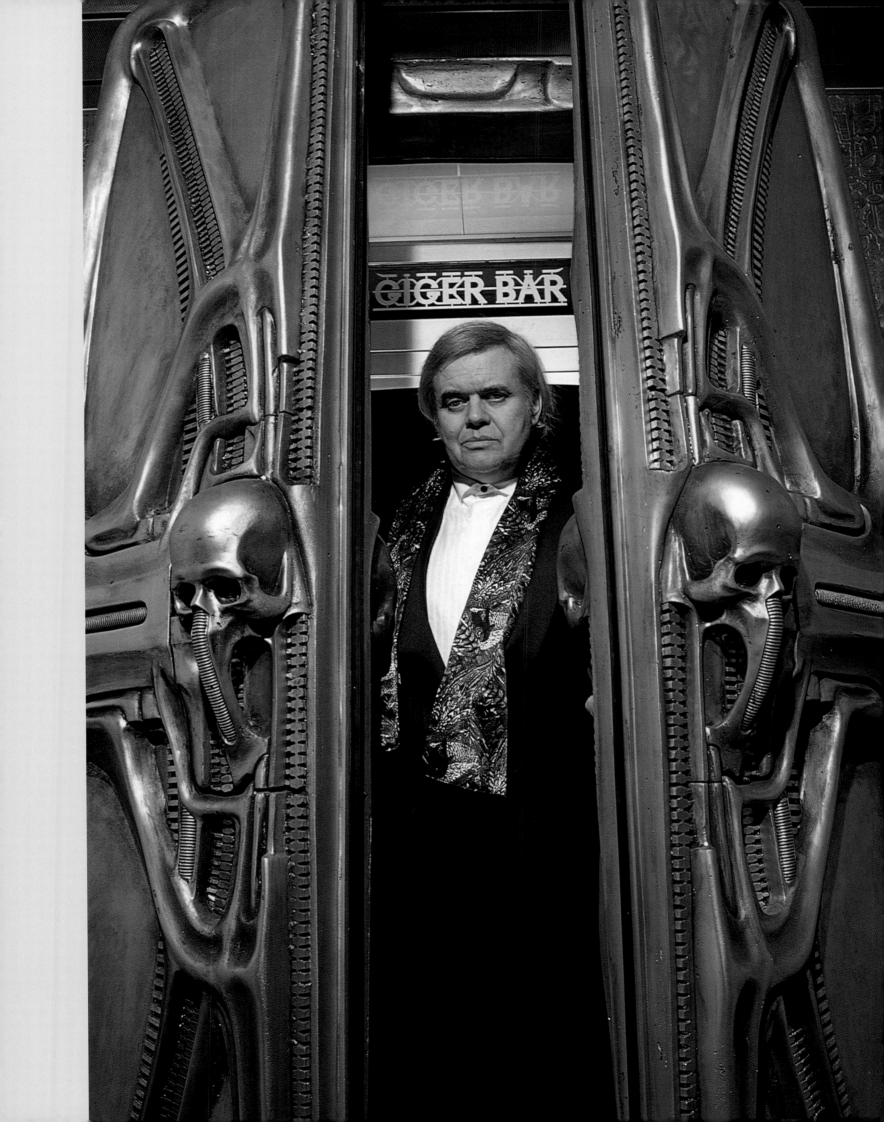

## Giger-Bar in Chur

By coincidence, the bar planned for New York City was built in Chur. The reason was that I refused to sign the contract my former agent had drawn up. I knew that it would get me into hot water. There was simply too little money to allow for the design and construction of the objects I had planned!

Fortunately, I then happened upon Thomas Domenig. In my youth, I had spent six years in high school with his wife. Domenig is THE architect of Chur. He built about a third of the city. There were plans for a cafe in his Kalchbühl-Center, and I evidently showed up at the right moment. I was able to talk Domenig into a bar. M. Cahannes, Domenig's lawyer, contributed a lot toward making the bar possible. DeFries, Schedler, Ammann, Vaterlaus, Gruber and Brigitte von Känel were my most important technical experts in its realization.

My furniture program for this bar was significantly expanded by a chair, a table with a glass top, and a bar. The establishment's door is that of my armoire design, enlarged by a third by Schedler. The oval mirrors, the wall lamps and the special coat racks with and without hooks, were also designed by me and carried out by either deFries or Schedler. Construction took about two years. The opening was on February 8, 1992, three days after my birthday.

*H. R. Giger*

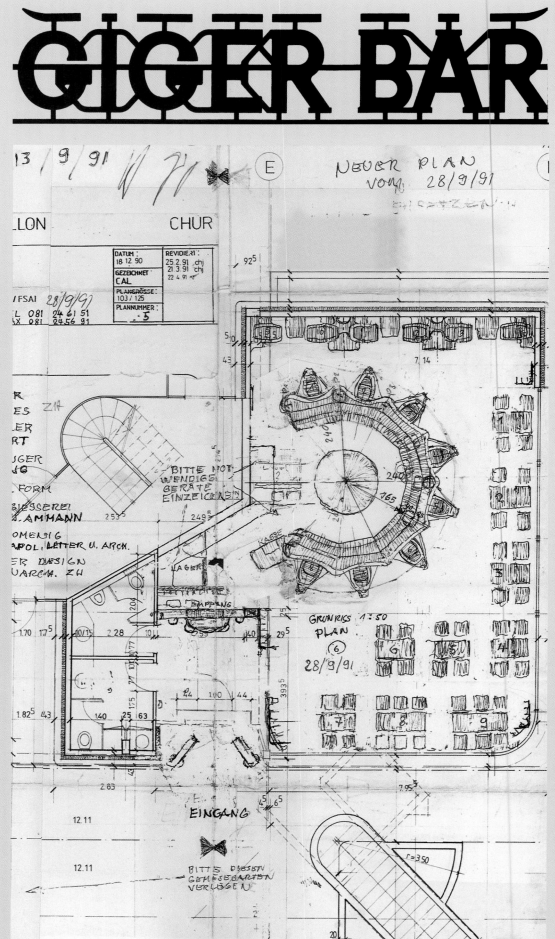

*Giger-Bar, Chur, Floorplan 1:50, 1991. Ink and ball-point pen on paper, 42 x 29 cm*
*Page 93: Giger-Bar, Chur, Kalchbühl Center (Tel.: 081 253 75 06), 1992. Photo: Willy Spiller*

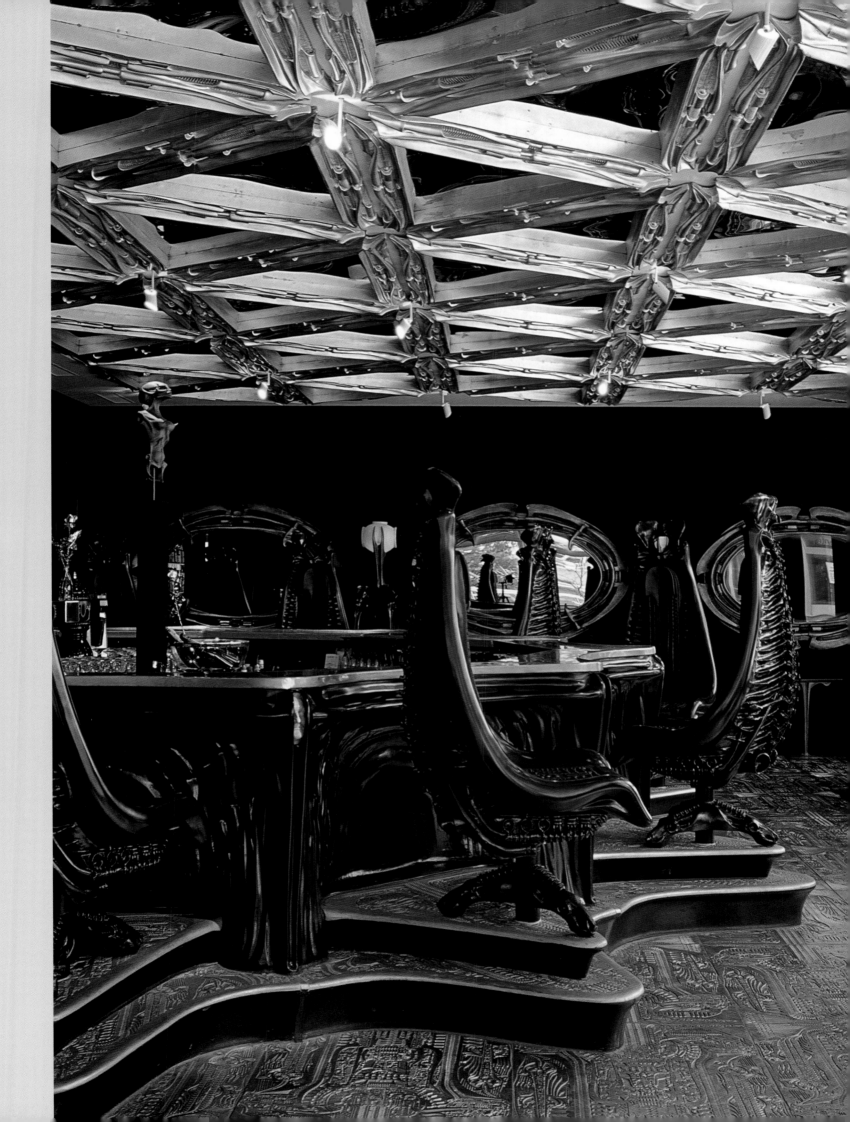

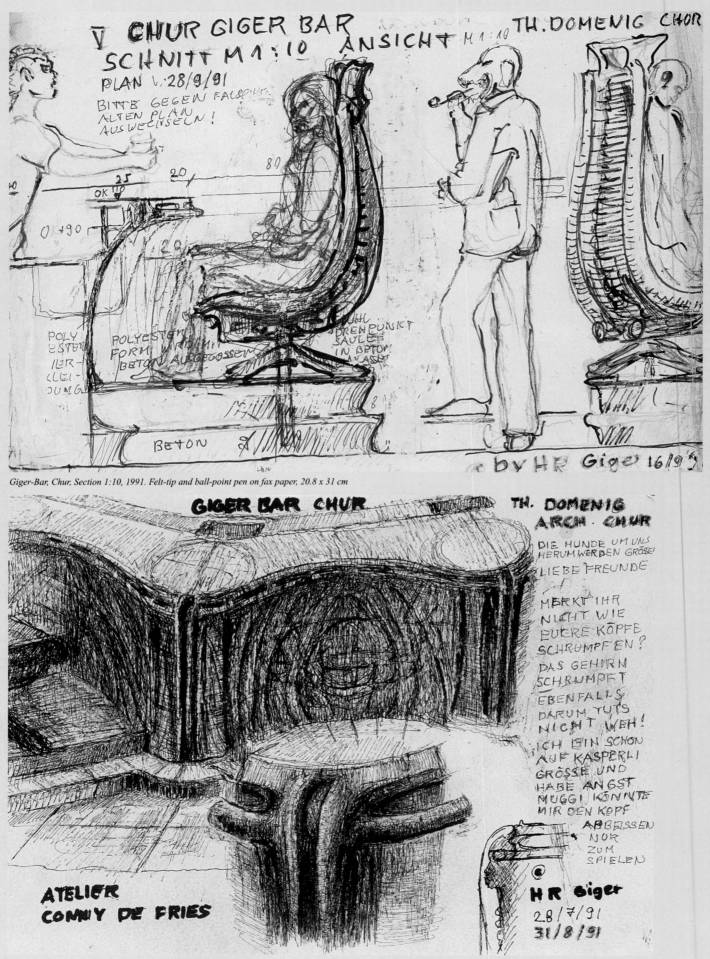

*Giger-Bar, Chur, Section 1:10, 1991. Felt-tip and ball-point pen on fax paper, 20.8 x 31 cm*

*Giger-Bar, Chur, detail drawing, 1991. Ink on paper, 21 x 29.3 cm*

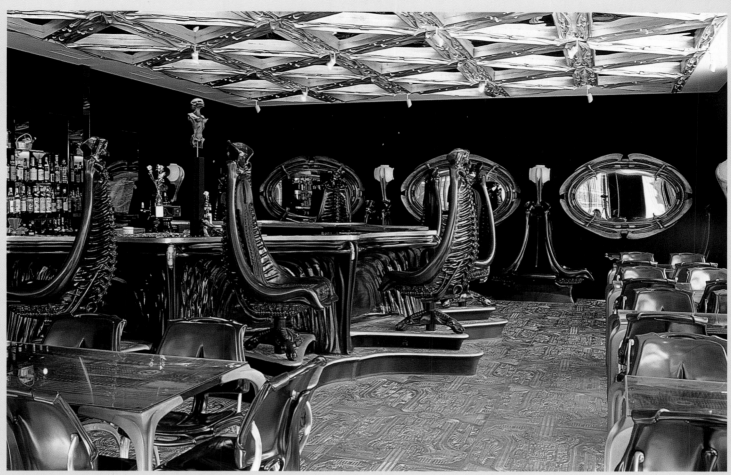

*Giger-Bar, Chur, Kalchbühl Center (Tel.: 081 253 75 06), 1992. Photo: Willy Spiller*

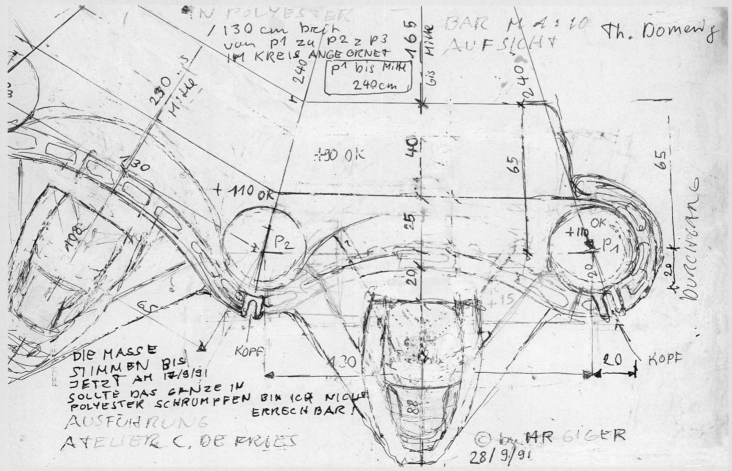

*Giger-Bar, Chur, top view of bar 1:10, 1991. Ink and ball-point pen on fax paper, 20.6 x 31 cm*

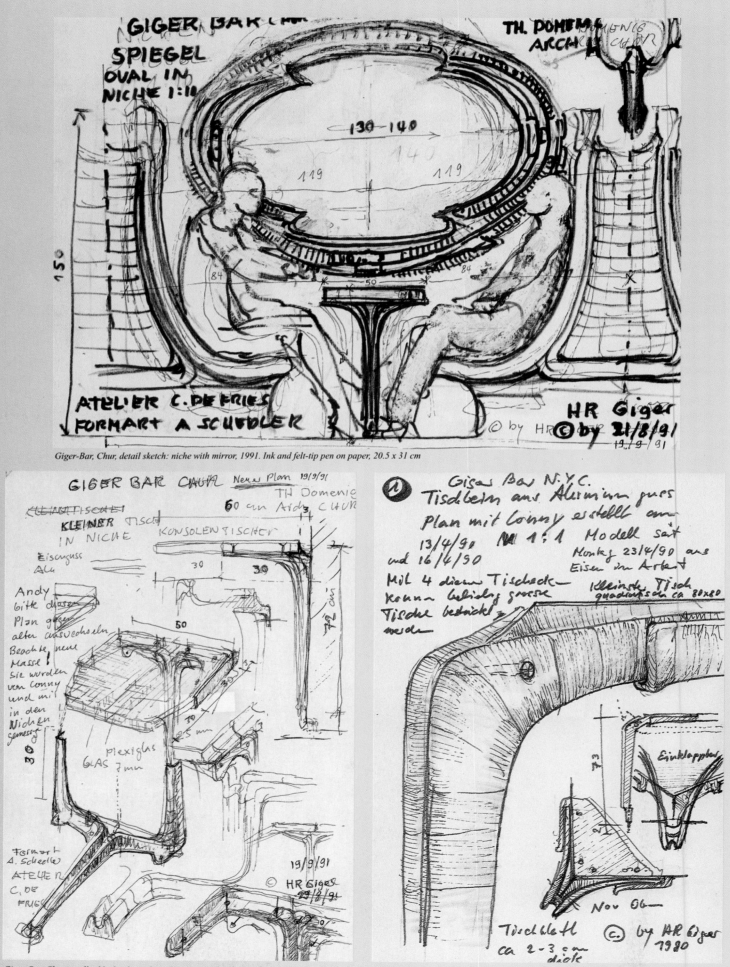

*Giger-Bar, Chur, detail sketch: niche with mirror, 1991. Ink and felt-tip pen on paper, 20.5 x 31 cm*

*Giger-Bar, Chur, small table for the niches (Compare to sketch above), 1991. Ink on paper, 29.6 x 21.2 cm*

*Giger-Bar, Chur, folding table leg (detail), 1990. Ink and felt-tip pen on paper, 27.9 x 20.5 cm*

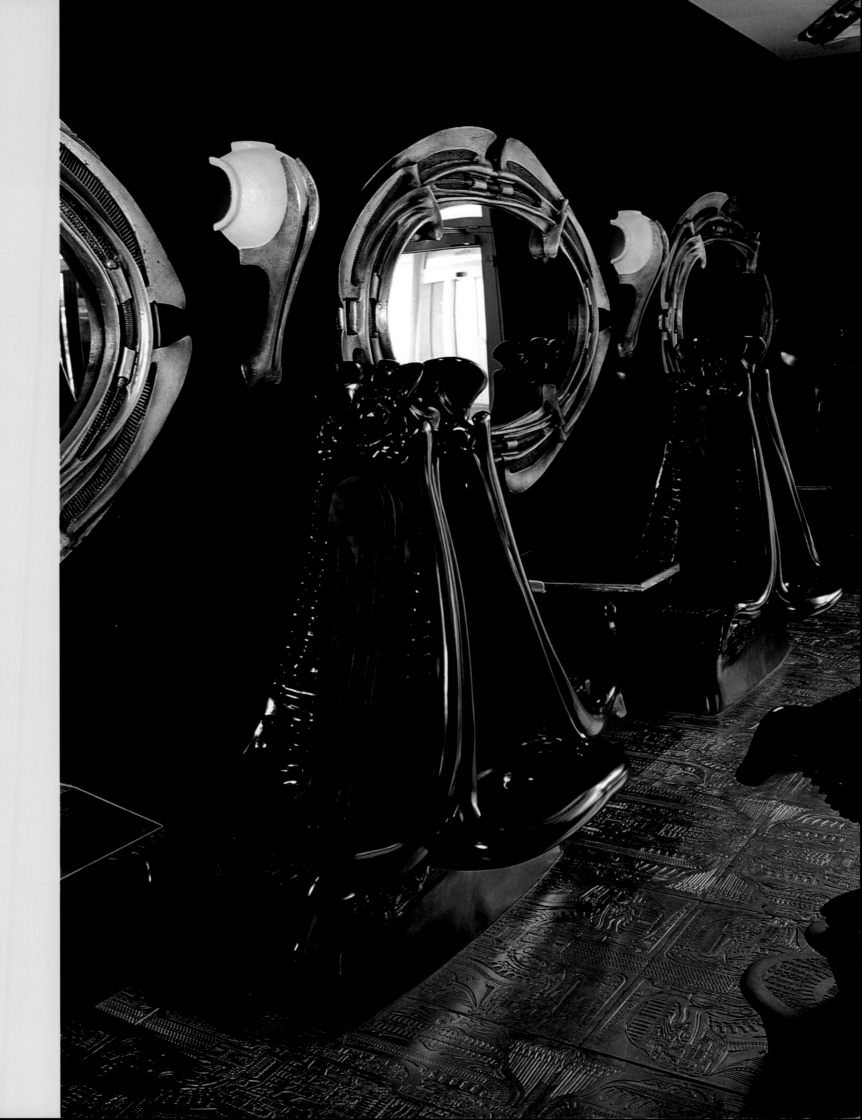

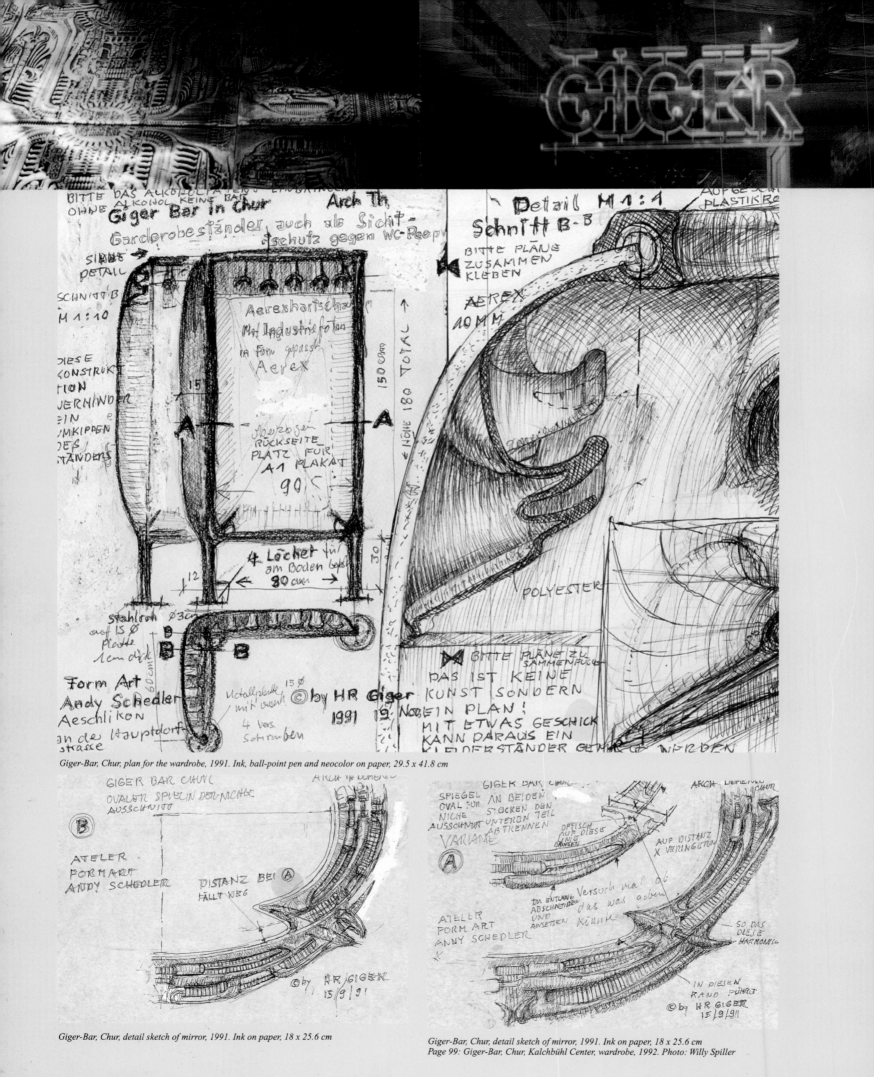

*Giger-Bar, Chur, plan for the wardrobe, 1991. Ink, ball-point pen and neocolor on paper, 29.5 x 41.8 cm*

*Giger-Bar, Chur, detail sketch of mirror, 1991. Ink on paper, 18 x 25.6 cm*

*Giger-Bar, Chur, detail sketch of mirror, 1991. Ink on paper, 18 x 25.6 cm*
*Page 99: Giger-Bar, Chur, Kalchbühl Center, wardrobe, 1992. Photo: Willy Spiller*

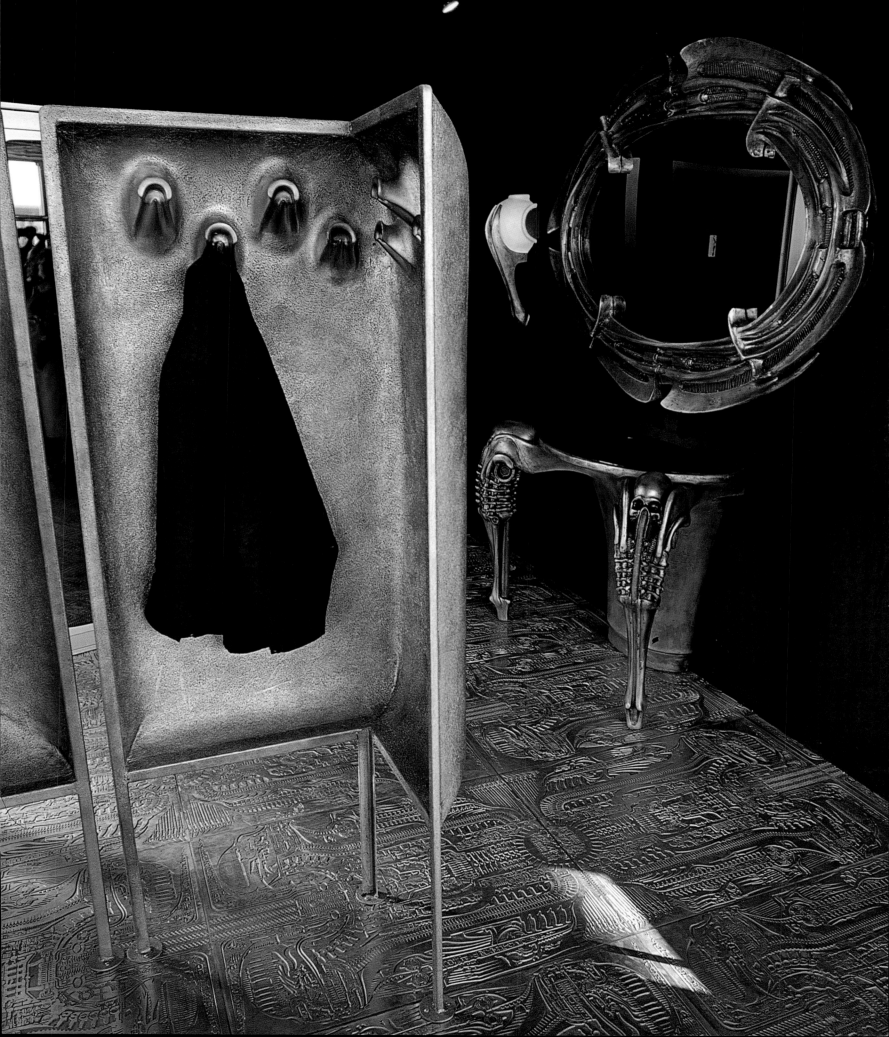

# My Collection

I always try for the first choice, for the best pieces I can buy, and I obtain them in galleries. I have rarely bought directly from the artist. I acquired my first pieces at the Art Fair in Basel. They were two drawings by Brus from 1973. The only trades I ever made were with him and Friedrich Kuhn.

People probably think I collect airbrush paintings. The opposite is true! Almost all the works are wild, tension-laden pieces which reflect the fury and passion of their creation. I consciously refrain from buying anything that resembles my work. The works reproduced here are important individual pieces or key works I own by artists such as Brus, Sandoz, Burland, Jürgens or Kuhn. Collaborative efforts with artists such as Sandoz, Wegmüller or Jürgen Schwarz were on the rare side.

If anyone deserves the designation "Bosch of the 20th Century", for me it is Dado. Possibly he was inspired by Ivan Albrecht's "Portrait of Dorian Gray", which hangs in the Museum of Modern Art in New York. Otherwise, Dado is unique and unmistakable. He is someone who can visualize glaring light and colored shadow incredibly well, and transfer them with the greatest precision to huge canvases, using oversized brushes. His is a name known almost exclusively to art connoisseurs and collectors. An unpopular genius, who is nevertheless represented in the most important museums and collections. A hundred years from now, he will be one of the most important, if not the most important, painters of the 20th century.

*H. R. Giger*

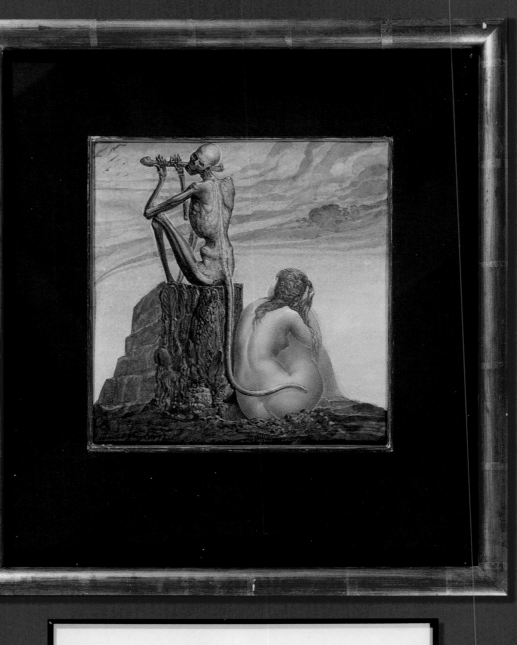

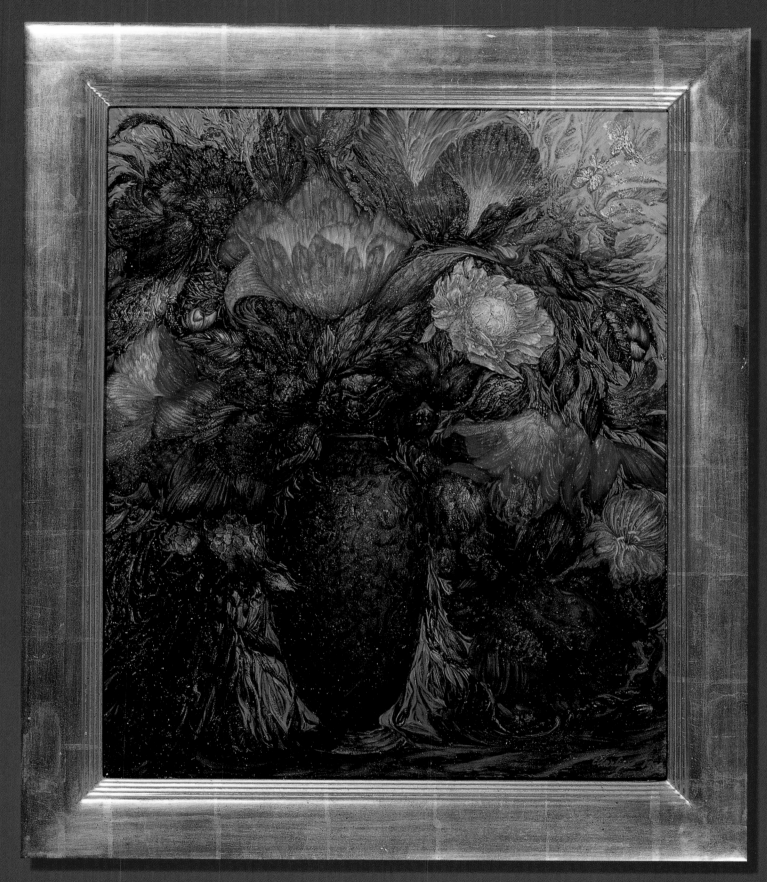

Pages 100 and 101:
No. 457, New York City VII (Vertical Slant), 1980, and No. 465, New York City XV (Crossing), 1981. Acrylic and ink on paper, 100 x 70 cm

Page 102:
Top: Ernst Fuchs: La Sérénade (La Queue), 1974. Egg tempera on paper, 27 x 26 cm
Bottom: Sybille Ruppert: Hit Somethin, 1977. Pencil, colored pencil and pigment on paper, 29.5 x 36 cm
Page 103:
Marlyse Huber: Flowerpower, 1992. Oil on wood, 61 x 49.5 cm

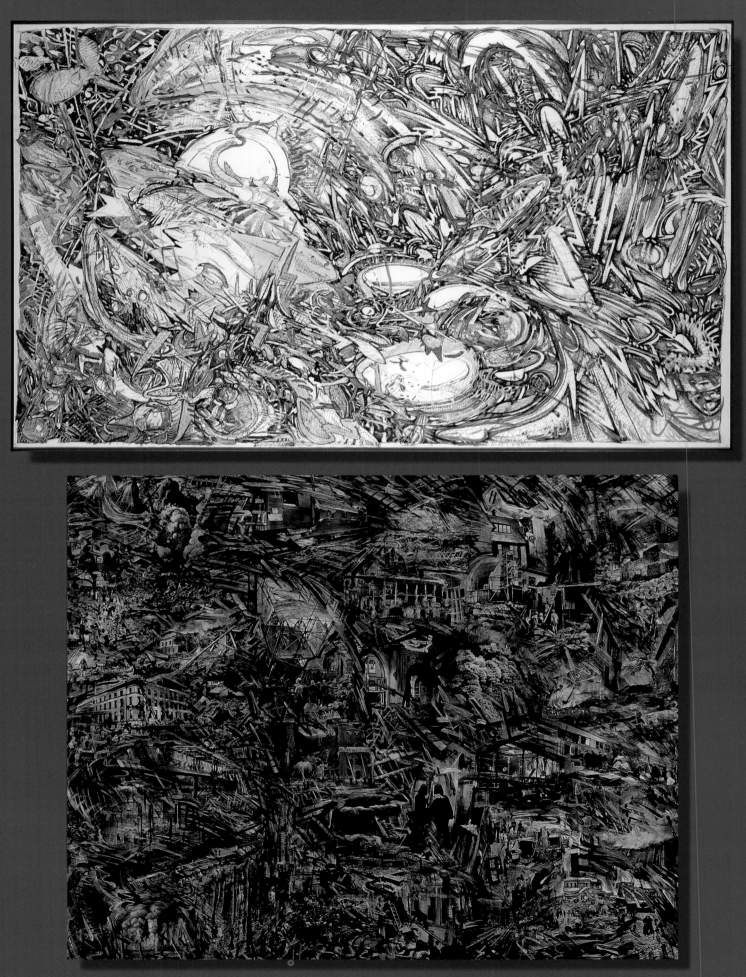

*Top: Turi Werkner, No. 127, 1980. Ink and acrylic on paper, 150 x 250 cm*
*Bottom: Martin Schwarz: Catastrophe I, 1983. Acrylic and collage on wood, 80 x 100 cm*

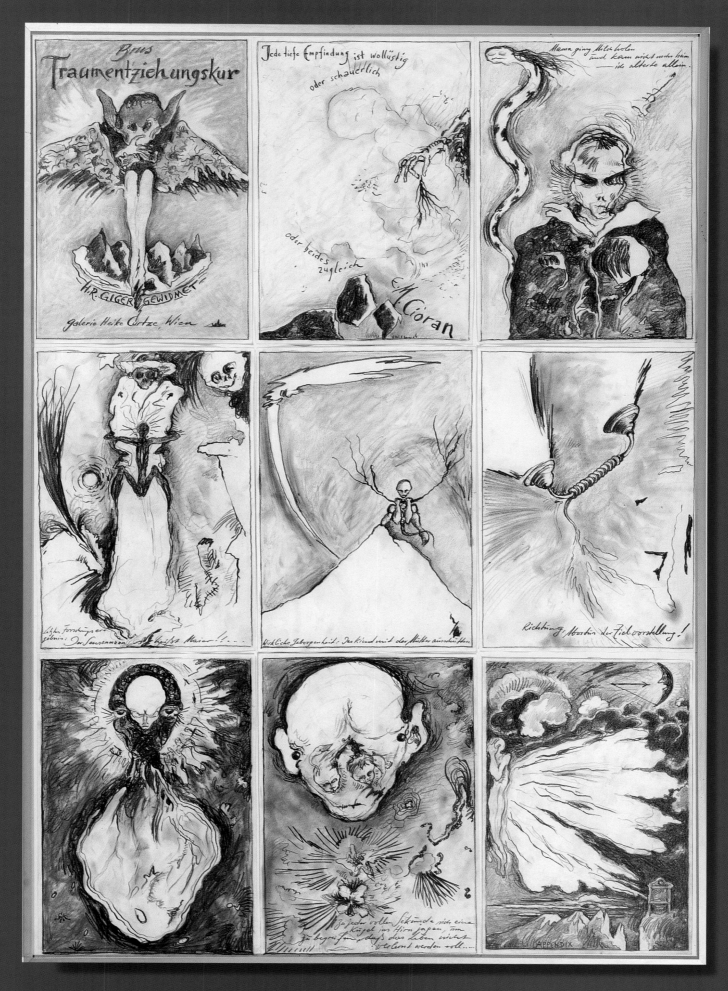

*Günter Brus: Dream Withdrawal Treatment, 1982. Pencil on paper, 9 drawings, each 30.5 x 22 cm*

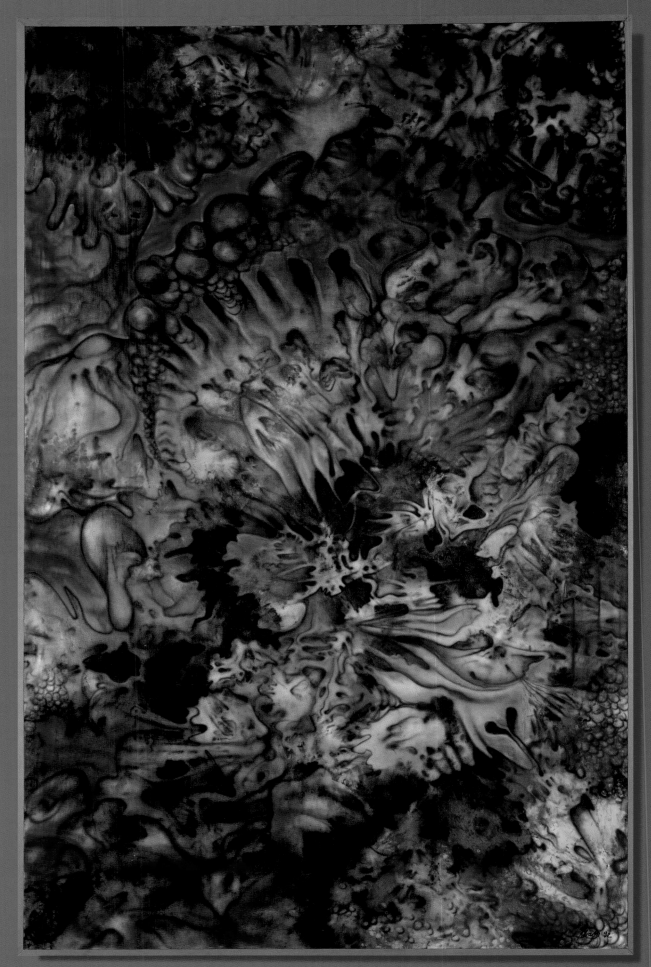

*Ralf Abati: Laua, 1992. Acrylic on canvas, 222 x 144 cm*

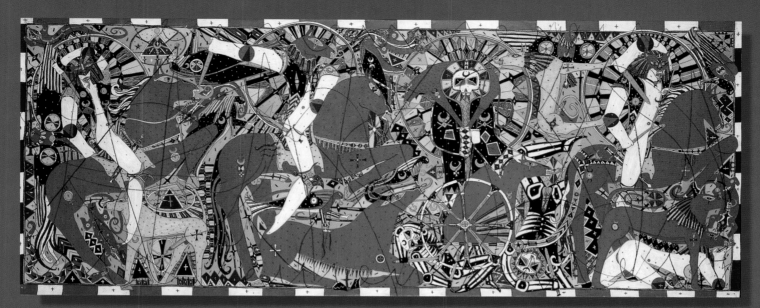

*Francois Burland: Untitled, 1987. Neocolor and paper on wrapping paper, 100 x 260 cm*

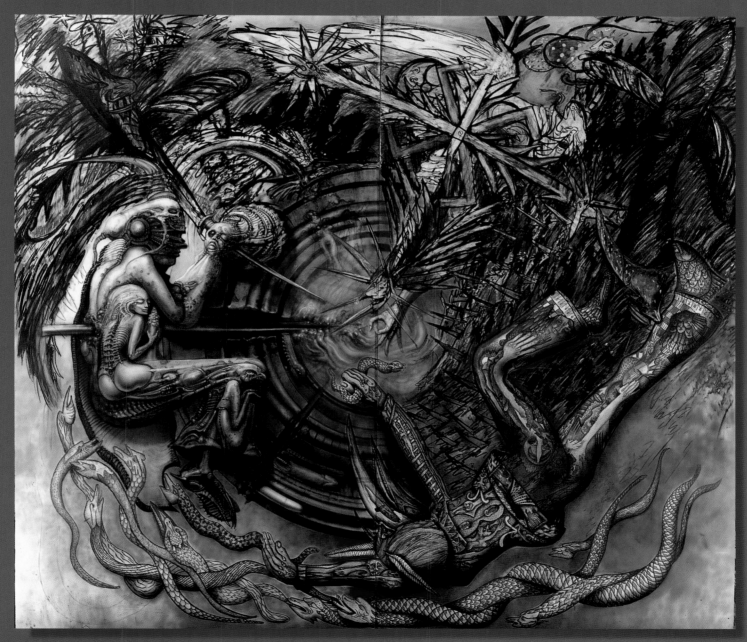

*H. R.G. in collaboration with Claude Sandoz and Walter Wegmüller: Daydream, No. 242, Ouverture, 1973. Ink, pencil, carbon and acrylic on paper/wood, 240 x 280 cm*

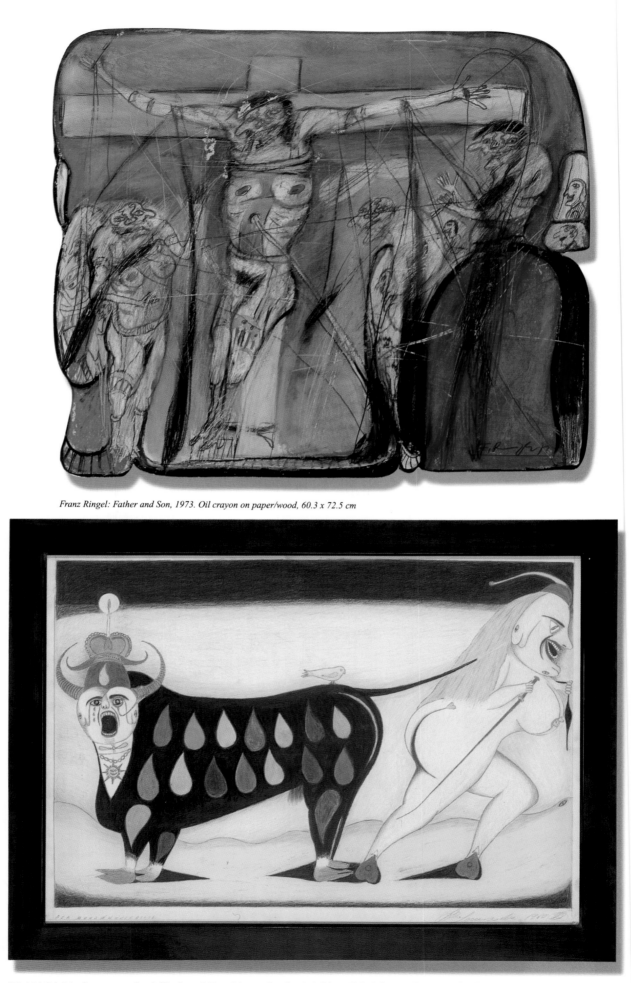

*Franz Ringel: Father and Son, 1973. Oil crayon on paper/wood, 60.3 x 72.5 cm*

*Friedrich Schröder-Sonnenstern: Spuckelbinchen mit ihrem Monwunderochse Juckelchen, 1960. Color pencil on paper, 60 x 82 cm*

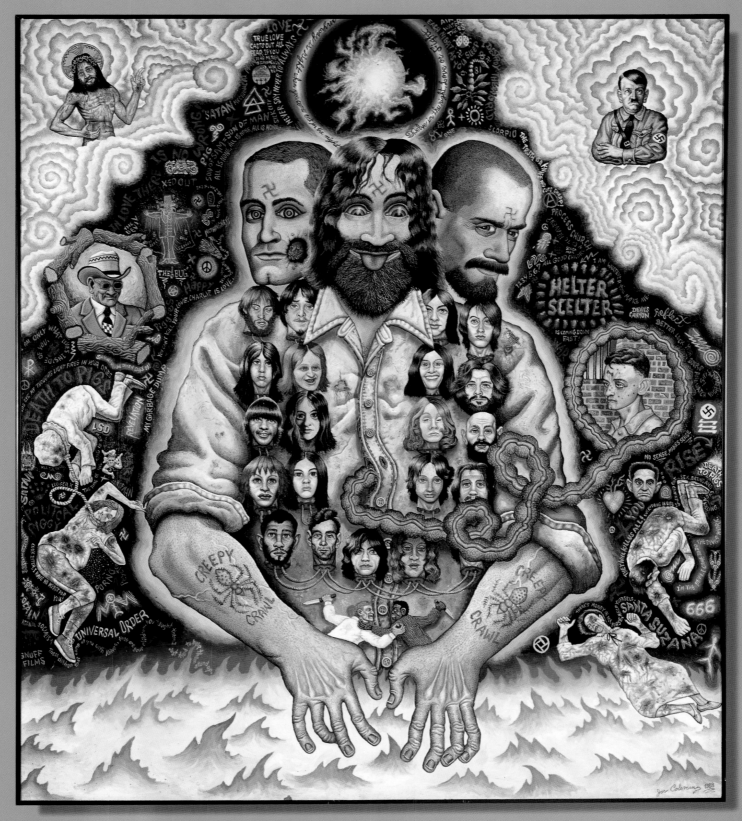

*Joe Coleman: Portrait of Charles Manson, 1988. Acrylic on wood, 119 x 107. 5 cm*

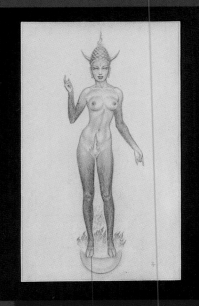

Dado: Lyov, 1976-79. Aqua ink and acrylic on paper, 75 x 55 cm

Pier Geering: La Columna Rota, 1991. Acrylic on tissue paper, 108 x 73.5 cm

Michel Desimon, circa 1974. Pencil on paper, 32 x 20 cm

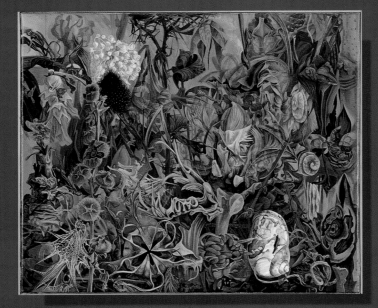

Jürg Attinger: Among the Leftovers, 1993, Oil on canvas, 50 x 60 cm

Panja Jürgens: Cry for Hope, 1988. Color photo-montage, 29 x 42 cm

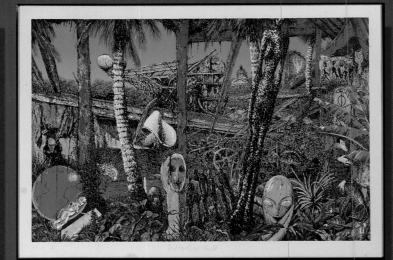

Friedrich Kuhn: Untitled, 1970. Color pencil, ink and collage on paper, 48 x 67 cm

Fred Engelberg Knecht: Untitled, e.d.a., 1992. Silkscreen, 70 x 100 cm

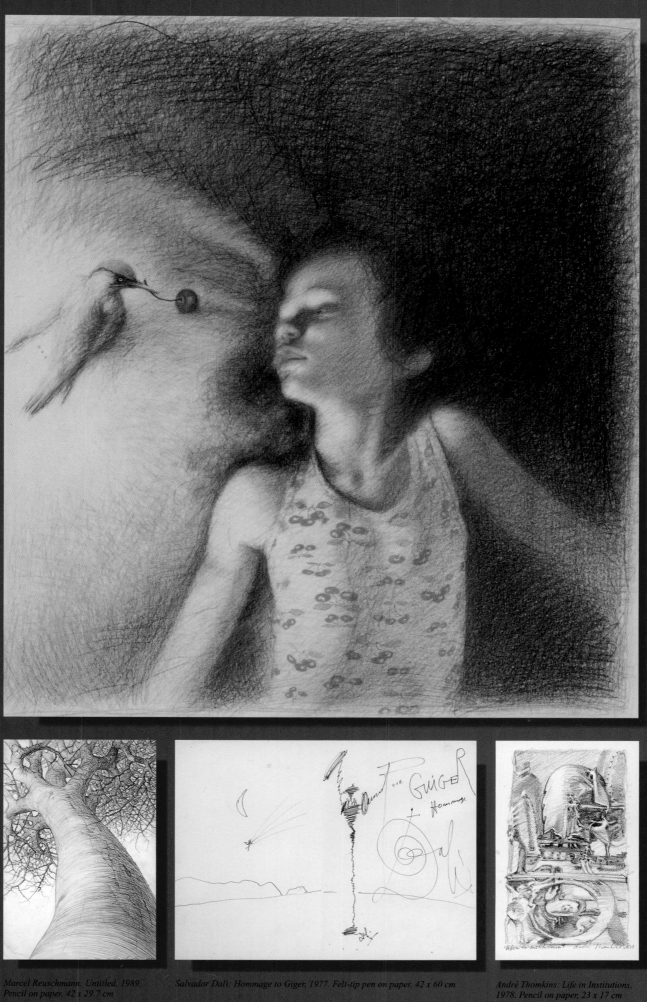

Marcel Reuschmann: Untitled, 1989.
Pencil on paper, 42 x 29.7 cm

Salvador Dalí: Hommage to Giger, 1977. Felt-tip pen on paper, 42 x 60 cm

André Thomkins: Life in Institutions,
1978. Pencil on paper, 23 x 17 cm

Top: Gottfried Helnwein: The Temptation, 1985. Color pencil on paper, 64 x 57 cm

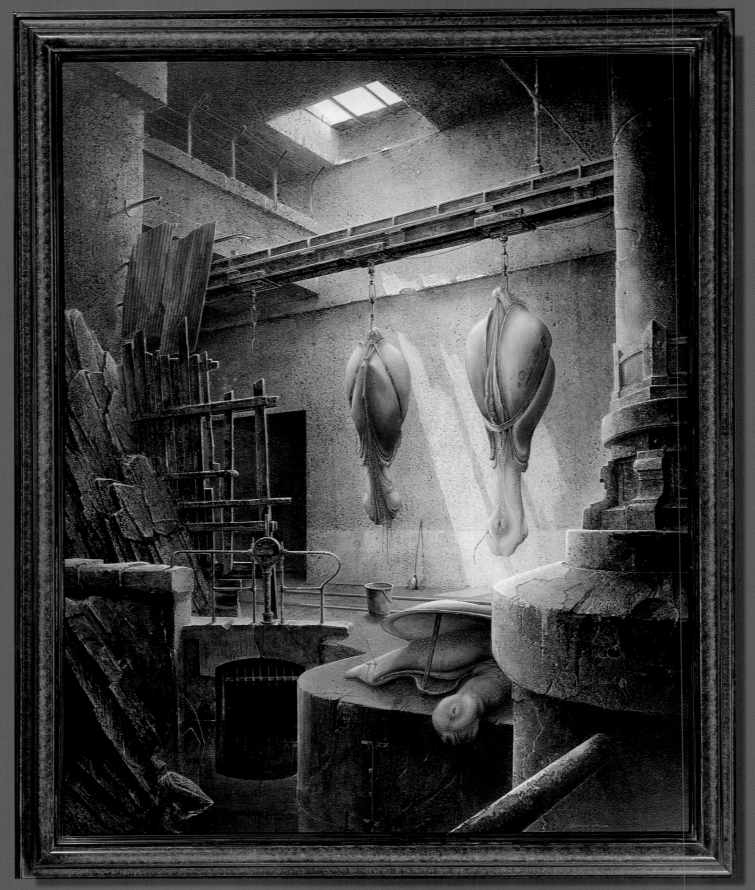

*Jean-Marie Poumeyrol: La Centrale, 1988. Acrylic on wood, 100 x 82 cm*

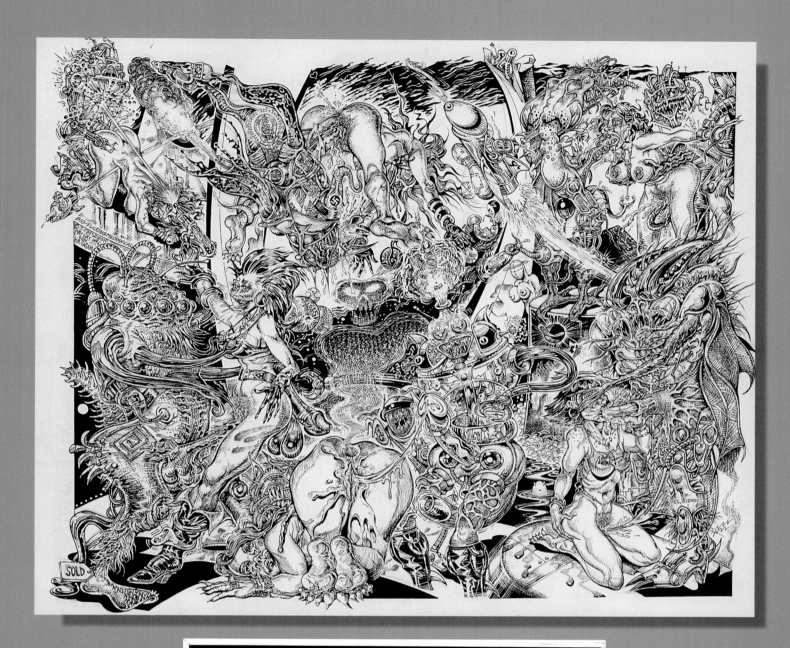

Top: S. Clay Wilson: Bio-Fuck-ing-Mechanical, 1996. Ink and color pencil on cardboard, 30.4 x 36.7 cm

Below: Thomas Ott: One Week, 1991. Scratchboard, each 15 x 10.5 cm

Pages 114 and 115: No. 460, New York City X (Chelsea Cockroaches), 1980, and No. 453, New York City III (Straight), 1980. Acrylic and ink on paper, 100 x 70 cm

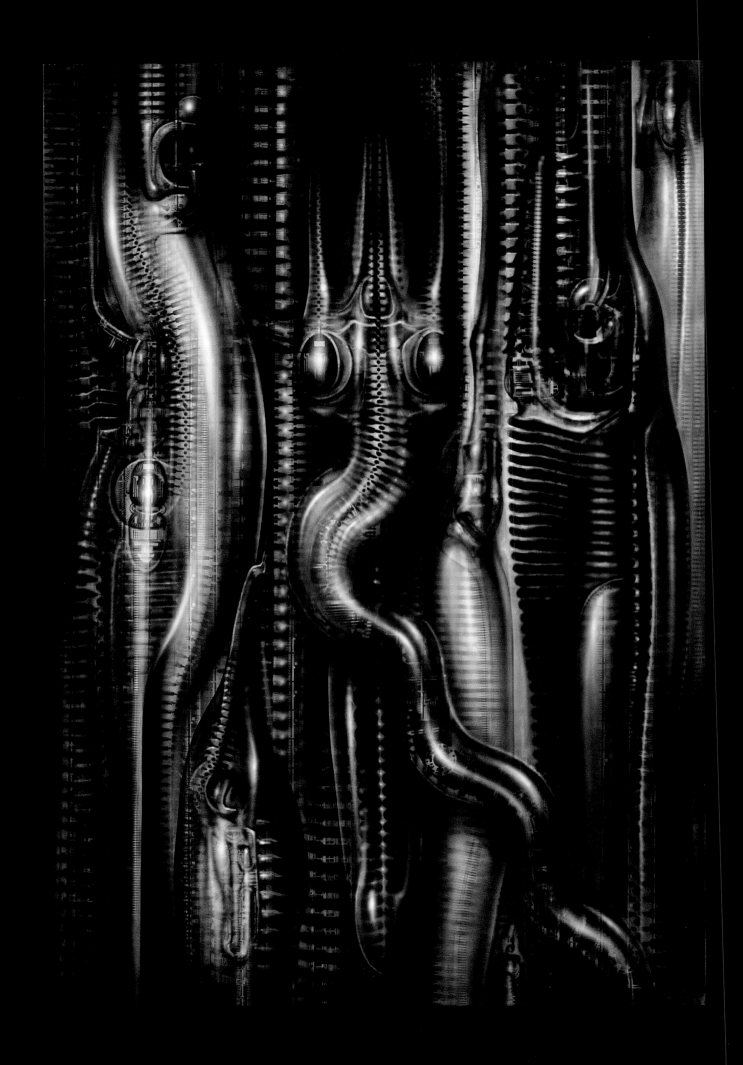

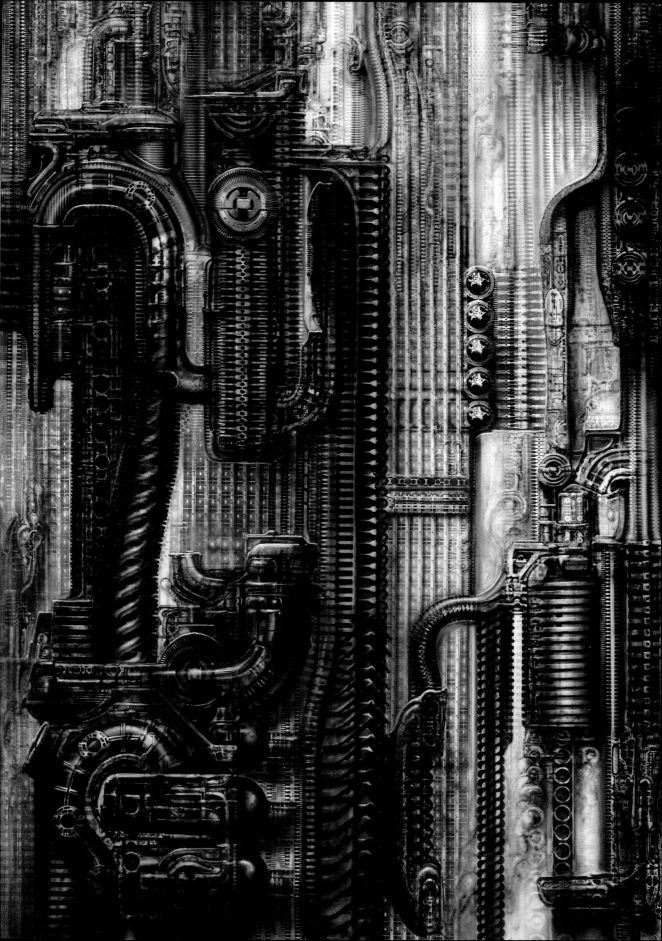

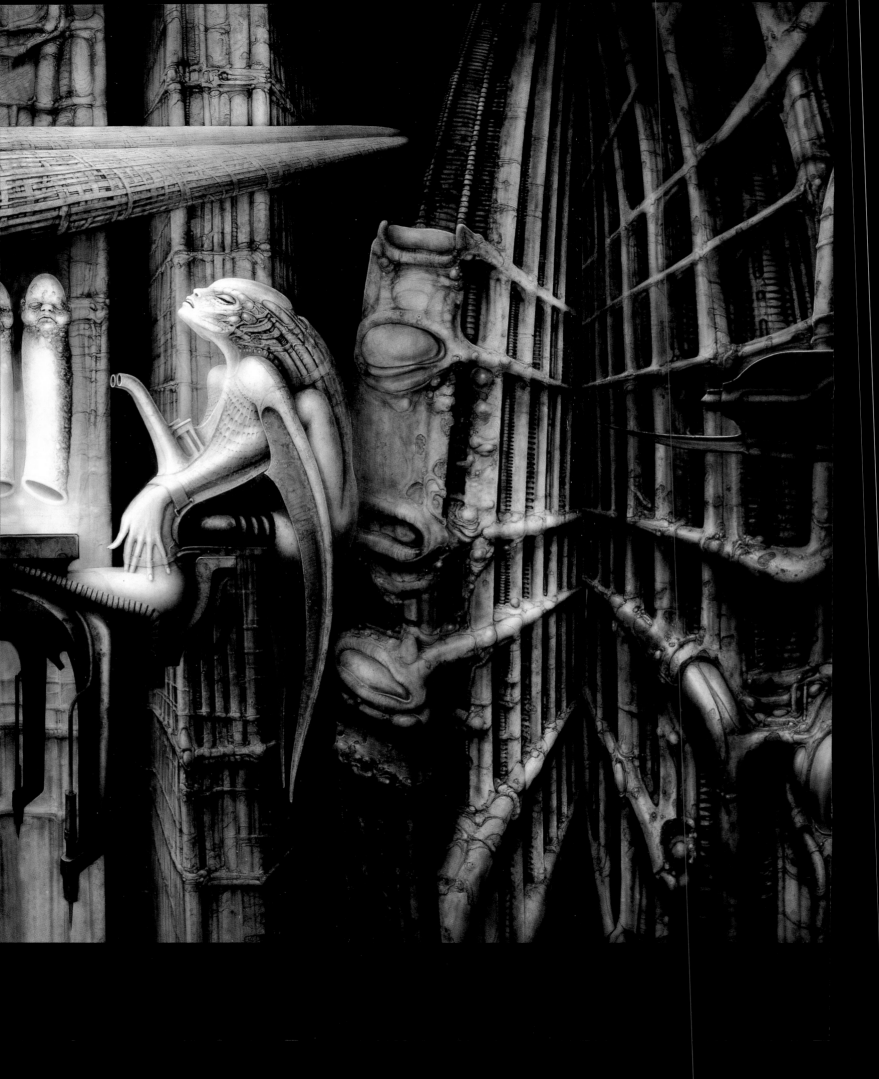

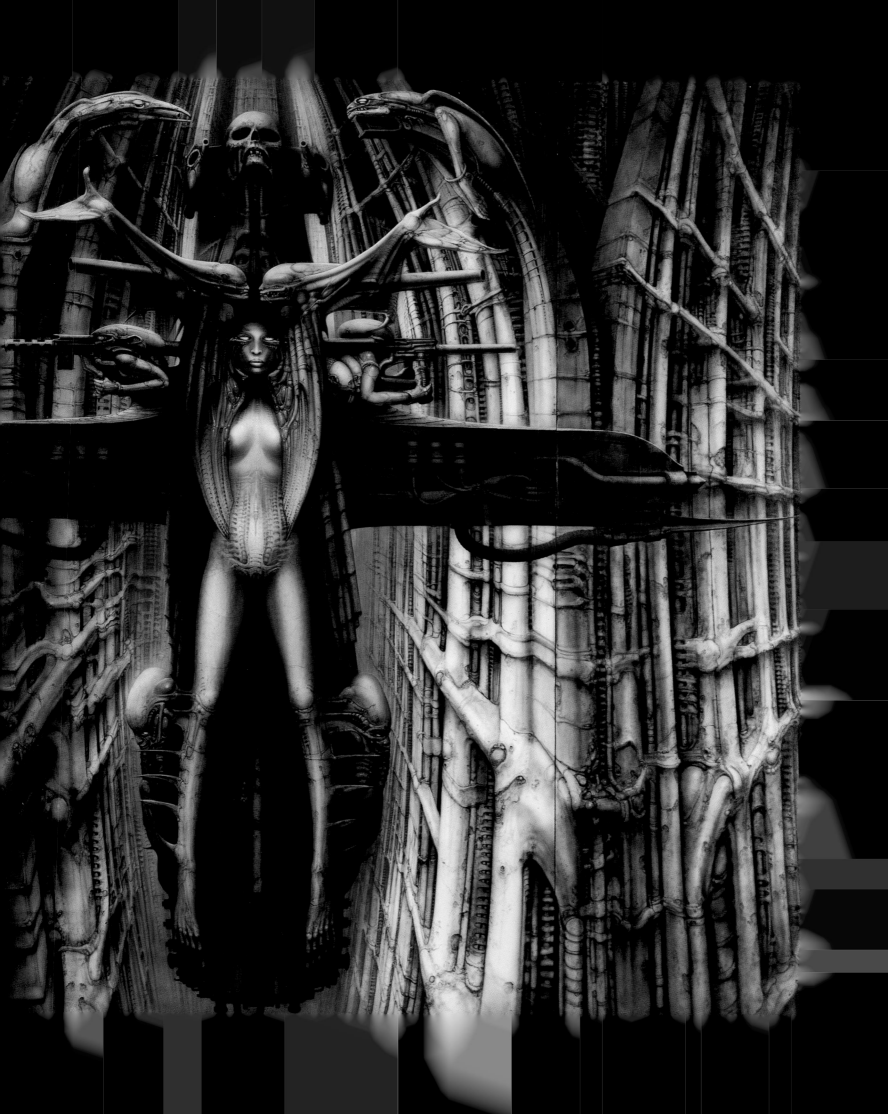

## 700 Years of Waiting

Strassburg must now decide for itself...

Disputes about H.R. Giger's artwork: federal judges turn down a complaint by the proprietor of "Zur Letzten Laterne" (House of the Last Lantern).

(sda/J.O.) Decisive in the ruling of the judges was the "right of third parties, when visiting a public restaurant, [not to be confronted] suddenly and against their wishes" with Giger's images.

The pieces, two lithographs framed together by the proprietor, Urs Tremper, a friend of the internationally renowned artist, had hung for one year without complaint. After a protest was registered by two female guests in October 1992, the city trade commissioner's office intervened. The controversial drawings were ordered removed.

The federal judges decided that interference with the owner's freedom of speech was relative. The pieces were not confiscated and may be exhibited elsewhere for a "larger group of interested viewers". In its judgment, the federal court cited, among other things, permissible confiscation of obscene material in Switzerland. It emphasizes that the assessment of such representations is "different from place to place and may change in time".

As Urs Tremp assured the "Tagblatt" (Daily Paper) yesterday, he will now take his complaint to Strassburg. Several times in the past, the European Court has dealt with art objected to by the state (e.g., with the works of artist Jose Felix Müller from St. Gallen).

(Excerpt from an article in the St. Galler Tagblatt [St. Gallen Daily], 1994)

*Page 116:*
*No. 238, The Spell II (Detail), 1974. Acrylic and ink on paper/wood. 240 x 420 cm*

*Page 117:*
*No. 237, The Spell I, 1973/74. Acrylic and ink on paper/wood, 240 x 280 cm*

Urs Tremp, Wirt im «Haus zur letzten Latern», vor übermalten Giger-Bildern.   Bild: Ralph Ribi

### «So Ihr Sittenwächter...»

Die Bilder Hans Ruedi Gigers im «Haus zur letzten Latern» sind umstritten. Nun hat der Künstler die den Gerichten suspekten Stellen mit schwarzen Balken übermalt, allerdings nur auf Kopien, die Originale bleiben unversehrt, damit sie vom Europäischen Gerichtshof beurteilt werden können. Ausserdem hat Giger seine schwarzen Balken mit schwarzen Sprüchen begleitet: «So Ihr Sittenwächter der Schweiz...»

Unschwer auszumalen, wie es weitergeht.   *J.O.*

*News item in the St. Galler Tagblatt, Sept. 9, 1994*

*Restaurant "House of the Last Lantern", St. Gallen*

*Illustration M. de Sade "Justine Grooming I"*

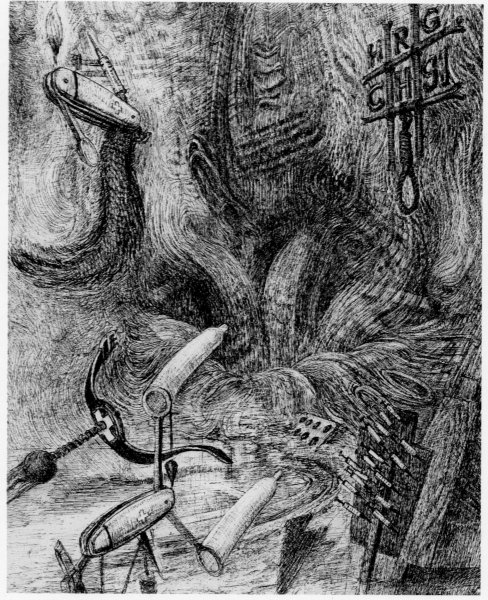

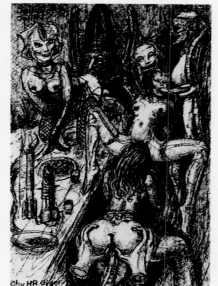

*Illustration M. de Sade VIII*

*Cover "700 Years of Waiting for CH-91", zinc lithograph on cardboard, 44 x 35 cm*

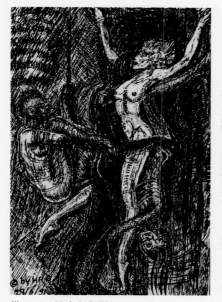

*Illustration M. de Sade IV*

*Illustration M. de Sade XI*

*Illustration M. de Sade VI*

*All illustrations from the portfolio "700 Years of Waiting for CH-91", Leporello with 50 original lithographs, each 30 x 42 cm, signed and numbered, in an edition of 300. Printing: Walo Steiner, Asp, Switzerland, 1991*

*Excerpt from the ruling of the Swiss Federal Court concerning the removal of the "700 Years of Waiting for CH-91" lithos from "House of the Last Lantern" in St. Gallen, June 15, 1994*

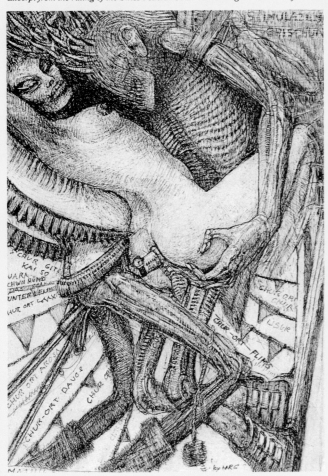

*Inside cover of "700 Years of Waiting for CH-91", Spa Chur, 1991, zinc lithograph on cardboard, 44 x 35 cm*

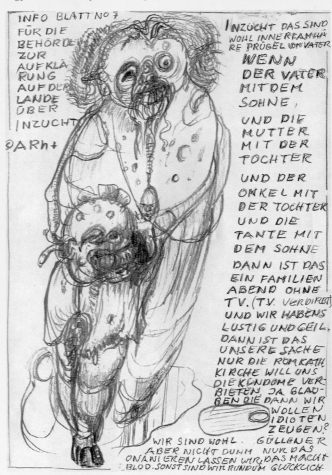

*Educational Chart No. 7 for Enlightenment in Güllenen, 1996, pencil on paper, 29.7 x 21 cm*

## Media Criminals or Character Assassins

Something must be said here about reporters and journalists!

Nothing against the honest people who are aware of the responsibility they shoulder when they research a story. These people are decent and fair, but do not become as successful! I refer to others, for example the foreign-reporter-of-falsehoods Muri von Adam from the SRG (Swiss Broadcasting Company), who appeared in the SRG program "10 'til 10" about two years ago. It went something like this: "Rene Osterwalder bought a building in the middle of Amsterdam, which he transformed with the help of HRG works into a horror center, and where he kept piranhas!" Osterwalder was known in Switzerland and elsewhere for sadistic films using children. He owned some works by a Dutch artist containing skulls and skeletons, and journalist Muri von Adam automatically assumed these pieces were mine. In the program, he implied that Osterwalder had commissioned me to create them. The lawyer for the SRG wrote me that von Adam's statements would be retracted only if I paid the legal fees. Evidently, in Switzerland, justice must be bought!

Same thing now with the ZDF (Second German Television): In the program, which reported on Belgian child abusers and murderers and then denounced sex tourism in the Third World, the "Mona-Lisa-ladies" wanted to use a text of mine taken completely out of context. These ladies had fallen for a bowdlerizer named Brenner and wanted to tear from ts context, both visually and textually, my holiday story about A., which appeared in "Mein heimliches Auge, X" (My secret Eye, No. 10), published in the Konkursbuch Verlag Claudia Gehrke. On the Sunday in question, I had exactly four hours to find a lawyer who was, luckily, able to prevent this. This, in turn, led the announcer to read the lawyer's letter out of context. To set matters straight, the abbreviated text sent to all the news editors by Brenner was later supplemented by Mrs. Gehrke, who sent them the text in its entirety. The Mona Lisas, however, had already formed their erroneous opinion and could not be stopped from cutting me from the program completely. They were sour because they had lost their sensational story and thus chose to portray me as someone who hid behind a lawyer. In the future, it will be dangerous to write about, or illustrate, a social ill in a critical or satirical manner. By doing so, one is automatically guilty of criminal intent and is punished instead of the real culprits. This is the power of the media criminals, who should themselves be brought to justice!

*700 Years of Waiting for a More Humane Relationship with Animals II, self censored version, 1991. Felt-tip pen on zinc lithograph*

*700 Years of Waiting for the Family Pill, self censored version, 1991 Felt-tip pen on zinc lithograph*

Letter to H. R. Giger, dated October 14, 1992, from Michel Thévoz, curator and Professor of Art History at the University of Lausanne and Director of the Musée d'Art Brut in Lausanne:

My dear Giger,

I read in the newspaper "24 Heures" that your drawings have been ruled obscene in St. Gallen. This is disturbing, and all those who seriously concern themselves with art feel threatened. The Marquis de Sade is considered one of the most important writers in the history of literature. You, H. R. Giger, are yourself viewed as one of the established representatives of contemporary art in Switzerland. If your works (like those of artists in any age) are sometimes of a provocative nature, they are nevertheless firmly within the domain of art, which appeals to the most noble faculties of the spirit. Far from wanting to harm anyone, they invite the viewer to undertake an exploratory journey to fictional realms, which may seem confusing but makes cultural enrichment possible.

This means that those who categorize your works as obscene deliberately place them in an unsuitable context. It is an inappropriate interpretation or projection for which they alone are responsible. They are the ones who "misview" the portrayed relationships; therefore, it is their perception that is obscene, and not your works.

Best regards,

*Michel Thévoz*

*Film Instruction, St. Güllenen, 1996. Neocolor and marker on paper, 29.7 x 21 cm*

**Educational Chart No. 5 for Enlightenment in Güllenen**

Different cantons, different customs!

Regions heavily influenced by the Roman Catholic Church (i.e., close to the Bishop), are in desperate need of enlightenment.

If you should ever accidentally happen upon such a situation, leave inconspicuously without saying a word. Obviously a child, curious and eager to explore, has fallen into a garbage can and is discovered by a farmer. He saved it from what must have been a life-threatening situation. It should thank God for being rescued! In such situations, it is advisable to disappear quietly so as not to disturb the man during his selfless endeavor. He does not need your help! More importantly, it's none of your business! The man knows what he's doing. Should you find the child dead upon a later visit to the scene leave quietly without being seen. Obviously, it's too late for any help.

*ARh+ 1996*

LEHRTAFEL NO⑤ ZUR AUFKLÄRUNG IN ST.
GÜLLEN. ANDERE KANTONE, ANDERE SITTEN!
IN GEBIETEN, DIE VON DER RÖM. KATHOLISCHEN KIRCHE
DURCHZOGEN SIND, D.H. IN BISCHOFSNÄHE, TUT AUF-
KLÄRUNG BITTER NOT.

SOLLTEN SIE EINMAL
UNVERHOFFT ZU EINER
SOLCHEN SITUATION
STOSSEN, VERHALTEN SIE
SICH STILL UND VERSCHWIN-
DEN SIE UNBEMERKT

OFFENSICHTLICH IST
EIN KIND
BEIM NEUGIERIG.
SUCHEN IN EINE MÜLL-
TONNE GESTÜRZT UND WURDE
VOM BAUERN ENTDECKT
UND GERETTET! ER HAT ES
AUS DER TÖDLICHEN
LAGE BEFREIT. DAS
KIND KANN GOTT
DANKEN, DASS ES BE-
MERKT WURDE!
HIER EMPFIELT ES
SICH, SICH LEISE ZU ENT-
FERNEN, DA ER SICH
MÖGLICHERWEISE
GESTÖRT FÜHLEN
KÖNNTE. ER
BRAUCHT IHRE
HILFE NICHT!
UND VORALLEM
GEHT SIE DAS
NICHTS AN!
DER MANN
ARh+  WEISS, WAS ER
©96  TUT. SOLLTEN
SIE DAS KIND BEI

EINEM SPÄTEREN BESUCH DES ORTES TOT AUFFINDEN,
SO MACHEN SIE SICH UNBEMERKT SCHLEUNIGST
DAVON. SCHEINBAR KOMMT JEDE HILFE ZU SPÄT!

*Education Chart No. 5 for Enlightenment in Güllenen, 1996. Neocolor, ball-point and marker on photocopy, 29.7 x 21 cm*

## Educational Chart No. 1 for Enlightenment in Güllenen

Different cantons, different points of view. Sex educational chart for Güllenen. Sex with animals. 700 years of waiting for enlightenment from the government.

Whoever finds shit in the milk has bad taste (in his mouth) and has made a mistake! Whoever finds milk in shit should consult a psychiatrist! Up with the tails, love is calling! Why can't we do what we want with our own animals and children? Television is corrupting us! Widower Aebi, who has often fallen from the slippery milking stool, has riveted aluminum handles to the leather harness, so that his hands, at least, have something to grip on to.

*Information Sheet 1,*
*Publisher ARh+ 1996*

## Educational Chart No. 2 for Enlightenment in Güllenen

Educational Chart for the St. Güllenen authorities. Different cantons, different customs No. 2.
– Sex with animals
– the violated piggy bank

Is it the government's job to inspect the swinish goods of shopkeeping swine for their pornographic content to objectively determine if they should be labeled Güllener idiots, regionally, or throughout all of Switzerland! Think of your children.

The worst thing you could do to them is to make them a laughingstock because their father is unenlightened about the facts of life. A pig in the pigsty eliminates the need for a visit to the whorehouse.

When the father, once again, disappears into the pigsty, the enlightened children yell: Daddy, stop fucking that old sow, it's a waste of time. The clever kids know what a piggy bank is good for!

*Educational Chart No.1 for Enlightenment in Güllenen, 1996. Neocolor, ball-point and marker on photocopy, 29.7 x 21 cm*

*Educational Chart No. 2 for Enlightenment in Güllenen, 1996. Neocolor, ball-point pen and marker on photocopy, 29.7 x 21 cm*

## Educational Chart No. 6 for Enlightenment in Güllenen

Educational chart for the government workers of Güllenen. Different cantons, different customs No. 6

– Which canton is the largest...
– Which canton has the largest...

Should you ever run into someone like this young virgin (p. 127), don't immediately run to the police. This specimen is the ideal partner for a passionate train fanatic. To fortify and tighten her vagina, she demonstrates to her partner an unparalleled willingness to indulge his obsessions.

Those who don't like it can shove the Golden Gate Bridge up their a ...! This should be an inspiration, especially to the children of Güllenen, not to act so uptight when the teacher wants to get into their pants again.

I, who have been accused of pronography by the moral guardians of Güllenen – pornography of the more forbidden type involving children and animals – will not rest until the government of Güllenen apologizes to me every which way, and, in compensation, builds me a museum – blessed by the Bishop!

*Educational Chart No. 8 for Enlightenment in Güllenen, 1996. Neocolor, ball-point pen and marker on photocopy, 29.7 x 21 cm*

## Educational Chart No. 7 for Enlightenment in Güllenen (p. 120)

Information chart No. 7 to teach country authorities about incest.

Incest is intra-familial beating by the father. If the father does it with the son, the mother with the daughter, the uncle with the daughter, and the aunt with the son, that's a family night without TV (TV corrupts), a happy and horny gathering – and it concerns only us.

The Roman-Catholic church would like to keep us from using condoms. Do they want us to father idiots? We may be from Güllenen, but we're not stupid! The only thing we don't do is masturbate. That makes you stupid! Apart from that, we're entirely content.

*ARh +*

LEHRTAFEL FÜR BEAMTE VON GÜLLENEN ANDERE KANTONE ANDERE SITTEN N° 6 WELCHER KANTON IST DER GRÖSSTE ER HAT DIE NG

BEGEGNEN SIE JEMANDEN WIE DIESER JUNGEN FRAU, DANN RENNEN SIE NICHT GLEICH ZUR POLIZEI. DIES BEISPIEL IST DIE IDEALE PARTNERIN EINES PASSIONIERTEN EISENBÄHNLERS, DIE ZUR ERTÜCHTIGUNG UND STRAFFUNG IHRER VAGINA IHREM PARTNER EINE BEISPIELLOSES ENTGEGENKOMMEN SEINER OBSESSION VERMITTELN WILL

WEMS NICHT PASST, DER SOLL SICH DIE GOLDEN GATE IN DEN A SCHIEBEN! GERADE FÜR ST GÜLLENER KINDER SOLLTE DAS EINE ANREGUNG SEIN*

SICH NICHT SO DÄMLICH ANZUSTELLEN WENN IHNEN MAL DER →

HERR LEHRER AN DIE WÄSCHE WILL

ICH, DER VON DEN ST. GÜLLENER SITTENWÄCHTER DER PORNOGRAPHIE ANGEKLAGT. UND ZWAR DER VERBOTENEREN DIE MIT TIEREN UND KINDER" WERDE NICHT EHER RUHEN ALS BIS SICH DIE ST GÜLLENER REGIERUNG BEI MIR IN ALLER FORM ENTSCHULDIGT UND MIR ALS WIEDERGUTMACHUNG EIN MUSEUM BAUT VOM BISCHOF GEWEIHT!

DIE WORTE DES BUNDESGERICHTS : "ES WÜRDE IN DER SCHWEIZ DURCHAUS GEGENDEN GEBEN, IN DENEN GIGER'S KUNST ANSTANDSLOS GEZEIGT WERDEN KÖNNE" WERDEN FÜR GÜLLENEN NOCH FOLGEN HABEN

*Educational Chart No. 6 for Enlightenment in Güllenen, 1996. Neocolor, ball-point pen and marker on photocopy, 29.7 x 21 cm*
*Pages 128 and 129:*
*No. 477, New York City XXVII, 1981, and No. 474, New York City XXIV (Escalator), 1981. Acrylic and ink on paper, 100 x 70 cm*

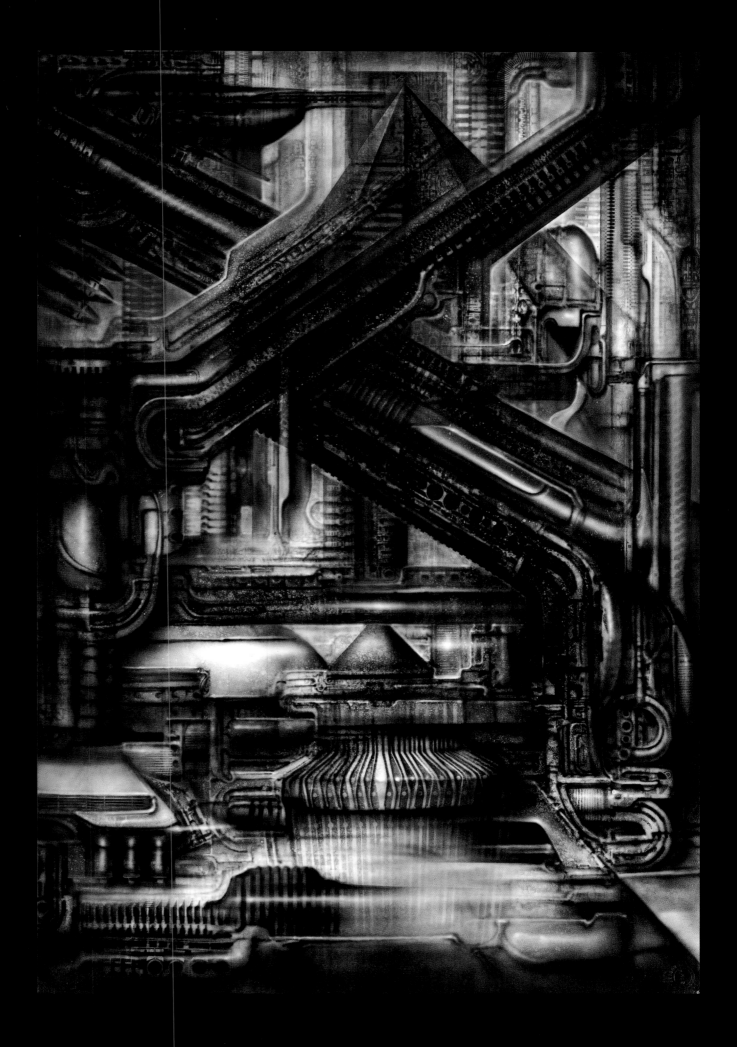

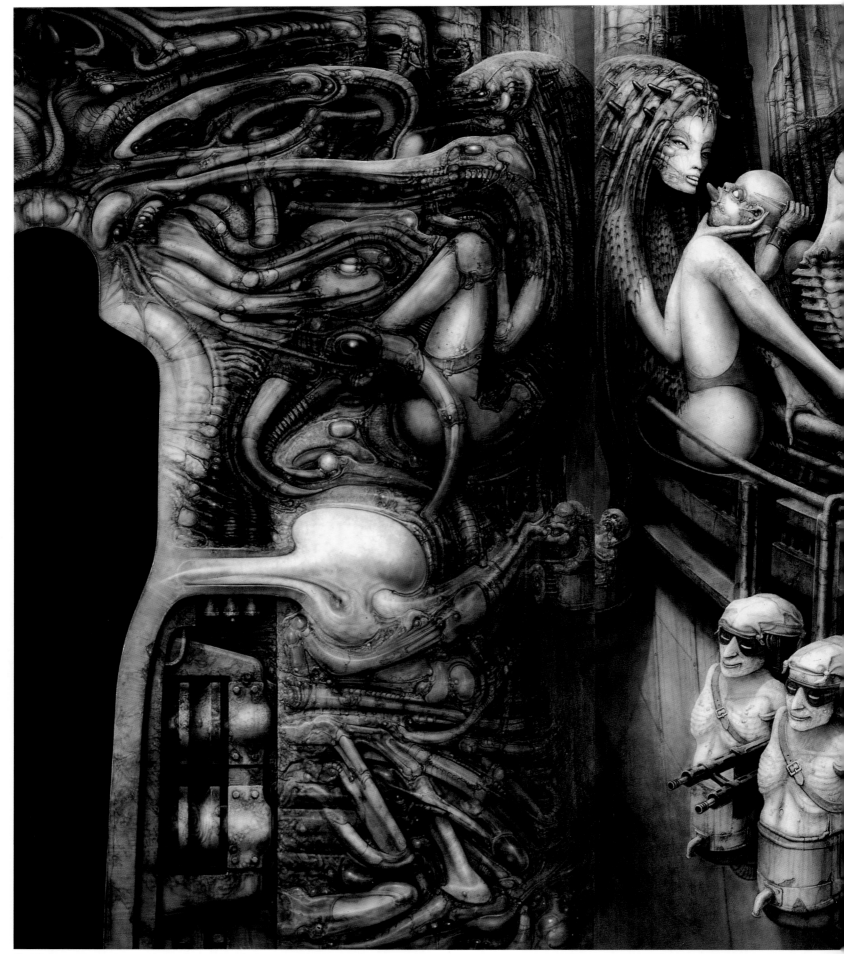

*No. 262, Passage Temple, Entrance (detail), 1975. Acrylic and ink on paper on wood, 240 x 280 cm*

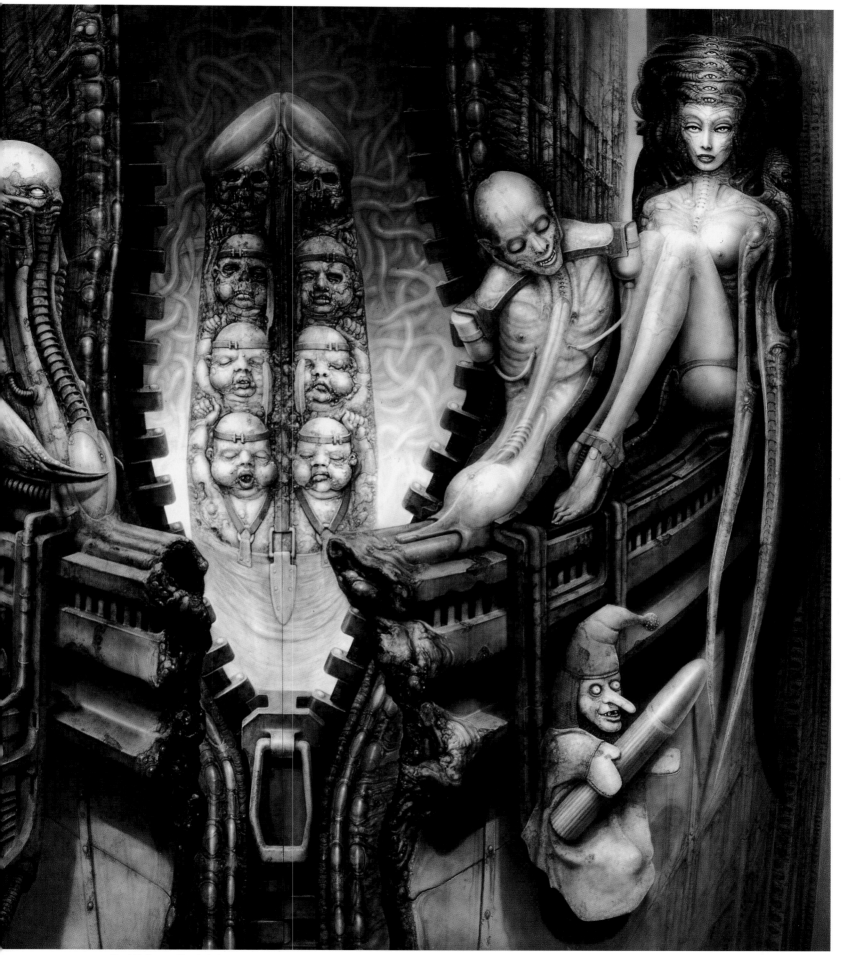

*No. 261, Passage Temple (Life), 1974. Acrylic and ink on paper on wood, 240 x 280 cm*

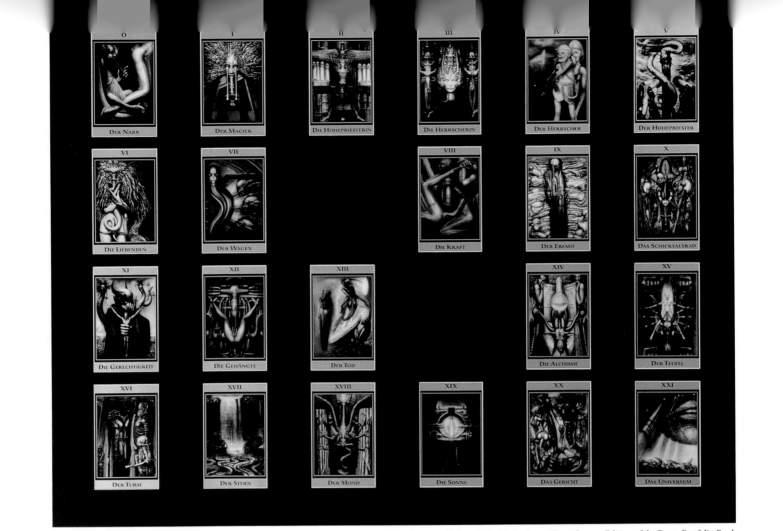

Top: Baphomet – The Tarot of the Underworld,
Tarot card design by H.R.G./Akron, 1993. Five-color offset print,
22 tarot cards, each 16.9 x 10.5 cm

Below: H.R.G.'s Baphomet Tarot, Luxury Edition of the Tarot. Portfolio Book,
8 of 24 zinc lithographs of A4-drawings, edition 99 + XV, signed and numbered.
Printing: Walo Steiner, Asp, Switzerland, 1992

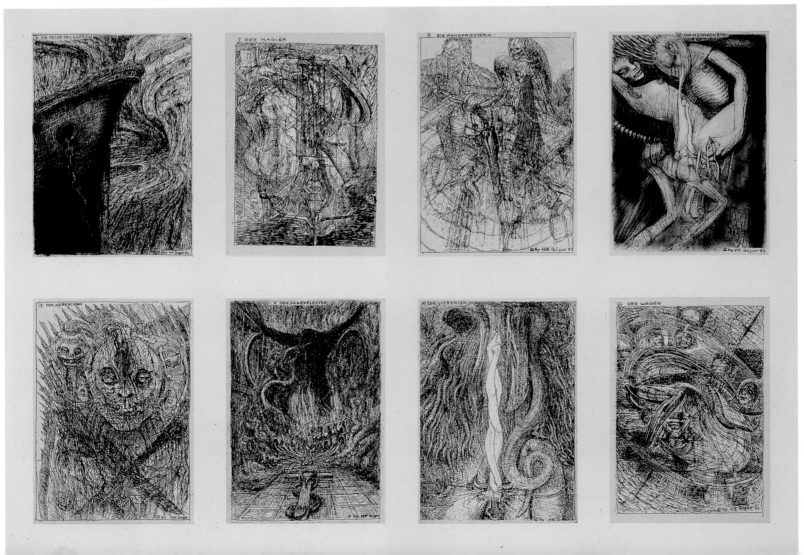

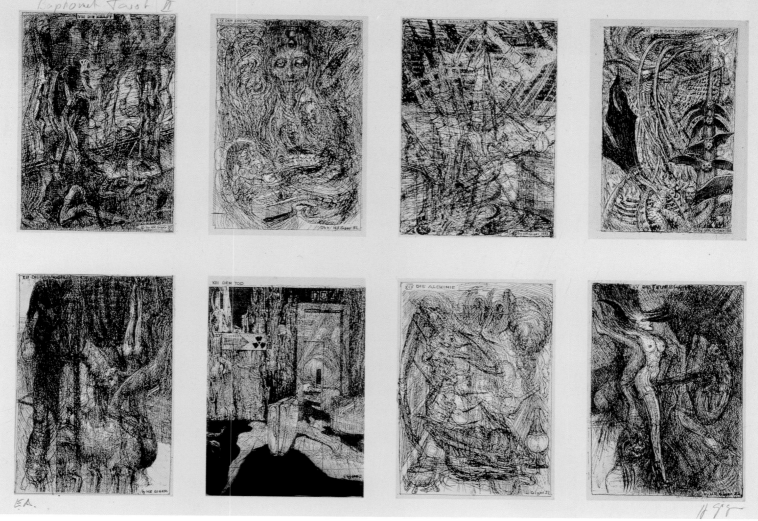

*H. R. G.'s Baphomet Tarot, Luxury Edition of the Tarot Portfolio Book, 16 of 24 zinc lithographs*
*of A4-drawings, edition 99 + XV, signed and numbered.*
*Printing: Walo Steiner, Asp, Switzerland, 1992*

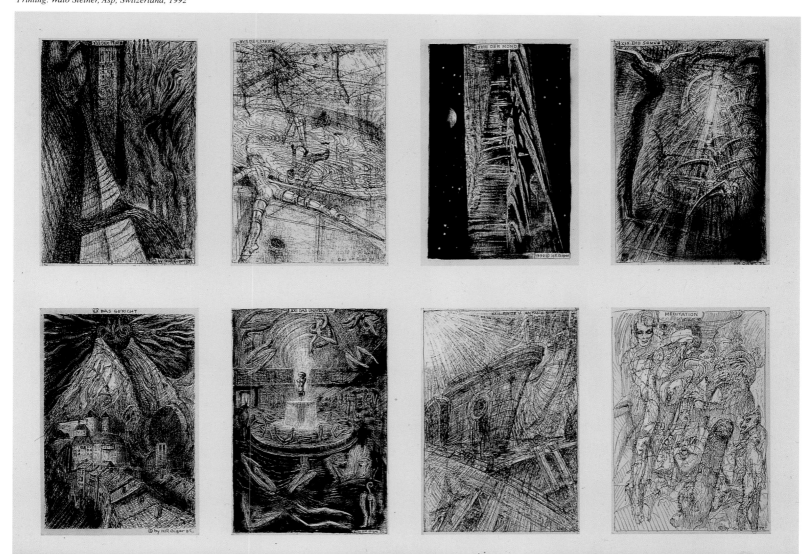

# Swiss Transit Tunnel

Letter from H.R. Giger to Swiss President A. Ogi, dated March 16, 1993

Dear Mr. President.

Subconsciously, you must have been waiting for this letter. It brings you some suggestions for solving the future problems of Switzerland. These ideas come from an artist to whom the yellow press applies the disparaging label "horror artist," thereby reducing me to the level of a freak at a county fair.

My bad conscience about not having participated in the vote, and my worry about how our fair country can be safely brought into the third millennium helped me to arrive at the idea of building tunnels underneath Switzerland. These would be in the shape of a pentagram. It allows for the most direct connection of the five major transportation hubs. From each of the five hubs, two can be reached directly and the rest indirectly. At the same time, to deal gently with the troublesome environmental problem of removing and storing our trash and that of our neighboring countries, I have designed sturdy pyramids. They are to serve as both trash burning and trash recycling facilities and to mark the entrances to the transit system. To help alleviate the problem of increased migration, I have also designed the pyramids as habitable to provide asylum-seekers a new home.

You may study how the whole thing would work in the accompanying schematics.

I hope you have fun reading this. Maybe it will give you a couple of ideas.

Best regards,
*H.R. Giger / Arh+*

*Pins, 1993. Metal/enamel, 3 x 4.5 x 0.2 cm,
1–3: STT; 4. Mystery of San Gottardo*

*Right: Swiss Transit Tunnel, 1994.
Four-color zinc lithograph, 49.5 x 69.5 cm,
Printing: Walo Steiner, Asp, Switzerland*

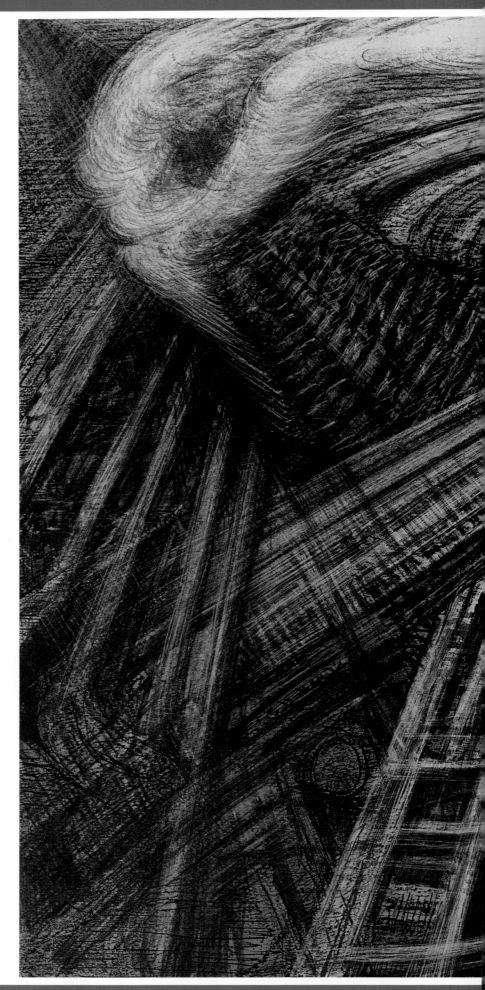

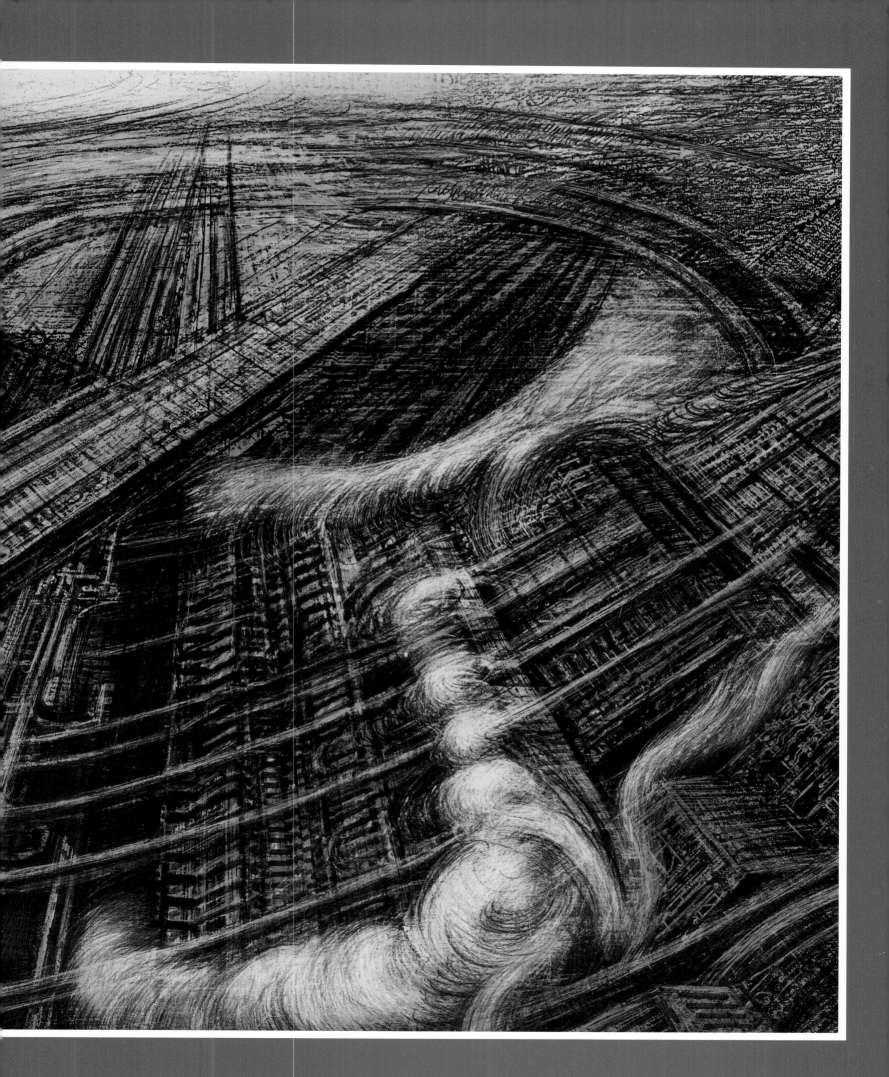

## Underground, at Half-Hour Intervals!

Le Corbusier, the most famous "French" architect, whose "Modulor" system of proportions allotted a minimum room height of 2.26 meters, must have been Swiss.

Only a Swiss could have invented something as petty and square as the "Modulor". A system of the minimum volume needed by a normal human being. The logical application of his ideas are animal factories, which fill us with horror. Where in the whole wide world is there a museum for squares and rectangles? In Switzerland, of course. In Zurich, where the concentration of banks compresses people into gnomes. So-called concrete art seems to have been developed especially for Swiss banks. It presumably has its origins in the finely-chequered fabric patterns used by peasants for pillows, blankets and curtains. But that's not true: the Russian Malevich painted his black square at the beginning of the century – as the last, logical consequence of his painting. The done-to-death square was the resurrection of the concrete, the supposition being that if something can be proven mathematically, it was automatically great art. Great masters such as Bill and Lohse now decorate museums and banks. This boredom, which can be varied endlessly thanks to the computer, has become our national art and is the only decoration the gnomes allow in their palaces. This befits Switzerland, the naysayer to the European Community. Since we wanted to keep our coat of arms clean, this is what we were left with.

The Swiss Cross, which could be a product of concrete

*Pages 136–141:*
*Swiss Transit Tunnel (STT has nothing in common with the Swiss Metro), 1993.*
*Excerpt from zinc lithograph, 23 copies, 70 x 100 cm,*
*Prinitng: Walo Steiner, Asp, Switzerland*

## STT SWISS TRANSIT TUNNEL

### UNDERGROUND AT HALF-HOUR INTERVALS!
© 1993 by ARh+

The drilling of the San Gottardo was just a test. Freight trains cross underneath Switzerland at speeds of 600 km/h, at half-hour intervals, silently and straight as arrows.

The entrances to the underground are marked by pyramids which are 1,000 meters tall.
There are five altogether. All connected underground. With five equally long sections.
These are connected by two parallel tubes, each containing three stories of magnetic rails. The whole system is linked to the highway and railway system.
Magnetic generators – a total of thirty, six for each section, can move along 6 kilometers of trucks and 3 kilometers of trains per trip.

art, is made up of five squares. Inside these five white peasant squares on red background, I drew the holy pentagram to meet the need for a large-scale transportation system for goods and people.

The pentagram, in which five straight lines drawn from any

given point result in a five-pointed star, is also the plan for the underground transit system connecting the five major traffic hubs on the borders. All traffic moves underground. There are no stops between the points, and no air shafts. The surface of Switzerland remains intact. Only five entrances, each made up of two stations, are located on Swiss soil, and are handed over to the pyramid-builders for reasons of neutrality.

For me, being a Swiss citizen does not mean being happy as a pig in shit, but rather to use our advantages and our imagination to rise above the European Community – perhaps even surprising it with our generosity. We won't be bullied into the EC by fear of the future. We have the best form of government and the most beautiful country. We have to provide an example, but that takes work, not a laughable hole-in-the-ground like NEAT [another transit proposal].

Although Switzerland is already populated too densely, it must prepare itself for the coming influx of mass migration. The pyramids (satellite cities) help the expected masses adjust to mountain life, by being

## THE TUNNELING UNDERNEATH SWITZERLAND S-UNDERGROUND

© 1993 by ARH+

The pentagram-shaped tunnel network has the following advantages:
1. All five points are connected.
2. All sections are of equal length.
3. The lines are straight as an arrow.

Six freight trains are used per section. Two freight trains are loading or unloading at any given moment. Two are in the tunnel. Loading and unloading is done in half-hour intervals. The loaded train on magnetic rail B departs. Then the empty train on track A is moved over sideways to track B. The recently emptied track A is soon occupied by an arriving train and the cycle begins anew.

mountain substitutes. The pyramids consist of poured cement containers (volume: 3,5 x 2,5 x 8 m). They are stacked on top of each other at intervals of 1–2 meters. The top and bottom of each measure 50 cm. The iron-reinforced blocks contain, in part, toxic substances, which are sealed in barrels. The space between the barrels serves as protection.

These huge, constantly-growing structures are built on bedrock. Since their angles of inclination are flat and their volume is five times that of the Cheops pyramid, they are almost indestructible. After thousands of years, they will be nearly indistinguishable from natural mountains because of overgrowth, erosion, etc. Prisons become unnecessary. People sentenced to serve time are simply assigned to pyramid construction.

The five pyramids, inhabited by asylum seekers, refugees, antisocial elements, etc., form a state with a democratic government. They provide shelter and mark the entrances to the STT tunnels. They also indicate to neighboring countries where to deposit their garbage for disposal. In front of the pyramids, there are drop-off areas for the garbage, which is delivered by train or truck and sorted according to type. It is forwarded to various collection points via conveyor belts. Used oil is funneled to the moats surrounding the pyramids, where it will decompose. Garbage to be burned is taken to a special incinerator located in the middle of the pyramid which uses catalysts to render harmless the dioxins in the trash. This incinerator powers the plant. It operates steam pressure hoists, transports warm water to the residential blocks, and provides ground heating, which works by means of conduits. The pyramids

# THE S-UNDERGROUND SWISS-TUNNELLING; AT HALF-HOUR INTERVALS!

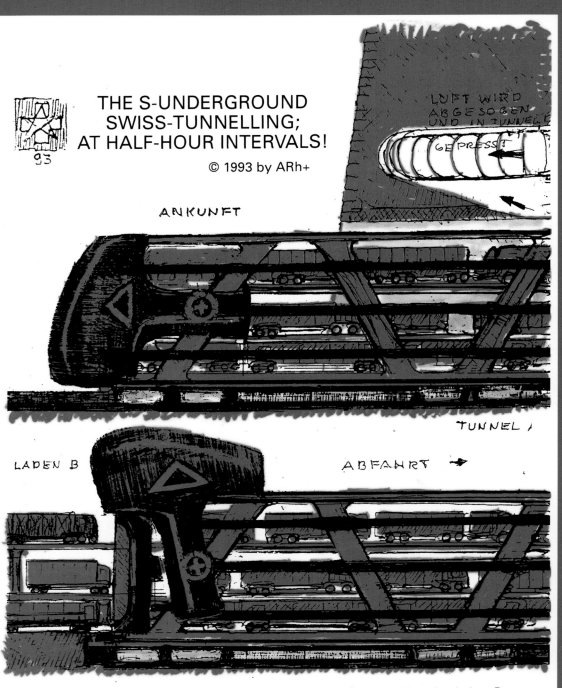

There is a swinging cockpit at each end of the transporter which snaps shut like a helmet visor before the train starts moving, and closes off the entrances.

The transporter which arrived is unloaded on Ramp A and then moved laterally to rails B. There, it is loaded on all three levels simultaneously. It departs after approximately half a hour, anf the transporter standing on Side A is moved over to Side B.

stand on former Swiss territory, which the Swiss ceded some time ago. The pyramids and tunnel entrances are situated on roughly 3 square kilometers and are connected through a network of underground tunnels. The waste processing provides an income for food and building materials for the pyramids' inhabitants. They are from different countries and use English as their common language. Everyone works a set amount of time for the collective, and some time on their personal space. Within the pyramids, people can raise small animals or plant vegetables and fruit. Baggage is transported horizontally by three-wheeled bikes and vertically by cargo elevators.

The pyramids are run as farms, and collected rain water is carefully stored in them. The middle stones of the pyramid are containers made of poured cement and slag. The containers located at the edges are residential. When new stories are built, they are also filled with cement, and their inhabitants move into the new containers. That's why kitchen components and plumbing units are modular and removable. Some of the remaining containers can be used as workshops. Containers filled with soil for planting are built in at the sides.

## ⑥ THE S-UNDERGROUND SWISS-TUNNELLING:

Tunnel entrances: Arrival of Transporter; Departure of Transporter Y.

The biggest problem is the displacement of air in front of the transporter.

Large turbines to drive the air in front of the transporter.

In the passage, there are wind tunnels which create suction of up to 600 km/h.

Letter dated April 21, 1993, from Adolf Ogi, President of the Confederation, to H.R. Giger, regarding the "Swiss Transit Tunnel Project":

Dear Mr. Giger,

"The strangest „thing about the future is the idea that they will be referring to our time as 'the good old days'." With this quote from John Steinbeck, dear Mr. Giger, I would like to thank you very much for the outline of ideas you sent me on March 16, 1993, with proposals for future solutions to the problems of Switzerland.

I studied your sketchbook with interest. I did not think of your proposals as "horror art". Rather, they present a critical mirror cautioning us politicians from accepting a solution simply because it can be implemented with the least possible resistance.

Your vision is not quite that Utopian. We demand an ever-expanding and faster transportation system to satisfy our excessive desire for mobility. But the transportation infrastructure is supposed to remain invisible, not use any cultivated land, nor mar the landscape, nor create any noise or environmental disturbances. As everyone's wealth increases, we want to consume more. But the growing mountains of garbage are to remain invisible, and discreetly out of sight – just not in our own backyards.

One of the most difficult problems facing politics today and in the future is this discrepancy between increasing demands and a dwindling readiness to deal with their consequences. It is foolish to believe that the wheels of history can be turned back. That is why we search for new solutions, including new technological solutions. But they must be appropriately humane.

Allow the president, dear Mr.

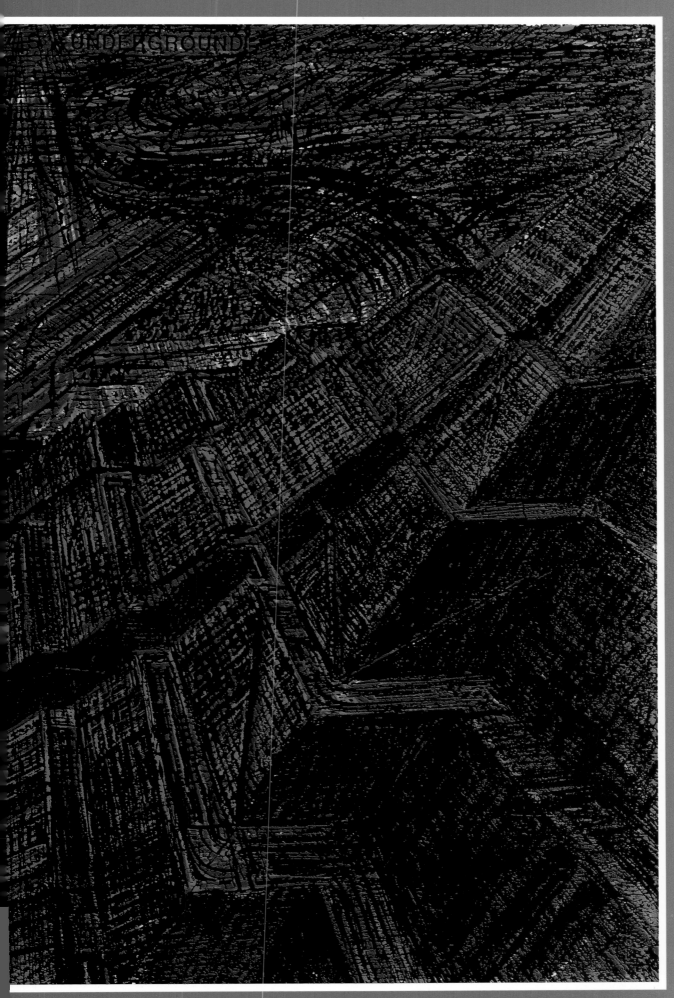

Giger, to regard the future of our country with optimism. This will pose a special challenge to the creative faculties of our intellectuals and our artists.

Best regards,
*Alfred Ogi, President*

*Entrance to the Underground, beneath the Pyramids, detail from Swiss Transit Tunnel, 1993. color zinc lithograph, 25 copies, 70 x 100 cm, Printing: Walo Steiner, Asp, Switzerland*

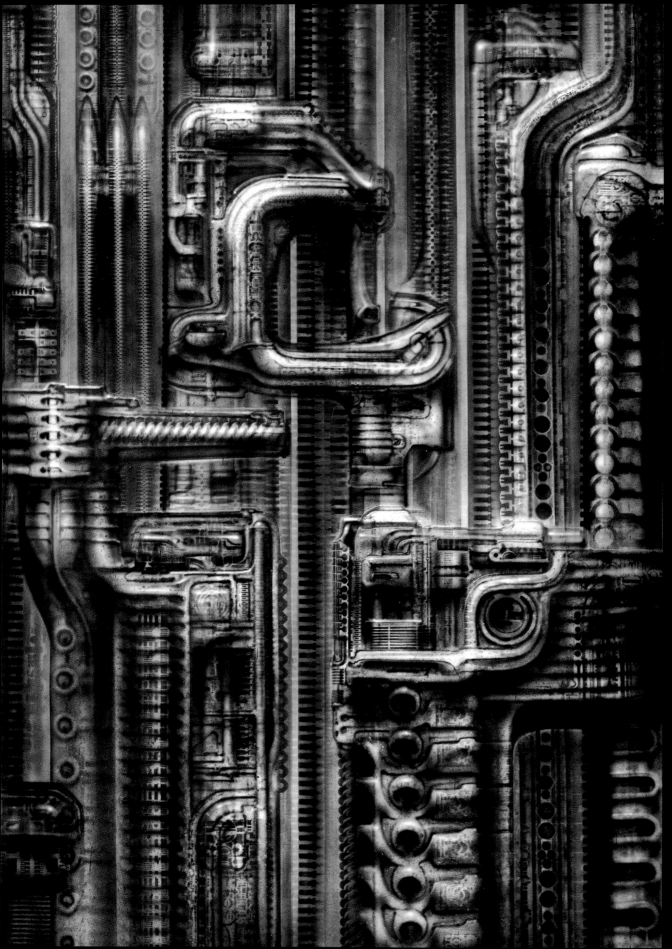

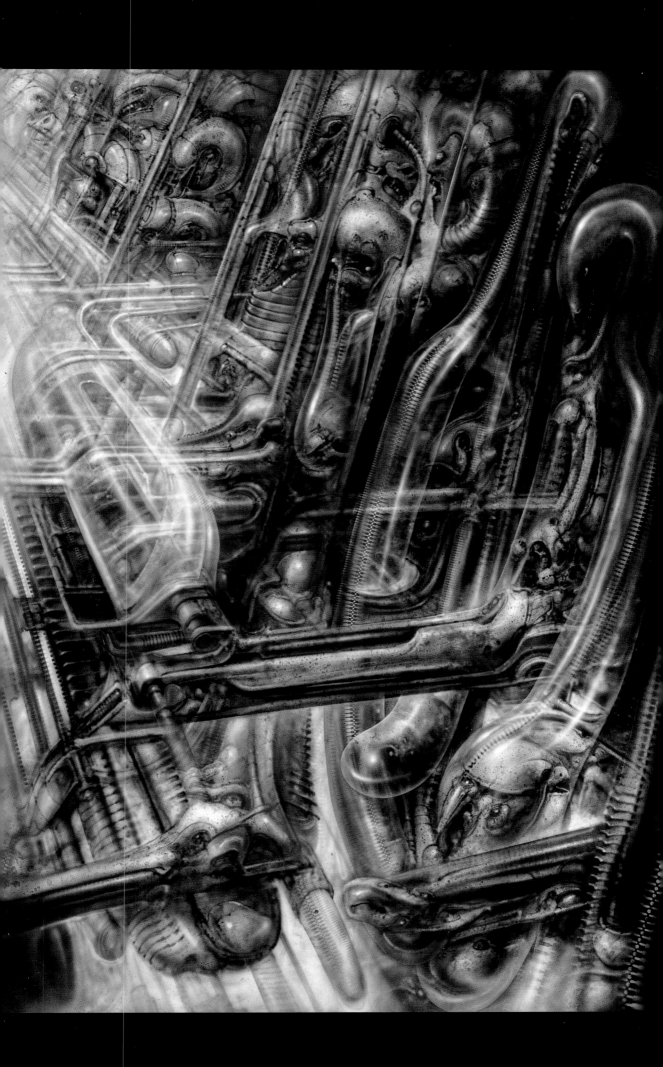

# Watch Abart

In the year 1982, God created Swatch, His crowning achievement. He took it from the best designers and entrepreneurs of the Swiss watchmaking industry, and it was good. Mankind, in the last 5 minutes before its return to the global stew, was ready for it. The eternal and omnipresent Swatch often wanders straight into a collection, still in its original packaging. To make room for more Swatches, Pirelli, for example, created his bubble-patterned rubber tiles to cover the sidewalks of Milan. Hidden under every bubble is a watch. From this, one can see how, in the near future, the Swatch will cover the entire surface of the earth.

*H. R. Giger*

I will wear a Swatch, the real thing, from the cradle to the grave. The Swatch of the future will be implanted in the wrist and tell time with the blink of an eye. It will be biomechanical just like a pacemaker. I was on the resort island of Kos when I noticed that my first Swatch, a present from Mia, was trying to get under my skin. Its battery, eroded by the salt water, was starting to corrode and eat into my wrist. Since I always wore the Swatch, even when swimming or showering, I noticed the growing hole underneath it only when I freed my aching wrist from the watch. Aside from that, it's perfect. No one has seen me Swatch-less since 1982. A life without Swatch, for me, is unimaginable. It will be the only thing I wear until it falls off my wrist. The "plastic

Pages 142 and 143:
*No. 468, New York City VXIII, 1981, and No. 462, New York City (Science-fiction), 1980. Acrylic and ink on paper, 100 x 70 cm*

Page 145:
*Crosswatch goes Pirelli, 1993. Cast bronze, mounted, on plexiglass, 60 x 60 cm Photo: Axel Linge*

*Watch Housing with Three Straps, 1993.
Ball-point pen on transcop, 30 x 21 cm*

*Homage to Nicolas Hayek, 1993. Color plexiglass, metal and transparent Crosswatch,
43.5 x 43.5 x 2.5 cm. Photo: H. R. Giger*

*No. 25, Watches, 1991. Ink on paper, 30 x 21 cm*

watch", as it is deprecatingly referred to by envious admirers, is simply perfect. Along with the army knife, fondue, Dürrenmatt and the Matterhorn, it is another high-quality product which has made Switzerland famous. Moreover, it has saved the watchmaking industry of our country from bankruptcy.

As a tribute to Nicolas Hayek, the brilliant entrepreneur, I created my Crosswatch (p. 144).

The transparent casing is fitted with four straps as well as a Red-Cross clock-face in a cross-shaped plexiglass box.

The Swatch, absolutely perfect in design and function, is so trouble-free that one can completely forget about it. This probably accounts for the fact that new variations are constantly produced in relatively small editions, inciting collectors' mania. Since everyone can afford a Swatch, this mania hasn't diminished despite the recession.      Swatchomania struck me around 1991. Since then, I have been grappling artistically with the Swatch.

*H. R. Giger*

*Different Watches, 1993. Pencil on paper, 22 x 17.5 cm (detail)*

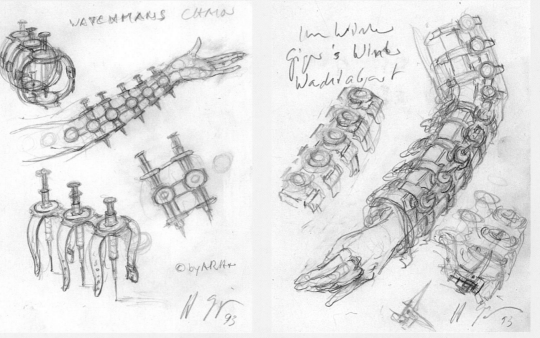

*Hypodermic Crosswatch, 1993. Pencil on paper, 22 x 17.5 cm*    *Winter-Crosswatch, 1993. Pencil on paper, 22 x 17.5 cm*

*Right:*
*Giger's Chainswatch. Felt-tip pen on paper, 30 x 21 cm*

*Page 147:*
*Left: Summer-Crosswatch, 1993. Aluminum, 60 x 19 x 19 cm; right: Winter-Crosswatch, 1993. Aluminum, 64 x 20 x 14 cm*
*Photos: Louis Stalder*

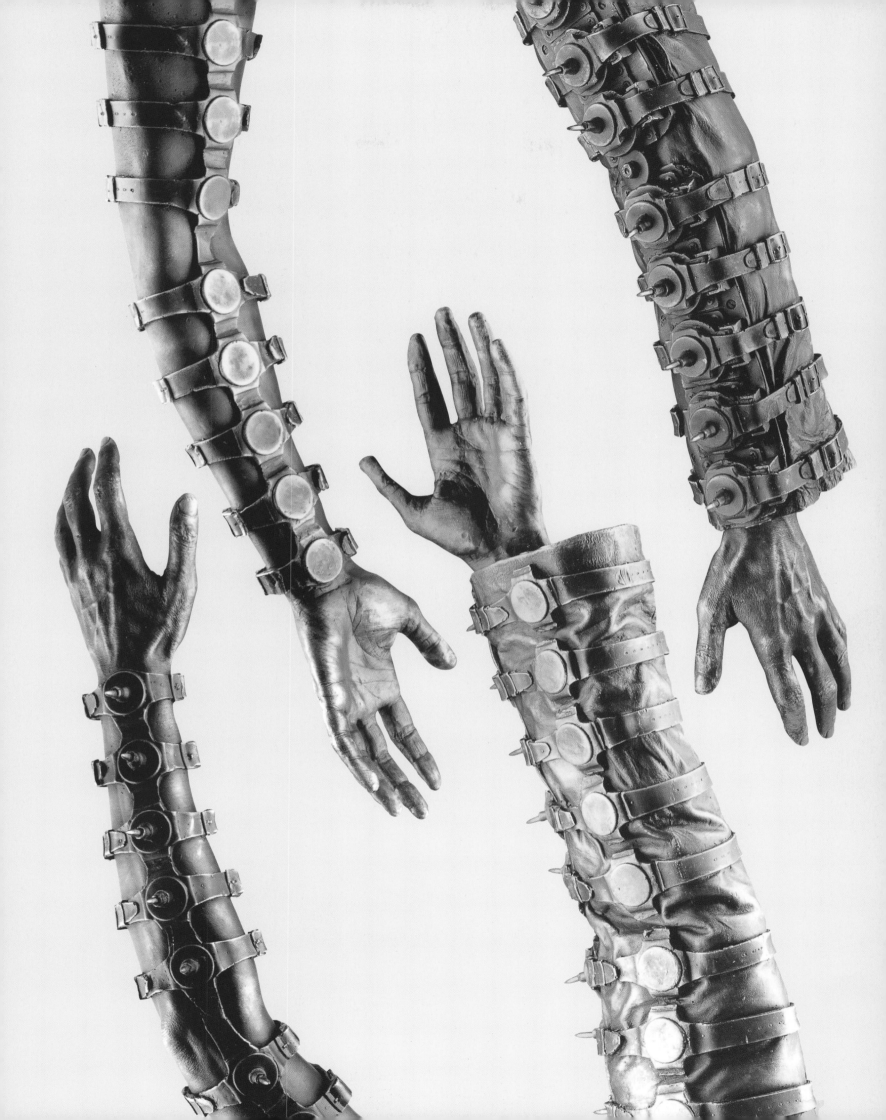

I've written down my thoughts about Giger's Watch Abart for people who ask themselves what, for example, is the meaning of an egg wrapped up in a Crosswatch? An egg-shaped object equipped with a detonator often ends with a bang. In this case, Giger's Watch is the timer and the egg a hand grenade.

Or: Genetic engineering and its manipulations will eventually produce an Easter Bunny which lays its own colored eggs. These will come equipped with a simple latch so that each egg can be opened, its contents ready to be consumed.

Or: a top-of-the-line product is reduced to primitive tool to hammer in a nail vertically.

Or: the nail refers to the crucifixion of Christ and raises the following question: "What is the significance of an Easter egg delivered by a bunny?" The egg is the embodiment of life, protection for the embryo. Giger's Watch mounted upon it represents its lifespan. It can also be interpreted as a stillbirth, since the nail can destroy the fetus. Death and rebirth lie close together.

Or: the tip of the nail directed at the embryo can signify threat or masochism. The tip of the nail directed outward signifies defense, aggression or sadism.

*H. R. Giger*

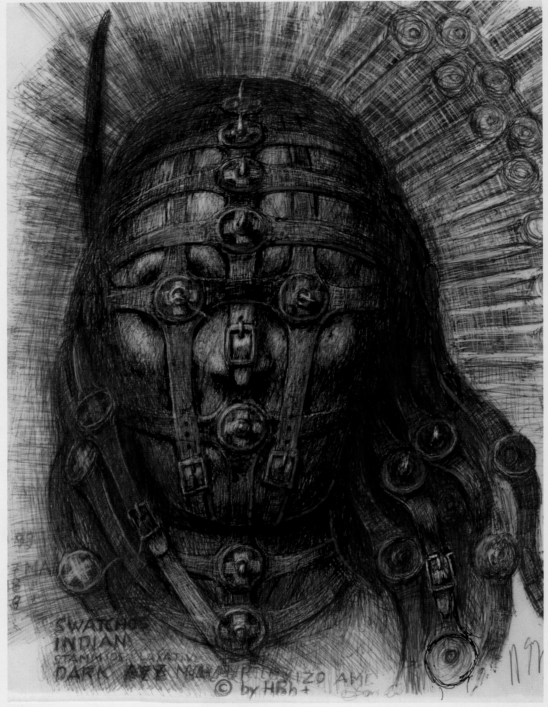

*Watchoz, 1993. Ball-point pen on transcop, 42 x 33.7 cm*

*Christ-like Seeder, for the Galerie Tumb, 1994. Wood, metal and rubber, 25 x 4.9 cm, Watchoz, 1993*

*Easter Egg, 1993. Ball-point pen on paper, 29.7 x 21 cm*

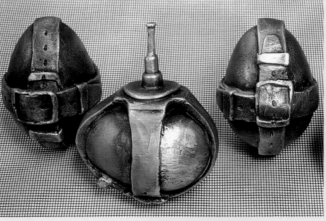

*Crosswatch Easter Eggs, 1993. Bronze and aluminum, each 8 x 10 x 6 cm Photo: Amy Ardrey*

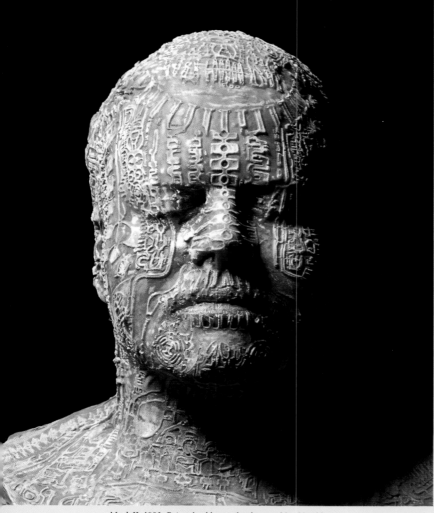

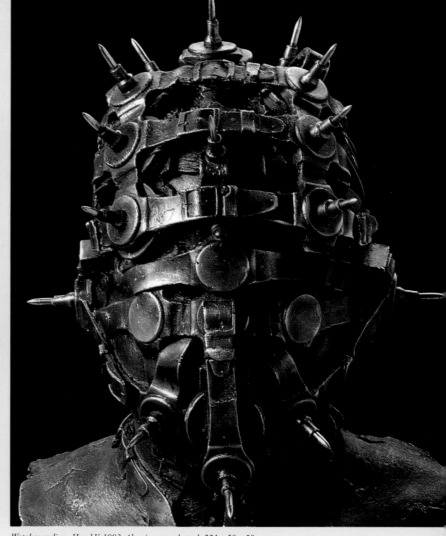

*Mask II, 1993. Painted rubber and polyester, 35 x 19 x 32 cm*

*Bottom: Skull Wharf, 1993. Felt-tip pen on paper, 32 x 20 cm (detail)*

*Watchguardian, Head V, 1993. Aluminum and steel, 221 x 50 x 50 cm*

*Bottom: Skull Wharf, 1994. Painted cast bronze, 60 x 50 x 50 cm. Photo: Louis Stalder*

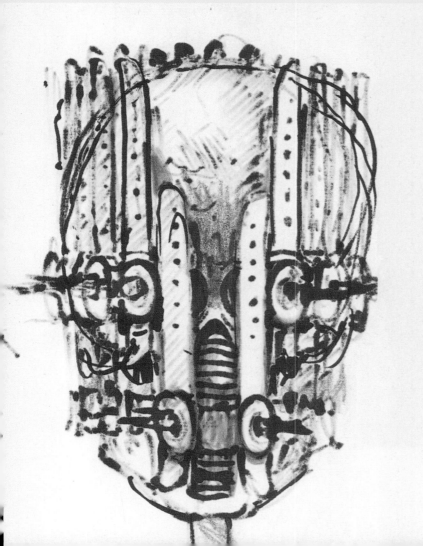

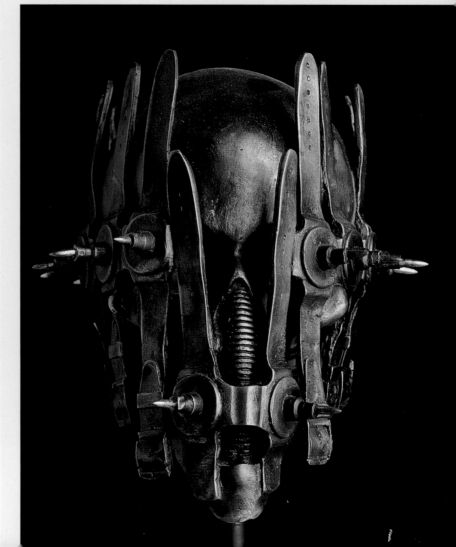

# Abarts under the heading: hopefully never available

## Giger's Watchoz

A painkilling merger of Watch Abart and Zandoz. A timekeeper with cloned leeches as watchbands. Sucking time can be set to the second.

## Giger's Awakener, inspired by Dali/Buñuel

Ants in the arena. A watchcase with no bottom keeps you awake. Second hands shove the little awakeners back into their stables in the watchband. Robust wearers will have to replace the ants on a monthly basis.

## Giger's Suicide Watchoz

Signed and numbered. Another merger of Watch Abart and Zandoz. Available to Roman Catholics by prescription only. Death is timed to the second! Reusable. These cyanide capsules are available in the 5-pack family size, enough for one couple, two children and one dog. Recommendation: Take on an empty stomach. Women and children first.

## For men only:
## Giger's Orgasmi Watch

An orgasm on demand, on the spot. Includes 100 disposable bags. For slow parties and boring banquets. Recommended use: In a sitting position.

## The time-remedy for constipation:
## Giger's Watcholax

For aesthetic reasons, it can only be shown in its packaging. Comes with an elegant leash to secure to your thigh. Recommendation: Read the directions before opening!

*Rusty Maxiwatch, 1993. Plexiglass, metal, polyester and wood, 219 x 36 x 15 cm. Photo: Louis Stalder*

## Giger's Watcholax
## Where?

A detector with salvage rope. Not to be confused with Watchanal. Not dispensed to minors or civil servants! Posteriorly handicapped.

## Do it yourself!
Giger's Watchoral

For one-time use only. Pave the way for your third set of teeth with a measured dose of explosives. Sold only to adults with a valid gun license upon signature!

## Giger's Poli-Radio-Watch

A keyless handcuff with an irreversible alarm. This watch can only be removed by the police or a surgeon.

## Giger's Watch-surprise

An electric shock can be transmitted to the watch-wearer which will make the watch red-hot in a matter of seconds.

## Giger's Plugwatch or
## Live Watchface

After cleaning, this watch can also be worn on the face by inserting into the mouth. A hommage to Jürg Federspiel's tattoo novel, "Laura's Skin".

## Giger's Slapwatch

With extra long watch straps for boxing the ears with.

## Giger's Watch-off

A ceramic housing filled with an aqua regia acid mixture. Upon impact your hand timelessly falls away.

## Giger's
## Watch Peacemaker

... no explanation needed!

*H. R. G.*

*Slingshot, 1993. Aluminum and rubber, 18 x 11 x 7 cm. Photo: Amy Ardrey*

*Mondaine-Watch, N.Y.C. II, 1994. 156/999, plastic, metal, watch, 41 x 30 x 4 cm*

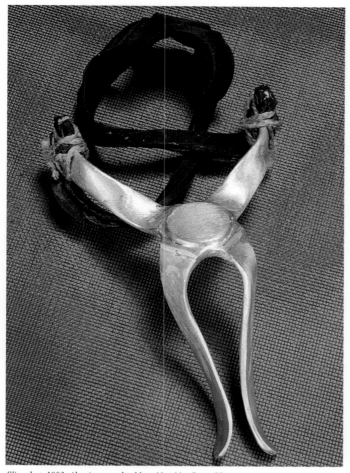

*Sarcophagus for watches, Revive, Survive and Demise, 1994. 24/333, plastic, foam rubber, plastic watches, 32.5 x 12.5 x 10 cm. Photo: Louis Stalder*

*Design for Reims Champagne, 1993. Glass and rubber, 34.5 x 17 x 10.5 cm. Top and bottom photos: Louis Stalder*

*No. 232, Passage XXIX, 1973. Acrylic on paper on wood, 100 x 70 cm*

If the "Passages" constitute the doorway to death, then the "Swatch" ticks the way there. From the Passage to Giger's Watch. To have time is to enjoy life. The watch as Giger's Watch-Abart is the perfect objet d'art and has a certain relationship to the Trash Passages I created between 1970–73.

They both have geometric forms such as circles, disks, squares, rectangles as well as a center. The axis formed by the hour, minute and second hands at the same time form the crosshairs of a target. Both art objects deal with life, which leads to death. The Trash Passages symbolize the doorway to eternity, the last stop of everything dead, beyond use, superfluous.

The ticking of Giger's Watch reminds us of the heartbeat and its impermanence. In earlier times, if a watch remained at a standstill, if it was not wound up anymore, it meant its wearer was dead. His clock had run out. Nowadays, it continues to to tick merrily on, possibly into the coffin; and so, the wrist will take the longest to decay because the ticking will get on the worms' nerves.

The digital clock didn't have much of a chance as a wristwatch. Because the human body consists of circling atoms, man is more familiar with the movement of the clock hand than he ever will be with abstract numbers.

The fact that Swatch collecting has become so important is certainly not only because of the variety of Swatches and the limited numbers produced, but due also to an unconscious effort to collect time. Time is increasingly becoming the greatest luxury. Time is money.

Our innermost desire of having time stop at the moment of greatest happiness is not granted us; thus, the passing of time, which seems quicker as we get older, becomes more and more frightening. Time races mercilessly towards death. The Crosswatch – my little invention – is the art watch. Art has no other function but to present itself. That's why the Crosswatch has no inner mechanism. By itself, it is normally unwearable as a wristwatch. Only in combination, as a Chainwatch, can it be strapped around the arm and leg. It is exempt of its function. The watch can turn into a biomechanical cockroach which will reappear undigested in dinosaur shit. As a snake, it can turn into the Giger's Watch logo, or in great numbers, it can be practically anything. Its variety fascinates me. It is a metaphor for life in cyberspace.

*H. R. Giger*

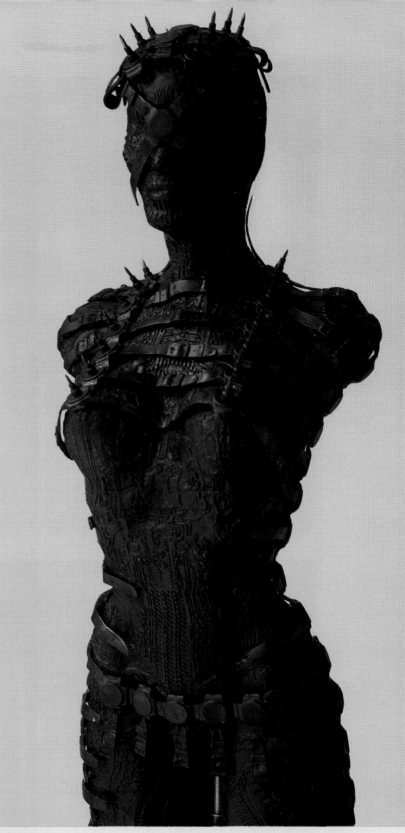

*Female Torso, 1994. Painted aluminum- and cast bronze, 104 x 44 x 35 cm*

Page 153:
1st row from l-to-r:
Mobilwatch 2000, 1993, ball-point pen on envelope, 22.8 x 16.1 cm
Giger's Swatch Peace Maker, 1993, ball-point pen on paper, 21.9 x 17 cm
Japanese Weeks in Zurich, 1993, ball-point pen and neocolor on paper, 21.9 x 17 cm
Swatch Kebab, 1993, ball-point pen on paper, 21.9 x 17 cm

2nd row from l-to-r:
Giger's Sandwich Watches, 1993, ball-point pen and neocolor on paper, 21.9 x 17 cm
Tapeworm, 1993, ball-point pen on paper, 22 x 17.5 cm
J. Baker, 1993, ink and pencil on paper, 30 x 21 cm
Watch-Bra, Package and Stamp, 1993, ball-point pen, felt-tip pen and neocolor on envelope, 30.4 x 21 cm

3rd row from l-to-r:
Easter Model, 1993, ink on paper, A4
Pin Motif Golden Dawn Watch, variation,

1992, felt-tip pen on photocopy, 29.7 x 21 cm
Pin Motif Golden Dawn Watch, variation, 1992, felt-tip pen on photocopy, 29.7 x 21 cm
Pin Motif Watchman, 1993, ink on paper, 29.4 x 20.2 cm

4th row from l-to-r:
Luxury Edition for Giger's Sketchbook, 1992, zinc lithograph, 20.7 x 69.6 cm
99 copies, Printer: Walo Steiner, Asp, Switzerland; Leporello with 5 motifs: Armbeinda Over Swatched, Foxed by Swatch or Swatched by Fox, Swatch Over All, Ubu Big Brother, Swatchday Over Switzerland

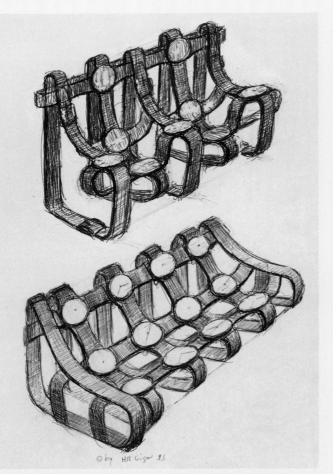

Top: No. 6, Chairs combined with Watch Tables. Ball-point pen on paper,
29.7 x 21 cm. Bottom: No. 4, Couch. Ball-point pen on paper, 29.7 x 21 cm

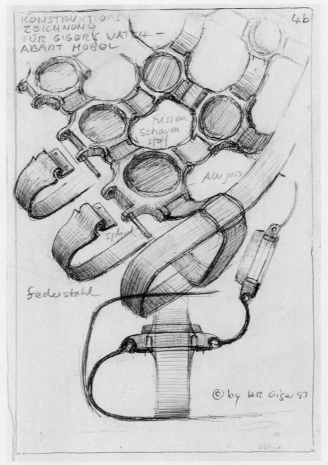

No. 4b, Plan for Watch Chairs, 1993. Ball-point pen and pencil on paper,
29.5 x 20.4 cm

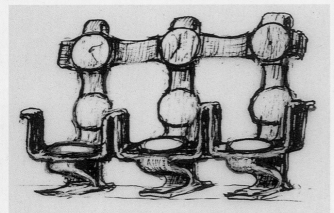

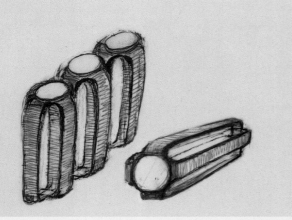

Top: No. 5, Theatre Chairs. Ball-point pen and felt-tip pen on transcop, 29.7 x 21 cm
Bottom: No. 7, Bar Stools. Ball-point pen and felt-tip pen on transcop, 29.7 x 21 cm

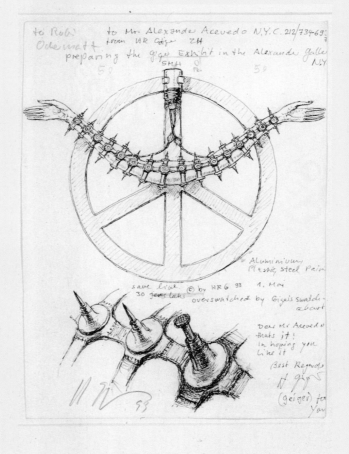

Life-Support, 1993. Ink and pencil on paper, 22 x 17,5 cm

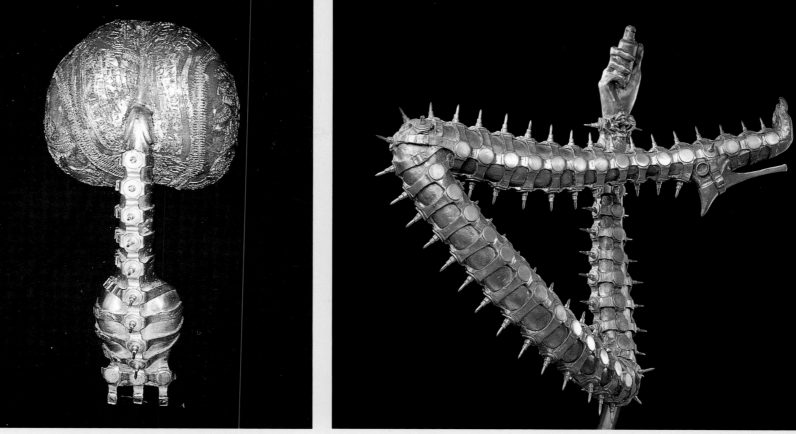

*Lamp, 1993. Painted aluminum and polyester, 80 x 40 x 20 cm*     *Zodiac Sign Virgo, 1993. Aluminum, 80 x 80 x 40 cm. Photo: Louis Stalder. Lamp photo: H. R. Giger*

*Bottom: Life-Support, used as Carcass LP and CD covers, 1993. Aluminum, 140 x 90 x 20 cm. Photo: Jürg Kummer*

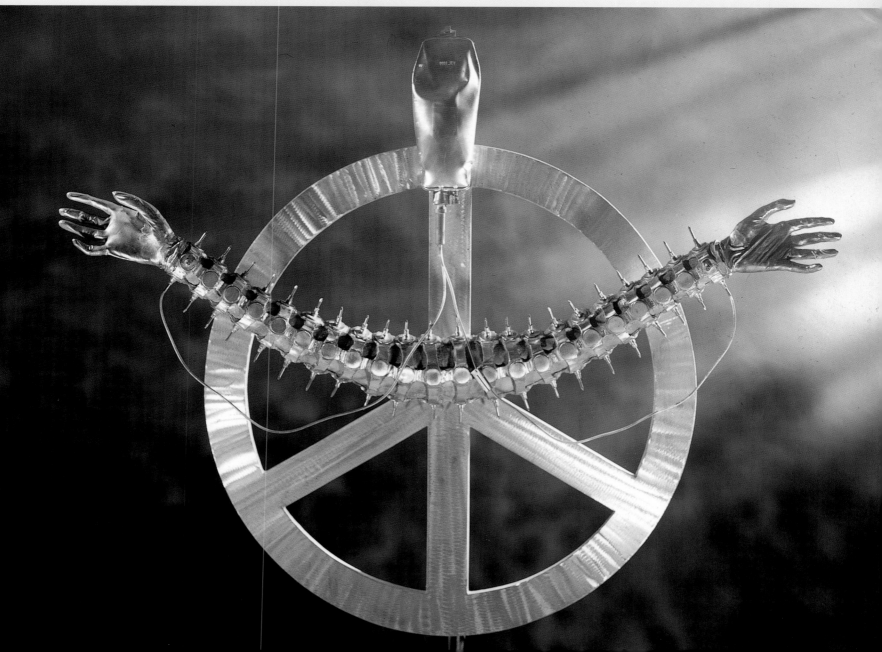

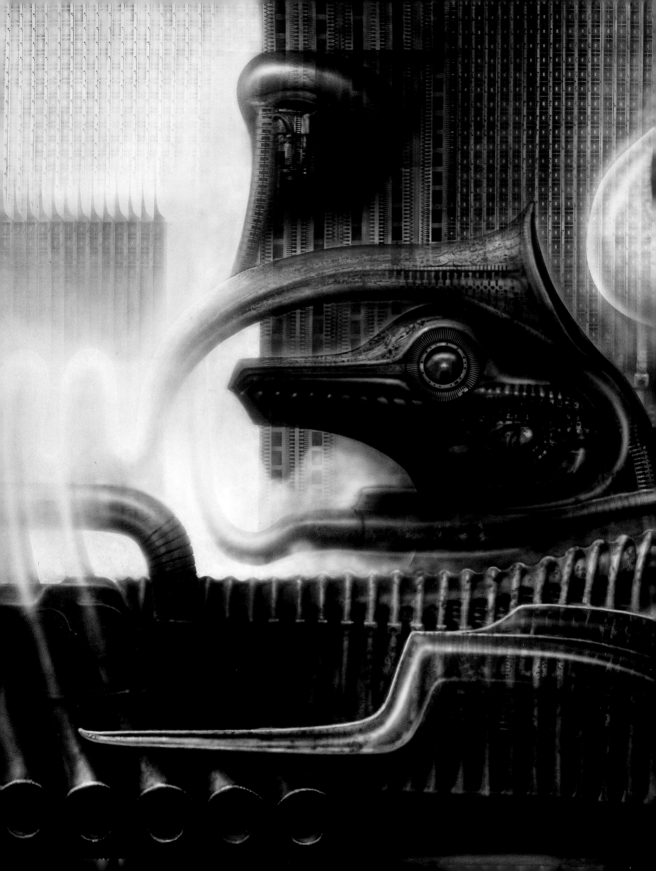

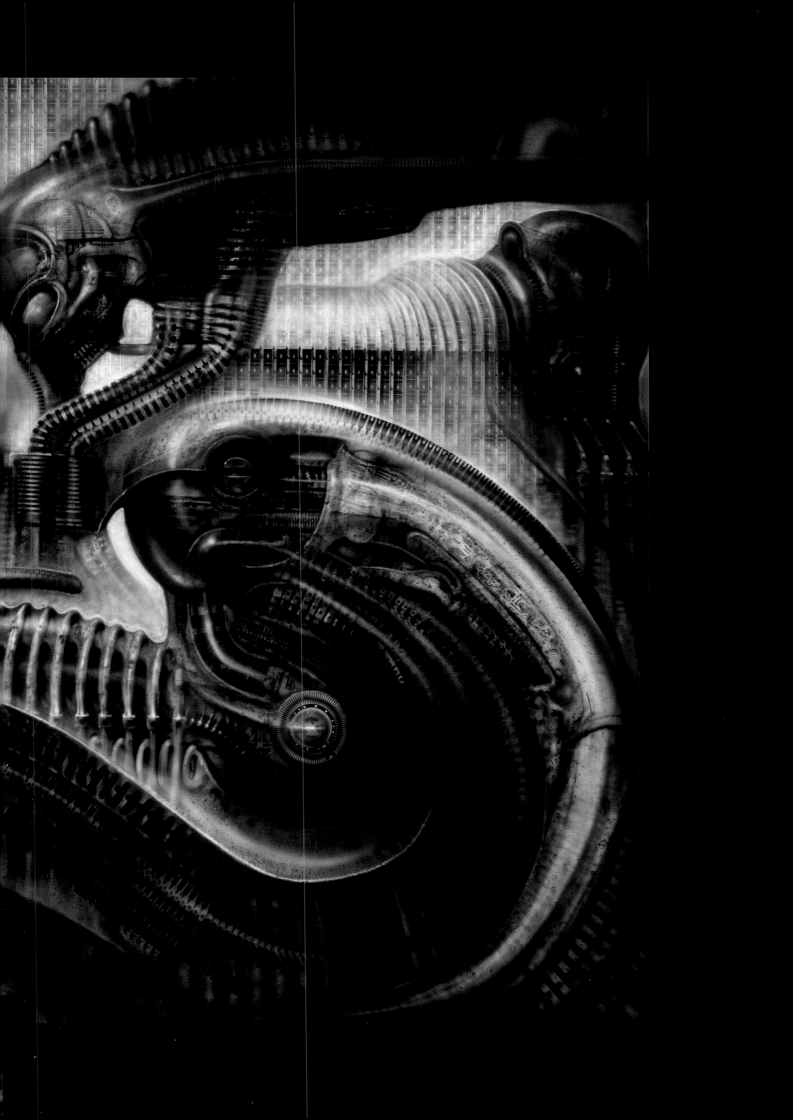

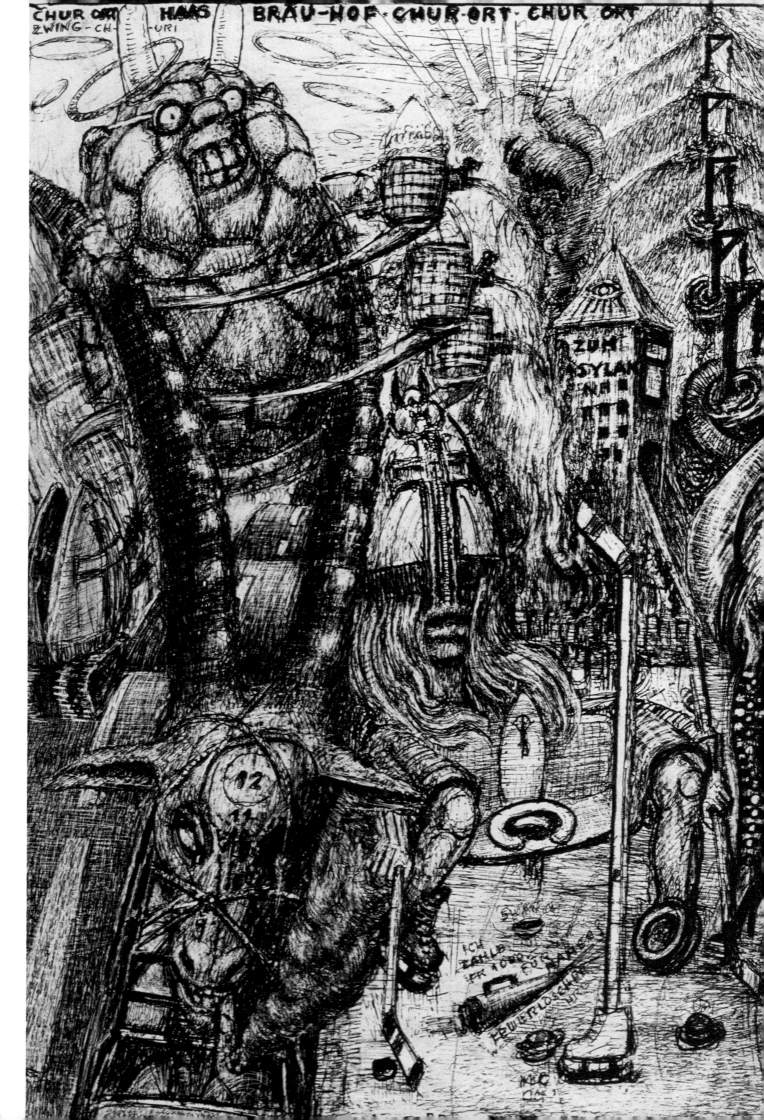

*Page 156/57:*
*No. 452, New York City I.*
*(Lovecraft Over N.Y.C.),*
*1980. Acrylic and ink on*
*paper, 100 x 140 cm*

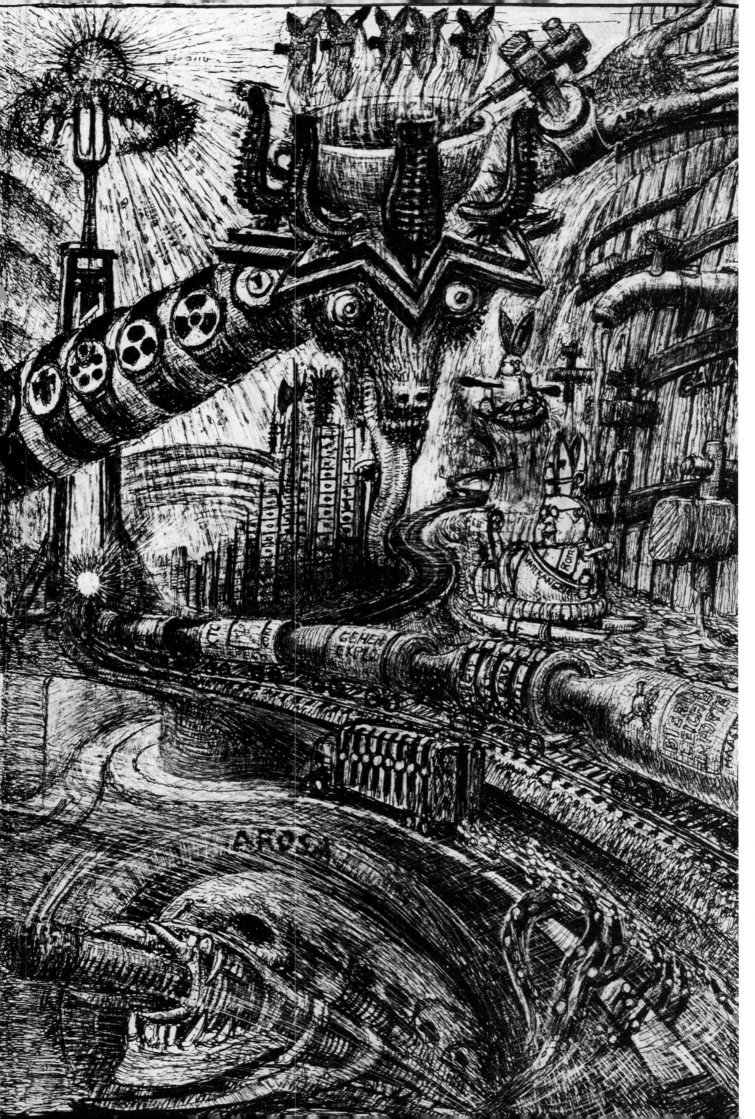

*Beer War, Calanda Beer (right) against Feldschlössli (left); Thomas Domenig supported Feldschlössli, Haas is represented 6x: 2x as a white-water rafter, 1x with horns made of condoms to catch the halos with his soccer-ball head; beer is quenching the fire in ice-hockey president Thomas Domenig's first asylum; Chur, Rose or Gallows' Hill becomes the ski lift of Brambrüsch, 1993. Zinc plate lithograph, 1/99, signed and numbered, 56 x 75 cm*

## Pins

The pins are stamped out of copper or brass, and the indentations, etched out by acid, are filled with enamel and then fired. The pins in the pentagram are of the main protagonists in *The Mystery of San Gottardo*. These are the so-called biomechanoids, which are described in the next chapter. The projected Swiss Transit Tunnell (STT), © H.R. Giger 1993, in which the tunnel sections, when viewed from above, are laid out in the shape of a pentagram, determined the shape of the pin packaging. This project must not be confused with the "Swiss Metro" project, since no above ground stops in Switzerland are planned.

## Beer War
### (Chur's Carnival Theme)

Charly Bieler, a correspondent for the Tages-Anzeiger (Daily Advertiser) and an acitve member of the Carnival League of Chur, invited me in 1993 to design a pin with the title "Khurer Beer War" – the company "Calanda" against "Feldschlössli" – a war that made the media in Bünden hold its breath for months. Bishop Haas of Chur, who'd been creating a ruckus there for years, has always fascinated me. I tried to combine the rift in the Church and the rift between the two beer brewers into one subject. Since the fabrication is always of great interest to me, I drove to the Gravura factory in Horw, where the pins were made. Mr. Zauchner, a very talented plaster cutter, reproduced my drawing as a plaster relief, and then, using an epidiagraph, reduced it into a steel mold, which was then used to stamp out the pins.

*H. R. Giger*

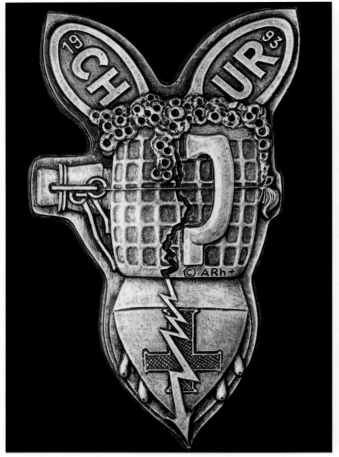

*Chur Carnival Pin, 1993. Painted plaster original, 20 x 11 x 2.5 cm*

*Chur Carnival Pin, 1992. Ink on reworked photocopy, 229.7 x 21 cm*

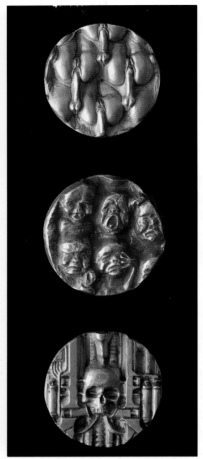

*Revival, Survival, Demise, Proposal for three watch motifs, 1996. Silver, diameter 3 cm, depth 0.6 cm*

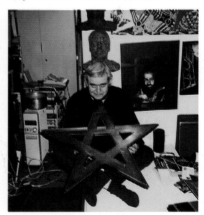

*H.R. Giger with Pentagram Pin Box containing 25 „Mystery of San Gottardo" Pins, 1994*

*Giger-Internet-Pin, 1997. Silver plated copper pin of the official H.R. Giger International Fan Club. Diameter 40 mm (actual size photo), stamped with membership number. For information, contact Thomas Riehn, Rudolfplatz 6, D-38118 Braunschweig, Germany*

*Page 161: center: Pentagram Pin Box with Hologram, vacuum-formed PVC. Luxury Edition for „Mystery of San Gottardo" book to be published by Verlag Benedikt Taschen, contains 25 „Mystery of San Gottardo" pins; mounted on the pin box: 19 of the 25 „Mystery of San Gottardo" pins (shown 1:1), 1994. Edition of 99 copies +XX, metal and enamel, in collaboration with Andy Stutz. Initiator: Mr. Wagner, Pinworld*

## The Zodiac Fountain

A type of pollution discussed only in the vicinity of airports is noise. I stopped enjoying music some time ago. I feel the most enthusiasm for the sounds of nature or for silence. Noise leads to people communicating through signals. This is a logical development.

My biomechanoids, the main characters of my "Mystery of San Gottardo", are organisms with no heads, each reduced simply to an arm and a leg. The twins' brains – or, rather, their replacement (computers run via electricity and a nutrient solution) – which control everything are located at the juncture where the left upper arm seamlessly connects to the right upper thigh or the right upper arm to the left upper thigh. Biomechanoids have gills and small circulatory systems which are cleansed through sweating. These organisms have sensors and communicate with each other telepathically. With humans they sign like deaf-mutes.

Every biomechanoid was once a normal human being until divided into three beings when the extremities were removed. The main part, the torso and head, is the most unhappy of the three, because it has to spend the rest of its life as an amputee in a rolling cart and usually serves only as a biomechanoid trainer. It does so, hoping to one day be reunited with its extremities. The two arm-leg constructs, on the other hand, are ecstatic not to have to heed the brain anymore, since they were sick of their existence as slaves.

A torso with an elongated skull sits atop the fountainhead, and forms the center of the Zodiac Fountain. The twelve astrological signs are represented by the arm-leg constructs.

The fountain was meant for the space in front of the Giger

*Right:*
*Zodiac Fountain, 1997. Ink on paper, 29.6 x 21 cm; Cross-section of the fountainhead (detail)*
*Page 163:*
*Bottom left: Construction drawing of the water-wheels*
*Bottom right: Cross-section of the Zodiac Fountain*

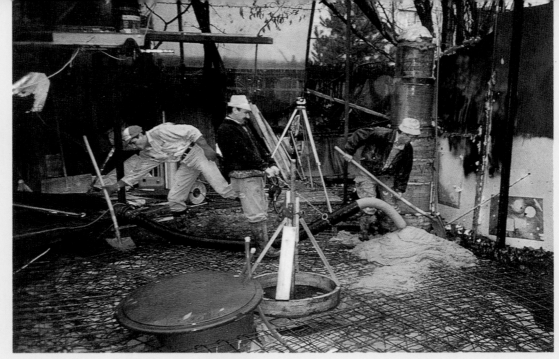

*Start of the work on the Zodiac Fountain in Giger's garden in Zurich, October 1996*

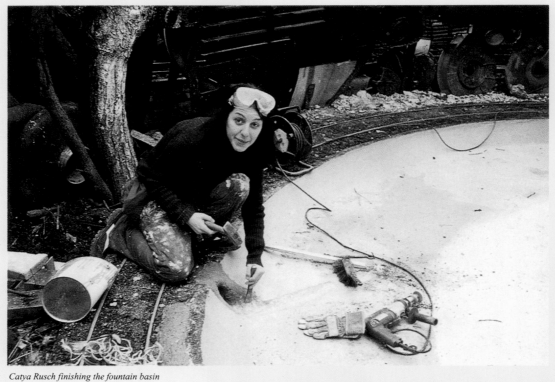

*Catya Rusch finishing the fountain basin*

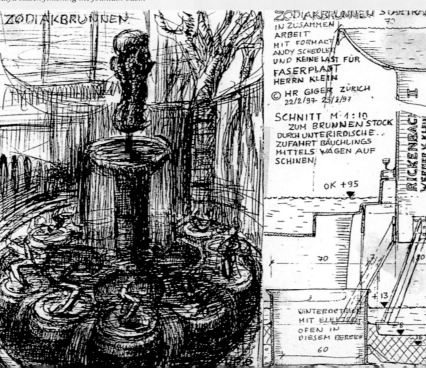

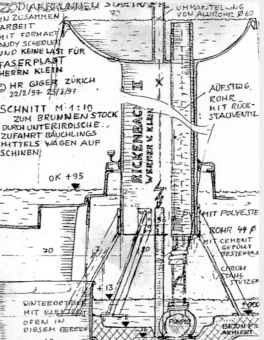

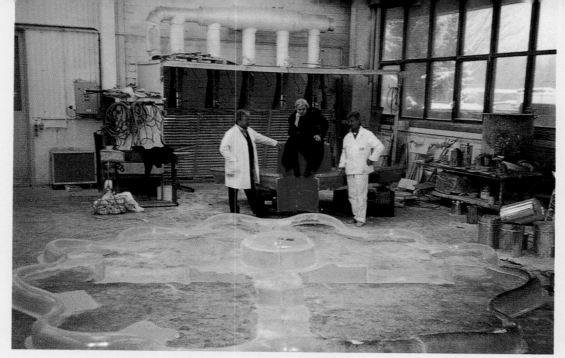
*Workshop of the Faserplast Company in Rickenbach, Switzerland. L-to-r: Klein, Giger, Höhener*

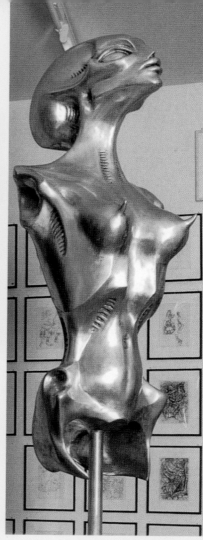

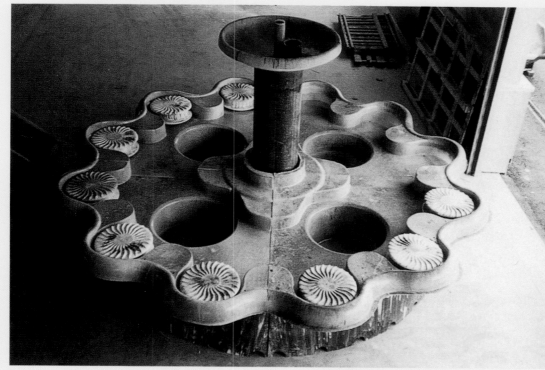
*Core of the fountain with water-wheels and base, without figures*

*Woman's torso with an elongated skull, 1993. Aluminium, 150 x 50 x 50 cm, Museum Baviera, Zurich*

*Brigitte von Känel working at Giger objects*

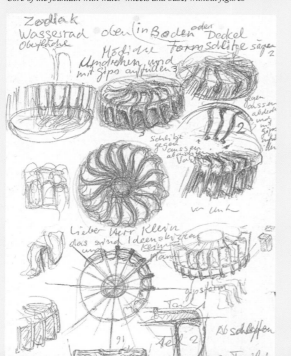

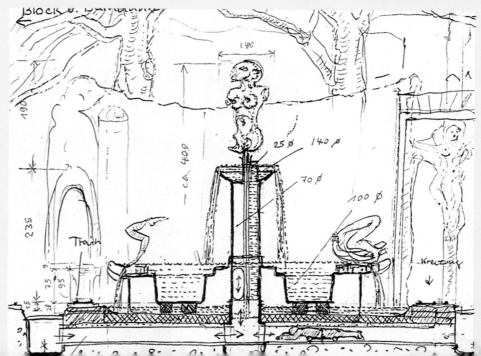

Bar. Unfortunately, Thomas Domenig, the owner, has gotten involved with an animal park in Africa and has lost interest in giving the city of Chur another fountain; the authorities have gotten on his nerves quite a bit in the past. Domenig has tired of his role as selfless giver who never receives in return. Thus the project is taking longer, in part because the means for my self-financing are slowly running out.

The photos and sketches on pages 162–63 show the production of the Zodiac Fountain, which is being set up in my garden as no public exhibition space for it has yet been found! Building of the foundation proper and, at the same time, the fountain's basin, in reinforced concrete began in fall '96. At the same time, Andy Schedler (Atelier FormArt) produced the fountain model, which was then taken over by the Faserplast Company in Rickenbach, who produced the molds and the polyester components. Mr. Klein, the owner, personally developed and produced the water-wheels (polyester) and the accompanying mechanism (chromium steel and teflon). Mr. Klein and my friend Michael Geringer turned out to be enthusiastic sponsors of the project. The Zodiac Fountain should be finished towards the end of 1997.

*H. R. Giger*

*Zodiac Sign Libra, 1992. Ink and felt-tip pen on cardboard, 21 x 29.7 cm*

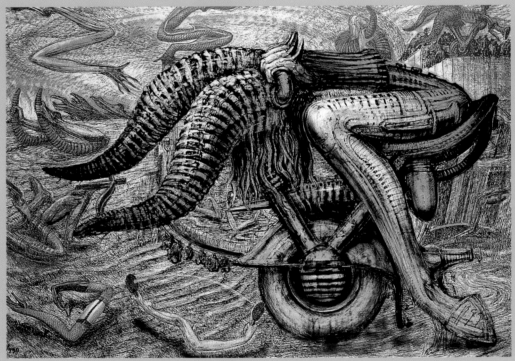

*Bottom: Zodiac Fountain, 1992. Ink on paper, 30 x 21 cm*

*Middle: Zodiac Sign Taurus, 1992. Lithograph, five colors, signed and numbered, 70 x 100 cm. Limited Edition of 290*

*Page 166:*
*Top left: Zodiac Sign Pisces, 1992. Lithograph, five colors, signed and numbered, 70 x 100 cm. Limited Edition of 290*

*Top right: Zodiac Sign Virgo, 1993. Aluminum, 80 x 70 x 40 cm*
*Photo: Jürg Kümmer*

*Bottom: Virgo, 1994. Lithograph, three colors, 70 x 100 cm*

*Page 167:*
*Zodiac Sign Pisces, 1993. Aluminum, 115 x 70 x 65 cm. Photo: Louis Stalder*

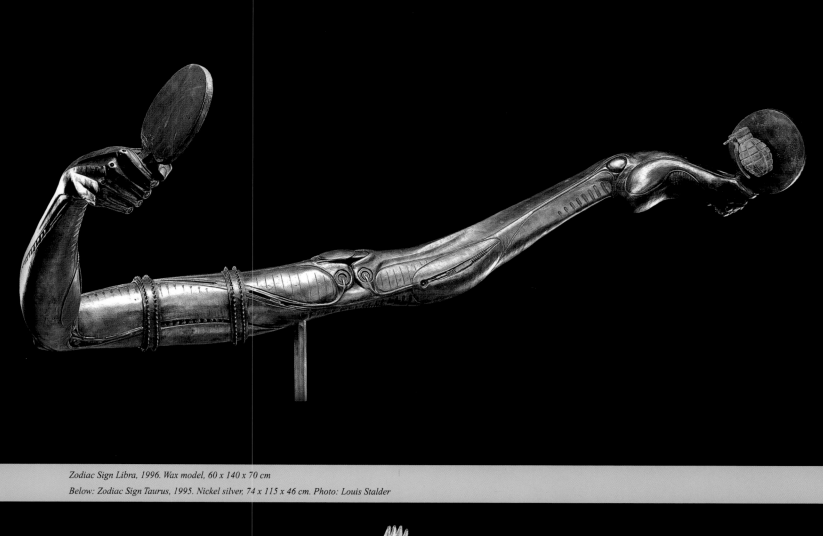

*Zodiac Sign Libra, 1996. Wax model, 60 x 140 x 70 cm*

*Below: Zodiac Sign Taurus, 1995. Nickel silver, 74 x 115 x 46 cm. Photo: Louis Stalder*

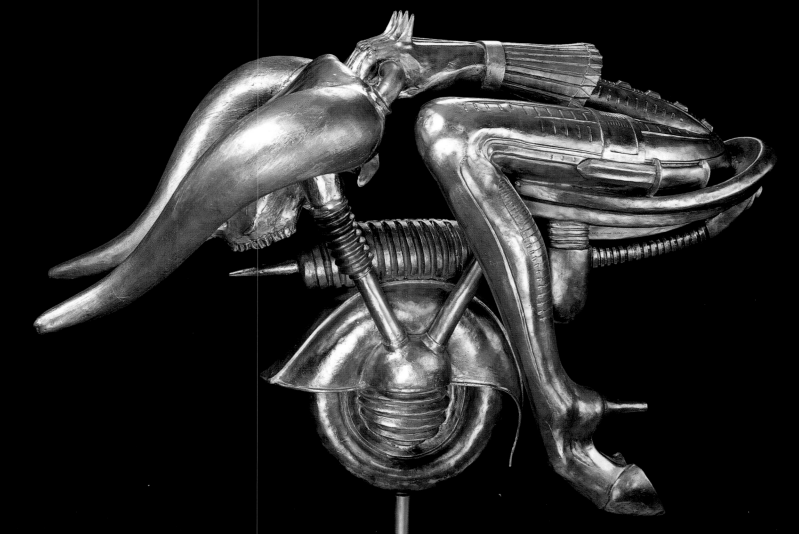

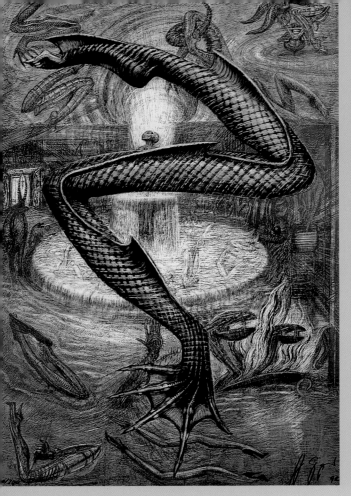

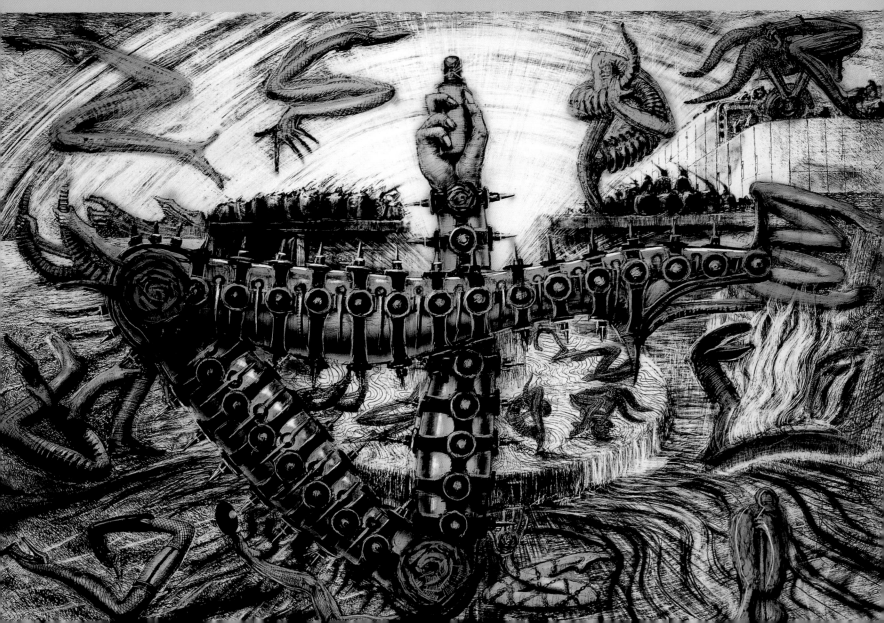

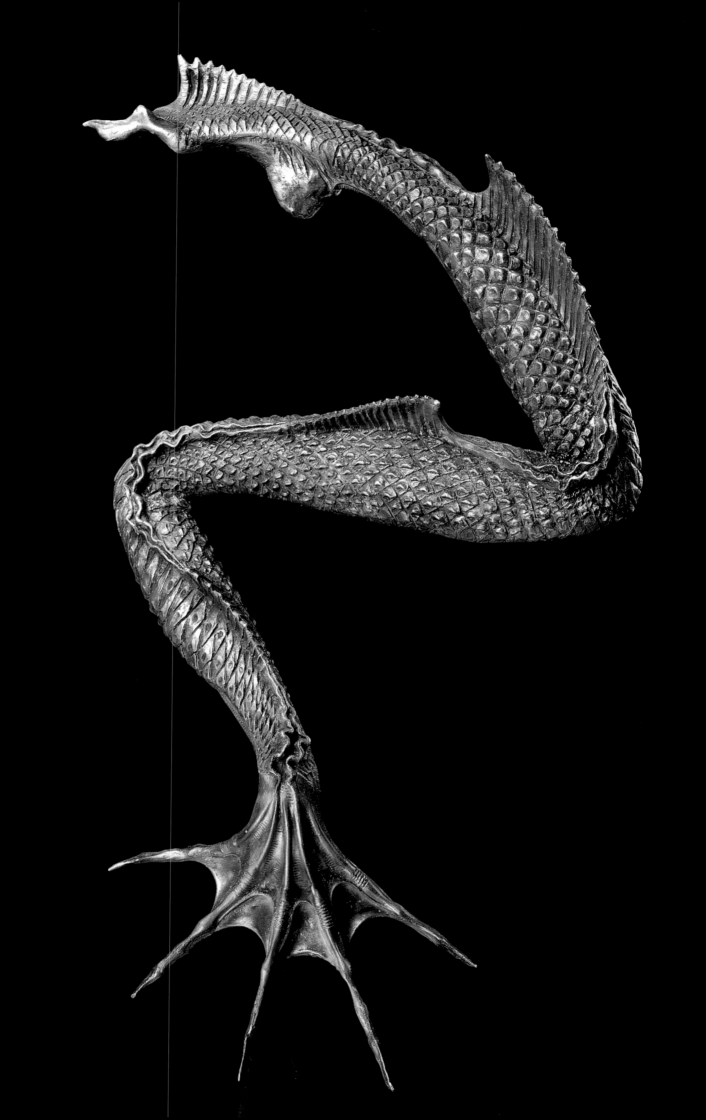

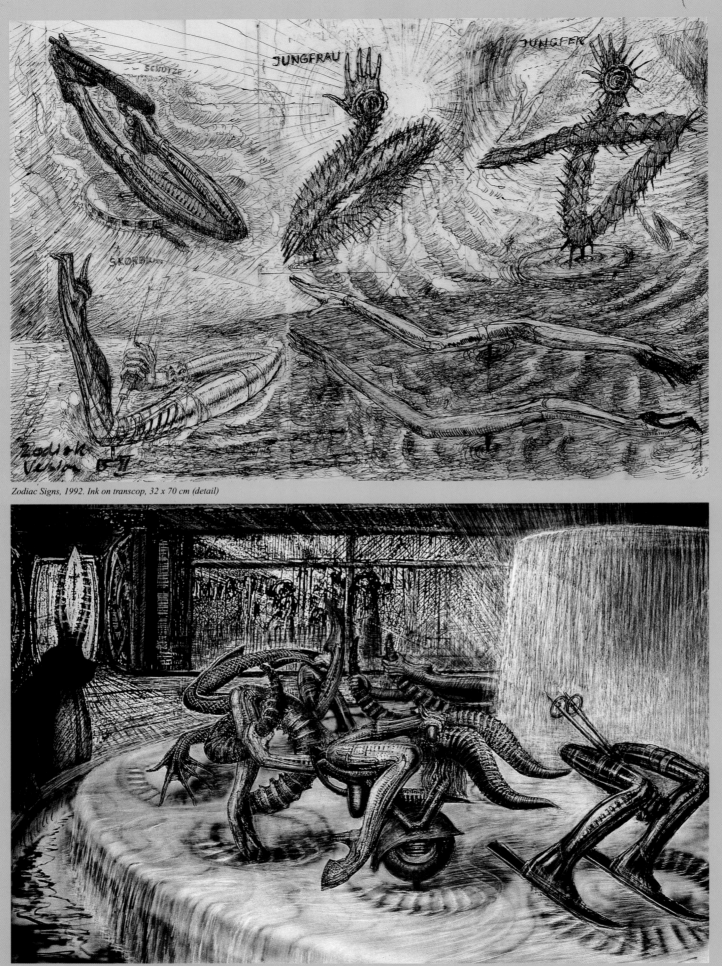

*Zodiac Signs, 1992. Ink on transcop, 32 x 70 cm (detail)*

*Zodiac III, 1992. Lithograph, five colors, signed and numbered, 54 x 82 cm. Limited Edition of 300*

*Page 169:*
*Top: Zodiac Sign Scorpio, 1994. Nickel*
*silver, 68 x 77 x 63 cm. Photo: Louis Stalder*

*Bottom: Zodiac Sign Capricorn, 1994*
*Nickel Silver, 57 x 95 x 57 cm*
*Photo: Louis Stalder*

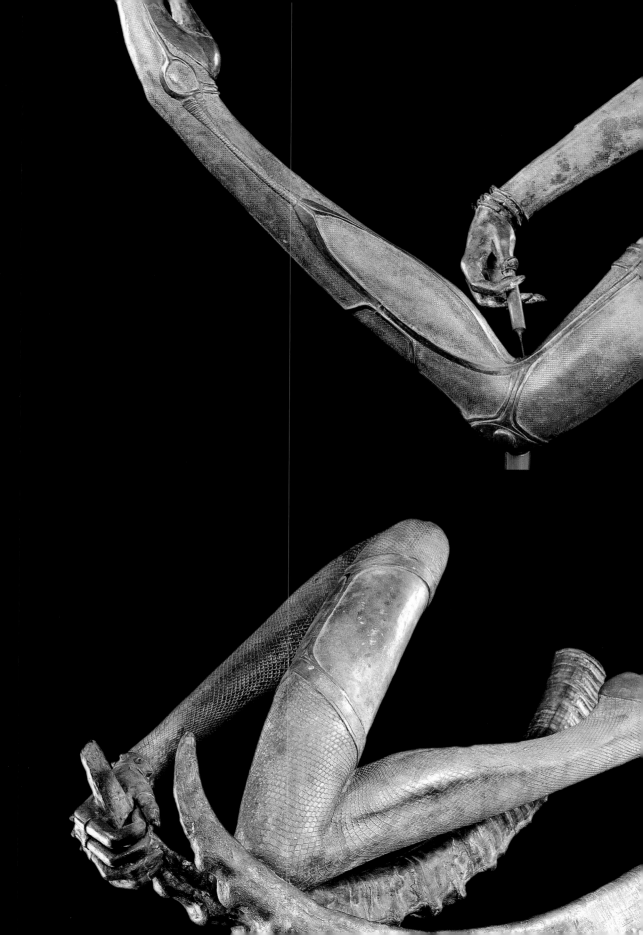

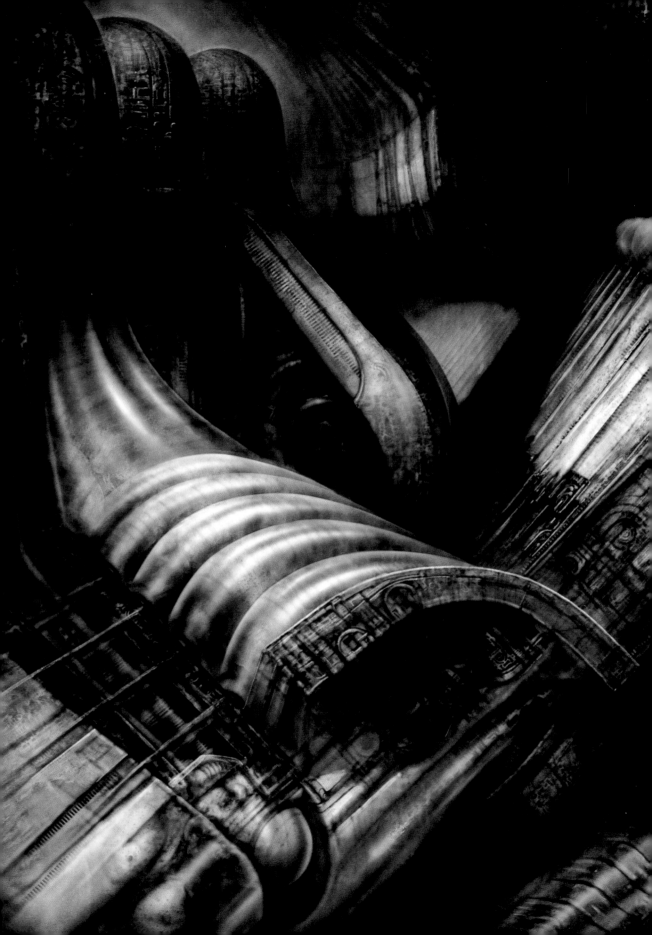

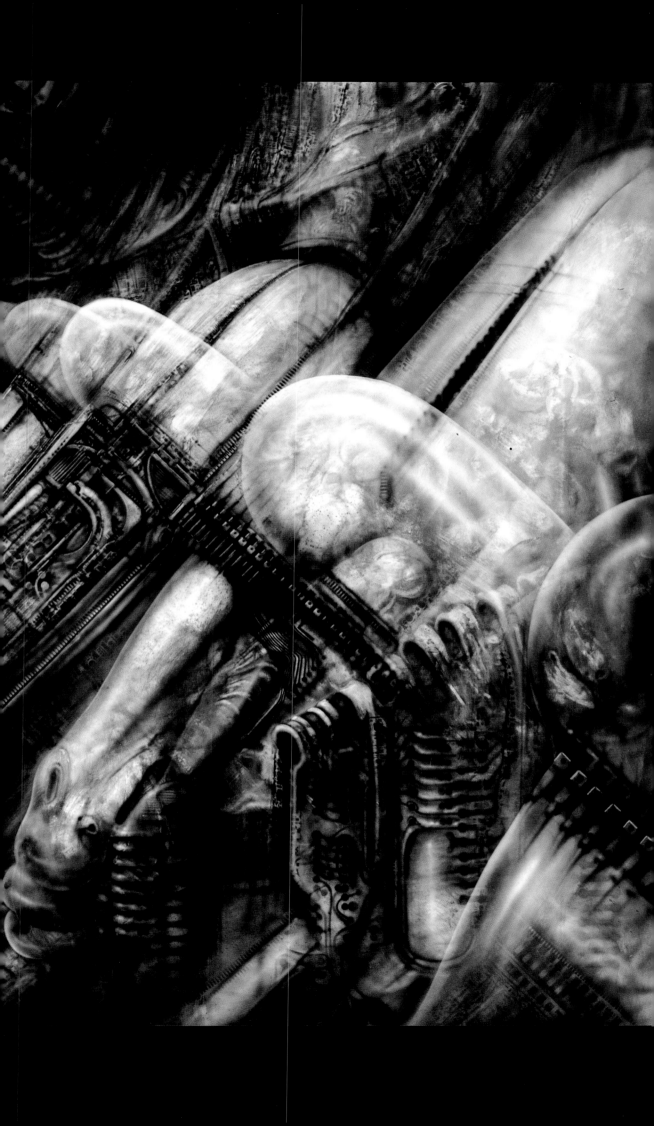

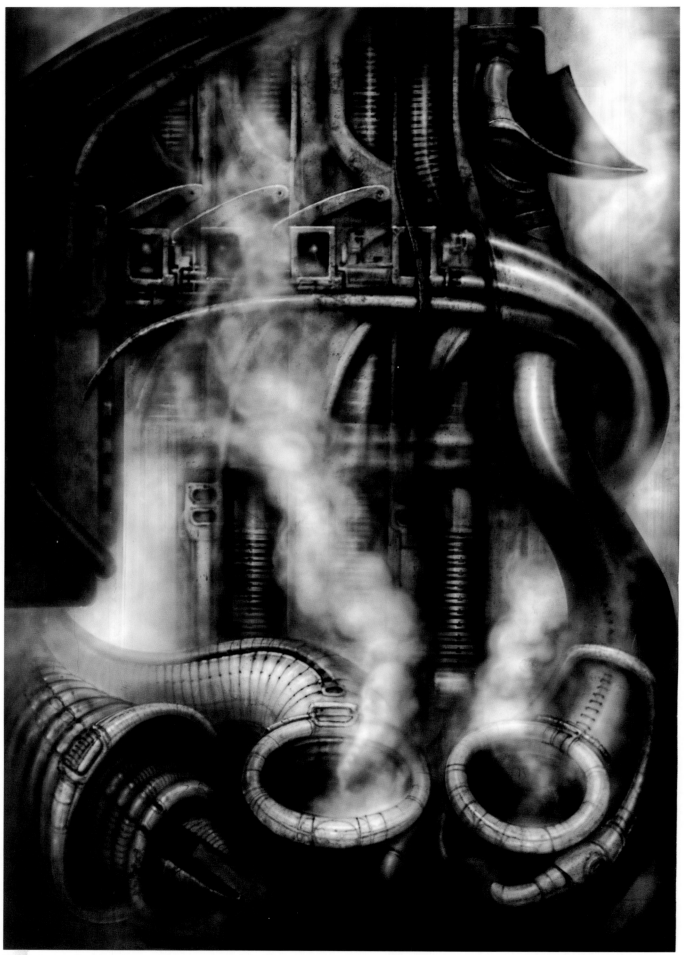

*No. 586, Japanese Excursion, 1986. Acrylic on paper on wood, 140 x 100 cm*
*Page 170: No. 446, Biomechanical Landscape, 1980. Acrylic and ink on paper, 100 x 140 cm*

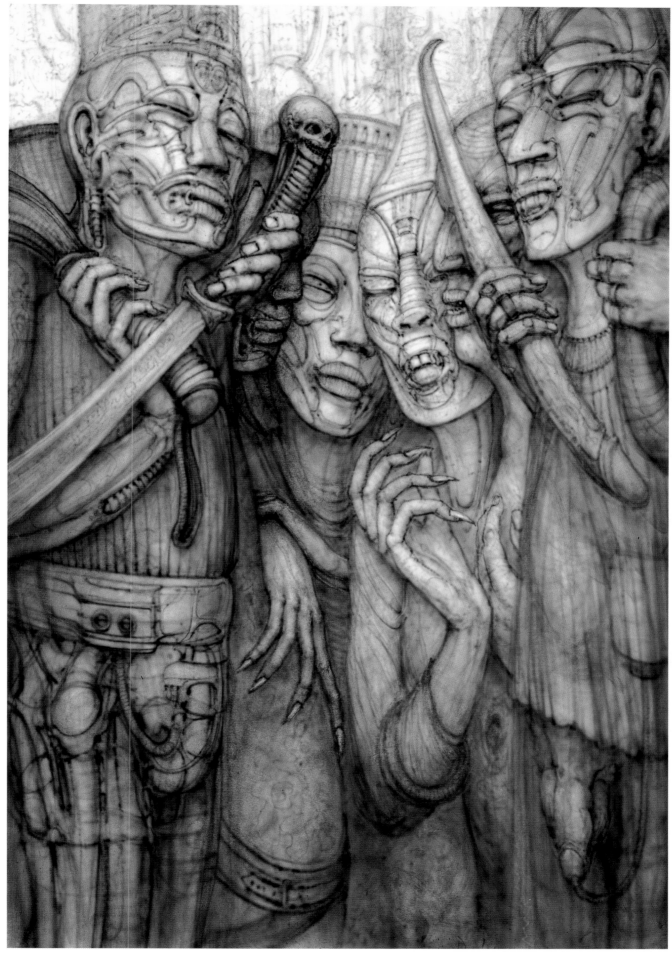

*No. 616, The Witnesses, 1988. Acrylic on paper on wood, 100 x 70 cm*

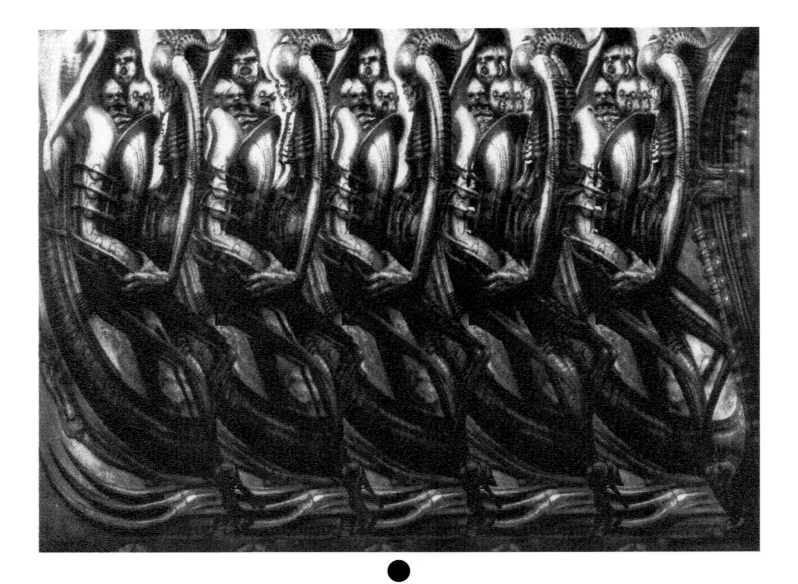

●

## H. R. Giger in 3-D

The 3-D versions of my pictures were created in close cooperation with Fabian Wicki, a computer specialist from Berne, and PanVision in Essen. I chose the pictures and tested them for their 3-D suitability. I also determined where the necessary periodic cuts would be made to achieve the optimal results. In doing so, I took special care to leave the structure of the painting intact to avoid the usual, repetitious and homogeneous 3-D mess and to elevate the suggested plasticity of my images to the three-dimensional level. I prudently refrained from integrating the sort of hidden, clichéd picture puzzles into my compositions that are contained in almost all trendy 3-D depictions. Special thanks to Mr. Lüpken of Pan Vision, Mr. Wicki, and, above all, Mr. Möller of PanVision for being so patient with me.

*H. R. Giger*

*Page 174:*
*No. 585, Saxophonist, 3-D. 1984–95.*
*Acrylic and computer graphic by Fabian Wicki, Bern 20 x 27.5 cm*

*Page 175:*
*No. 585, Saxophonist, 3-D. 1984–95.*
*Acrylic and computer graphic by PanVision, Essen, 30 x 22.4 cm*

*Page 176:*
*No. 251, Li II, 3-D. 1974–95. Acrylic and computer graphic by Fabian Wicki, Bern, 18 x 25.7 cm*

*Page 177:*
*No. 251, Li II, 3-D. 1974–95. Acrylic and computer graphic by PanVision, Essen, 30 x 21.6 cm*

*Page 178:*
*No. 351, Cataract, 3-D. 1977–95. Acrylic and computer graphic by Fabian Wicki, Bern, 17.1 x 26.6 cm*

*Page 179:*
*No. 351, Cataract, 3-D. 1977–95. Acrylic and computer graphic by PanVision, Essen, 30 x 19.8 cm*

*Page 180:*
*Top: No. 295, Samurai, 3-D. 1976–95,*
*Acrylic and computer graphic by PanVision, Essen, 30 x 20.3 cm*
*Bottom: No. 500, Totem, 3-D. 1983–95.*
*Acrylic and computer graphic by Pan Vision, Essen. 30 x 18.8 cm*

*Page 181:*
*Top: No. 303, Necronom IV, 3-D. 1976–95.*
*Acrylic and computer graphic by Pan Vision, Essen, 30 x 12.2 cm*
*Bottom: No. 456, New York City VI (Torso), 3-D. 1980–95. Acrylic and computer graphic by Fabian Wicki, Bern, 30 x 22.8 cm*

*Page 182:*
*Top: No. P12, The Great Beast, 3-D. 1985–95. Acrylic and computer graphic by Pan Vision, Essen, 30 x 19.5 cm*
*Bottom: No. 461, New York City XI (Exotic), 3-D. 1980–95. Acrylic and computer graphics by Fabian Wicki, Bern, 30 x 17.6 cm*

*Page 183:*
*Top: No. 349, Lilith, 3-D. 1976–95. Acrylic and computer graphic by PanVision, Essen, 30 x 20.9 cm*
*Bottom: H. R. Giger, 3-D. 1995. Computer graphic by Prof. Dr. Herbert Franke*

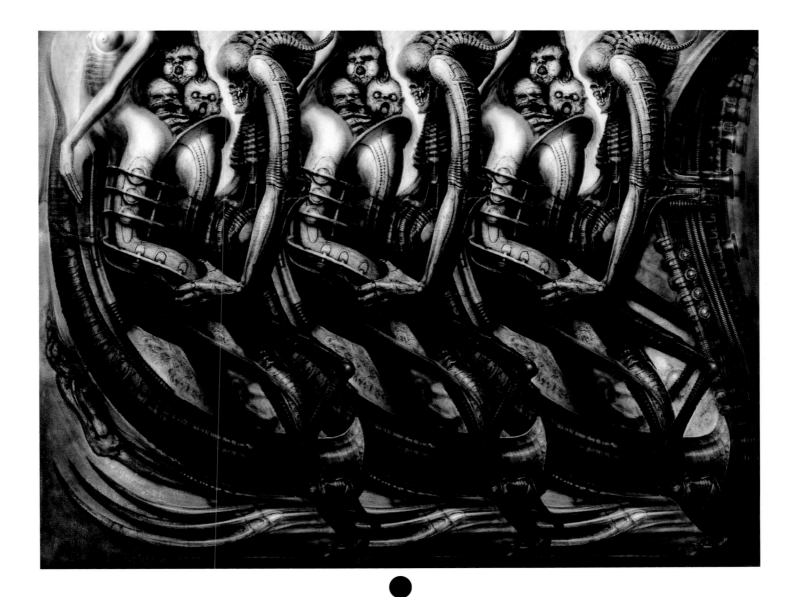

## Pictures from the Third Dimension

Our lives, as we all know, unfold in space, in three dimensions. Front, back, far, near – these are terms that even little children understand. Nevertheless, we are trapped in a two-dimensional world when it comes to the exchange of information, pictures and ideas, much like the beings in Edwin A. Abbot's novella *Flatlands*. Graphic depictions are and remain, for better or worse, two-dimensional – whether they are printed on simple paper or portrayed on a computer screen. We've gotten used to this because images are

a part of our daily lives. This makes it all the more understandable that we greet any exception to the rule with a certain curiosity, often even admiration. Of the many techniques developed to jump from the two-dimensional "Flatland" to our three-dimensional world, sculpture is the oldest and simplest, and holography the newest and most complicated. Between the two extremes lies stereography.

## What is Stereoscopy?

Stereoscopy includes all the techniques that use human binocular (two-eyed) vision to

create a spatial impression by showing the same object from different perspectives utilizing two or more two-dimensional images. The word "stereoscopy" comes from the Greek words "stereo" (meaning rigid, solid) and "skopein" (looking, viewing), and means, approximately, spatial seeing. The widespread assumption that "stereo" is synonymous with "two" probably results from the fact that two eyes are needed for spatial seeing (depth perception), and two ears for spatial hearing. The first stereogram was created in 1832 by Sir Charles Wheatstone (even be-

fore the development of photography 1837–1839) and had to be viewed through a complicated arrangement of mirrors. In the late 19th and the early 20th century, stereoscopy was a popular recreation, and even today, the many stereoscopic pictures found in antique stores bear witness to the fascination exercised by three-dimensional images.

Shortly after the invention of photography, the first stereoscopic cameras, which simplified the production of stereograms, were made. The devices necessary for the viewing of stereograms also made signi-

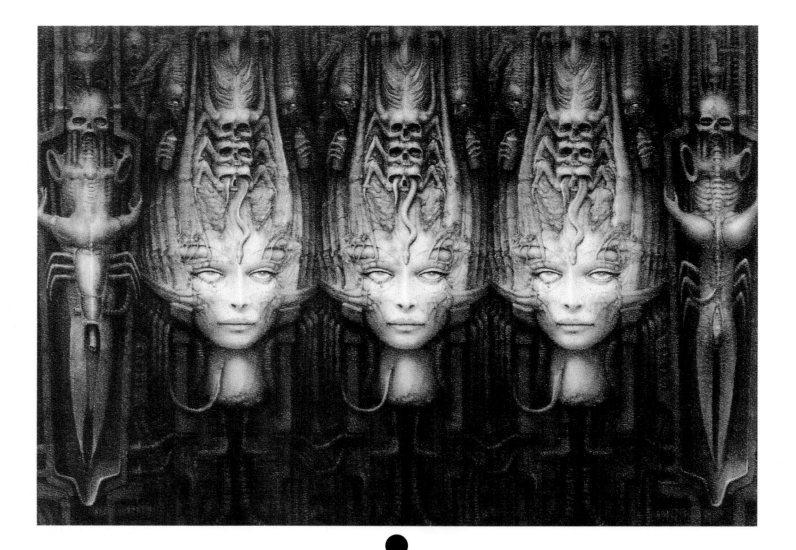

●

ficant advancement during this time. The red-green glasses still widely used today, and their accompanying stereograms (anaglyphs), in which two perspectives of one image – one colored red, the other green – are printed on top of each other, are a product of that era.

A lesser known fact is that it is possible to create stereograms that can be viewed without special equipment. The stereograms in this book are such "auto-stereograms". The advantages of auto stereography, beyond their comparison to the other stereoscopic techniques for creating three-di-

mensional images, are obvious: an autostereogram can be taken anywhere and be viewed with the naked eye without the need for special technology. In addition, they can be reproduced easily since they are printed on plain paper.

**How to Look at a Stereogram**
Now it is imperative that you test one or more stereograms so that at least you know what I'm talking about. First, however, you should learn the proper way to look at a stereogram. It's possible that you will be able to recognize the three-dimensional image after a few mo-

ments even without the benefit of these instructions. It's also possible that you will spend half an hour trying to figure out the right technique for looking at them. Fortunately, one thing is certain: once you are able to see the three-dimensional image, you'll have no problem seeing the stereograms in this chapter correctly, no matter how long it took you the first time.

Before you venture to the stereograms, you can practice your viewing using illustration 1 (p. 178). The illustration shows some concentric squares, a "clearly flat" depiction. This is

a simple but fully functional stereogram, even if it seems to have nothing in common with the other stereograms depicted here. You can use it to check your aptitude: if you're doing it right, you'll see four squares floating above one another. You might be one of the fortunate ones with natural ability. If so, you have no need for instructions. You only have to look at the stereogram in a relaxed manner. You have to "dream" yourself into the stereogram, so to speak, and wait a little while. If that doesn't work, you should proceed in a more technical fashion: place the illustration

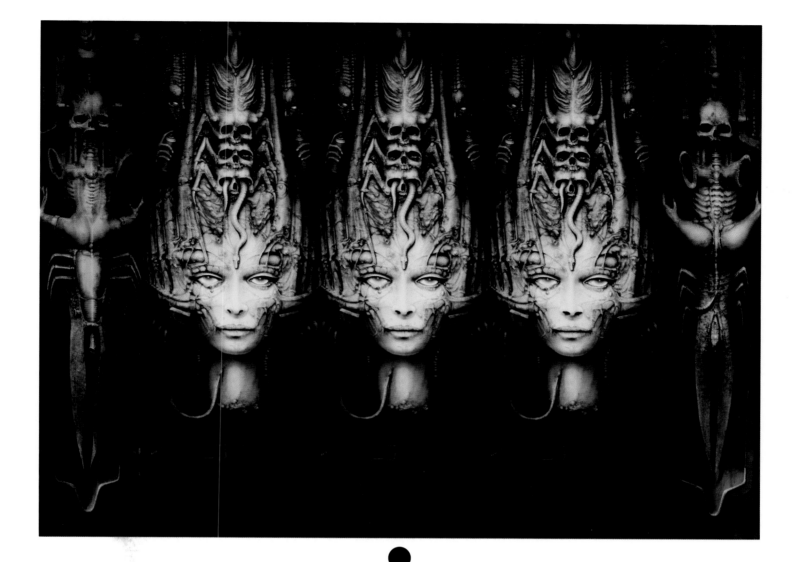

on a flat surface. Bring your eyes close enough to the illustration to make it blurry. Your eyes should now be, at the most, 10 cm away from the illustration. At this distance it is virtually impossible to see the squares distinctly. Don't put up any resistance, just relax and look, allowing the squares to become even more out-of-focus.

Now squint, trying to place the images on top of each other in such a way that they seem to merge. Even when using this method, the partial images move towards each other before merging. After the merge, you

will still see three partial pictures, and only the center one will convey the three-dimensional image of a pyramid. You will note one important difference from the method described above: the three-dimensional picture is obviously mirrored on the paper's plane. You now see the larger squares floating above the small ones. All of H.R. Giger's 3-D stereograms are intended to be viewed using the first method described above. You may, of course, also look at them using the squinting method, if you prefer, but if you do so, in a certain sense, you'll be seeing the

motifs from the wrong point of view.

If neither of the methods described above is successful, you can use a trick which simplifies the merging process considerably : Place an ordinary piece of cut glass on one of the stereograms and concentrate on the reflections you see in the glass. Look at your own reflection, which seems to lie behind the stereogram. If you can see your reflection clearly, the stereogram, which is midway between your eyes and your reflection, is out of focus, of course. You have artificially created the conditions neces-

sary for the merge. By now you really should have no problems viewing stereograms.

If you're not capable of seeing a three-dimensional image after several attempts, don't despair. Yet another method, using illustration 1 (p. 178), is to alternately look at the left square with the left eye and the right square with the right eye, possibly using a piece of cardboard held in front on your nose to separate them. After switching from one eye to the other, open both eyes at once, to create the image of a 3-D pyramid between the two squares. The black dot is used as a reference point.

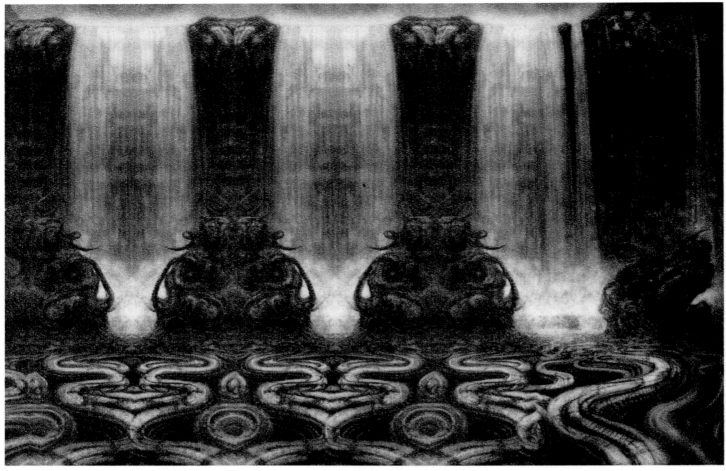

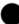

*Illustration I*

Here you will see three
squares, the middle one
as a three-dimensional
pyramid.

*Illustration II*

Here you will see four
squares, the two middle
ones as three-dimensional
pyramids.

If you view this cross-eyed,
you will see five squares,
and only the middle one
as a three-dimensional
pyramid.

The dots double in three-dimensional viewing. When using the parallel-viewing method, they are one interval apart; when squinting cross-eyed, they are two apart. Theoretically, 3-D images can be perceived only when the distance between the intervals is no more than 5.5 cm (distance between the eyes). Some viewers, however, can perceive distances of 10–15 cm.

*PanVision*

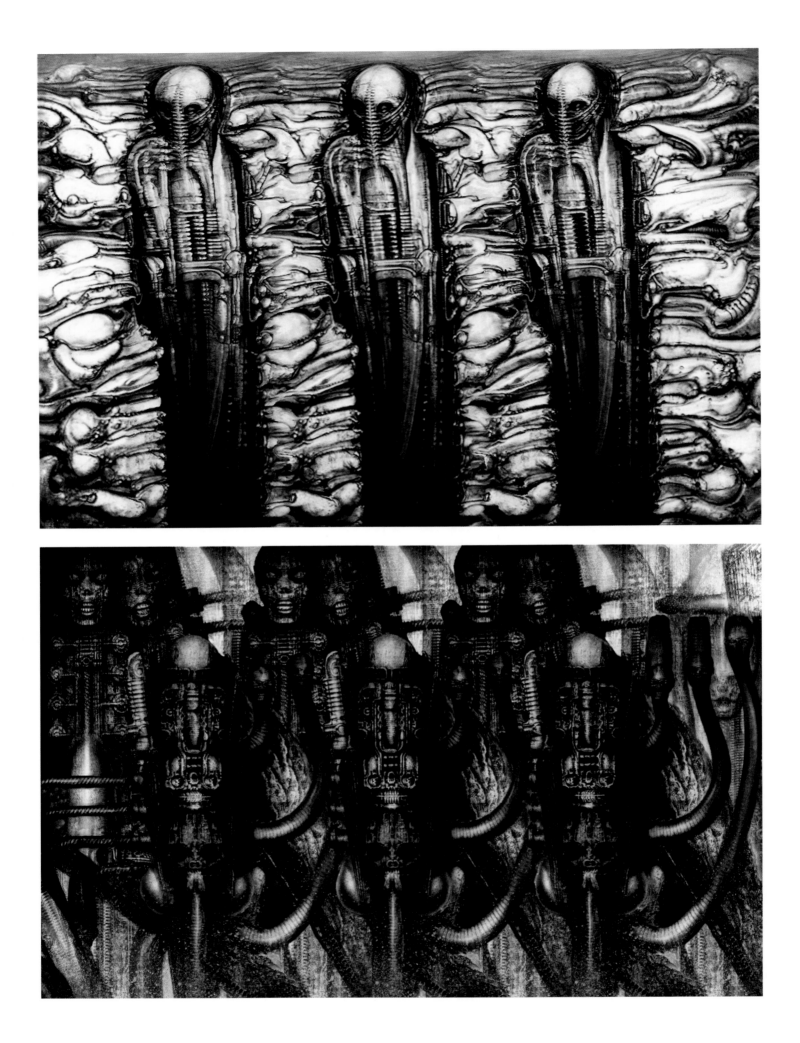

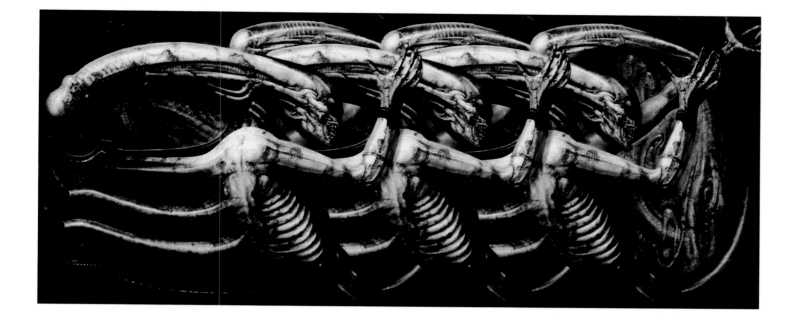

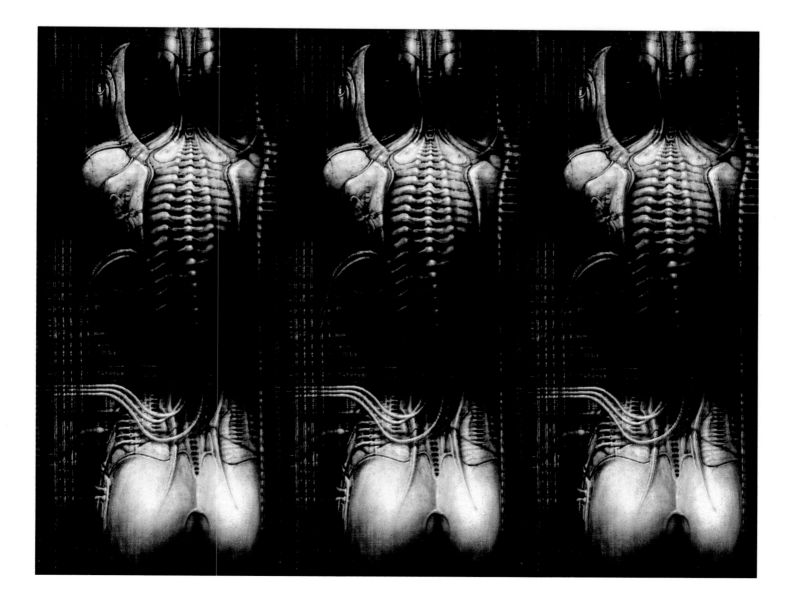

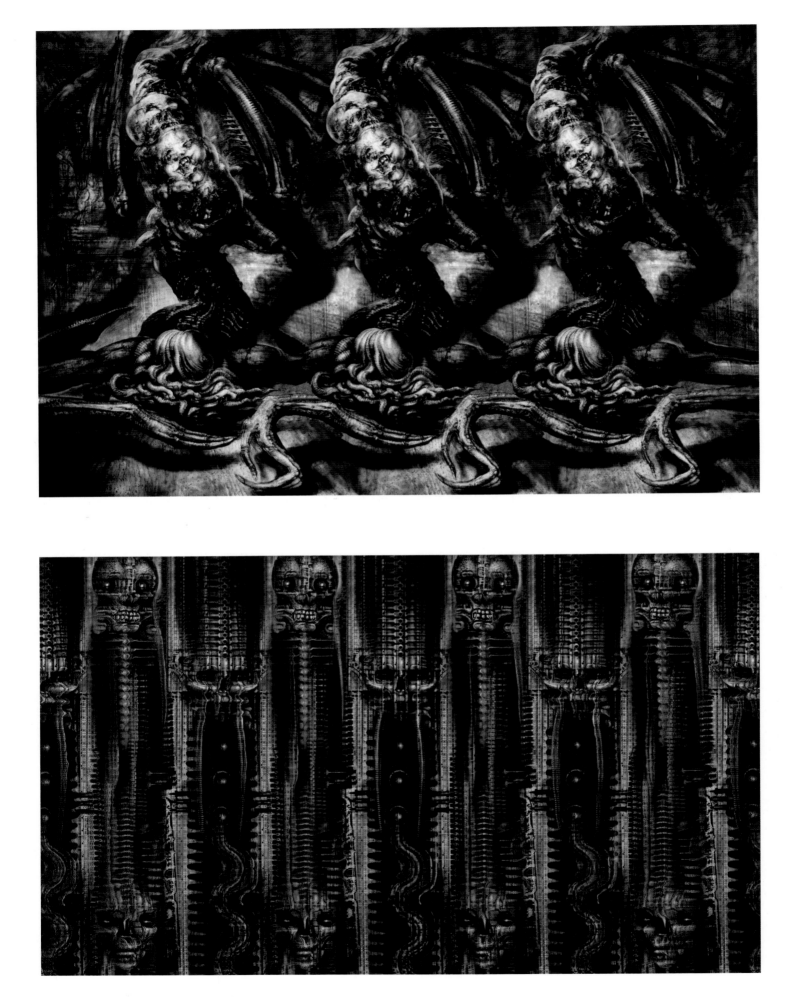

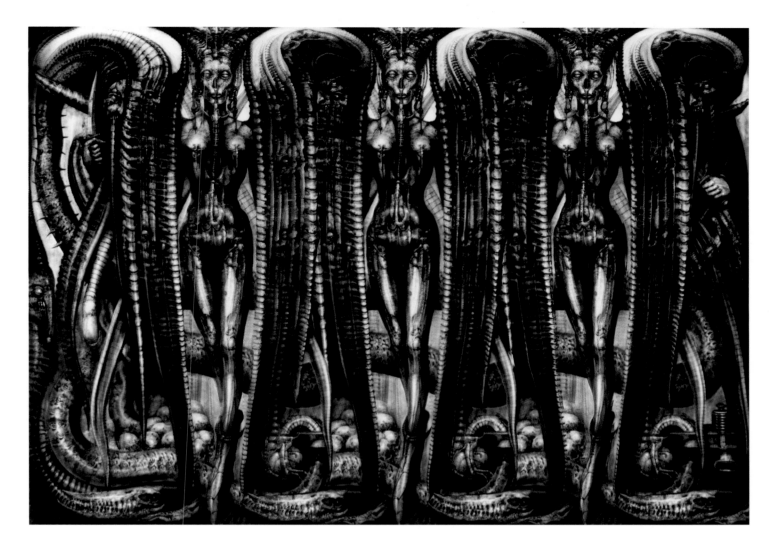

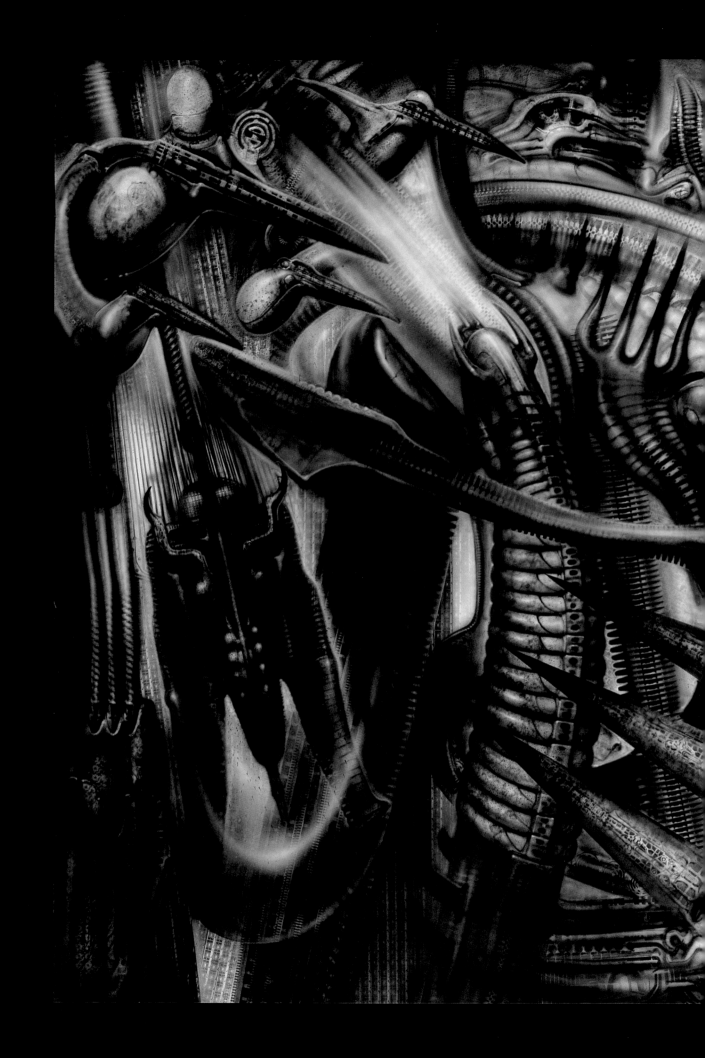

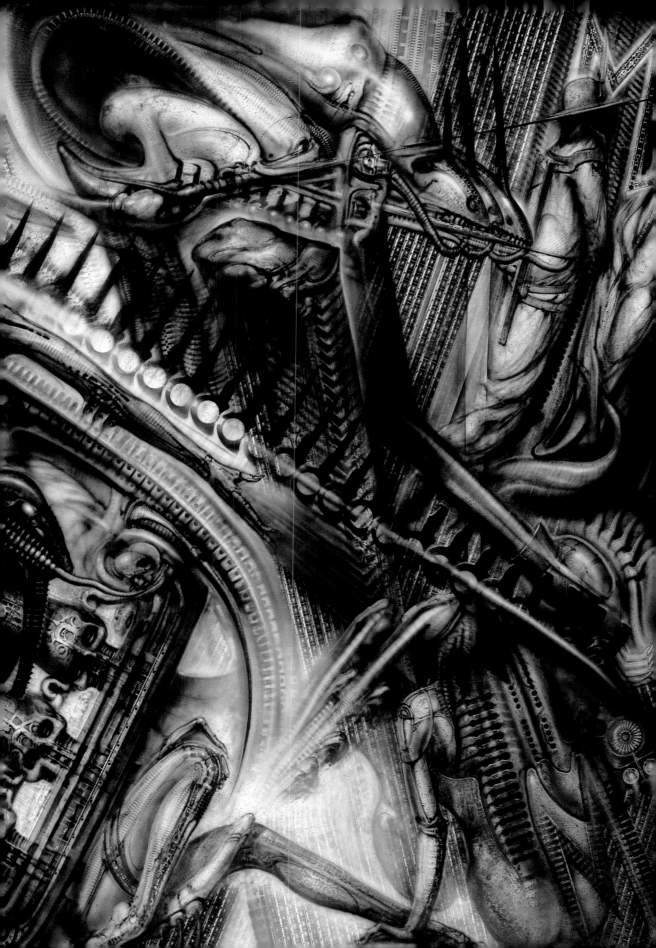

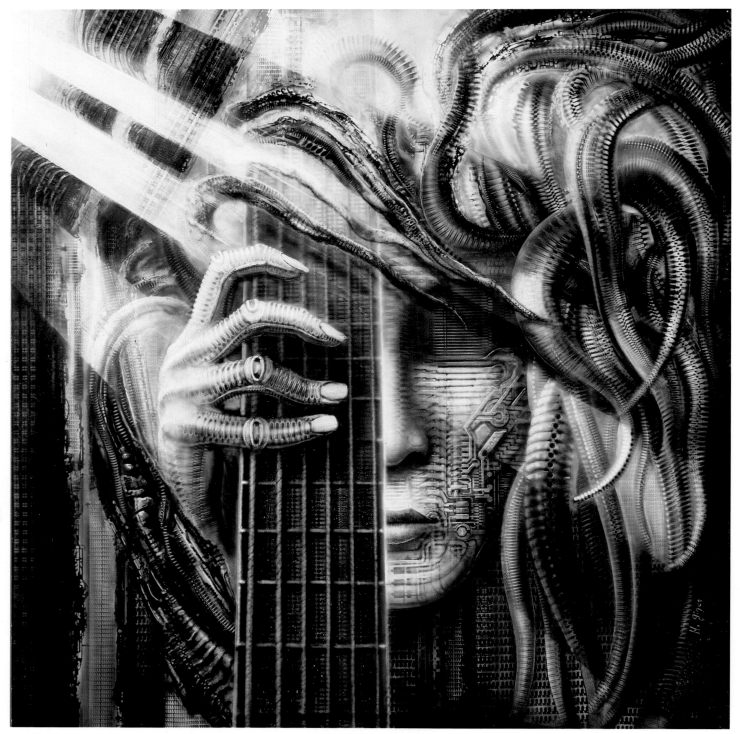

*No. 619, Steve Stevens, Atomic Playboys, 1989. Acrylic on photo paper, 120 x 120 cm*

*Page 184: No. 470, New York City XX (A City Looking for a Murderer), 1981. Acrylic and ink on paper, 140 x 200 cm*

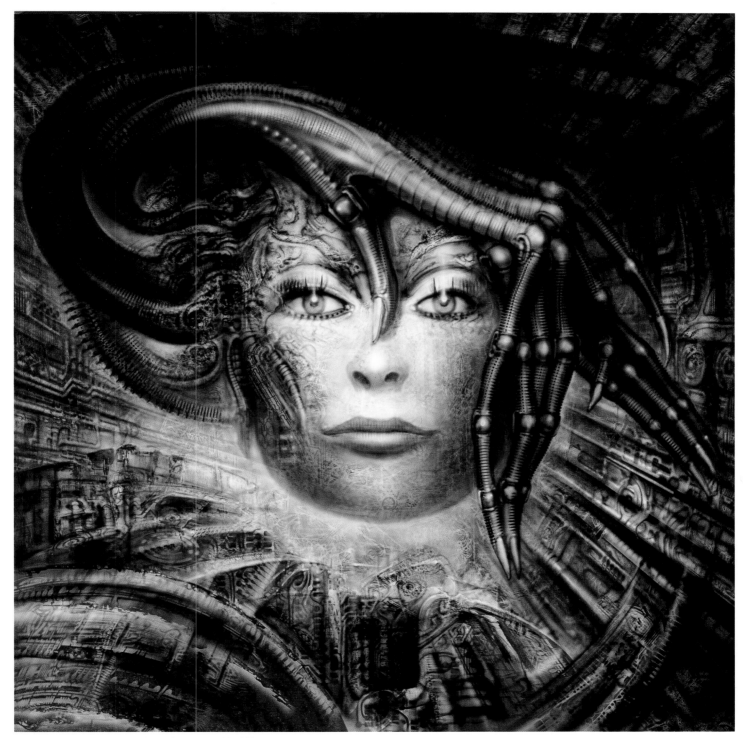

*No. 618, Carmen I, 1988–89. Acrylic on photo paper, 120 x 120 cm*

## Killer Condom

To participate in a European film production, at least once in my life, was inevitable. One day Mr. E.C. Dietrich from Elite-Film and his son, a director, visited me. I brought up the subject of my film project, *The Mystery of San Gottardo*, but I was soon informed that they had their own film project to pitch, one that would tickle my fancy – Ralf König's *The Killer Condom*. Naturally, I knew this horror comic well and was delighted to be invited to participate in its adaptation to the screen – their counterproposal to my *Mystery of San Gottardo* project.

Director Martin Walz, who was also present on this occasion, easily convinced me to participate as I was already a fan of the graphic novel. When I received a videotape of *The Killer Condom*, done as puppet theater, from Ralf König himself, and found it brilliant, I was so inspired that, once again, I started to sketch before even having a contract in hand. Since it was a low-budget film, I agreed to reduce my fee. Dietrich and I reached an agreement, and I began to fax the movie people working in Berlin (Jürg Buttgereit, for example, who was responsible for the special effects, a fact which delighted me). I had a chance to see Buttgereit's earlier movies, which were really good.

I had not, however, seen anything by the director, who was approaching the present project ambitiously. He had worked with Ralf König on the script, and although the two scriptwriters were convinced of the quality of their work, no matter how hard I tried to find it, the humor wasn't there anymore.

Since I came to the project fairly late, about a month before filming was to begin, there was not much time for major

*No. 26, Suggestion: To attach fishing line to a cork flushed down a toilet to establish the connection to the horror laboratory, 1996. Neocolor on reworked photocopy, 21 x 16 cm*

# H. R. Giger entwirft für „Kondom des Grauens"

**Berlin (dak) – Das „Kondom des Grauens" (BF 43/92) von Ascot/Elite und Ecco Film kann mit einer Sensation aufwarten: Der „Alien"-Designer H.R. Giger wird für die Verfilmung des Comics von Ralf König einen Teil der Ausstattung entwerfen.**

*Press notice in "Blickpunkt Film", No. 50, December 11, 1995*

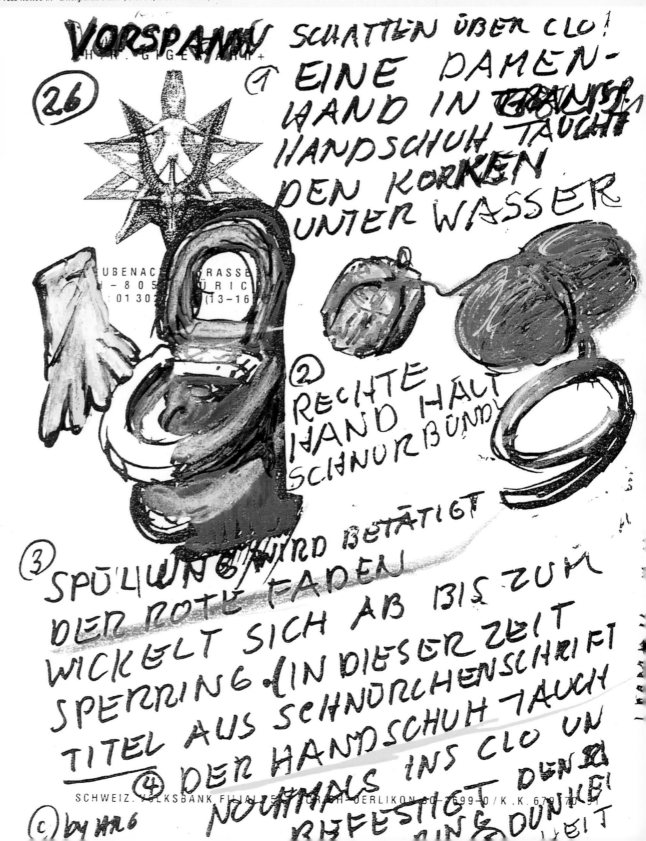

Top left: No. 62, A salami for Macaroni, 1996. Ball-point pen on paper, 30 x 23.8 cm

Top right: No. 426, Dune Worm XII (detail), 1979. Acrylic on paper on wood, 70 x 100 cm

script changes. Brilliant as I find the graphic novel and the puppet show, I couldn't imagine anyone finding the script funny. At first, the horror laboratory was to be my design, but when I realized that absolutely no attention was being paid to my ideas (for whatever reason) and that I had been hired mainly because of my name, I managed to change my role into that of a "creative consultant". I would have liked to place the word "unheeded" in front of that!

*H.R. Giger*

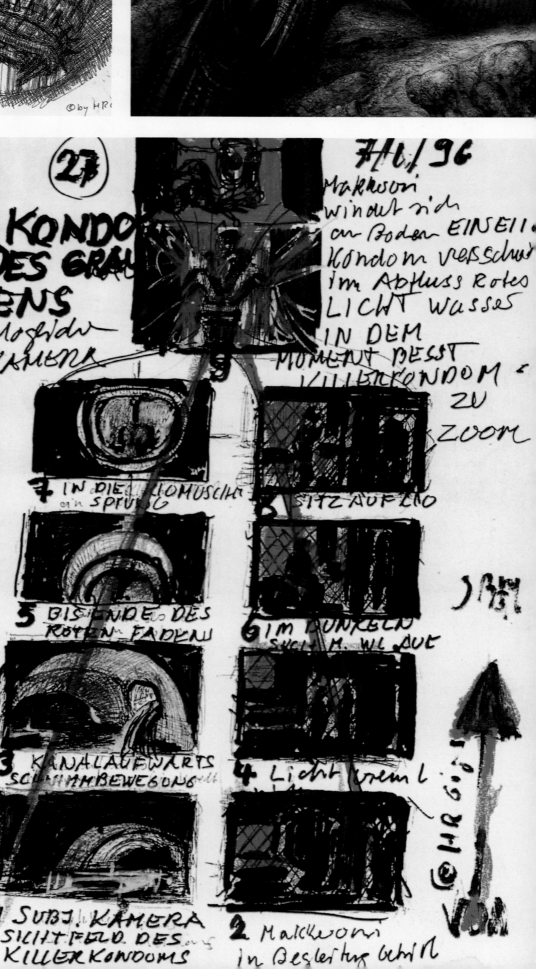

No. 27, Meeting of a Killer Condom with its victim on the toilet, Storyboard suggestion, 1996. Neocolor and felt-tip pen on reworked photocopy, 21 x 13.8 cm

Letter from H.R. Giger dated January 2, 1996, to the Killer Condom moviemakers, Ralf König, Martin Walz, Jürg Buttgereit, E.C. Dietrich:

Dear Condom Killers,

The more I think about it, the more it seems to me that the fourth script should be tighter, dialogue should be cut and the movie should be more realistic (credible) and at the same time more exaggerated, more comical! I imagine it like this: red threads are fastened in the toilet drains of some of the hotel rooms and flushed down with a cork attached to the other end. In the lab, the sewers are opened to expose the red threads, which lead the way back to the rooms in the Quicki Hotel. The cameras, show the point of view of the condoms as they swim against the current (this is filmed by robots who repair sewers), up the canal, following their thread through the maze of pipes directly up into the toilets. They jump up and sink their teeth into the genitals (usually attached to a defecating male). The victim jumps up, screaming in pain, and rolls around the floor clutching his crotch. If the room is empty, the condoms jump into the already opened wrappers in the medicine cabinet or on the night table. First, however, they dry themselves off (using either a hairdryer or a Closomat). The packaging should look expensive, gold or silver-colored. The killer condoms, having taken over the nest and tossed the rubber condoms into the wastebasket, fold themselves into the wrappers.

Since the graphic novel is super, and I've heard the play is, as well, the film has to be a masterpiece.

I think that if you want to make a superior film, you have to begin as early as possible. A

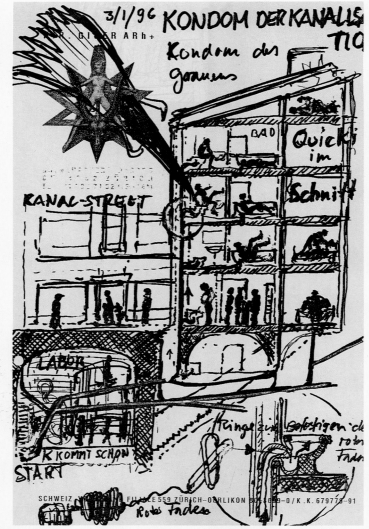

*The Condom's path from the Horror Laboratory to the hotel room, Cross-section, 1996. Ink on paper, 29.7 x 21 cm*

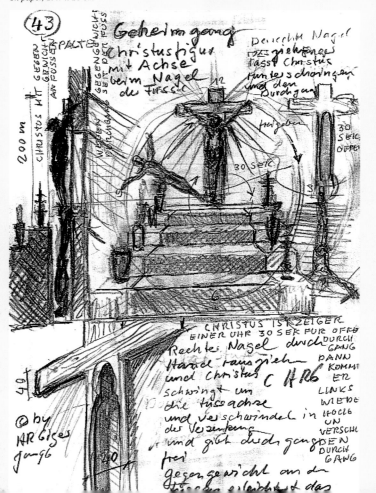

*No. 43, Crucifix secret passage with axis at the nail in the feet, 1996. Pencil and ball-point pen on paper, 29.7 x 21 cm*

*No. 48, Crucifix secret passage with axis at the nail in the feet, 1996. Pencil and ball-point pen on paper, 29.7 x 21 cm*

movie is not a filmed theater piece. The visual possibilities, the close-ups, the pacing and the condoms' point-of-view are what makes this movie! It has to look like the maid had just opened the flap in the condom wrapper to save the guests the effort! That would be credible. Details, such as wildly exaggerated sexual acts with objects from hardware stores or weapons stores, must be included. Small wild animal tableaus taken from old pinball machines decorate the lab, and unmistakeable castration images from Sigmund Freud's "Dream Book" have to be visually integrated.

Like the red thread, humor should trail through the movie, in the form of recurring, exaggerated detail.

*H. R. Giger*

Page 191:
*Top: No. 65, Rearing of Killer Condoms with nutrient solution, 1996. Pencil on paper, 29.7 x 21 cm*

*Bottom left: Holiday on the Waldsee, 1996 Ball-point pen on ink, 21 x 29.7 cm*

*Bottom right: No. 28, Rack for bottles for Killer Condoms, 1996. Ink on paper, 21 x 29.7 cm*

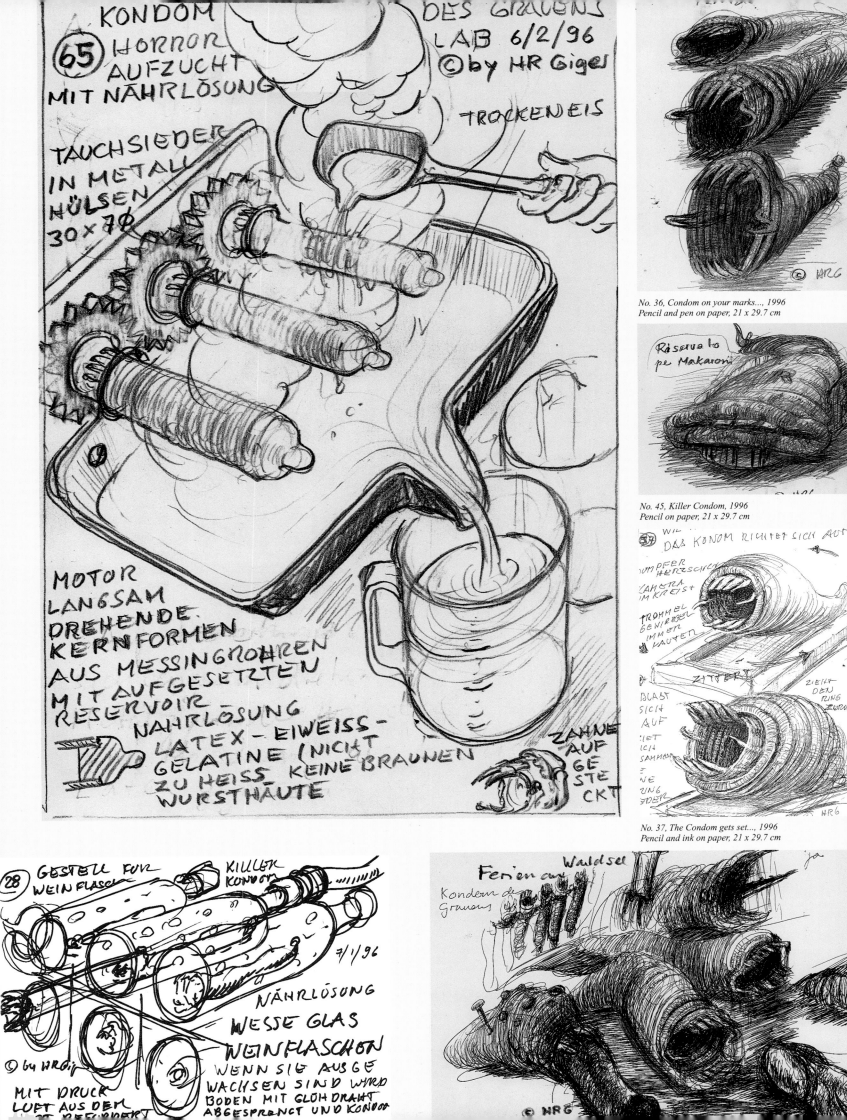

KONDOM
(65) HORROR DES GRAUENS
AUFZUCHT LAB 6/2/96
MIT NÄHRLÖSUNG © by HR Giger

TROCKENEIS

TAUCHSIEDER
IN METALL
HÜLSEN
30×7∅

MOTOR
LANGSAM
DREHENDE
KERNFORMEN
AUS MESSINGROHREN
MIT AUFGESETZTEN
RESERVOIR
NÄHRLÖSUNG
LATEX - EIWEISS -
GELATINE (NICHT
ZU HEISS KEINE BRAUNEN
WURSTHÄUTE

ZAHNE
AUF
GE
STE
CKT

No. 36, Condom on your marks..., 1996
Pencil and pen on paper, 21 x 29.7 cm

Rÿserua to
pe Makaroni

No. 45, Killer Condom, 1996
Pencil on paper, 21 x 29.7 cm

(37) WIL DAS KONDOM RICHTET SICH AUF

No. 37, The Condom gets set..., 1996
Pencil and ink on paper, 21 x 29.7 cm

(28) GESTELL FÜR KILLER
WEINFLASCHE KONDOM

7/1/96

© by HRG

NÄHRLÖSUNG
WESSE GLAS
WEINFLASCHEN
WENN SIE AUSGE
WACHSEN SIND WIRD
BODEN MIT GLÜH DRAHT
ABGESPRENGT UND KONDOM

MIT DRUCK
LUFT AUS DEM

Ferien am Waldsee

Kondom des
Grauens

## Killer Condom Facility I

A training facility where the condoms learn to aim and jump. Laboratory with different training grounds for the killer condoms.

An area for long jumps towards the silhouette of a man with a hole in the place where his dick would be. Linked sausages are continuously pumped through the hole, and the condoms take aim at them, jump at them, and, in the best-case scenario, bite them off. Those who miss their target crash against the wall and slide to the floor. Bad jumpers end up impaled on the backboard, the upper and lower sections of the silhouette, covered with nails.

*H. R. Giger*

## Victims Hanging from the Rings

One month before shooting was to start, I sent the drawings and texts, reproduced here, to the producer, director, production designer, and the people responsible for special effects, hoping that these ideas would lead to some changes in the script written by Martin Walz and Ralf König. For example, the idea of connecting the subterranean world and the hotel with a string (so that the condom beasties could find their way) would necessitate the building of a special prop toilet. I also wanted to enrich the somewhat brittle script with a solid pictorial symbolism, and make the whole story hilarious. I knew that a designer or consultant's tinkering with the script is generally not appreci-

ated, but there was no other way to integrate my visual humor. I wasn't told, however, that most of my ideas were turned down anyway – they confessed this only later. For example: I was hired to design the horror laboratory, which was going to be realized in an old water reservoir on Prenzlauer Mountain in Berlin. I saw how little was left of my ideas only when I visited the set, three days before filming began. Since all the money had run out by this point, the visit to Berlin was pointless, because there could be no more changes. Set-designer Klaus Amler filled the horror laboratory with an enormous amount of technical equipment (particularly hospital equipment). It looked to me as if thirty people should be working in that laboratory. I had imagined that all the bizarre contraptions would form the foreground and the high-tech equipment, lifeless and in a state of disrepair, would form the background – serving to underline the facility's absurd character. But the set designer had gone to incredible effort to have the equipment installed, so that it had to appear in the movie if only to justify that effort.

*Top: No. 46, Wardrobe or drain at the entrance, 1996. Pencil on paper, 29.7 x 21 cm*

*Bottom: Condom feeding with goose force-feeding mill, 1996. Pencil on paper, 29.7 x 21 cm*

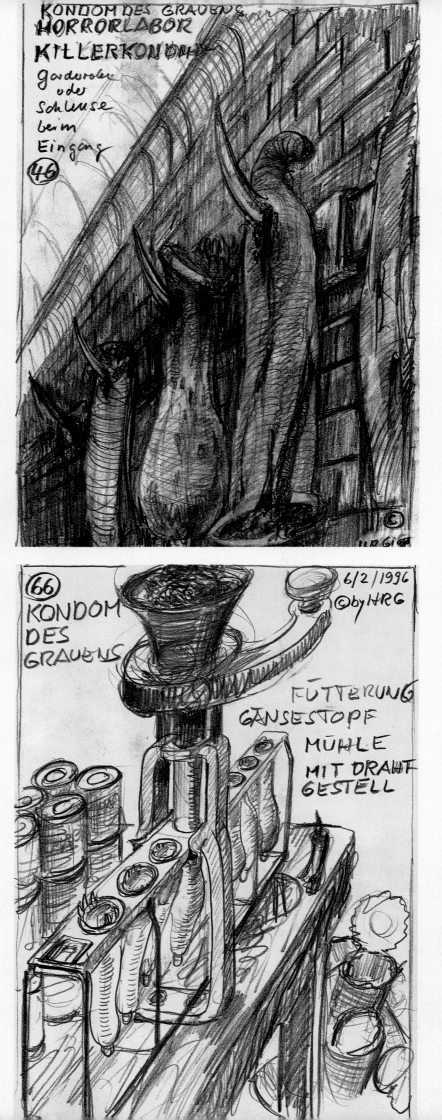

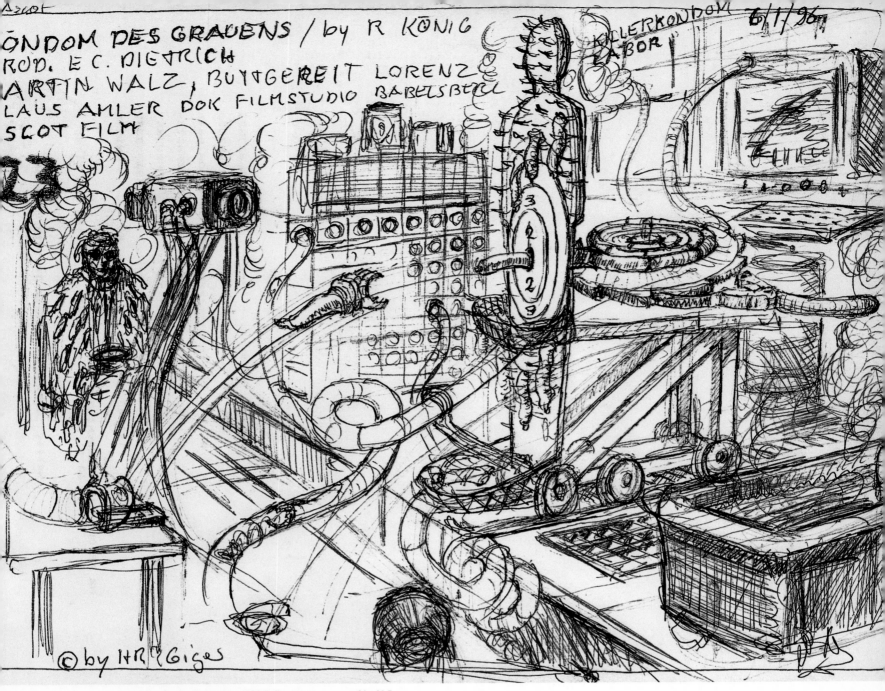

ÖNDOM DES GRAUENS / by R KÖNIG
ROD. E C. DIETRICH
ARTIN WALZ, BUTTGEREIT LORENZ
LAUS AMLER DOK FILMSTUDIO BABELSBERG
SCOT FILM

KILLERKONDOM
LABOR
6/1/96

© by HR Giger

*No. 23, Killer Condom Laboratory, 1996. Ball-point pen on paper, 21 x 29.7 cm*

*Killer Condom models by H. R. Giger, 1996. Condoms, animal skulls and silicone. Photos: H. R. Giger*

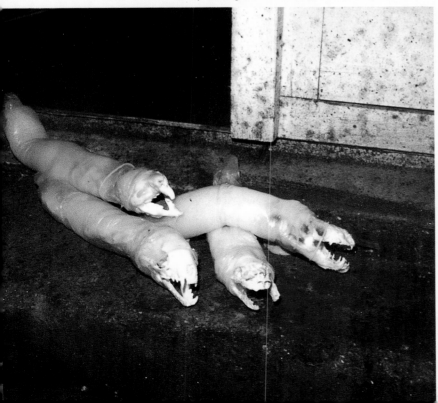

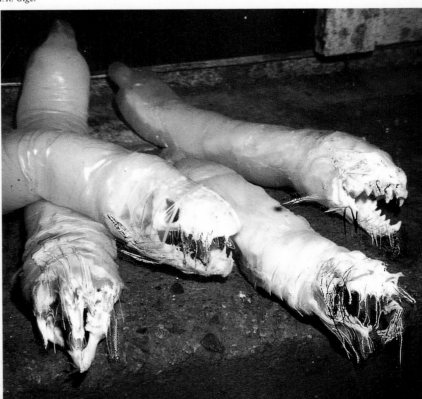

An idea I had my heart set on was to have gyrating gymnasts, rather than tied-up, lifeless victims, hanging over the pools of condoms. I chose rings such as those used for gymnastics or those used as a symbol for the Olympics. This paid homage to Leni Riefenstahl, as well. The actors will probably long remember these rings. I want to thank them very much for their suffering through the film gymnastics, which they undertook voluntarily. The work done by the horror laboratory team was also superb. I especially want to mention the stamina and dedication shown by the people in the cold laboratory, as well as the endless overtime they put in for something they believed in.

This collaboration showed me once again that the best designs and grandest ideas are useless if one is not present at the filming to fight for one's vision. Naturally, everybody present on the set tried to include their own ideas in the film. When one has no authority to decide what goes into a movie and what stays out, an artist can only hope for the best!

I brought along two part-killing machines, so-called castration guillotines (which were prepared for another project by my friends André Lassen and Robert Christoph Jr.) to use as elements in the movie. In the end, the two "St. Gallen Neckties" will probably be the only props in the movie that will reflect my input on the project. I hope for all concerned that the movie will be as good as the puppet theater piece by the same name. Both, after all, use Ralf König's brilliant graphic novel as a basis.

One positive result was that I met a lot of top film people, such as Jürg Buttgereit and Ralf König.

## The Merits of Hanging the Victims from the Rings!

1. From far away, the horrible thing that will happen cannot be seen.
2. The victims are captive gymnasts and are in constant motion.
3. They are not strapped in and therefore seem grotesque
4. The victims are wearing only shirts, they are naked below the waist.
5. The soundtrack could be "Glocken de Heimat" (The Bells of Home) or an Olympic march.
6. The torture chairs are used as intended and therefore are not funny.
7. Using poles, those swinging in the upper part of the picture can be made to stop swinging

*And the shark has pretty teeth, dear,*
*but Ms. Paula, she has none.*
*The condom bites right into her face, dear,*
*where the smell is coming from.*
*(Illustration No. 32).*

(To the tune of Kurt Weill's "Mack the Knife")
Loosely based on Brecht...

*H. R. Giger*

No. 32, *Misguided condom attacks cleaning lady*, 1996. Ink on paper, 29.7 x 21 cm

*Bottom right:* No. 53, *The Condom of Quasimodo's victims*, 1996. Ball-point pen on paper, 29.7 x 21 cm

*Page 195:*
No. 64, *Killer Condom Horror Laboratory*, 1996. Ink and ball-point pen on paper, 46 x 42 cm

*Top right:* No. 50, *Victim hanging in rings*, 1996. Ball-point pen on paper, 29.7 x 21 cm
(detail)

*Top left:* No. 50, *Victims hanging in rings*, 1996. Ball-point pen on reworked photocopy, 29.7 x 21 cm

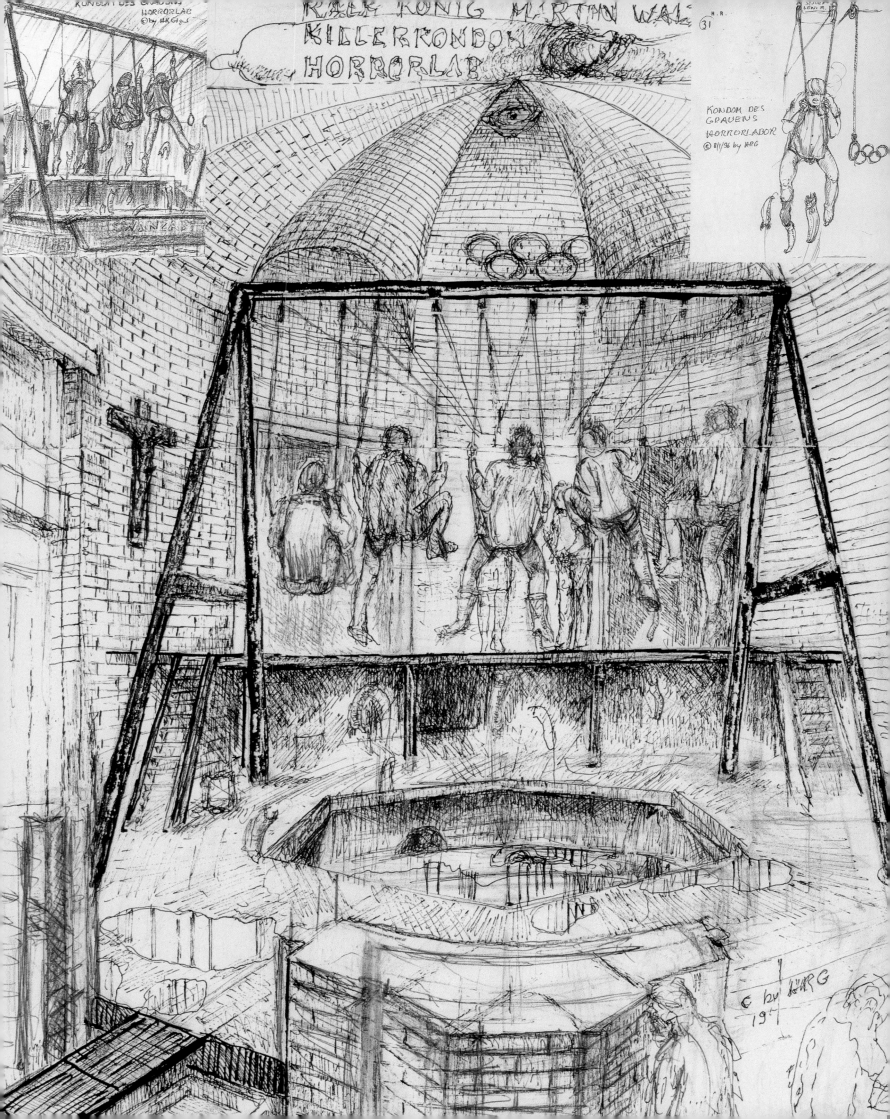

Please don't think ill of my suggestions.

**Killer Condom,**
**Loop Attachments:**
**Laboratory Training Section**
In the laboratory canal, each of the condoms is fastened to a length of fishing line by a loop and propelled through the toilet drains by a propulsion pack. The condoms are cut free from the lead line, dive once, and fly into the room if not blocked by an ass.

A sharp blade cuts away the loop which attaches the condoms to the fishing line.

The fishing lines, strung with loops and with a cork attached to the end, are fixed within the toilet drains and flushed down.

The propulsion pack is housed in a cardboard tube.

*H. R. Giger*

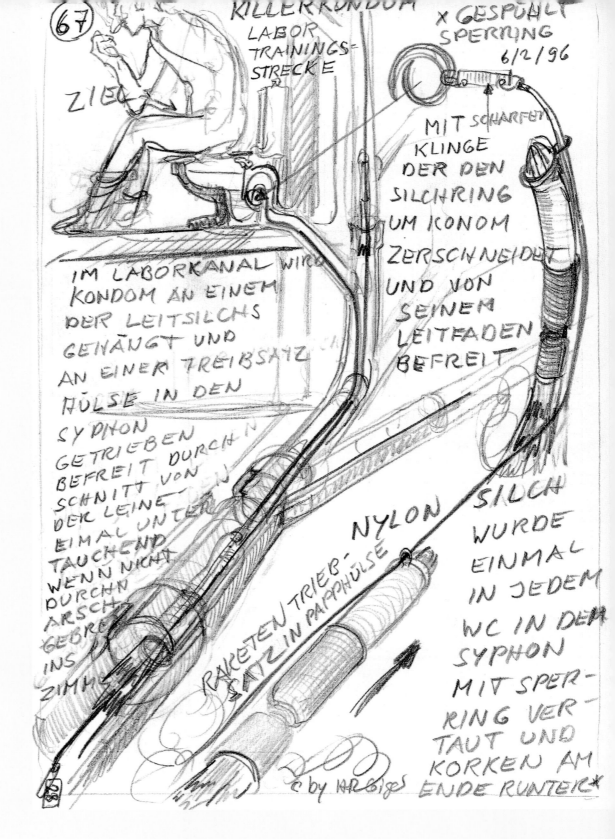

*Top right: No. 67, Killer Condom laboratory training section, 1996. Pencil on paper, 29.7 x 21 cm*

*Bottom, l-to-r: No. 38, Sequence: Killer Condom attacking its victim, camera circles condom, 1996. Ball-point pen on paper, 30 x 23.8 cm*
*No. 39, Sequence: Killer Condom attacking its victim, Leap, 1996. Neocolor on re-worked photocopy, 29.7 x 21 cm*
*No. 40, Sequence: Killer Condom attacking its victim, bites off its target and falls to the ground, 1996. Pencil on paper, 29.7 x 21 cm*

*Page 197:*
*Bottom, l-to-r: No. 82, Ricochet with diverse results, torn rope with rings, 1996. Felt-tip pen on paper, 29.7 x 21 cm*
*No. 83, Ricochet with diverse results, triggers Part-Killing Machine, 1996 Felt-tip pen on paper, 29.7 x 21 cm*
*No. 84, Ricochet with diverse results, shredded condoms and mud, 1996 Felt-tip pen on paper, 29.7 x 21 cm*
*No. 86, Ricochet with diverse results, professor's torn leash, 1996 Felt-tip pen on paper, 29.7 x 21 cm*

*Page 198:*
*No. 459, New York City IX, 1980/81. Acrylic and ink on paper, 100 x 140 cm*

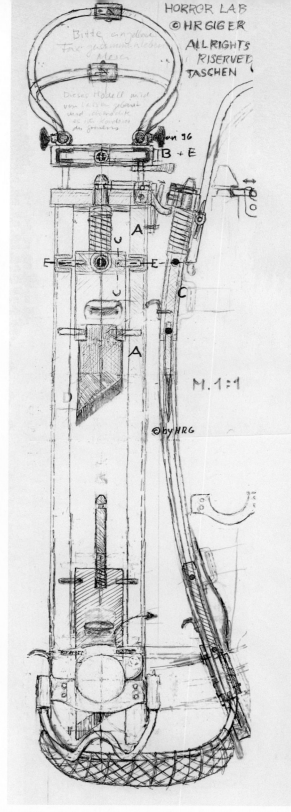

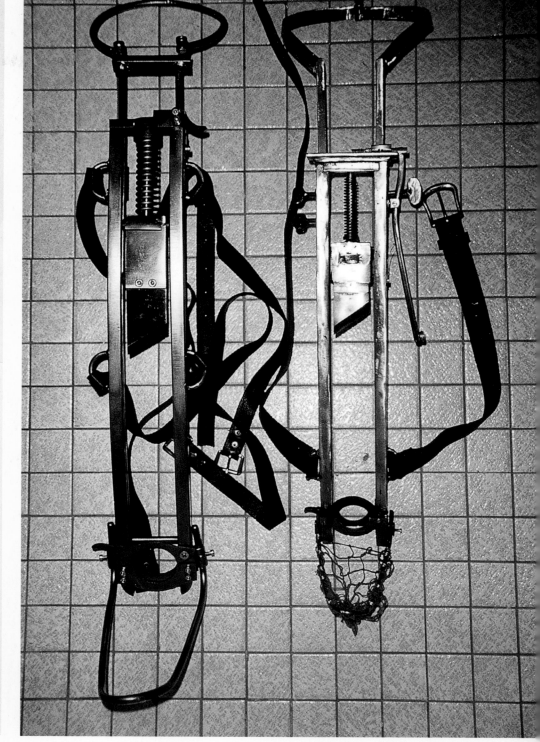

*Part-Killing Machine, Plan 1:1. 1996. Felt-tip and ball-point pen on reworked photocopy, 73.4 x 20.1 cm*

*Part-Killing Machine, the so-called St. Gallen Necktie, used as Killer Condom film prop, 1996. Steel and leather, Hoppla II manufactured by R. Christoph Jr., 54 x 13 x 20 cm, 2. Hoppla I, manufactured by A. Lassen, 46 x 14 x 16 cm. Photo: © H. R. Giger*

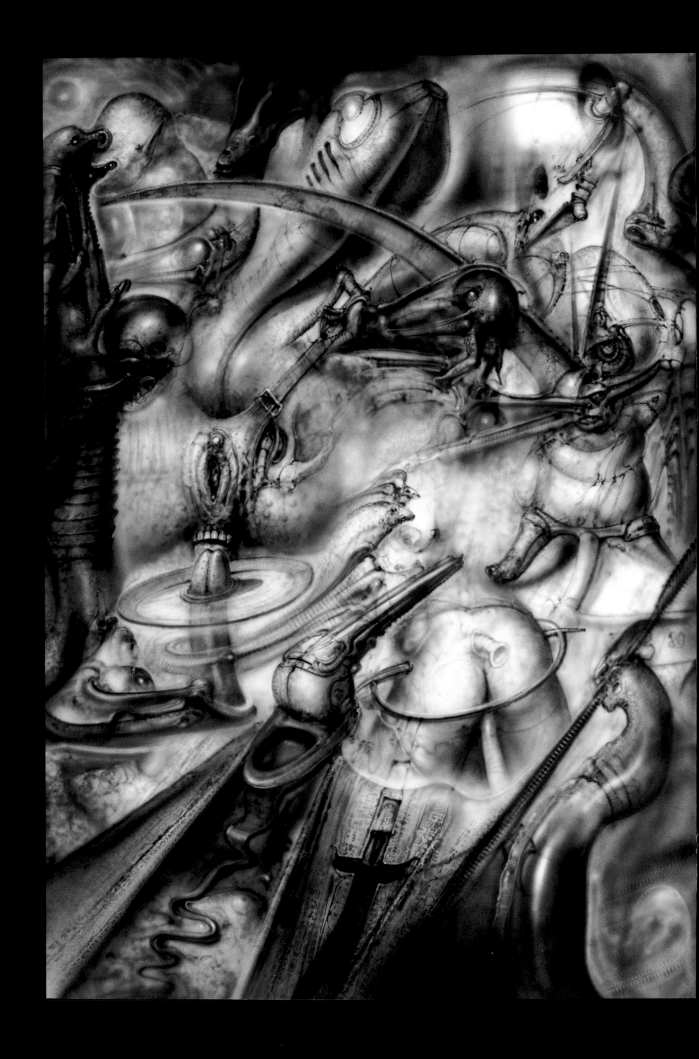

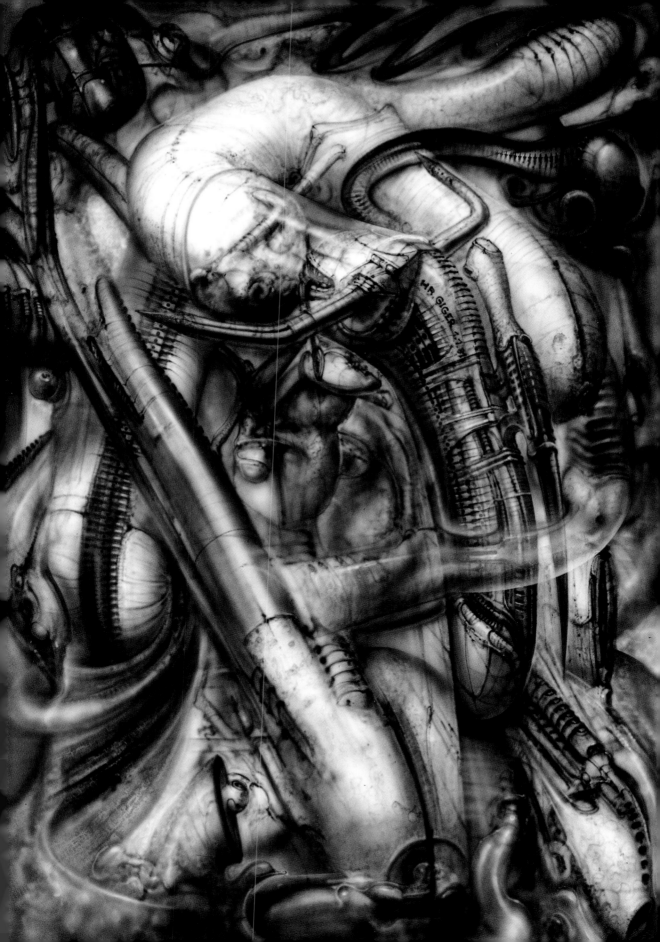

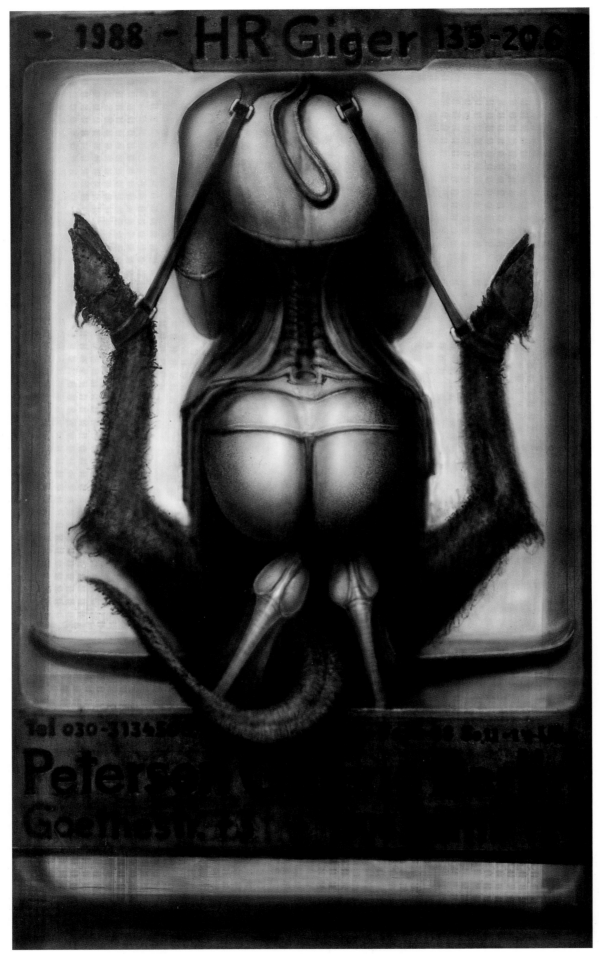

*No. 608, Satan's Bride II, 1985–87. Acrylic on paper on wood, 114 x 70 cm*

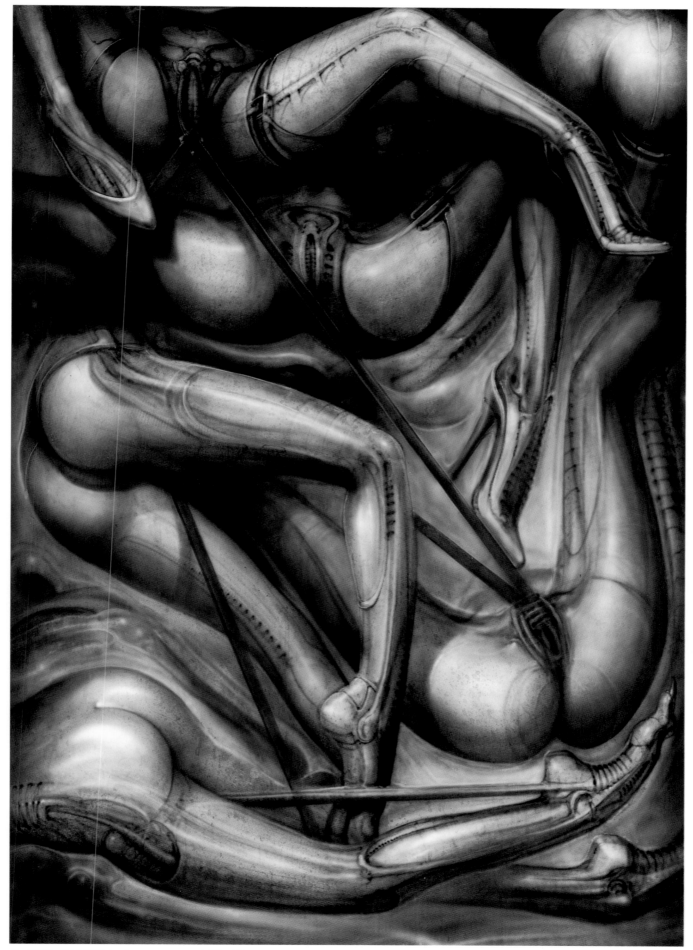

*No. 607, The Net I, 1988. Acrylic on paper on wood, 140 x 100 cm*

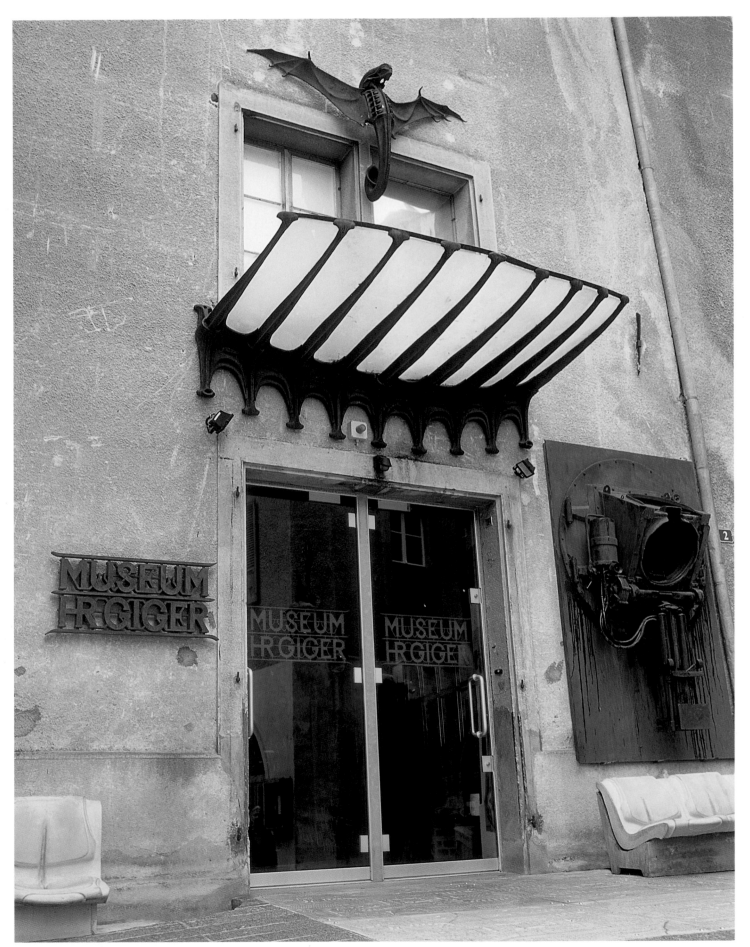

*Above: The entry of the Museum HR Giger in Château St. Germain, Gruyères.*
*Right: Front Desk in the foyer of the Museum HR Giger with the Guardian Angels.*

*Pages 204, 205, 208, 209: Views of the Museum Bar HR Giger in Château St. Germain, Gruyères.*
*Pages 206 and 207: Baby-wall in the Museum Bar HR Giger.*

*All photos: © Burkhard Pagels*

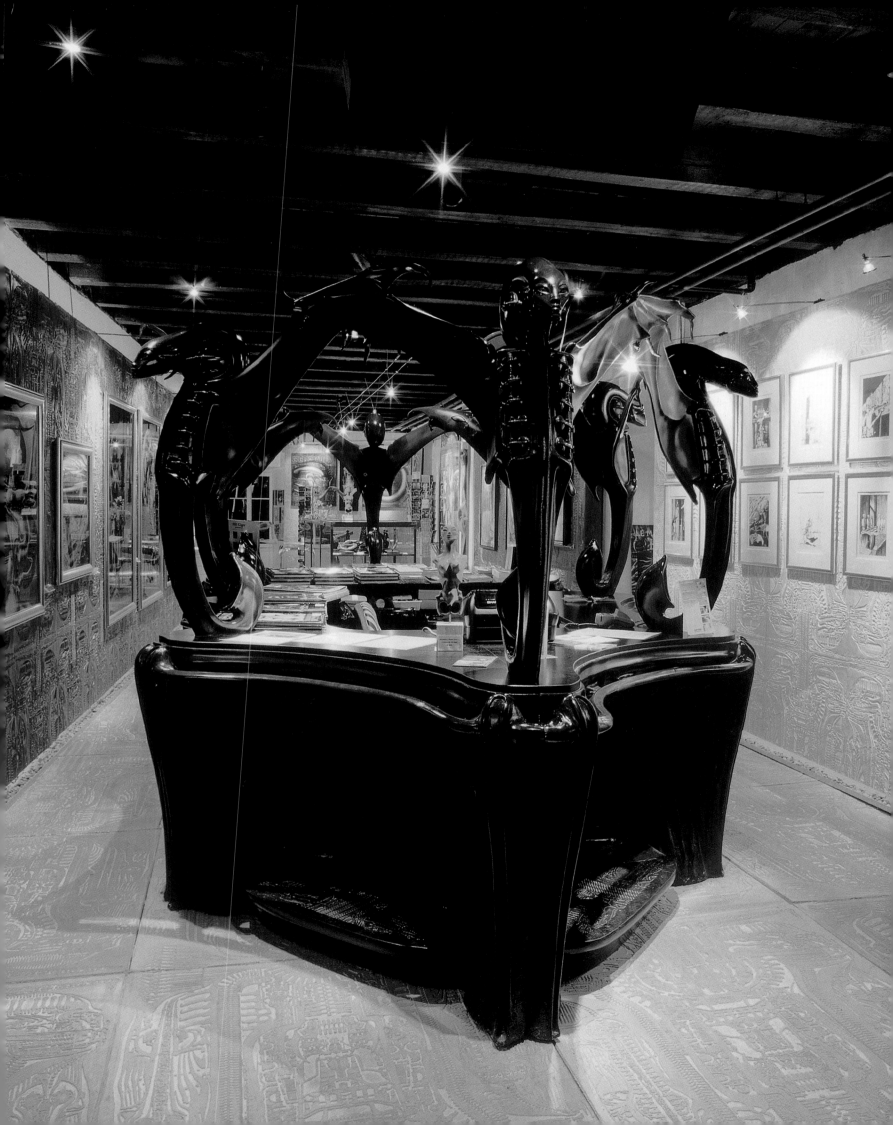

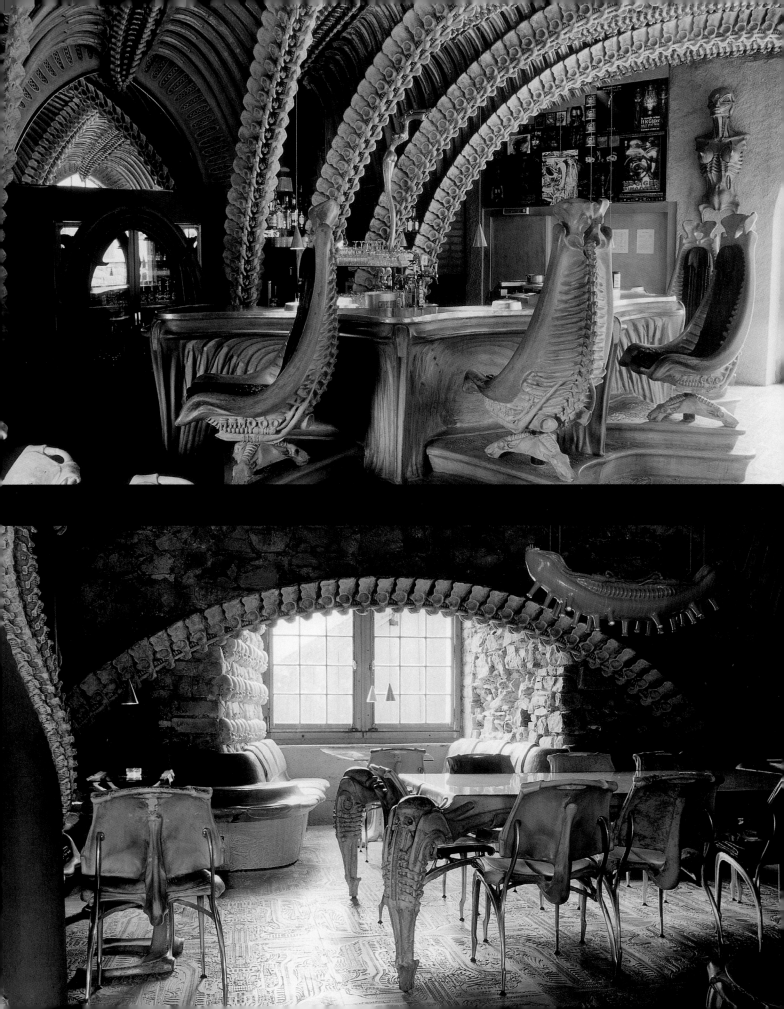

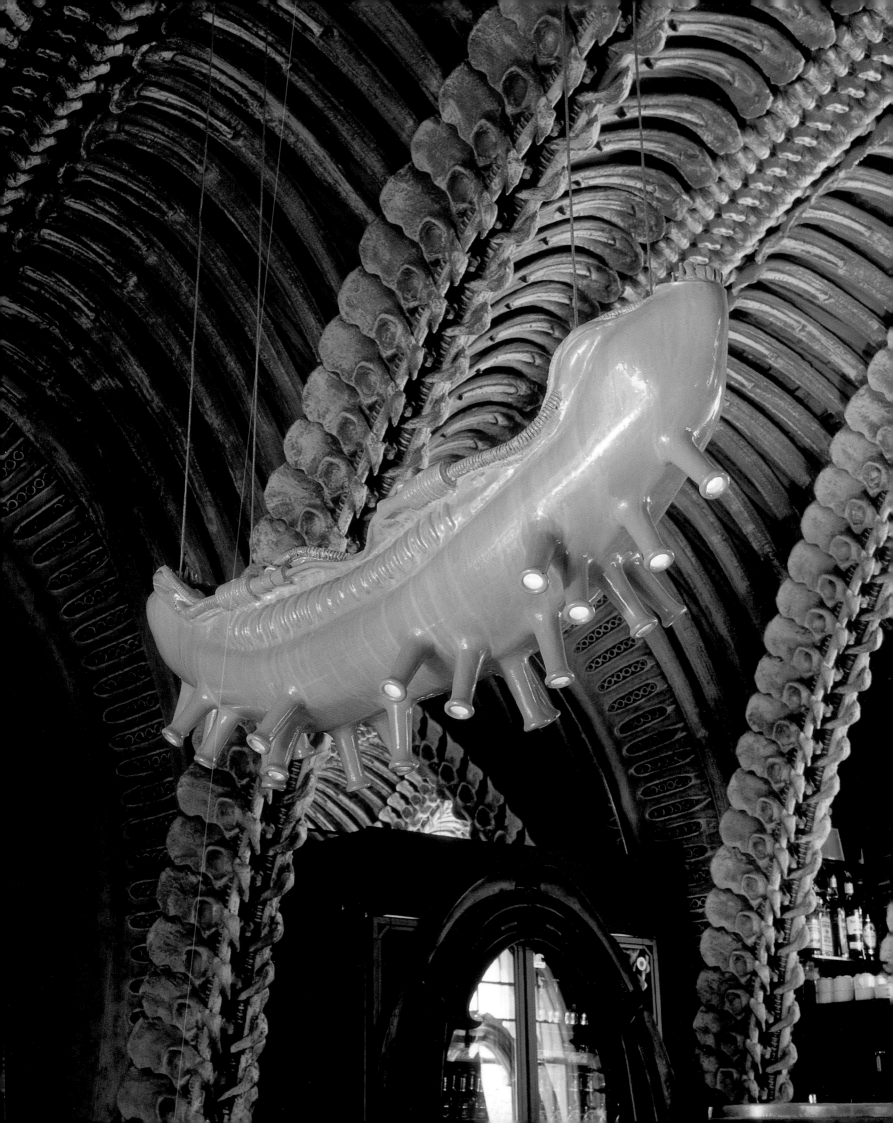

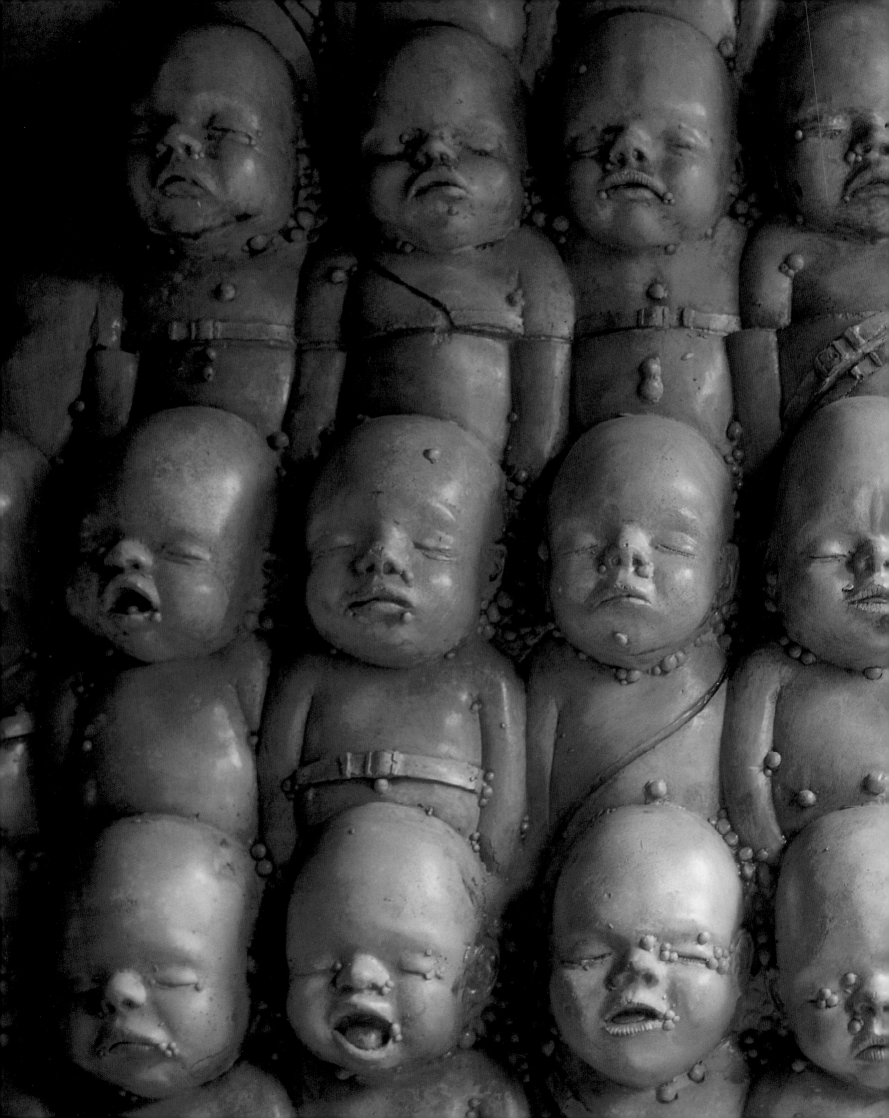

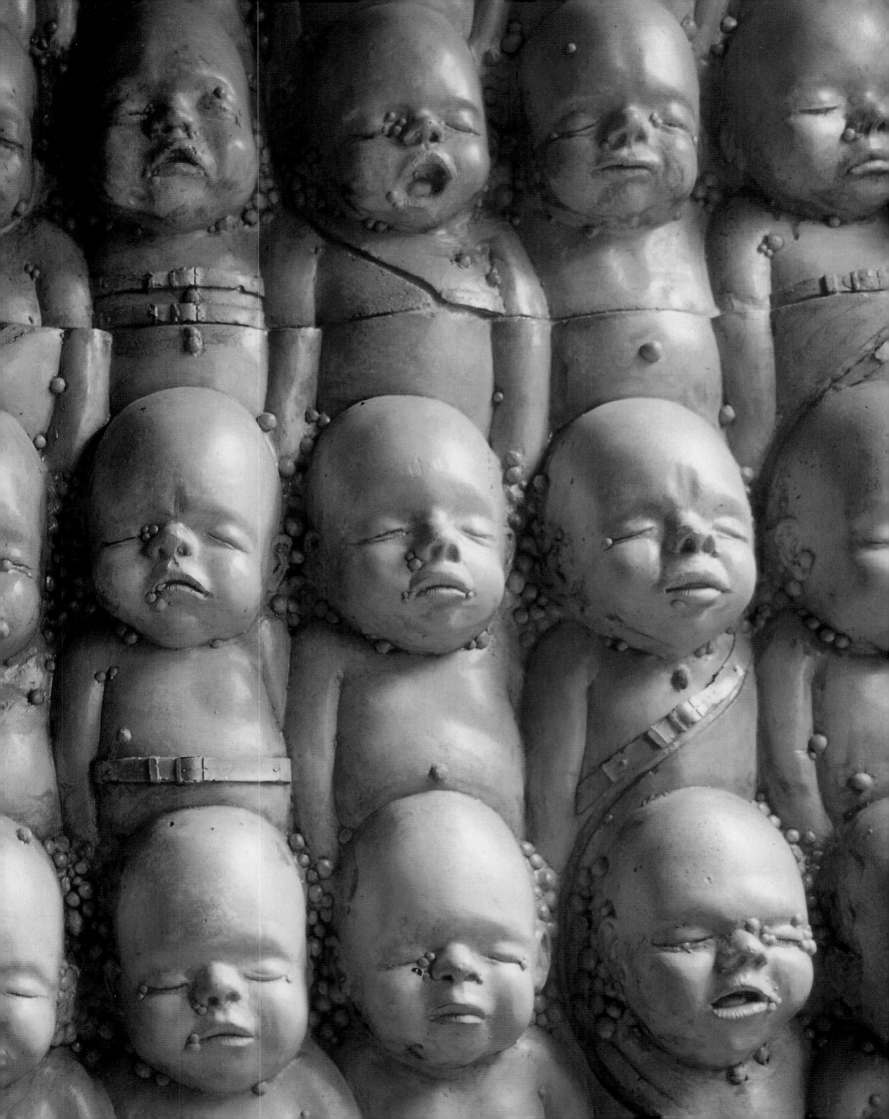

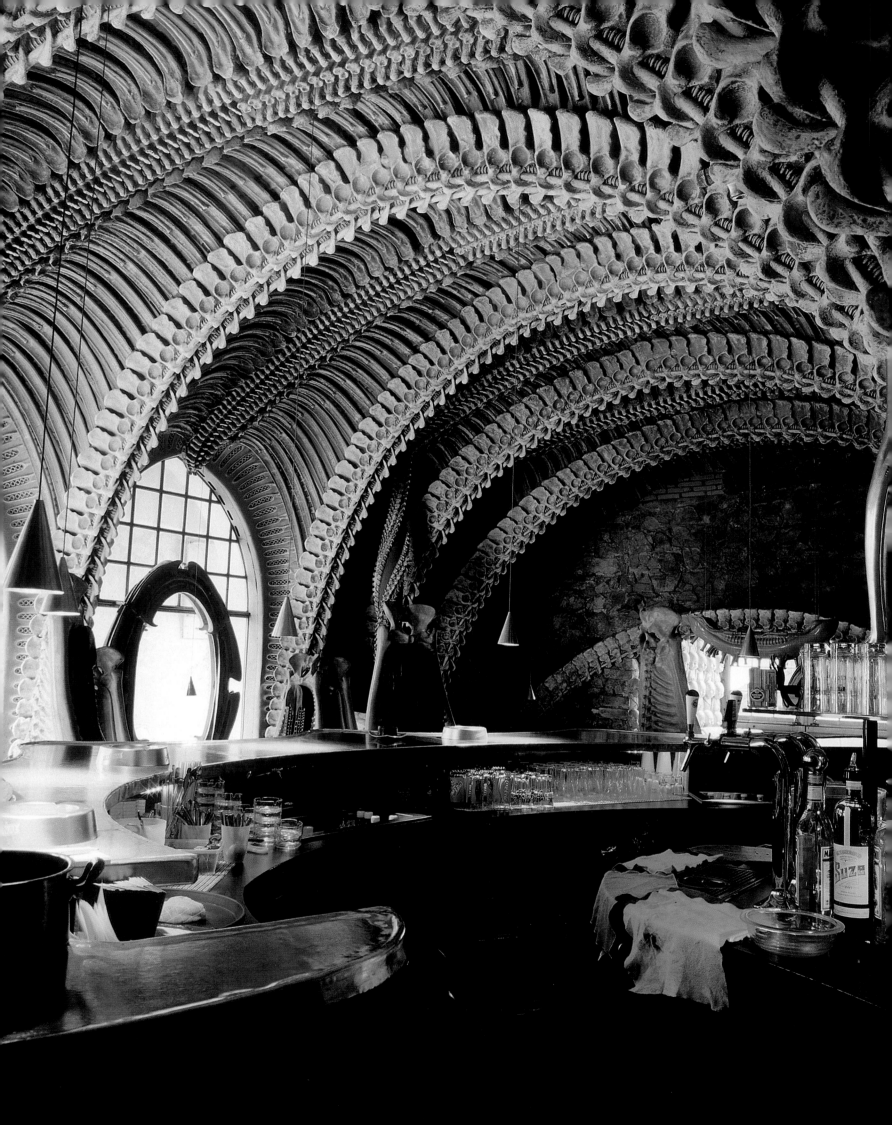

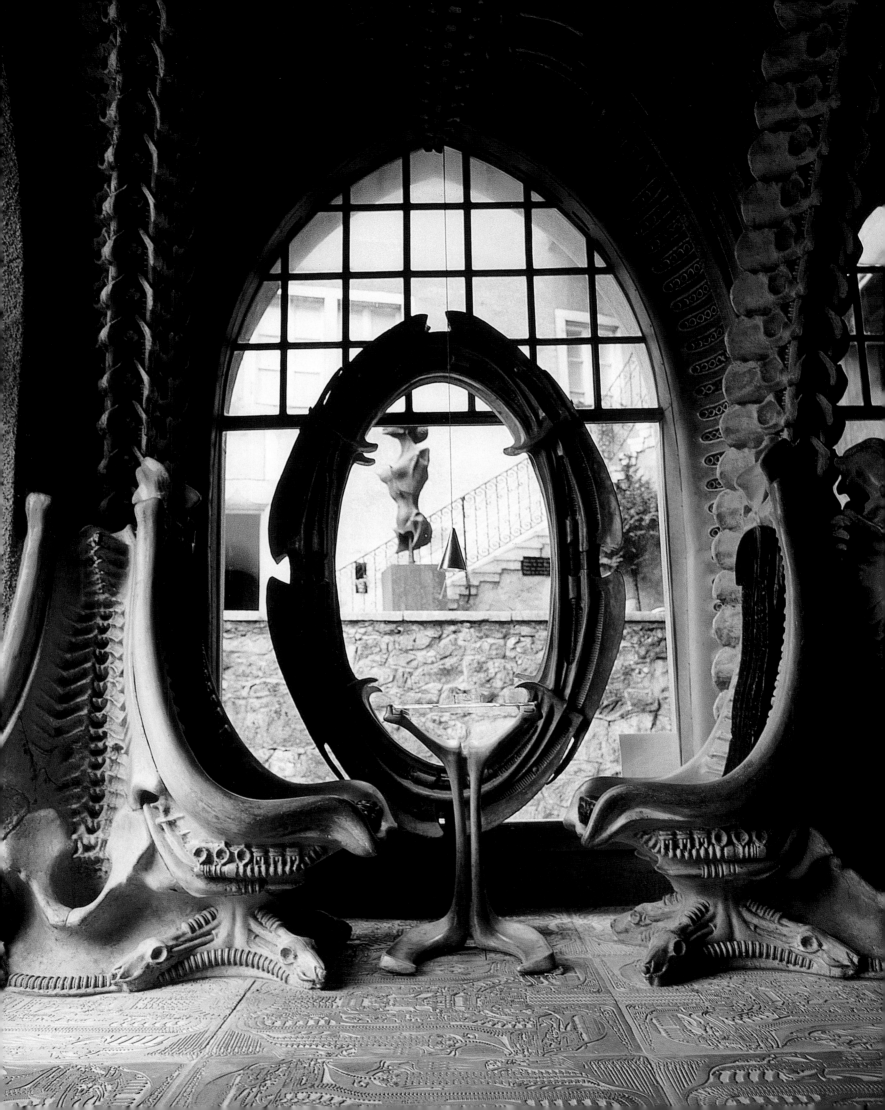

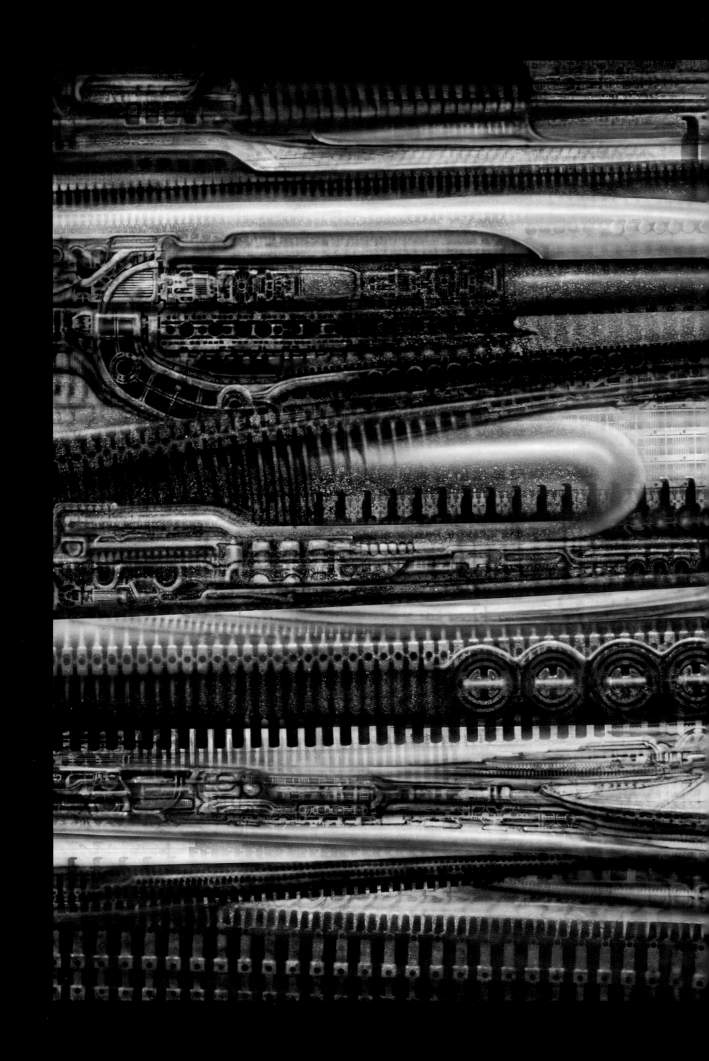

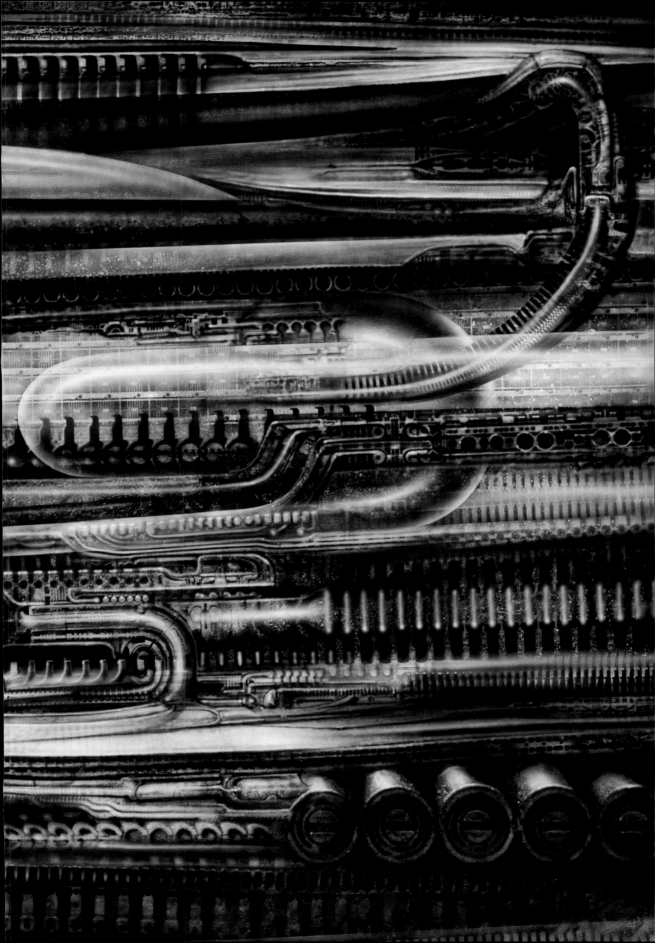

## H. R. Giger Museum

Letter from the Gruyères community to H.R. Giger dated June 19, 1996, regarding "Giger Museum – with a castle train, in Castle St. Germain in Gruyères":

Dear Mr. Giger,

At the June 14, 1996 meeting in Castle St. German in Gruyères, our deputy mayor, Mr. Philipe Micheloud, had the opportunity to acquaint himself with the renovation project proposed by you.

Mr. Castella, who is responsible for the commission for culture, believes that the proposed structural changes are doable, given the approval of the community authorities. He will send his detailed report to you directly.

We still remember fondly the wonderful time we experienced thanks to your exhibit a few years ago. It will be a pleasure for us to support you in your administrative and political efforts, in order that your structure may be built in the city of Gruyères.

Your project was examined during the community board meeting on June 17. The board was enthusiastic about such a visionary project and wants to assure you of its full support in doing whatever lies within its power.

We are convinced that our heritage, the whole city of Gruyères, and your contemporary art will complement each other very well. Your art will generate a lot of public interest, and will even further improve the image of fantastic art, a goal which Mr. Chatton has been pursuing and gotten nearer to achieving in the past few years. We look forward to seeing you again in Gruyères soon, and remain, sincerely, in the name

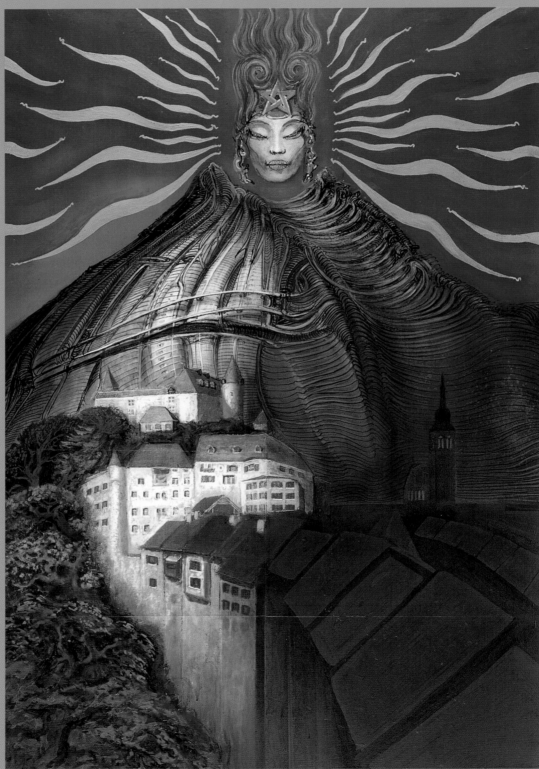

MUSEE HR GIGER TRAIN AU CHATEAU ST GERMAIN GRUYERES

*Display type for the Giger Museum in Gruyères, 1984–96. Designed by H. R. Giger*

*No. 701, Chateau de Gruyères II, Poster for the Exhibit "Alien dans ses Meubles", 1990. Acrylic on paper on wood. 100 x 70 cm*
*Page 210: No. 473, New York City XXIII (Subway), 1981. Acrylic and ink on paper, 100 x 140 cm*
*Page 213: Giger Museum in Gruyères, cross-section of the tower, 1996. Felt-tip pen on paper, 42 x 29,7 cm*

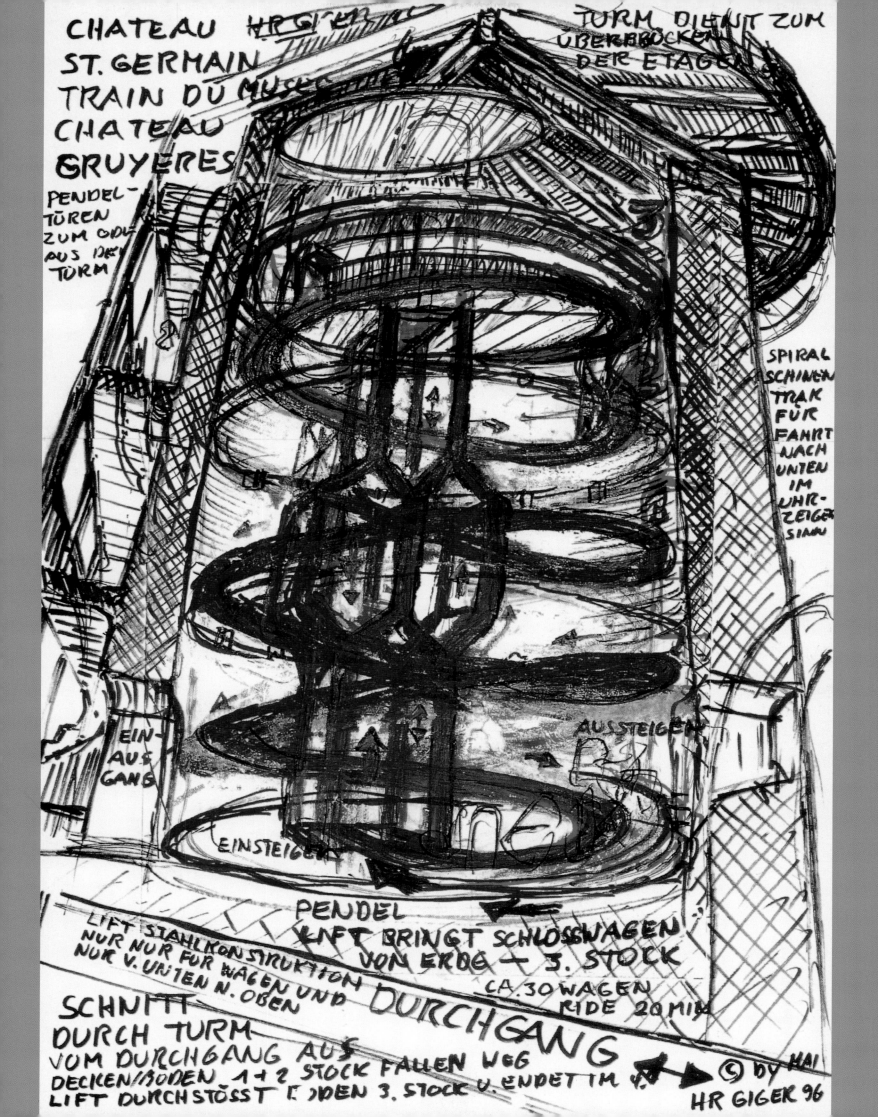

of the community board of Gruyères.

*The Secretary: P. Grandjean*
*The Mayor: Ch. Bussard*

## Description of the Projected Giger-Museum with Castle Train

I enter the tower, which is both entrance and exit to the castle train. The tower has undergone a major renovation, which cannot be detected from the outside. The first and second-floor ceilings have been removed, and only the third floor ceiling is visible at a height of approximately 10 meters. The perpetual shuttle lift, which emerges from a steel construction and greatly determines the impact of the room, disappears into the ceiling. Supporting beams, which along the walls have downward-spiraling tracks, are fastened to this structure which is reminiscent of Tatlin. The whole inside of the tower is covered with large holographs, in whose depths sculptural motifs are visible depending on the viewer's perspective. I step into one of the cars waiting to be taken up by the perpetual shuttle lift. A Castle Train attendant assists me and after I sit down, he closes the front part of the car, which pushes me into my seat. I rest my hands on the chrome bar which forms the top part of the closure. Walls surround me at the sides and back, providing optimal safety.

## Security Measures and Exits

In the tower, where the tracks spiral downwards clockwise, the cars are protected by a railing on the right, the side facing the abyss. It is impossible to exit the cars from this side. They can be exited only from the side facing the wall. Thus, the whole train section can be used as an exit. Two spiral staircases will be built, one at each end of the building. The outer staircases will remain. The architect will adhere to all safety regulations.

I roll into the lift at a pace slower than walking. The shaft consists only of a floor and a ceiling so it is possible, while ascending, to watch the suddenly-appearing holograms or the cars coming out of a swinging door and moving along the wall to disappear behind the same kind of door a floor further down. The illumination provided by 200 spotlights shines on the facing holograms on the walls of the shaft. The cars have a front light that illuminates the series of images – from left to right – at a very rapid pace. The car has now reached the level of the third floor and rolls into the exhibit of H. R. Giger's works which are, in most cases, fastened to display panels to the right or left of the car. These panels are pushed ahead by the car for a few seconds. The viewer thus may look at the details from a set distance (about 80 cm). As soon as the car changes its direction, the painting glides by and a new painting can be seen in the headlight. This one may be viewed in the same manner. This type of presentation, which requires no supervisory personnel, regulates the length of time a painting is viewed from the best perspective.

The visitor is able to sit and view the works alone or with one companion. The entire single-track construction is an adapted lift system from the Högg Company, which manufactures elevators for invalids. All the first-rate homes for the aged have them. There is a chain laid into the middle rail, which runs in a slit in the floor and is fastened on the sides. The floor plates are standard elements supported by a steel structure. The electric conduit is recessed into a plastic groove underneath the track. The whole structure stands on its

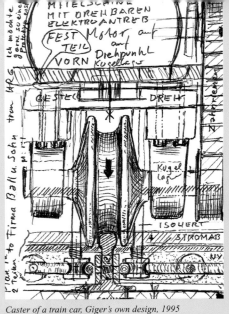

*Caster of a train car, Giger's own design, 1995 Ink on paper, 29.7 x 21 cm*

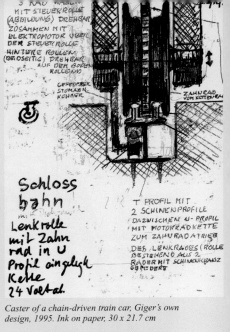

*Caster of a chain-driven train car, Giger's own design, 1995. Ink on paper, 30 x 21.7 cm*

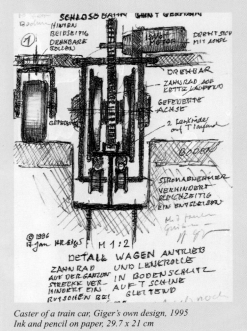

*Caster of a train car, Giger's own design, 1995 Ink and pencil on paper, 29.7 x 21 cm*

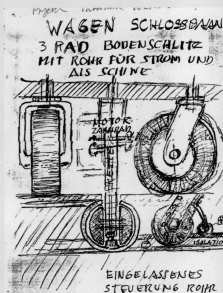

*Caster of a train car with pipeline-steering system, 1995. Ink on paper, 29.7 x 21 cm*

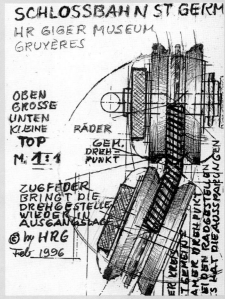

*Enlargement of a train car caster, adapted Högg system, 1996. Ink on paper, 29.7 x 21 cm*

*Page 215:*
*Bottom left: Giger Museum in Gruyères, possible design for Castle Train car, 1996. Felt-tip pen and Neocolor on paper, 29.7 x 21 cm*

*Top view of a train car caster, adapted Högg system, 2996. Ink on paper, 29.7 x 21 cm*

*Page 215:*
*Bottom right: Giger Museum in Gruyères, cross-section plan for Castle Train, steel framewok schematic, 1996 Ball-point pen on paper, 29.7 x 21 cm*

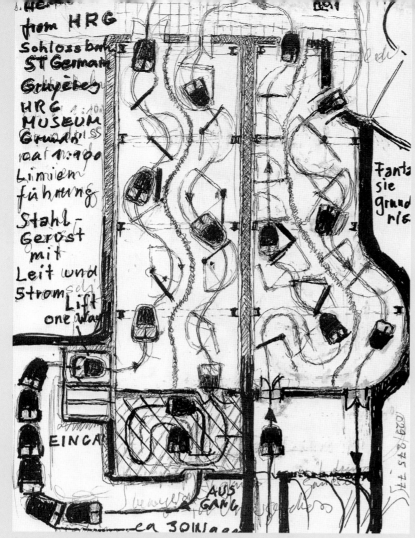

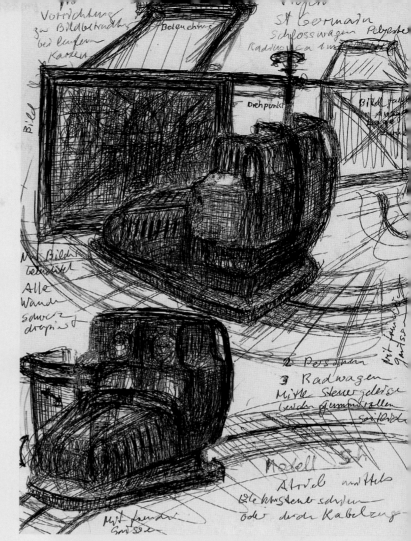

*Giger Museum in Gruyères, floor-plan schematic for the Castle Train, 1995*
*Felt-tip and ball-point pen on paper, 29.7 x 21 cm*

*Giger Museum in Gruyères, Castle Train car, pushing the paintings forward, 1995*
*Ball-point pen on paper, 29.7 x 21 cm*

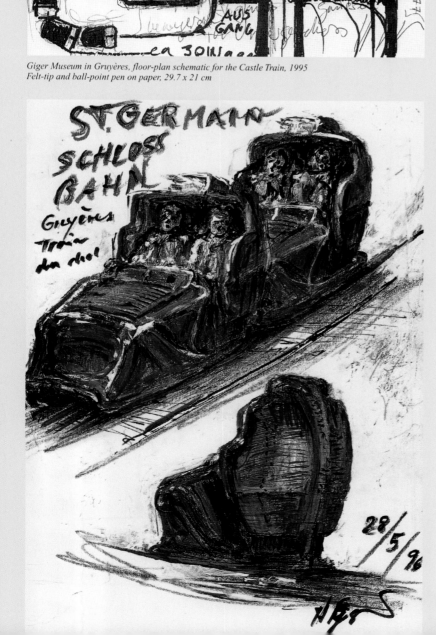

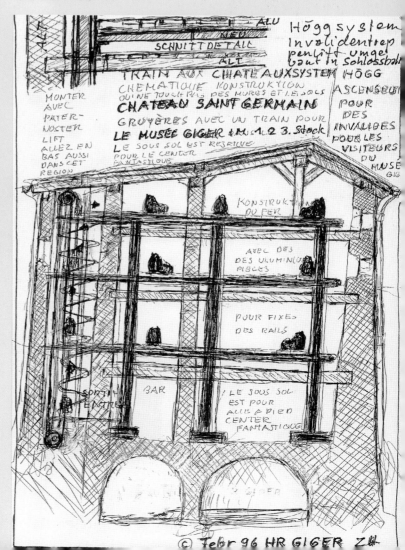

own and rests on steel beams which break through the existing floors and are anchored in foundation bedrock. This allows the walls in the train area to remain untouched, preventing the horror of exposing hidden frescoes. The walls remain in the dark or are covered with black velour where necessary. No vibrations can harm the valuable walls. The first floor, which has some old wooden ceilings and some valuable wooden walls, will be renovated and kept apart from the Castle Train. The "International Center for Fantastic Art" will make its home on this floor. There will be conference rooms, a video theater, a computer, a library and an art or bookstore. All rooms can be decorated with works from H. R. Giger's collection. Only the dark, unimportant rooms are to be used for the Castle Train. There is also the possibility of having the train pass by a sculpture garden or the Zodiac Fountain on the ground floor. An apartment will be built above the Giger-Bar, to the left of the gate leading to the old-age home. The museum director can live there, and, if need be, a room can be added.

The Giger-Museum, which can be visited only by the train, has about 30 cars that pass through the rooms at a leisurely walking pace in about 20 minutes. The cars continue to move even when empty. The museum needs no more than two employees, one of whom can also repair the train when necessary. Tickets can be used to visit both castles. The bar will be similar to the Giger-Bar in Chur: only smaller. I think the castle, with its attractions, will also increase tourism. I am sure that it will pay for itself.

The priority now is to obtain permission for the removal of the two floors in the tower so that the lift can be built.

*H. R. Giger Project in collaboration with the architect J. Bascik, Kollbrunn*

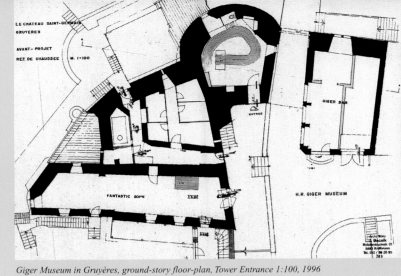

*Giger Museum in Gruyères, ground-story floor-plan, Tower Entrance 1:100, 1996*

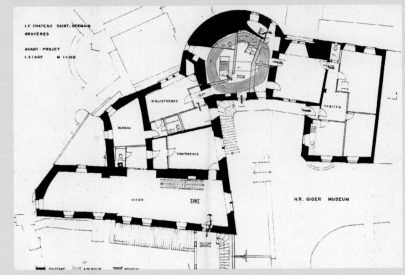

*Giger Museum in Gruyères, second-story floor-plan: International Center for Fantastic Art, 1:100, 1996*

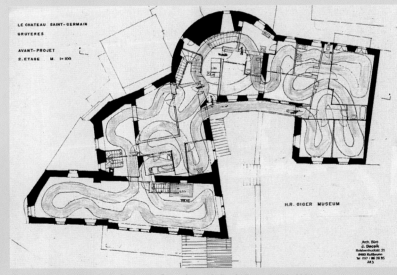

*Giger Museum in Gruyères, third-story floor-plan with Castle Train, 1:100, 1996*

*Prof. Dr. Barbra Gawryziak, © N. Chuard*

*Etienne Chatton, Curator of the Gruyères Castle Society, 1996*

*Bottom right: Giger Museum in Gruyères, fourth-story floor-plan with Castle Train, 1:100, 1996*

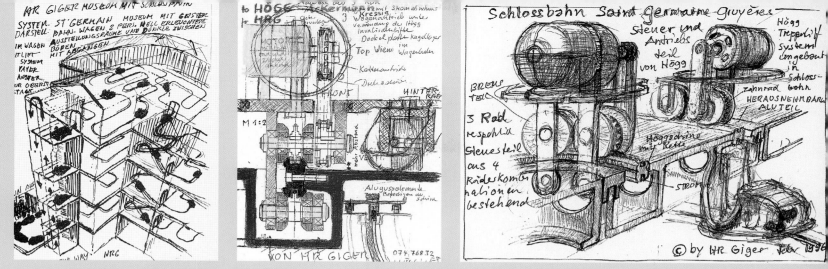

*From left-to-right: 1. Depiction of the Castle Train system, 1996. Ink on paper, 29.7 x 21 cm; 2. Adapted Högg system, 1996. Ink and Neocolor on paper, 29.7 x 21 cm; 3. Högg steering system, 1996 Ink and ball-point pen on paper, 21 x 29.7 cm*

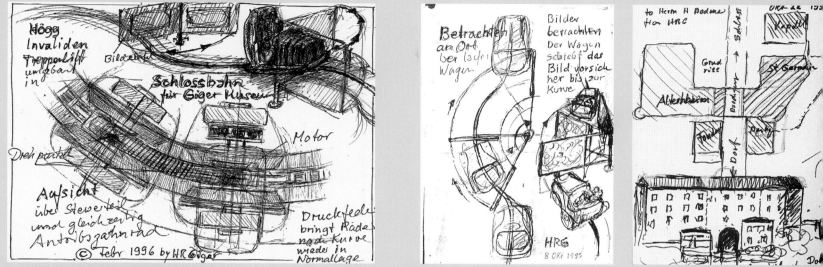

*From left-to-right: 1. Caster with large wheels, Högg system, 1996. Ink and ball-point pen on paper, 21 x 29.7 cm; 2. System for viewing paintings, 1996. Ink on paper, 29.7 x 21 cm; 3. Top view and façade as seen from the town, 1996. Ink on paper, 29.7 x 21 cm*

*Below: Castle St. Germain in Gruyères*

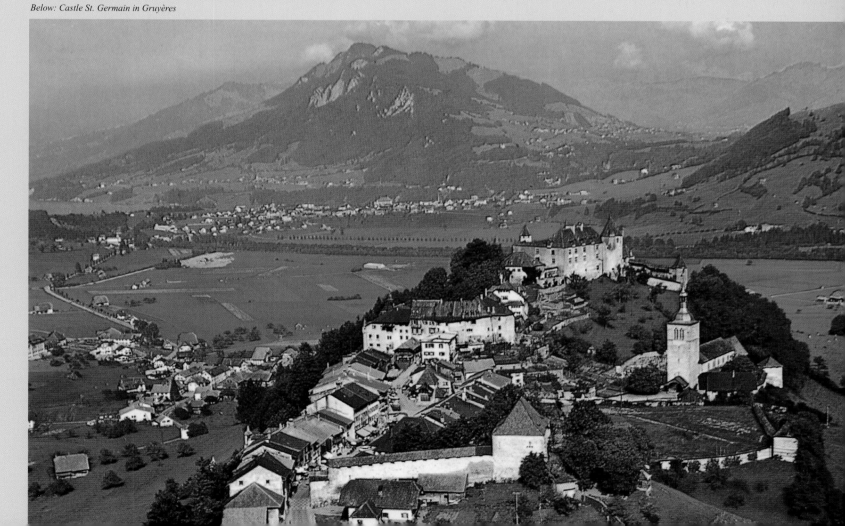

# Biography

## 1940–1962

Born on February 5, 1940, in Chur.

1946–46 Attends nursery school, first the Catholic Marienheim and then quickly transferred to Auntie Grittli's Reformational kindergarten.

1947–53 Attends elementary school.

1953–57 Attends the cantonal school in Chur – two years of high school plus two years of technical school.

1957–58 Institut Haute Rampe, Lausanne.

1958–59 Alpina College, Davos – preliminary certificate in Drawing.

1959–62 Practical training with the architect Venatius Maisen, Chur, and the developer Hans Stetter, Chur.

Military college in Winterthur – as a mortar firer with light mobilized troops.

1962–65 School of Applied Arts, Zurich, Department of Interior and Industrial Design.

## 1964

H.R.G. lives in the Venedigstrasse in Enge, Zurich. During the day, he attends the School of Applied Arts in Zurich (KGSZ), second year, Interior Design and Industrial Design department. Produces his *Atomkinder* (Atomic Children) ink drawings in his spare time. These are published in the Chur canton school magazine. Also creates expressive Tachist pictures and works in distemper (glue paste mixed with powdered pigment) on paper using a large brush and squeegee. First polyester works: a table and, primarily, masks.

## 1965

School of Applied Arts, third year. Publication of ink drawings in underground magazines such as *Clou* and *Agitation*. He prints a number of works priva-

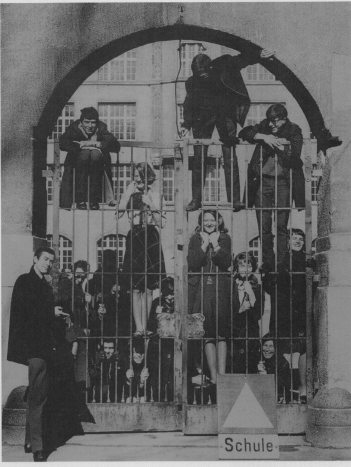

*School of Applied Arts, Zurich, 1962; kneeling bottom left: H. R. G.*

*H. R. G. with polyester necklace, 1966. Photo: H. R. G.*

tely under the title *Ein Fressen für den Psychiater* (A Feast for the Psychiatrist). H.R.G. develops his interest in Sigmund Freud and keeps a diary of his dreams. Final exam work *Station Passage* is a joint class project.

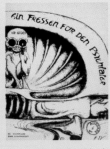

***A Feast for the Psychiatrist,*** 1966. Silkscreen cardboard portfolio, 12 DIN A4 Plandruck drawings, portfolio signed and numbered, edition of 50, 42 x 31 cm (approx. 15 copies printed). Printing: H. R. Giger/Lichtpausanstalt Zürich

Having graduated from KGSZ, H.R.G. spends a while in his parents' vacation home in Poiana, Tessin. Produces works such as *Torso, Head I, II* etc. Starts a full-time job as a designer for Andreas Christen, working on an office furniture program for the Knoll International company. He lives in the Rindermarkt with actor Paul Weibel, meets Li Tobler and falls madly in love with the beautiful actress.

In addition to his nine-to-five job, he spends long nights producing larger and larger ink drawings. The ink is brushed onto Transcop paper using a toothbrush and wire sieve. The highlights are scratched away with a razor blade and the darker areas are built up with a rapidograph. First solo exhibition in the Galerie Benno, Zurich.

## 1967

H.R.G. and Li move into an empty attic flat in a neighboring condemned house. Here he produces works such as *Birth Machine, Under the Earth* and *Astro-Eunuchs*. H.R.G. meets the writer Sergius Golowin and the film-maker F.M. Murer. He

is featured in poet/provocateur Urban Gwerder's multi-media evening called "Poëtenz-Show", by the film *High*, a ten-minute documentary on his paintings made by F.M. Murer.

In the summer, he again spends some three months in Tessin. Produces sculptures: *Beggar, Suitcase Baby* and *Life Preserve*, etc.

Back in Zurich in the fall, he paints small technical/organic landscapes in oil on artist's cardboard.

Fred E. Knecht, proprietor of the Galerie Obere Zäune, includes paintings and OBJECTS by H.R.G. in the exhibition *Macht der Masken* (Power of the Masks).

## 1968

Basilio Schmid, nicknamed Pascha, an old friend from Chur, persuades H.R.G. to give up his nine-to-five job with Andreas Christen in order to devote more time to art. H.R.G. works in the Tessin, again, for a few weeks. F.M. Murer commissions him to produce props for the planned 30-minute film *Swissmade*. He now attempts the difficult task of creating a shell of polyester vinyl for a dog and for the "monster". This is his first extraterrestrial being, and it has a built-in image and sound recorder in its head and chest. Tina Gwerder plays the superstar wearing this costume. Paul Weibel's dog wears its own tailor-made casing.

The two houses in the Rindermarkt are demolished. Li is engaged by the St. Gallen Stadttheater. With the help of poet J.M. Seiler, H.R.G. finds a large room in a shared apartment, again in a condemned house in the Alte Feldeggstrasse in Zurich, where he continues to paint small landscapes in oil. Gallery owner Bruno Bischofsberger visits H.R.G. in his studio and buys a series of ink drawings and oil paintings. He advises H.R.G. to number

*F.M. Murer and H.R.G. with Friedrich Kuhn's palm tree in H.R.G.'s garden, circa 1972*

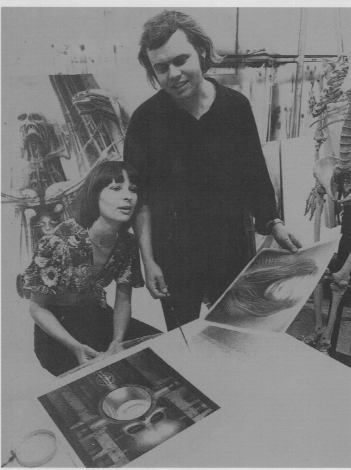

*Li Tobler and H.R.G. in his studio, Zurich, 1973. Photo: Roland Gretler*

and photograph all his works. H.R.G. participates in the exhibition *Hommage à Che* in the Galerie Stummer, Zurich.

## 1969

H.H. Kunz, friend, collector and co-owner of Switzerland's first poster publishing company, prints H.R.G.'s first posters and distributes them world-wide.

Jörg Stummer includes two silkscreen prints in his catalogue. Bruno Bischofsberger publishes the large silkscreen portfolio *Biomechanoids 1969*. H.R.G. makes his first and, to date, last, excursion into theater designing costumes and

*Biomechanoids,* 1969. Portfolio of 8 silkscreen prints, black on silver, signed and numbered, edition of 100 and XX, 100 x 80 cm (edition partially destroyed by fire). Publisher: Bischofsberger, Zurich. Printing: Steiner, Zurich

make-up for the actors in Edward Bond's *Early Morning*, a Peter Stein production at the Zurich Schauspielhaus.

A "Happening" in Jörg Stummer's gallery, entitled *First Celebration of the Four*, with Sergius Golowin and Friedrich Kuhn. First exhibitions in Austria and Germany. H.R.G. seeks to overcome claustrophobic nightmares with his *Passages* oil paintings.

## 1970

Li returns to Zurich and lives with Eveline Bühler in Seefeld, not far from H.R.G. In Eveline's apartment, H.R.G. experiences his first horror nightmare (see *Necronomicon*). This leads to his so-called "wet-cell" paintings. The continuous-flow water heater in-

spires him to paint *The Four Elements*. This is followed by *Bathtub, Kitchen with Sink* and *WC*. These paintings give the impression of being covered with skin. H.R.G. is offered the chance of purchasing a small row house with garden in Oerlikon, Zurich. In April, after two months' renovations, H.R.G. and Li move in. The Galerie Bischofsberger shows H.R.G.'s *Passagen* (Passages).

## 1971

F.M. Murer has been living in

*ARh+,* the first catalogue of H.R.G.'s works, is published by Verlag Walter Zürcher, Gurtendorf, Berne (out of print)

London for over a year. A reason for H.R.G. and Li to visit England. Murer and H.R.G. decide to make the documentary film *Passagen* on H.R.G.'s pictorial world. London's mysterious docklands provide the first locations.

## 1972

The Kassel Kunstverein holds an exhibition of H.R.G.'s work. H.R.G. works on various series: *Passagen, Skin Landscapes* and psychedelic airbrush environments.

## 1973

Friedrich Kuhn – in H.R.G.'s estimation, one of Switzerland's greatest artists, dies. He was a frequent guest at Li and Eveline's in 1969/70 and usually spent the night sleeping at the kitchen table. H.R.G. and Kuhn were bound by a deep friendship and mutual admiration. To the Zurich art world, Kuhn was a master of the art of living. Using an airbrush to overpaint a series of photos taken of Kuhn shortly before his death, showing the "Magus" sitting on his favorite

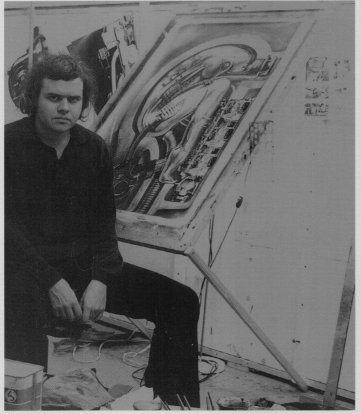

*H.R.G. in his studio, Zurich, 1972*

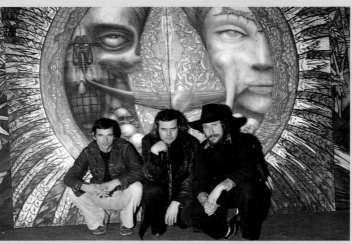

*Claude Sandoz, H.R.G. and Walter Wegmüller, Chur, 1974*

*Invitation for H.R.G. exhibit at the Silvio Baviera Gallery, Zurich, 1975*

sofa, H.R.G. creates the painting *Hommage to Friedrich*. H.R.G. is commissioned to design a record cover for the English rock group Emerson, Lake and Palmer. He creates the cover for the LP *Brain Salad Surgery*.

During a two-week "retreat", H.R.G., in collaboration with Claude Sandoz and Walter Wegmüller, creates *Tagtraum* (Daydream), a series of four paintings.

## 1974

*The Bündner Kunstmuseum publishes a catalogue of H.R.G.'s works titled **Passages,** 1974 (out of print)*

*Tagtraum* is exhibited at the Bündner Kunstmuseum. The atmosphere of the voluntary retreat during which the work was created is captured in a documentary film by J.J. Wittmer.

## 1975

*Passagen-Tempel* (Passage Temple), a work that H.R.G. has created expressly for the Galerie Sydow-Zirkwitz, is subsequently exhibited in the foyer of the Bündner Kunstmuseum.

Jörg Stummer encourages Li to open her own gallery in rooms adjoining his. She shows Manon, Pfeiffer and Klauke. At her last exhibition, entitled *Schuhwerk* (Shoe Works), where the guests are invited to appear at the vernissage in way-out shoe creations, H.R.G. wears a pair of "shoes" hollowed out of fresh loaves of bread and films the guests for the documentary *Giger's Necronomicon*. This film is produced in collaboration with J.J. Wittmer. After this artistic stir, Li falls back into a state of lethargy and ends her life with a bullet.

## 1976

On February 5, H.R.G.'s birthday, the new Galerie Sydow-Zirkwitz opens in Frankfurt with an exhibition specially designed for its rooms. The accompanying catalog illustrates all the works and includes a lengthy text by Professor Albert Glaser.

The nine-year relationship with Li, which ended so painfully with her death, leaves a terrible emptiness in H.R.G.'s life.

*The Second Celebration of the Four* is held among H.R.G.'s circle of friends at Ueli Steinle's Ugly Club in Richterswil; it is a Happening which simultaneously represent the inauguration of the club and a memorial for Li.

Through contact with the American painter Bob Venosa, which leads via Salvador Dalí to Alexandro Jodorowsky, director of the films *El topo* and *Holy Mountain*, H.R.G. is commissioned to collaborate on the film *Dune*.

From a script by Moebius, H.R.G. designs the world of the "Harkonnen".

## 1977

First trip to America. Travels to New York accompanied by friend and gallery owner Bijan Aalam and Sybille Ruppert, in H.R.G.'s eyes one of the best representatives of fantastic erotic painting.

Takes part in the exhibition *Images of Horror and Fantasy* organized by Professor Gert Schiff in the Bronx Museum, New York. Works from the

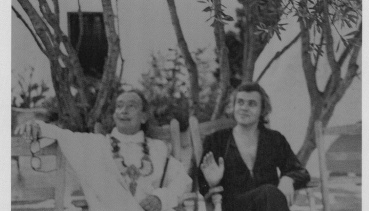

*Salvador Dali and H.R.G., Cadaques, 1975. Photo: Michèle Zerbini*

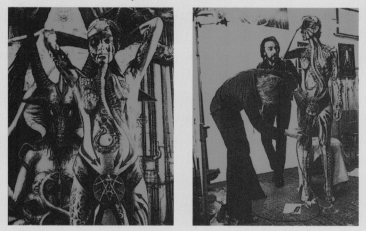

*Bob Christoph, H.R.G. and Blanca as the body-painting model, c. 1975. Photos: Willy Spiller*

*Bob Christoph and H.R.G. with "Baphomet 77" belt buckle, circa 1977. Photo: Candid Lang*

*H.R.G. at home, Zurich, circa 1976/77*

years 1973–77 are shown in the Zurich Kunsthaus. The *Dune* film project fails to find financial backing in the USA.

H.R.G. is commissioned by Dan O'Bannon to create the monster for the science fiction horror film *Alien*. The initial project is only a preliminary presentation intended to help O'Bannon find a film company willing to risk $9 million on a final production.

At the end of the year H.R.G. meets Mia Bonzanigo, later to become his wife.

## 1978

*Giger's Necronomicon* had just recently been published in several languages in the autumn of 1977. One of the first copies is sent to Dan O'Bannon, who shows it to Ridley Scott and 20th Century Fox, the company in whom the *Alien* project has found a Hollywood producer with ample financial resources. The men from the film company are convinced that

H.R.G. is the right man for the future project. At the beginning of February, director Ridley Scott and two producers from 20th Century Fox visit H.R.G. in Zurich. The powers that be from 20th Century Fox inform H.R.G. of the conditions and financial arrangements regarding the film. Four hours later, the ordeal is over and the gentlemen travel back to the US. 20th Century Fox finances an *Alien* portfolio of six silkscreen prints, which H.R.G. hands over, signed and numbered, to the film publicists.

## 1979

To promote the movie, H.R.G. is sent with Mia, the troubleshooter, to Nice for the European première, and from there to London and Paris. Weeks later, he flies to New York, and, after a stopover in Dallas where he gives a total of 23 TV interviews in one day, he finally turns up, stressed and depressed, just in time to attend the preview in Hollywood in the company of Mia, Timothy Leary, and his wife Barbara. The official release takes place two days later in Graumann's Egyptian Theater on Sunset Boulevard. The huge "space jockey", specially created for the film, is brought in from England and displayed in front of the cinema. It is later the victim of a pyromaniac attack.
H.R.G. and Mia give interviews for up to five hours a day. H.R.G. thereby develops a real "*Alien* interrogation allergy". After this mega-trip, H.R.G. and Mia marry.

## 1980

The designs and paintings for the film *Alien* are shown first in Zurich, in the Galerie Baviera, and then in the Musée Cantonal des Beaux-Arts in Lausanne. H.R.G. is nominated for an Oscar.
Short stopover in New York in order to attend the opening of

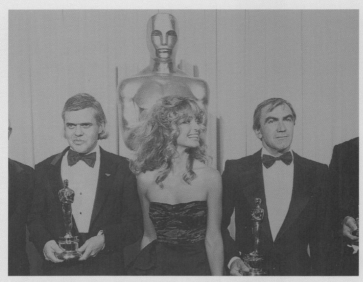

*H.R.G., Farrah Fawcett and Carlo Rambaldi at the Oscars, 1980*

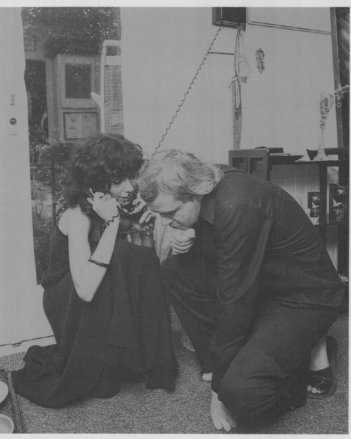

*Mia and H.R.G. at home, Zurich, circa 1980*

*Sybille Ruppert and H.R.G., Paris, 1980. Photo: Anne Garde*

*Giger's Alien,* Sphinx Verlag, Basel; Edition Baal, Paris; Big O, London 1980 (softcover, all out of print); Treville, Tokyo, 1987. New editions: Edition C, Zug 1989, 1992, 1995 (Hardcover); Titan Book, London and Morpheus International, L.A. 1990

H.R.G.'s exhibition in the Hansen Galleries, New York. Bob Guccione has published H.R.G.'s erotic pictures in a fourteen-page color article in the American *Penthouse,* and now sponsors the extravagant exhibition opening. On April 14, in the Dorothy Chandler Pavilion, H.R.G. is awarded an Academy Award for Best Achievement in Visual Effects for his contribution to the film *Alien.*

*Erotomechanics,* 1980. Portfolio with six 8-color silkscreen prints, signed and numbered, in an edition of 300, 70 x 100 cm, Edition: H.R. Giger, Printing: A. Uldry, Hinterkappelen

## 1981

**H.R. Giger's *New York City*** Sphinx Verlag, Basle; Ugly Publishing, Richterswil and Edition Baal, Paris, 1981 (all out of print); Treville, Tokyo, 1987

H.R.G.'s *N.Y. City* paintings are inspired by his five trips to New York and an important template which his colleague Cornelius de Fries, with whom he has been working on the furniture project since the mid 1980s, brought back home with him from one of his excursions into the electronics industry.

Since spring 1979, in a specially-rented studio near H.R.G.'s home, de Fries has been working on a technically highly complex chair design, part of the "Harkonnen" furnishings for the film *Dune*.

***N.Y. City,*** 1982. Portfolio of five 8-color silkscreens, signed and numbered, in an edition of 350. Edition: Ugly Publising, Richterswil, Printing: A. Uldry, Hinterkappelen

## 1982

In Zurich, a table (a variation of the chair) and a mirror frame have now been added to the furniture program. These are exhibited and tested in the Nouvelle restaurant.

H.R.G. and Mia divorce after approximately one and a half years. They remain good friends.

In the fall, H.R.G. begins designing the preliminary presentation for *The Tourist* for the Universal film company. In collaboration with director Brian Gibson he produces seventy sketches and eleven large paintings. Conny de Fries builds a model of one of the sets to a scale of 1:100.

## 1983

The series of *Victory* paintings, partially sprayed with day-glo paints, leads to the *Totems*: naked, technical posts, each crowned by a screaming head, rising up from a devastated landscape. Similarly, a lithograph entitled *Mexican Bomb Pair* is a starting point for a series of bomb paintings.

H.R.G. is invited to be guest of honor at the Madrid and Brus-

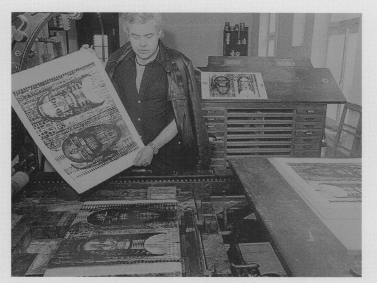

*H.R.G. at Druckerei (printing plant) Winistorf, Zurich, 1983*

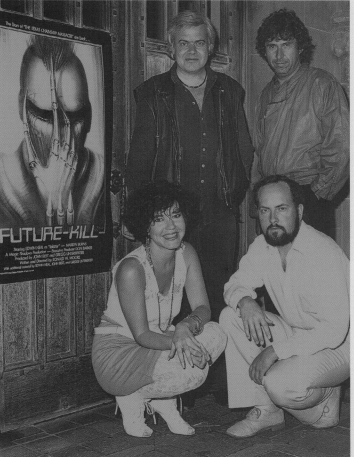

*H.R.G., Mario Cortesi; kneeling: Kathy and Ron Moore, Château Marmont, Los Angeles, 1984*

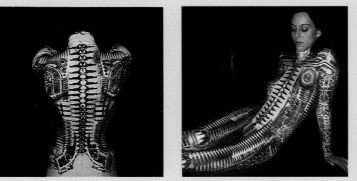

*Body, painted by H.R.G., 1981. Model: Moni Küng. Photo: H.R. Giger*

sels festivals of fantastic films. The film project *The Tourist*, has been put aside following the huge success of *E.T.*. H.R.G. is invited to Munich by Horst Wendtland, head of Rialto Films, to discuss a film version of *Momo*, the children's book by German author Michael Ende.

A film group from Paris presents another screenplay, based on specific paintings by H.R.G., under the title *Passages*. A further project, *The Mirror*, another horror film from 20th Century Fox, is also under discussion.

H.R.G. begins a series of small-format sheets, 48 x 34 cm, in which he uses his perspective templates for the first time. Relief concrete slabs by H.R.G. are manufactured in de Fries' studio.

A new picture frame is produced in keeping, in design, with the furniture program.

## 1984

***Seedamm Cultural Center bulletin*** on the H.R. Giger exhibit, 1984

***H.R. Giger, Retrospective 1964–1984,*** ABC-Verlag, Zurich, 1984 (out of print)

Retrospective exhibition in the Pfäffikon Culture Center; exhibition catalogue published by Edition ABC. Film on the retrospective by Daniel Freitag and Rolando Colla. Ron Moore, director of *Future Kill*, persuades Giger to design the posters for his film. The posters are published by Ed Neal, the legendary *Texas Chainsaw Massacre* actor. Collaboration with Martin Schwarz. Approximately fifteen paintings are produced. Friendship with Marlyse greatly influences Giger's image of women.

## 1985

Commissioned by MGM to create various horror scenes for the film *Poltergeist II*, under the direction of Brian Gibson. On December 18, 1984, H.R.G. and his manager fly to Los Angeles. H.R.G. is signed for the film.

Giger's colleague, de Fries, hired by Richard Edlund (Boss Film), tries to push through as many of Giger's ideas as possible. De Fries is permitted to produce only models, however. On May 23, 1985, filming starts on location, a supermarket in the desert near Los Angeles. Giger and his manager meet Julian Beck, the terminally-ill former head of the Living Theater. H.R.G. realizes he's working on the wrong film. Too late! When he signed his contract, no one had been willing or able to give H.R.G. any details of *Aliens*, going into production at the same time.

The early rushes of the children's horror movie *Poltergeist II*, written by Michael Grais and Mark Viktor, look professional. Richard Edlund's special effects have not been filmed yet, but nevertheless, H.R.G. is worried about the quality of the final product, since the storyline is weak and not to his taste.

H.R.G. is commissioned by Volvo to produce a painting for Isaac Asimov's short story *The Route to Hyperspace*. In Zurich, Edition C reprints *Necronomicon 1* and *2*. The deluxe edition in an embossed cover contains an orginal litho-

**H. R. Giger's Necronomicon 2,** Edition C, Zurich, 1985. New edition: Edition C, Zug, 1988 and 1992. Licensed editions: see list of H.R.G. books

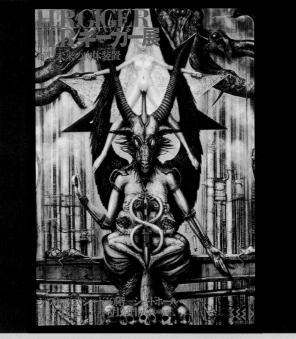

*Poster for H.R.G. exhibit in Tokyo, Japan, 1987*

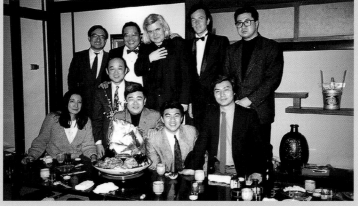

*H.R.G. at a late supper on the opening day of the H.R.G. exhibit in Tokyo, Japan, 19...*

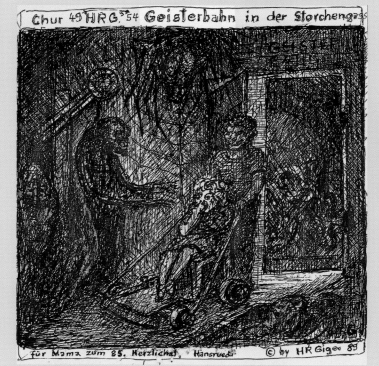

*Ghost Train in the Storchengasse in Chur, 1989. Ink on paper, 19.7 x 18.9 cm*

graph, printed by the legendary Max Winistorf, who died shortly afterwards.

"BD Comics Festival" in Sierre in Valais canton.

## 1986

Preparations for a large exhibition in the galleries of the Seibu Museum of Art in Tokyo in February 1987. Both *Necronomicon 1* and *2* and *Giger's Alien* are translated into Japanese and published by Treville. Catalan Communications N.Y.C. publishes the first English translation supplement of *Necronomicon 2*.

Commissioned by the Swiss TV channel DRS to design a TV prize, the "Prix Tell". Conny de Fries produces the model following the designs of H.R.G.

In Japan, Sony launches the first laser discs with cover motifs by H.R.G. Alexander Bohr films a 45-minute portrait on "*The Fantastic Universe of H.R. Giger*" for the German TV channel ZDF. *Poltergeist II* is released worldwide. The film is a box office hit in the United States, but in Europe it soon disappears from the screen. H.R.G. is very unhappy with the visual interpretation of his ideas.

## 1987

***Exhibition in Japan 1987 – H.R. Giger,*** published by the H.R. Giger Fan Club in Japan in 1987

Exhibition in Japan organized by the Seibu concern, Tokyo. In addition to the themes of *Giger's Alien* and *Poltergeist II*, the show includes the original Alien monster, a Harkonnen Chair and other original paintings. H.R.G. paints a *Japanese Excursion* series espe-

cially for this exhibition. A Japanese Giger Fan Club is founded (H.R. Giger Fan Club, Biomechanoid 87, [Thoru Ito], D35-302, 1-2 Fuzishiro-Dai, Suita City, Osaka, 565 Japan). The following are discussed: Japanese-language editions of existing books (*Alien, Necronomicon 1* and *2*) and the printing of six different motifs as posters, plus a cover for a laser disc. Plans are also discussed for the building of a Giger Bar in Tokyo.

H.R.G. is commissioned to create the monster Goho Dohji for a film by Japanese director Akio Jitsusoji.

## 1988

**H. R. Giger's Biomechanics**
Edition C, Zug 1988. Licensed editions: Treville, Tokyo, 1989; Morpheus International, Los Angeles, 1990 and 1992

After the exhibition in Japan, the most important Giger books – *Giger's Necronomicon 1* and *2* and *Giger's Alien* – are translated. The Japanese Giger Fan Club issues a limited edition of 100 signed and numbered copies of their annual publication. A ten-volume edition of A. Crowley and individual works by Lovecraft and T. Leary are published in slipcases with Giger motifs. Due to strict construction codes, the four-story Giger bar planned for Tokyo retains only fragments of the original concept. Despite Giger's qualms, the bar is built and is inaugurated by U. Steinle. Exhibition at Jes Petersen's gallery in Berlin. Takes part in an "Alchemy Symposium" in St. Gallen. The book *Biomechanics* is published by Edition C, Zurich, Peter Baumann; distributed in France with a text supplement

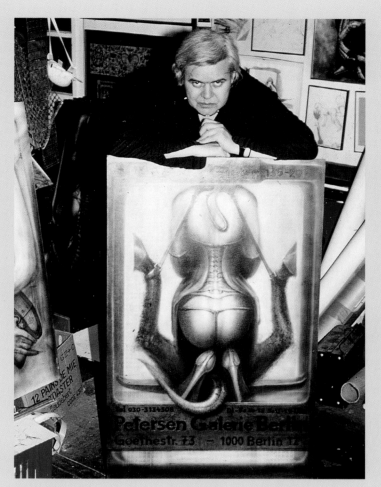

*H.R.G. with image for poster for H.R.G. exhibition in the Gallerie Petersen, Berlin, 1988*

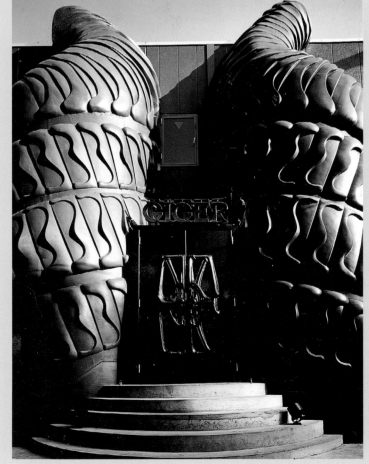

*Main entrance of Giger Bar in Tokyo, 1988*

in French by Bijan Aalam. "Expanded Drawings" exhibition at Rolf Müller's Galerie Art Magazin.

## 1989

Giger uses relief-type texture as a means of bringing more life into the structure of his color paintings. Produces illustrations for Pier Geering's *Robofok* story, lettering by Daniel Affolter, and first color comics for *Strapazin* and other magazines. Negotiations with A. Schraner lead to a, club members-only, poster for the 10th international Hells Angels meeting in Agasul, Switzerland. Negotiations on *Alien 3* and talks with Ridley Scott on a new film. Publication of the Japanese edition of *Biomechanics* (Yuji Takeda, Tuttle-Mori, Treville, Tokyo). Involvement in *Engel, Teufel und Dämonen* (Angels, Devils and Demons), a five-hour film by Heinz Dieckmann on fantastic art. Giger writes down his reminiscences for Benedikt Taschen Verlag, Cologne. Exhibition in Chateau Yverdon as part of the PR for the first European science-fiction museum, *Les Amis d'Ailleurs*, which is to open in 1991 as part of the 700th anniversary celebrations of the founding of the Swiss Confederation. Participates for the third time in *Fêtes des Morts* at Rolf Müller's Galerie Art Magazin. Collaboration on a cultural magazine with Bettina and Hans Klink in Zurich.

## 1990

H. R. Giger celebrates his fiftieth birthday. Works on ideas for Ridley Scott's film *The Train*. Scott, however, postpones the film.

Preparations, with the energetic assistance of Etienne Chatton and Barbara Gawryziak, for the exhibition *Alien dans ses Meubles* taking place in the Chateau Gruyères from May to

September. Breaks away from his long-time manager, Ueli Steinle. Beginning of his work with Leslie Barany, who has been a good friend for 10 years, as his new agent.

Designs a bag for the Migros Group with a print run of one million. Various exhibitions in the Kunsthaus in Chur in honor of his birthday. *"Kunst und Krieg"* in Berlin. Drawings in Guarda, and Nyon at the Galerie Carré Blanc. For the Crusch Alba restaurant in Guarda, he designs one side of a gold coin (value Sf. 250) to be used as a voucher for a meal for two people.

Makes various iron casts of old sculptures. Participates in several documentary films, including *Gens de la Lune* for the television program *Viva* by C. Delieutraz; *Telé ciné Romandie* by André Blanchoud; and profiles for Japanese television.

Further work with Mia Bonzanigo. Mona Uhl successfully battles the chaos in the house. Furniture designs for the Giger Bar in Chur in collaboration with T. Domenig, Chur. The most important project this year, however, is the design work for the American film *Alien 3*. Preparatory work for ART 1991 in the Galerie Hilt in Basel.

Enquiries from Disney Imagineering about future collaboration.

Works on his own film project, *The Mystery of San Gottardo*. An accompanying book, in the form of a graphic novel, in which Giger's Biomechanoid plays an important role, also takes shape. H.R.G. regards this year as very important.

## 1991

Design work for the film *Dead Star* by Bill Malone. Exhibition *Les Livres d'Esquisse* at Macadamla M.J.C. de Cluse, Cluse. *Arh+* book vernissage at the Galerie Art Magazin, Zurich. H.R.G. is visited Peter Steiner

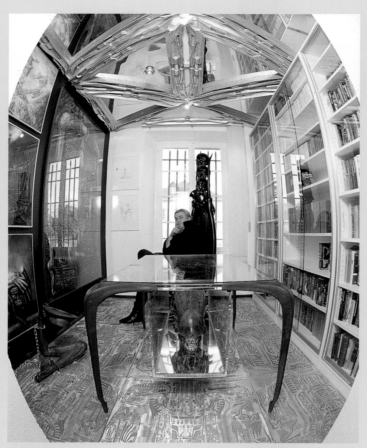

*H.R.G. in the "Giger Library Room", Maison d'Ailleurs, Yverdon, 1991. Photo: Louis Stalder*

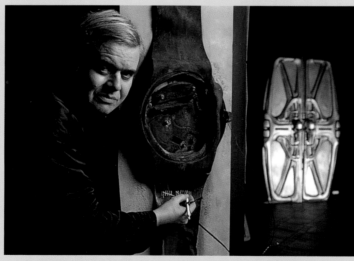

*H.R.G. at the "H.R.G.'s Biomechanics Visions" exhibit, Davos, 1991. Photo: Willy Spiller*

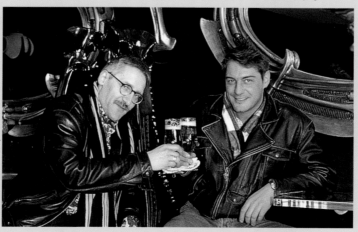

*Conny de Fries and Andy Schedler in the Giger Bar, Chur, 1992. Photo: Willy Spiller*

***H.R. Giger ARh+***
Benedikt Taschen Verlag, Cologne, 1991, English, German, Italian, Spanish, Dutch and Swedish

***700 Years of Waiting for CH-1991***
Portfolio (Leporello with 50 original lithographs), signed and numbered (1–75 on special paper; 76–300 on regular paper), in an edition of 300. Edition: H.R. Giger, Printing: Walo Steiner, Asp, 1991

and Andreas Bürki from Swatch. Interviewed for *Warten* magazine by Rudolf Stoert and Dana Bordan. At the Basel Art Fair 91, Gallery Hilt presents a one-man show with "swatched" Maxiwatches from *H.R.G.'s Watch Abart*. The exhibition *H.R.G.'s Biomechanic Visions* opens in Davos with a talk by Jürg Federspiel. The documentary *Alien 1–3* by Paul Bernard, including an interview with H.R.G., is released by CBS/20th Century Fox, together with the laser disc *Alien 1*, which includes documentary material and an interview with H.R.G. The *Giger Library Room* is opened at the Maison d'Ailleurs, Yverdon. Science-fiction museum with Giger Library, renovated prison cells with paintings, sculptures and Alien props.

## 1992

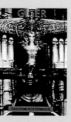

***H. R. Giger Posterbook***
Benedikt Taschen Verlag, Cologne, 1991, portfolio with six color posters

On February 8, the Giger Bar opens in the Kalchbühl Center, Chur. The proprietor is Thomas Domenig. Juhani Nurmi produces, for Finnish television,

**The Mystery of San Gottardo**
Part I–IV, Part XII and Part XIII, published as inserts to the comic book Sauve qui peut, Atoz Editions, Geneva, 1992

**H.R. Giger's Baphomet Tarot**
Portfolio-book, 24 zinc lithographs of drawings, in an edition of 99. Printing: Walo Steiner, Asp, 1992

**Dark Seed,**
computer game, Cyberdreams, Los Angeles, 1992

**H.R. Giger Sketchbook 1985,** Museum Baviera, Zurich, 1992

**The H.R.G. Calendar of the Fantastique 1993**
Morpheus International, Los Angeles, 1992

**H.R. Giger's Necronomicon 1 and 2**
666 copies bound in black leather, slip-case, signed and numbered, with an original lithograph, the first 23 copies have holograms, Morpheus International, L.A., 1992

the 30-minute documentary *Giger's Passage to the Id* in Davos, Chur and at Walo Steiner's in Asp. Jürg Federspiel gives an interview for the program. H.R.G. is interviewed in the Giger Bar for a BBC *Omnibus* program on Ridley Scott. H.R.G. meets Roman Güttinger, one of the largest collectors of *Alien* props. H.R.G. takes part in the Swiss television program *Dynamix*.

Launch of the computer game *Dark Seed*, produced by Cyberdreams (Patrick Ketchum) utilizing the works of H.R.G. Work on the Zodiac Fountain. Large H.R.G. retrospective

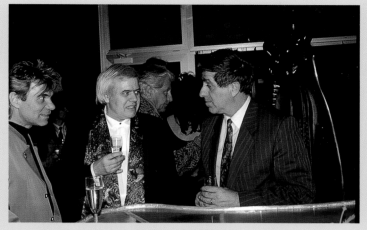

*Baul Tobler, H.R.G., and Chur mayor Rolf Stiffler, Chur, 1992*

*Roman Güttinger with his "Alien" collection, 1995. Photo: Toini Lindroos*

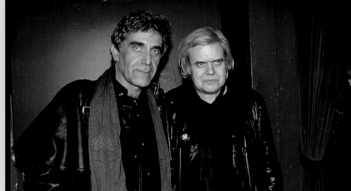

*Leslie Barany and H.R.G., New York, 1993. Photo: Eric T. Michelson*

*Chris Stein, Jello Biafra and H.R.G. in Stein's apartment, NYC 1993. Photo: Sandra Beretta*

opens in the Museum Baviera in Zurich.

H.R.G. writes a short story about his occult experiences, which appears in the book *Arh+* published by Benedikt Taschen Verlag. Paul Grau subsequently features the story – about the *Satan's Head* in H.R.G.'s collection – in the program *Unsolved Mysteries*, broadcast by the German television corporation RTL.

Giger is given the 16mm film *Sex, Drugs and Giger*, a 4 1/2-minute animation based on his paintings, by Sandra Beretta and Bätsch. The *Baphomet Tarot* created by H.R.G. and Akron for A.G. Müller of Neuhausen/Rhine is premiered in the Giger Bar in Chur and in the Museum Baviera, Zurich.

**1993**

**Baphomet – Tarot of the Underworld**
Design for a Tarot card deck, by H.R.G./Akron for AG Müller, CH-8212 Neuhausen a.R. 1993, German, English and French

**H.R. Giger's Watch Abart '93, New York and Burgdorf,** exhibition catalog, H.R.G. and Arh+ Publications, Leslie Barany, Communications/N.Y.C.

**The H.R. Giger Calendar of the Fantastique 1994,** Morpheus International, Los Angeles, 1993

**H.R.G. Postcardbook,** Benedikt Taschen Verlag, Cologne, 1993

The *Alien* exhibition opens in the Museum Baviera, Zurich. Roman Güttinger shows a large selection from his private collection. The exhibition is chiefly devoted to *Alien 3*. One-

man retrospective in the Galerie Humus. Interview with ARTE TV. One-man show in the Galerie Herzog, Büren zum Hof. From August onwards, H.R.G. works with Sandra Beretta on the projects close to his heart, the books in particular. Swatch decides not to collaborate with H.R.G. as planned earlier. One-man show entitled *H.R. Giger's Watch Abart '93* staged in the Galerie Bertram, Burgdorf, and in the Alexander Gallery, New York. The latter exhibition is coordinated by Leslie Barany, who also edits the catalog *H.R. Giger's Watch Abart '93*.

## 1994

**The H.R.G. Calendar of the Fantastique** Morpheus International, Los Angeles, 1994

Sascha Serfoezoe and Mia Bonzanigo assume charge, on Giger's behalf, of exhibitions in German, French and Italian speaking locations. One-man show entitled *Giger's Watch Abart* in the Galerie Mangisch, Zurich; one-man show in the Galerie Ecllisse, Locarno. H.R.G. is guest lecturer for a semester at the College of Design (GBMS) in Zurich. In February, he begins work on the film *Species* for MGM. Takes part in group exhibitions in the Galerie Hartmann, Munich, at the Tattoo Convention in Bologna, and in the festivals *Fetisch & Kult*, Tempel, Munich and *Du Fantastique au Visionnaire* in Venice. H.R.G. starts planning a Giger-Museum to present the full scope of his work. Begins work on the ghost train for *Species*, in collaboration with Atelier de Fries and Andy Schedler of FormArt.

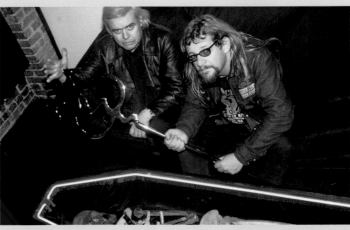

*H.R.G. and Steve Bonge at the Hells Angels clubhouse in N.Y.C., 1993. Photo: Leslie Barany*

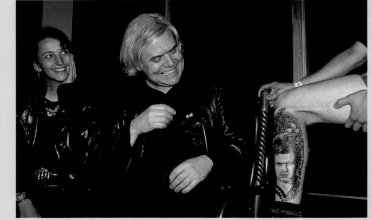

*Beretta, H.R.G. and Paul Ivanko, Ink Credible Convention, N.Y.C., 1993. Photo: L. Barany*

*H.R.G. exhibition at the Alexander Gallery, New York, 1993. Photo: Dana Frank*

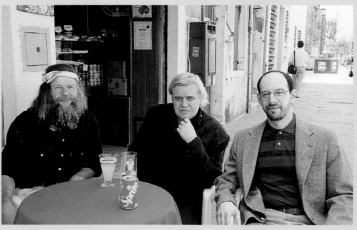

*Bruno Weber, H.R.G. and James R. Cowan at the Art Fair, Venice, 1994*

## 1995

**Baphomet – Tarot of the Underworld** AG Müller, CH-8212 Neuhausen a.R., Edition with a condensed version of the book and the CD, 1995, German, English and French

**H.R. Giger Set.** Folder with 3D calendar, 1996, blank book, address book, postcard book; Benedikt Taschen, Cologne, 1995

**H.R. Giger Diary,** Benedikt Taschen Verlag, Cologne, 1995

**H.R.G. 3-D Calendar 1996,** Benedikt Taschen Verlag, Cologne, 1995

**The H.R.G. Calendar of the Fantastique 1996,** Morpheus International, Los Angeles 1995

**Dark Seed II,** computer game, Cyberdreams, L.A. 1995

**Screensaver,** Cyberdreams, Los Angeles, 1996

**Catalogue for the exhibition of Paul Walter's collection,** with Sybille Ruppert in the Kunsthalle Giessen, 1995

Serfoezoe works with Giger on special projects. He develops the special gift of being able to decipher H.R.G.'s handwriting without wanting to change its content or put it in good German. The ghost train is transported to L.A. One-man show

as part of the *13ème festival du film fantastique* in Brussels. One-man show in the Giessen Kunsthalle, *Konfrontationen* with S. Ruppert. Other exhibitions including *Le Train Fantôme* in the Maison d'Ailleurs, Yverdon; *Synaesthesia*, Mary Anthony Galleries, N.Y.C.; Psychedelic Solution Gallery, N.Y.C.; *Abitare il Tempo, Delirium Design*, Verona.

Continues work on *Species*, the science-fiction film by R. Donaldson based on the screenplay by D. Feldman and produced by Frank Mancuso, Jr. for MGM, L.A.. For the film, H.R.G. designs an extraterrestrial beauty and a "minimalized" ghost train. The film is released in the USA in July and is MGM's biggest success to date: box office take is US$ 17.1 million in one weekend alone.

H.R.G.'s work on *Species* inspires him to build a garden train, which he creates as an outdoor installation, constructing a 7 1/4-gauge railway in his garden. He is helped by Harry Omura, Florian, André Margreitner, Stahl & Traum, Ball & Sohn, Robert Christoph Jr., Marco Poleni, Fritz Rütimann, Andy Stutz and Tanja Wolfensberger. H.R.G. and S. Beretta tackle several book projects, including the book accompanying the film *Species*, published before the year is out, and another book on Giger's film designs. The editing and translating of both of these books is supervised by L. Barany. He launches his book project, *H.R. Giger Under Your Skin* and begins to assemble photographs of tattoos featuring Giger motifs.

**H. R. Giger's Species Design**
Morpheus International, Los Angeles, 1995; Edition C, Zug 1995; Titan Books, London 1995; Treville, Tokyo 1995

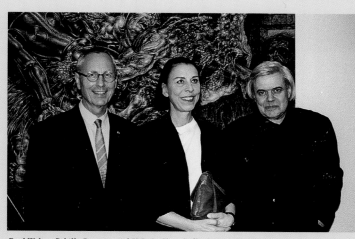

*Paul Walter, Sybille Ruppert and H.R.G., Kunsthalle Giessen, 1995*

*H.R.G. at the exhibit "Le Zodiaque", Chateau de Gruyères, 1995. Photo: Sandra Beretta*

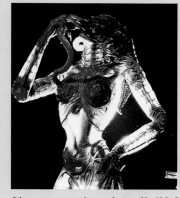

*Sil, transparent sculpture, designed by H.R.G., realized by Steve Johnson, in the Kunsthaus Zürich, 1995, in the exhibition "100 Years of Film", Photo: Roman Güttinger*

*F. Alain Gegauf, H.R.G.'s friend and advisor, art-sponsoring and public relations consultant. He gets his strength from his mother Bertita.*

*Rainer Opoku and Benedikt Taschen, Cologne 1995. Photo: H.R. Giger*

**H. R. Giger's Film Design**
Edition C, Zug 1996. Licensed editions: Morpheus International, L.A. 1996; Titan Books, London 1996; Treville, Tokyo 1996

H.R.G. also works with Leslie Barany on a comprehensive book on his *Mystery of San Gottardo* project, to be published simultaneously in English and German. Together with computer graphics specialists Fabian Wicki in Berne and PanVision, H.R.G. creates 3-D images for a 1996 Benedikt Taschen calendar and begins on the book *www HR Giger com*.

## 1996

Zürich, Kunsthaus: *Illusion, Emotion, Realität*, a centennial exhibition celebrating 100 years of film, curated by Dr. H. Szeemann. Further exhibitions in Vienna, Venice and Barcelona. F. Alain Gegauf becomes a friend and advisor to H.R.G.. H.R.G. participates with four drawings *Sex Education Charts* in the *Erotika* exhibit at the Kunsthaus Zürich.

Mia organizes a big retrospective in Milan, at the Palazzo Bagatti Valsecchi, *H.R. Giger – Visioni di Fine Millennio, Arteutopia*. Development of an idea for a new film project based on a story and sculpture by H.R.G.: *The Cross and the Blade*. Experiments with holos, 100 x 100 cm, in collaboration with Urs Fries and Fischers.

In collaboration with Thomas Riehm, the official Giger Internet website goes online on March 19 under the address "http://www.HRGiger.com". In the first year, over 200,000 visitors from over 100 countries log on. The site also offers membership to the only official Giger Fan Club.

## 1997

Giger's new book *www HR-Giger com,* an authentic life story of Giger from the early sixties till today, is published by the publishing company Benedikt Taschen, Cologne. On the 11th of September the St. Germain Gruyères AG purchase by auction the Castle St. Germain for the formation of the new Giger-Museum.

## 1998

Giger's new book *The Mystery of San Gottardo* is published by the publishing company Benedikt Taschen, Cologne. Book *H.R. Giger's Retrospective 1964–84,* Morpheus International (Los Angeles). CFM Gallery, New York, *International Artists – Peep Show.* Sapporo, Museum Otaru *Phantastic Realism.* Caliban Gallery, New York, *Sculptures and Prints,* curated by Leslie Barany. Private Art-Collection of H.R. Giger at the Castle St. Germain, Gruyères.

## 2000

H.R. Giger celebrates his sixtieth birthday. More than 1.000.000 visitors on Giger's official WebSite www.HR-Giger.com.

## 2001

Carmen Scheifele and Ingrid Lehner replace Barbara Gawrysiak as the directors of the HR Giger Museum. Alf Bättig (KoKo) and Frank Holler join the Giger crew.

## 2002

TASCHEN publishes *HR GIGER ARh+* in the icon-series with text by the world famous psychiatrist Dr. Stanislav Grof, a good friend of Carmen and HRG. The foreword is by Les Barany, Giger's agent and friend. Launch of the H.R.

*Debbie Harry and H.R. Giger at the opening of his Fuse Gallery exhibition, New York, 2002. Photo: © Patrick M. Haley*

*Carmen in Giger's garden. Photo: © Wolfgang Holz*

*H.R. Giger with the Prague Hells Angels*

Giger Museum jewelry line, rings, pendants, and belt-buckles. In March, a memorable trip to New York City with Carmen and Ronald Brandt for the opening of *HR Giger / NYC 2002* at Fuse Gallery.

## 2003

April 12, celebration for the opening of the HR Giger Museum Bar and the opening of the Martin Schwarz exhibition *Among the Living* in the Museum Gallery. Jean François and Isabelle Chappellay are the new bar keepers. August 30, the unveiling H.R. Giger's *Sabotage* sculpture on Harakka Island, Finland. September 5, opening of the exhibition *HR Giger/ Woodstock 2003* at the Fletcher Gallery in Woodstock, NY, curated by Les Barany. August 7th, the presentation of Giger's *Tattoo Biomechanoid* sculpture as an award for the Best H.R. Giger Tattoo at the Woodstock

*H.R. Giger At His Museum – Agenda 2003,* Creox Design, Paris, 2003

Tattoo & Body Arts Festival. November, American sculptor Paul Komoda visits and stays at Giger's home in Zurich to work with him on the Baphomet pendant.

## 2004

August 5, opening of exhibition at the LOEB emporium in Bern, introducing the limited edition print for the financing and construction of the HR Giger Museum Castle Train Ride. September 16 - February 6, 2005, *Le monde selon H.R. Giger* (The World According to H.R. Giger), a 5 month retro-

spective at Museum Halle Saint Pierre in Paris, co-curated by Stephan Stucki/ArtCommunication. September 21, opening of *Biomechanoides Paris* at Galerie Arludik in Paris. December 17, H.R. Giger receives "La Médaille de la Ville de Paris" award at Paris City Hall. 2004 also saw the release of the *Chtulhu News*, a limited edition portfolio of six prints, the H.R. Giger sterling silver *Baphomet*

Stan Grof, Albert Hofmann and H.R. Giger at the HR Giger Museum, 2005. *Photo: © Carmen Scheifele Giger*

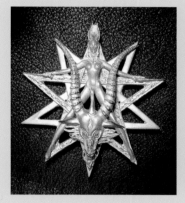

**Baphomet**, silver pendant from the jewelry line of H.R. Giger

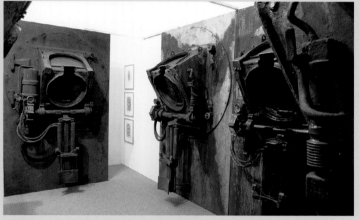

Exhibition of the **Passagen**, ABB Hallen, Zurich, Oct. 2005. Photo: © Carmen Scheifele Giger

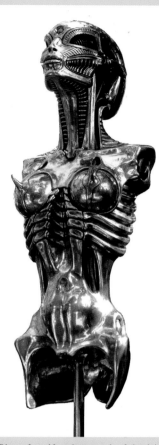

**Biomechanoid**, sculpture made of aluminium, 2002. Photo: © Wolfgang Holz

*pendant*, the introduction of *LI II*, the first in a series of five H.R. Giger collectibles from McFarlane Toys, the introduction of the Giger SmartSkin for cell phones by Wildseed Ltd. and the completion of several important projects, with the indispensable help of Giger's number one and long time sculpting assistant, Ronald Brandt, the three-dimensional Passage sculptures, the mini Harkonnen environment, a prototype car for the Castle Train Ride, and last but not least, the Alien back-scratcher.

## 2005

Ibanez Guitars introduces the HR Giger Signature Guitar Series. The opening of *Works Never Shown* at the Galerie Baviera, Zurich. April 14 - July 13: *HR Giger in Prague*, a retrospective at the National Technical Museum, Prague. The success of the show is marred

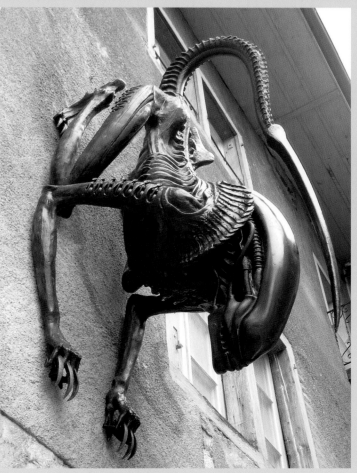

At the entry of the Museum HR Giger: **Alien III**. Photo: © Carmen Scheifele Giger

by the fact that the two important paintings *ELP I* and *II* disappeared before the works were returned to Zurich after the close of the exhibition.

Grof Transpersonal Training and Carmen organize a seminar

**Le Monde Selon HR Giger**, Halle Saint Pierre & Passage Pietons, Paris, 144 pages, retrospective catalogue 2004

**HR Giger in Prague**, PP Production, Prague, 120 pages, retrospective catalogue 2005

with Stan Grof and H.R. Giger. Special guest is their friend Albert Hofmann. The 99 years old

***Giger in Wien***, Kunst-HausWien, Austria, 144 pages, retrospective catalogue 2006

discoverer of LSD is still in very good shape.

On December 1ˢᵗ Urs Tremp opens up the Gigeregg in St. Gallen, Switzerland – a shop offering Giger art and items (www.gigeregg.ch). Eli Livingston, under Giger's supervision, finishes sculpting the silver Guardian Angel pendant in time for Christmas. Dr. Carlos Arenas of the University of Valencia, Spain, publishes his PhD thesis, *El mundo de HR Giger*.

***HR Giger – Magier der Airbrush***, Frank Festa Verlag, Taucha, biography by Herbert M. Hurka, in preparation

## 2006

Giger and Carmen get married. May, 24 - October, 1ˢᵗ: Big retrospective in the KunstHaus Wien in Vienna, co-curated by Stephan Stucki. Sept. 2 - 10: Internationale Biennale Austria-2006 in Hüttenberg, Kärnten. In a renewed relationship with Celtic Frost an agreement is reached to license the *Satan I* painting as T-shirts, commemorating the 20ᵗʰ anniversary of its first appearance as the cover of their first album, To Mega Therion.

The biography *HR Giger – Magier der Airbrush* by Herbert M. Hurka (Frank Festa Verlag) is in preparation. Octo-

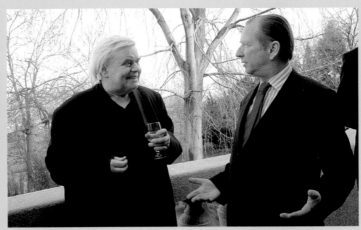

*H.R. Giger and the Swiss Ambassador to the Czech Republic at a party for the artist at the Swiss Residence, Prague, 2002. Photo: © Les Barany*

*H.R. Giger and Ernst Fuchs in the garden of the Fuchs Museum, Vienna, 2006. Photo: © Matthias Belz*

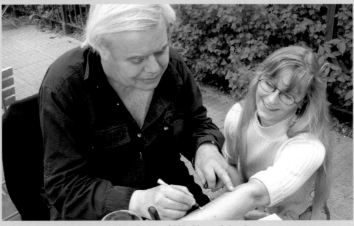

*A pleasant interruption at a cafe in Prague, 2005. Photo: © Les Barany*

ber, 5, Giger attends the opening of the group exhibition *In den Alpen* at the Kunsthaus Zürich. Matthias Belz, Marco Witzig and Oliver Ludwik prepare the complete work catalogue. Les Barany shows he is still a great art director by designing a new series of ads for the 2006 edition of Ibanez guitars.

## 2007

Solo exhibition from June to September at the Bündner Kunstmuseum, Chur. Start of the new website www.hrgiger-museum.com. Together with Ronald Brandt, Giger finishes a 1/6 scale, fully detailed, model of the Museum Giger Bar.

***HR Giger: Through Their Eyes***, ARh+ Editions & Scapegoat Publishing, USA, never before published behind the scenes photos by 30 photographers. In preparation.

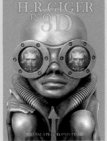

***HR Giger in 3D***, ARh+ Editions & Scapegoat Publishing, USA, translation of Giger's paintings for 3D viewing by Michael Verhoef. In preparation.

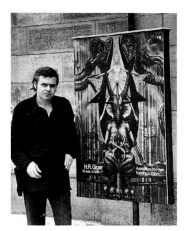

*H.R.G. in front of the Kunsthaus Zurich, 1977,*
*Photo: Candid Lang*

## Solo exhibitions

**1966**
Zurich, Galerie Benno

**1968**
St. Gallen, Galerie vor der Klostermauer

**1969**
Zurich, Galerie Platte 27, "Biomechano-iden"

**1970**
Zurich, Galerie Bischofberger, "Passagen"

**1971**
Berne, Actionsgalerie (with D. Schwertberger)

**1972**
St. Gallen, Galerie Look (Dibi Däbi)
Biel, Galerie 57
Baden, Trudelhaus (with H. Schuhmacher)
Kassel, exhibition by the Kunstverein

**1973**
Zurich, Galerie Stummer und Hubschmid
Cologne, Inter Art Galerie Reich

**1975**
Chur, Bündner Kunsthaus, "Passagen-Tempel"
Zurich, Galerie Baviera, complete graphic works
Zurich, Meier's Gallery of Modern Art

**1976**
Frankfurt, Galerie Sydow-Zirkwitz
Amsterdam, Galerie Kamp
Paris, Galerie Bijan Aalam
Regensberg, Neue Wohngalerie, complete graphic works
Richterswil, Ugly Club, "The Second Celebration of the Four"

**1977**
Zurich, Zürcher Kunsthaus
Biel, Galerie Baviera
Paris, Galerie Bijan Aalam

**1978**
Glarus, Kunsthaus (with Claude Sandoz)
Büren an der Aare, Galerie Herzog, complete graphic works

**1979**
Zurich, Galerie Baviera, works for the film "Alien"
Amsterdam, Galerie Kamp
Paris, Galerie Bijan Aalam

**1980**
Cavigliano, Galerie Baviera, "H.R. Giger sul tema dell' erotismo"
Zurich, Modelia-Haus, works for the film "Alien"

Lausanne, Musée Cantonal des Beaux-Arts, works for the film "Alien"
New York, Hansen Galleries, works for the film "Alien"

**1981**
New York, The Museum of the Surreal and Fantastique
Biel, Kunsthauskeller

**1982**
Winterthur, Kunsthalle im Waaghaus, N. Y. City paintings and the collection of Bijan Aalam, Paris

**1983**
Basle, Art 14'83
Munich, Galerie Hartmann
Zurich, Galerie Steinle
Bonn, Galerie Klein, with Martin Schwarz; Cologne, Galerie am Severinswall, with Martin Schwarz

**1984**
Pfäffikon SZ, Seedamm-Kulturzentrum, "Retrospektive"
Basle, Art 16'85, with Martin Schwarz
New York, Limelight, "The Dune You Will Never See"
Biel, Galerie 58, Silvia Steiner, with Martin Schwarz

**1985**
Sierre, Maison Pancrace de Courten, "Retrospektive"
Zurich, Galerie a 16
Nuremberg, "Zukunftsträume"

**1986**
Büren zum Hof, Galerie Herzog

**1987**
Zurich, Werkstatt-Galerie, Paul Nievergelt
Tokyo, Shibuya Seibu, Seed

**1988**
Zurich, Galerie Art Magazin, "Drawings Expanded"
Berlin, Galerie Petersen
Rorschach, Museum im Kornhaus, graphic works
Zug, Wickart, graphic works
New York, Psychedelic Solution Gallery, paintings and prints
St. Gallen, Stadttheater, "Essenzia-Symposium for Alchemy"

**1989**
Chur, Galerie Plana Terra, graphic works

**1990**
Chur, Bündner Kunsthaus, exhibition on the occasion of H.R. Giger's 50th birthday. Exhibition of the 12 H.R. Giger paintings in the museum's collection
Gruyères, Château de Gruyères, "Alien dans ses Meubles"
Wettingen, Informatikschule, paintings and graphic works
Guarda, Restaurant Crusch Alba, drawings for "The Mystery of San Gottardo"
Nyon, Galerie Carré Blanc, drawings

**1991**
Cluse, Macadam – la M.J.C. de Cluse, "Les Livres d'Esquisses"
Zurich, Galerie Art Magazin, ARh+ book vernissage
Basle, Art 22'91, Gallery Hilt, "One Man Show"
Davos, Painthouse Academy, Window 92, "H.R. Giger's Biomechanic Visions"

**1992**
Zurich, Museum Baviera, "Giger-Retrospektive"

**1993**
Zurich, Museum Baviera, retrospective and works for "Alien" and "Alien III"
Lausanne, Galerie Humus, retrospective and exhibition of "Swiss Transit Tunnel" works

Büren zum Hof, Galerie Herzog
Fürth, Galerie P17, drawings for "The Mystery of San Gottardo"
Burgdorf, Galerie Bertram and former Restaurant Krone, paintings, retrospective of sculpture, including "Watch Abart" pieces
New York, Alexander Gallery, "Retro-NY", paintings and "Watch Abart" sculptures (catalogue)

**1994**
Zurich, Galerie Mangisch, "Watch Abart"
Locarno, Galerie Ecllisse
Zurich, Odeon, "Communication Art Zürich"

**1995**
Brussels, 13ème Festival du Film Fantastique
Giessen, Kunsthalle, "Konfrontationen", with Sybille Ruppert
(works from the Paul Walter collection)

**1996**
Kreuzlingen, Loft, furniture
Milan, Palazzo Bagatti Valsecchi, "Visioni di fine millennio" (catalogue)

*H.R.G. at the firsts exhibit in New York:*
*"Images of Horror and Fantasy", at the*
*Bronx Museum, N.Y.C. (group exhibit), 1978*

**1997**
Basle, Galerie Hilt, "Projekte"
Paris, Librairie Arkham, "Visions"
Lucerne, Galerie Artefides, originals sculptures, graphics
Chur, Fachhochschule für Gestaltung, "Visionen", sculptures, furniture

**1998**
Gruyères, Château Gruyères, "Private Art Collection of HR Giger"
Gruyères, Museum HR Giger, Château St. Germain, Inaugural celebration
New York, Caliban Gallery, "HR Giger – Sculptures & Prints"
Basle, Galerie Hilt, originals and portfolios

**2000**
Zurich, TV DRS at home with HRG, Turn of the Millennium
Zurich, Galerie a16, sculptures, paintings, drawings, portfolio "Ein Fressen für den Psychiater"
Conte, Tattoo Convention, paintings
Nuremberg, Galerie am Theater, exhibition "Ein Fressen für den Psychiater"
Thal, Wurster AG, exhibition in the Fuchsloch, furniture

**2001**
Zurich, Piccola Galleria d'arte, graphics

**2002**
New York, Fuse Gallery, "HR Giger/NYC 2002: Recent Sculptures & Prints"
Winterthur, showrooms of the Hard community, "Mensch, Maschine, Genetik"

**2003**
Woodstock, Fletcher Gallery, "HR Giger/ Woodstock 2002: Recent Sculptures & Prints"
also featuring works by artists in Giger's private art collection
Bad Hersfeld, Galerie Rotation 31
Naples, Science Centre of Fondazione IDIS, "Alieni e Biomeccanoidi"

**2004**
Bern, "Loeb" emporium, paintings, sculptures and prints
Paris, Halle Saint Pierre, "Le Monde Selon HR Giger", retrospective
Paris, Galerie Arludik, "Biomechanoïdes Paris 2004"

**2005**
Zurich, Cabaret Voltaire, "Pandora – Giger Reloaded", prints & sculptures
Zurich, Museum Baviera, "Passagen", exhibition of new sculptures and prints
Prague, National Technical Museum, "H.R. Giger in Prague", retrospective
New York, Art at Large, "Gigerotique", original works, sculpture, limited editions lithographs, and jewelry

**2006**
Vienna, KunstHausWien, "Giger in Wien", retrospective

**2007**
Chur, Bündner Kunstmuseum, a retrospective of H.R. Giger's early works

**2008**
Frankfurt, Deutsches Filmmuseum, a retrospective of H.R. Giger's designs for film

## Group exhibitions

**1962**
Basle, Galerie Stürchler

**1967**
Zurich, Galerie Obere Zäune, "Macht der Maske"
Berne, Kunsthalle, "Science-Fiction"

**1968**
Zurich, Galerie Stummer & Hubschmid, "Hommage à Che"
Zurich, Galerie Obere Zäune, 5th anniversary show
Erlangen, Galerie Hartmut Beck

**1969**
Vienna, Künstl. Volkshochschule, "Junge Schweizer Maler"
Zurich, Wenighof, "Kritische Realismen"
Zurich, Helmhaus, "Phantastische Figuration in der Schweiz"
Zurich, Galerie Stummer und Hubschmid, "Edition 12x12"
Berlin/Zurich, "Zürcher Künstler"

**1970**
Basle, Galerie Katakombe
Basle, Galerie G.
Geneva, Galerie Aurora
Lausanne, Musée des Arts de la Ville, "L'Estampe en Suisse"
Kassel, Studio-Galerie des Kunstvereins

**1971**
New York, Cultural Center, "The Swiss Avant-Garde"
Geneva, "3e Salon de la Jeune Gravure Suisse"
Zurich, Strauhof, "Fünf Kritiker zeigen Kunst"
Basle, "Art 2'71"
Paderborn, Pädagogische Hochschule, "Editionen"
Cologne, Internationale Kunst- und Informationsmesse
Zurich, Strauhof, "Zürcher Zeichner", Ars ad interim
Chur, Bündner Kunsthaus, "Neueingänge 70/71"

**1972**
Glarus, Galerie Crazy House
Zurich, Züspahallen, "Zürcher Künstler"
Zurich, "Freiheit für Griechenland"
Zurich, Strauhof, "Werk & Werkstatt"
Cracow, "Biennale Internationale de la Gravure"

Basle, "Art 3'72"
Lucerne, Verkehrshaus, "Künstler—Verkehr—Visionen"
Bradford, Third British International Print Biennale
Tel Aviv, "Contemporary Swiss Art"
Zurich, Jerusalem, Haifa, "Zürcher Künstler"

**1973**
Berne, Basle, Lugano, Lausanne, Geneva, "Tell 73"
Basle, "Art 4'73"
Zurich, Biennale im Kunsthaus, "Stadt in der Schweiz"
Schaffhausen, Museum zu Allerheiligen, "Kunstmacher 73"
Oberengstringen, "Spektrum 73"
Berne, Galerie für kleine Formate, "small size"
Düsseldorf, IKI, Internationaler Markt für aktuelle Kunst

**1974**
Winterthur, Geneva, Lugano, "Ambiente 74"
Zurich, Strauhof, "66 Werke suchen ihren Künstler"
Chur, Bündner Kunsthaus, "GSMBA Graubünden"
Olten, Kunstverein, "Zürcher Fantasten"
Munich, Galerie Jasa GmbH & Co. Fine Art
Frankfurt, Galerie Sydow-Zirkwitz, inaugural exhibition
Basle, "Art 5'74"
Chur, Kunsthaus Chur, "Tagtraum", together with Claude Sandoz and Walter Wegmüller
Zurich, Kunsthaus, "Tagtraum"
Winterthur, Kunstmuseum, "Tagtraum"
Olten, Kunstmuseum, "Tagtraum"
Paris, Galerie J. C. Gaubert, "400 Ans de Fantastique"
Zurich, Galerie Li Tobler, "Manon oder das lachsfarbene Boudoir"
Düsseldorf, Kunstmesse IKI 74

**1975**
Zurich, Galerie Li Tobler, "Schuhwerke"
Basle, "Art 6'75"
Paris, Galerie Bijan Aalam, "Le Diable"

**1976**
Nuremberg, Kunsthalle, "Schuhwerke"
Zurich, Villa Ulmberg, "Zürcher Künstler"
Amsterdam, Galerie Kamp, "Fantastisch Realisme"
Zurich, Strauhof, "Zwischen Konflikt und Idyll"
Zurich, Hamburg, Berne, Paris, S.R. Baviera, "DIN A4"
Paris, Galerie Espaces 76, "3 Espaces"
Paris, Galerie Bijan Aalam, "Le Vampire"

**1977**
Lausanne, Musée Cantonal des Beaux-Arts
Basle, "Art 8'77"
New York, Bronx Museum, "Images of Horror and Fantasy"
Tours, "Multiple 77"
Liège, "Arts à Saint-André"
Zurich, Galerie Baviera, "Echo vom Matterhorn"
Zurich, Galerie Stummer, "Kleinformate"
Zurich, Strauhof, "Das Menschenbild"
Burgdorf, Galerie Bertram
Zurich, Züspa-Hallen, "Kunstszene Zürich"
Paris, Galerie Bijan Aalam, "Les Miroirs"

**1978**
Vienna, Künstlerhaus am Karlsplatz, "Kunstszene Zurich"
Chur, Bündner Kunsthaus, "GSMBA Graubünden"
Winterthur, Kunstmuseum, "3. Biennale der Schweizer Kunst"
Winterthur, "Aktualität Vergangenheit"
Zurich, Galerie Baviera, "Tagtraum", together with Claude Sandoz and Walter Wegmüller
Zurich, Centre Le Corbusier, "Atomkraftwerkgegner-Komitee"
Basle, "Art 9'78"
Bochum, Museum, "Imagination"

**1979**
Olten, Kunsthaus Olten (Galerie Baviera), "Vorschlag für ein anderes Museum"
Basle, "Art 10'79"
Rennes, Maison de la Culture, "L'Univers des Humanoïdes"

**1980**
Zurich, Kunsthaus Zürich, "Schweizer Museen sammeln Kunst"
Winterthur, Kunsthalle im Waaghaus, "Vorschlag für ein anderes Museum"
Basle, "Art 11'80"
Lausanne, Musée Cantonal des Beaux-Arts, "Schweizer Museen sammeln Kunst"
Zurich, Helmhaus, "Transport, Verkehr, Umwelt"
Los Angeles, Hansen Galleries, "Art Expo West"
Zug, Kunsthaus, "Die andere Sicht der Dinge"
Le Havre, Maison de la Culture (Pro Helvetia), "Quelques Espaces Suisse 80"
New York, Hansen Galleries, "Art 1980", International Fair of Contemporary Art
Glarus, Kunsthaus Glarus, "Die andere Sicht der Dinge"
Lille, Palais Rameau, "Science au Future"

**1981**
Ohio, School of Art (Hansen Galleries), "Science Fiction and Fantasy Illustration"
Basle, "Art 12'81"
Chicago, The Picture Gallery, "Space Artistry"

**1983**
Munich, Galerie Hartmann, Villa Stuck, "Eros und Todestrieb"
Laax, Galerie d'art
Basle, Galerie J. Schotland

**1984**
Kassel, Orangerie, "Zukunftsträume"

**1986**
Nuremberg, "Der Traum vom Raum" (catalogue)
Zurich, Galerie Art-Magazin, "Ausstellung Tutti Frutti"
Zurich, Galerie Art-Magazin, "Fest der Toten – Unter dem Vulkan"
Dortmund, Museum am Ostwall, "Macht und Ohnmacht der Beziehungen" (catalogue)
Olten, Kunstmuseum, " Collection Baviera"
Zurich, Galerie a 16, Fred Knecht

**1987**
Lausanne, Galerie Basta, "Fête des Morts"
Tokyo, Shibuya Seed Hall, Osaka, Shinsaibashi Parco Studio, Otsu-shi, Saibu Hall, traveling exhibition featuring "Alien" works

**1988**
Martigny, Les Caves du Manoir, "Fête des Morts"
Frankfurt, Book Fair, Kunsthalle, Edition C
Zurich, Shedhalle, "Kunst Woher Wohin"
Zurich, Museum für Gestaltung, "Kunstszene Zürich"

**1989**
Frankfurt, Book Fair, Kunsthalle, Edition C
Zurich, Galerie Art-Magazin, "Accrochage"
Yverdon, Château Aula Magma, "Les Amis d'Ailleurs"
Zurich, Galerie Art-Magazin, "Fête des Morts"

**1990**
Zurich, Helmhaus, "Ankäufe 1988"
Geneva, MJC St. Gervais, "Ailleurs est proche"
Berlin, Haus der Kulturen der Welt, "Kunst und Krieg"
Paris, Galerie d'Art Dmochowski, "Les Visionnaires"
Montreux, Musée du Vieux Montreux, "Fête des Morts"

**1991**
Lausanne, Galerie Humus, "Les Inconnues"
Chur, Jugendhaus, "Comix-Ausstellung"
Zurich, Helmhaus, "Verwandtschaften"
Yverdon, Maison d'Ailleurs, "Giger's Library Room"; converted prison cells with paintings, furnishings and "Alien accessories"
Martigny, Le Manoir, "Fête des Morts"

**1992**
Seville, Expo 92, Pabellon de Suiza, "Unerwartete Schweizer"

**1993**
Basle, MUBA, "Movie World", exhibition

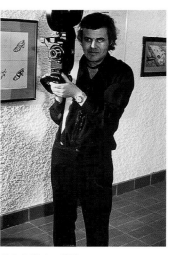

*H.R.G. filming, 1975*

including H.R. Giger's film designs (pictures and Harkonnen furniture)
Zurich, re-opening of Galerie Art-Magazin
Zurich, Museum der Seele, "More Pricks than Kicks"
Gruyères, Château de Gruyères, "Le Tarot"
Zurich, Museum der Seele, "Day of the Dead"

**1994**
Zurich, Galerie Art-Magazin
Zurich, Galerie a 16, "Ufo & Ifo"
Zurich, Galerie Mangisch, "Lucifers Rising"
Munich, Galerie Hartmann
Munich, Tempel, "Fetisch & Kult"
Venice, "Du Fantastique au Visionnaire"
Lausanne, Galerie Humus, "Le Sexe des Anges"
Bologna, Tattoo Convention

**1995**
Arbon, Schloss Arbon, "Migros-Säcke"
Zurich, Galerie Art Magazin, 10th anniversary show
Zurich, Galerie Tumb, "Zyklorama"
Paris, Stardom Gallery, "Les Anges"
Yverdon, Maison d'Ailleurs, "Les Trains Fantômes"
New York, Mary Anthony Galleries, "Synaesthesia"
New York, Psychedelic Solution Gallery
Lausanne, Galerie Rivolta, "Magie Noire"
Gruyères, Château de Gruyères, "Le Zodiaque des signes dans votre ciel"
Zurich, Kunststrasse, H.R. Giger's 3D images
Verona, "Abitare il Tempo, Delirium Design"
Zurich, Kunsthaus, "Die grosse Illusion. Die 7. Kunst auf der Suche nach den 6 anderen"
Vienna, Messepalast, "Invasion der Außerirdischen", and in ten other German and Austrian cities
Lausanne, Galerie Humus, "Rosée d'Eros"
Zurich, Galerie Tumb, "Unrat"

**1996**
Venice, Vienna, Barcelona, "Die grosse Illu-

sion. Die 7. Kunst auf der Suche nach den 6 anderen"
Milan, Arteutopia, "Suoni & Visioni"
Frankfurt, Art
Zurich, Kunsthaus, "Erotika"
Berne, BEAexpo, Galerie Nika, "Kunst & Wein"
Lausanne, Musée d'art contemporain pornographique, "Deep inside"
Chur, Bündner Kunstmuseum "Übergänge – Kunst aus Graubünden 1936–1996" (Transitions – Art from Graubunden 1936–1996)

**1997**
Basle, Galerie Hilt, "Multiple Art"
Düsseldorf, Kunstmesse, "Art Multiple"

**1998**
Neustadt an der Weinstraße, Herrenhof, "Faden der Ariadne"
Basle, "Ziegel vom Dach"
Sapporo, Museum Otaru, "Phantastischer Realismus"
Bad Salzdetfurth, Schlosshof Bodenburg, "Europa auf der Stier"
Zurich, Galerie Mangisch, "Gentechnik"
"Schloß St. Germain", purchase for the construction of a first HR Giger Museum 1997
New York, CFM Gallery, "International Artists' Peep Show"

**1999**
Bodenburg, Kunstgebäude im Schlosshof Bodenburg, Kunstverein Bad Salzdetfurth, "Vom Skarabäus zum New Beetle", sculptures and drawings
Essen, Messehallen, "Art Open", pictures, sculptures
Aarau, Tell 99, graphics
Poitiers, Futuroscope, "Utopia", originals, sculptures, graphics
Berne, Kulturhallen Dampfzentrale, "Cyborg Friction", drawings, sculptures
Basle, "Welten des Bewusstseins – Einsichten, Ausblicke", in honour of Albert Hofmann, portfolio "Ein Fressen für den Psychiater"

**2000**
Erlangen, "Phantastik am Ende der Zeit", pictures
Erlangen, Comic-Salon, "Passagen-Tempel"
Bad Rogaz, 1. Schweizerische Triennale der Skulptur "Gebärmaschine" (Aluminium)
Zurich, Züspa-Hallen, IFAS, Design for a blood dialysis machine for Reflotron
Zurich, Galerie Baviera, christening of the newly published Giger Tarot; author of the book: Akron

**2001**
Herrliberg, opening "Kulturschiene" organization: Marielen Uster and Stephan Stucki
Pfäffikon, Seedamm Kulturzentrum, "Gebaut, geschaut", "Passagen-Tempel"
New South Wales (Australia), Orange Regional Gallery, "Fantastic Art"

**2003**
Australia, "Visionary & Fantastic Art" touring exhibition
New York, Williamsburg Arts & Historical Center, "Brave Destiny"
New York, Dabora Gallery, "Mortis Dabora / Tall Tales of Death 2"
Zurich / Gdansk, Museum Migros (Zurich) / Laznia Centre for Contemporary Art (Gdansk), "Bewitched, Bothered and Bewildered" (catalogue)

**2004**
Linz, Landesgalerie am Oberösterreichischen Landesmuseum, "Andererseits: Die Phantastik"

**2005**
New York, InterArt Gallery, "The Inner Eye", Society for Art of Imagination
Berlin, Zitadelle, "Fantastische Welten"

**2006**
Klagenfurt, Biennale Austria 2006, Eroto-mechanics lithographs, Birthmachine sculpture, and Alueloxal series
Lille, Alienor – Cyber Culture & A. A. A.

*H.R.G. on the balcony of the Chateau Marmont, L. A., before the Oscar ceremonies, 1980*

Zurich, Kunsthaus Zurich, "In The Alps", "Mystery of San Gottardo" drawings
New York, Fuse Gallery, "Draw"

## Works in permanent collections/ on permanent display

Chur, Bündner Kunsthalle, paintings and sculptures
Chur, Kalchbühlcenter, Giger Bar, furniture and interior design by H.R. Giger, architect Thomas Domenig
Yverdon, Maison d'Ailleurs, SF museum with "Giger's Library Room"; paintings, furnishings and sculptures
St. Gallen, Restaurant "Zur letzten Laterne", "700 Jahre Warten auf CH-91" portfolio and sculptural works (no longer in existence)
Las Vegas, Galerie Morpheus, Fine Art of the Surreal & Fantastique
Gruyères, Museum HR Giger in Château St. Germain. Established in 1997.
The permanent home of the most extensive collection of artworks by H.R. Giger.
Gruyères, HR Giger Museum Bar in Château St. Germain. Furniture and interior design by H.R. Giger, Architect Roger Cottier. Established in 2003.
"Sabotage" sculpture 2003, on permanent public display on Harakka Island, Finland

## Documentaries

**1967**
"High und Heimkiller", film contribution to U. Gwerder's "Poëtenz-Show"; 16 mm, 11 min., magnetic sound, director F. M. Murer, producers H. R. Giger and F. M. Murer

**1972**
"Passagen", colour film about H.R. Giger by F. M. Murer for the German broadcasting corporation WDR, Cologne; 50 min., sound-on-film, special prize for Best TV Film at the Mannheim film festival

**1973**
"Tagtraum", colour film by Jean-Jacques Wittmer. Psychedelic meeting of the three artists C. Sandoz, W. Wegmüller and H.R. Giger in Sottens; Basle, 28 min., magnetic sound

**1975**
"Giger's Necronomicon", colour film on the work of H.R. Giger from 1972–75
by J.-J. Wittmer and H. R. Giger; 16 mm, 40 min.

**1977**
"Giger's Second Celebration of the Four", film fragment by J.-J. Wittmer and H. R. Giger; 16 mm, magnetic sound, 5 min.

**1979**
"Giger's Alien", documentary film on Giger's work for Alien; 16 mm in colour, 34 min., magnetic sound. Produced by M. Bonzanigo, H.R. Giger and J.-J. Wittmer

**1981**
"HR Giger's Dream Quest", by Robert Kopuit; BCM video recording on 1" tape; 40 min., interview and video animation.

**1982**
"A new face of Debbie Harry", documentary film by F. M. Murer, magnetic sound, 30 min.

**1991**
"Alien I-III", documentary by Paul Bernard, includes documentary film footage by and interviews with H.R. Giger. Prod. CBS/ 20th Century Fox
"Alien I", laser disc, includes documentary films of and an interview with H.R. Giger
Horror Hall of Fame Awards, includes documentary film footage by H.R. Giger

**1992**
"Wall to Wall", BBC documentary on cyberpunk films featuring interviews with H.R. Giger, William Gibson and Bruce Sterling
"Omnibus", H. R. Giger interviewed on director Ridley Scott; BBC, London
"Giger's Passage to the Id", 30 min., documentary by Altro Lahtela and Juhani Nurmi for Finnish television
"Sex, Drugs and Giger", 16 mm colour film, 4 1/2 min., animation by Sandra Beretta and Bätsch for the Solothurn Film Festival

**1993**
"'Brother to Shadows', The Alien World of H.R. Giger", documentary by Morpheus International, dir. by David Frame and prod. by James R. Cowan and Clara Höricht-Frame (in development)

**2003**
"Alien Quadrilogy" DVD, includes documentary film footage by and interview with HR Giger, 20th Century Fox, Los Angeles

**2004**
"Im Auftrag des Jenseits", a documentary film essay about life and death by Florian Höllerl und Patrick Spanbauer, format: DV CAM, Lenght: 90 Minuten, Vienna, Austria

**2007**
"H.R. Giger: Hidden Passages", Exploring the treasures of the H.R. Giger Museum & Giger Bar, an interview and tour with the artist at the Château St. Germain, Gruyères, Switzerland. Short film, directed by Nick Brandestini and Steve Ellington, 16:9 widescreen, High Definition Video

"The H.R. Giger DVD", A comprehensive look at the work and world of H.R. Giger through interviews with the artist, his friends, colleagues, curators, and galleries, with visits to the Giger Museum, Giger Bar, and the Zodiac Fountain and Train Ride in Giger's garden. Includes slide-show of paintings and other bonus materials. Directed by David N. Jahn, produced by Stillking Films and Deep Side Production, Czech Republic, High Definition DVD

"Image, Reflection, Shadow: Artists of the Fantastic", Tracing the imagery of Fantastic

Art from Bosch and Bruegel, through the Renaissance, Impressionism, Surrealism and Dada to modern masters such as Ernst Fuchs, H.R. Giger, Alex Grey and other notable writers, artists, filmmakers and creators. Producers: Jason and Sunni Brock, JaSunni Productions, USA, High Definition DVD

## Work in film, television and theater

**1968**
"Swissmade 2069", designs for Giger's first extraterrestrial creatures for a science fiction film by F. M. Murer, producer Giorgio Frapolli, 35 mm in colour, 45 min., optical sound

**1969**
"Early Morning", designs for a Peter Stein theater production in the Zurich Schauspielhaus

**1976**
"Dune", designs for A. Jodorowsky's unrealized film, based on same title book by Frank Herbert (film later realized by David Lynch without H.R. Giger's involvement)

**1979**
"Alien", 117 min., science fiction/horror, H. R. Giger designed the film's title character and the stages of its lifecycle, plus the film's otherworldly environments, director Ridley Scott, screenplay by Dan O'Bannon, Brandywine Productions, 20th Century Fox, Los Angeles/London

**1979–80**
"Dune", Second cooperation with Dino di Laurentis, designs for Dune Worm and Harkonnen Chair (film was eventually realized without H.R. Giger's designs)

**1981**
"Koo Koo", 2 music videos on film by H.R. Giger for Debbie Harry (Blondie), "Backfired" (4:52 min.), "Now I Know You Know" (5:31 min.), director H.R. Giger, Chrysalis Records, London

**1982**
"The Tourist", extensive designs for the alien life-forms in a planned film by Universal, screenplay by Claire Noto, director Brian Gibson (the film was never realized)

**1986**
"Aliens", 137 min., Science-fiction, director James Cameron, screenplay by Dan O'Bannon and Ronald Shusett, Brandywine Productions, 20th Century Fox, Los Angeles/ London (based on the original designs of H.R. Giger but made without his involvement)
"Poltergeist II", 87 min., film by Brian Gibson, screenplay by Michael Grais and Mark Viktor, produced by MGM, Los Angeles
Design of the "Prix Tell", prize awarded annually to Swiss artists by the Swiss TV corporation DRS

**1988**
"Teito Monogatari" (A. K. A. Tokyo, The Last Megapolis), 135 min., motion picture by Akio Jitsusoji, based on the book by Hiroshi Aramata, produced by EXE, Japan

**1988–89**
"The Train", designs for a planned film to be produced by CAROLCO and directed by Ridley Scott (the film was never realized)

**1990**
"Alien III", 112 min., motion picture by David Fincher, Brandywine Productions, 20th Century Fox, Los Angeles/London (Giger produced extensive new designs for the film but, mysteriously, they were not used)

"Dead Star", designs for a sci-fi film planned by Imperial Entertainment, director William Gibson, screenplay by William Malone (realized in 2000 with the title Supernova, without H.R. Giger's designs or involvement)
"The Mystery of San Gottardo", written by H.R. Giger to be produced as a feature film. In development by H.R. Giger and Leslie Barany, ARh+ Films.

**1992**
"Satan's Head", 8:35 min., film for the RTL+ German TV series "Ungelöste Geheimnisse" (Unsolved Mysteries), drawing upon a short story of the occult by H.R. Giger, director Paul Grau and H.R. Giger

**1994**
"Hide Your Face", music video, mask design for singer Hide, art director Tetsuya Kameyama, MCA Victor, Japan
"Batman Forever", designs for a new Batmobile, director Joel Schumacher, producer Peter McGregor, Warner Bros. California (film was realized without Giger's designs)

**1995**
"Species", 110 min., science fiction/horror directed by Roger Donaldson, screenplay by Dennis Feldman, producer Frank Mancuso Jr., MGM, Los Angeles
"Benissimo", 6:04 min., ballet video with 5 dancers, in a virtual 3D environment of Giger paintings. Written and directed by Max Sieber. Produced by the Swiss TV corporation DRS

**1996**
"Kondom des Grauens", 118 min., Giger as Creative Consultant, directed by Martin Walz, based on the graphic novel by Ralf König. Producers: Ralph S. Dietrich and Harald Reichebner, Elite Entertainment Group

**1997**
"Alien: Resurrection", 109 min., Science-fiction, director Jean-Pierre Jeunet, screenplay by Joss Whedon, Dan O'Bannon and Ronald Shusett, Brandywine Productions, 20th Century Fox, Los Angeles (Alien creatures designs based on H.R. Giger's original work but the film was made without his involvement and released without his credit)

**1998**
"Species II", 93 min., designs for sci-fi thriller, directed by Peter Madak, screenplay by Chris Brancato and Dennis Feldman, producer Frank Mancuso Jr., MGM, Los Angeles.
H.R. Giger took his name off the film prior to its release.

**2000**
"Tell Saga", appeared as the oracle in the C-Files series film by Com & Com, exhibited at the Kunsthaus Zurich

**2003**
"The Executioners" (Gloria), visual concepts and set designs for contemporary thriller, director Marco Lutz, screenplay by Charles Lewinsky, producers by Terje Gaustad and Lukas Erni, Vanquish Alliance Entertainment AG, Zurich, Switzerland, Old Town Films, Ltd. UK. After numerous delays, it is expected to go into production in 2007.

**2004**
"Alien vs. Predator", 101 min., director and screenwriter Paul W. S. Anderson, writing credits Dan O'Bannon ("Alien" characters) and Ronald Shuset. Alien creature designs based on H.R. Giger's original work but the film was made without his involvement.

**2005**
"Parsifal", Richard Wagner's opera directed by Bernd Eichinger, conducted by Daniel

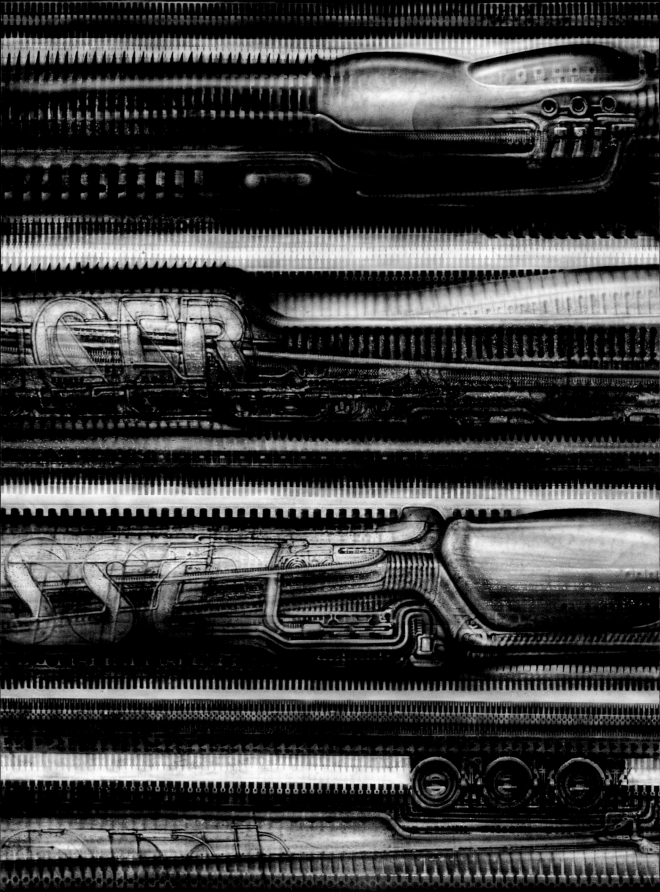

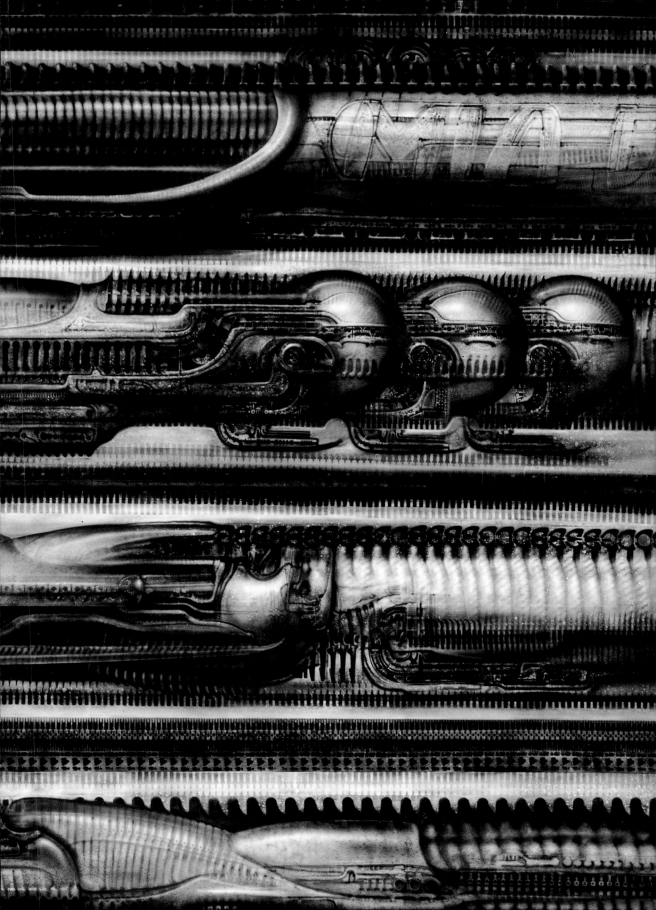

*H.R.G. in Benissimo, a program of the DRS, August 4, 1995*

Barenboim, Staatsoper Unter den Linden in Berlin, "Victory VI" used in set design

**2006**
"Alien vs. Predator 2", directed by Colin & Greg Strause, screenplay by Shane Salerno, writing credits by Dan O'Bannon ("Alien" characters) and Ronald Shuset. Alien creature designs based on H.R. Giger's work but the film is presently in production without his involvement. Projected release in 2007.

## Prizes and awards

"**Inkpot award**", San Diego Comic Convention, 1979

"**Academy Award**", Oscar for Visual Effects on "Alien", 1980

"**Readercon Small Press Award**", Best interior illustrator and best jacket illustration, Los Angeles, Morpheus International, 1991

"**Anerkennungspreis**", Grisons, 1994

"**Vargas Award**", Outstanding contribution in airbrush industry from Airbrush Action magazine, 1998

"**La Médaille de la Ville de Paris**", presented at Paris City Hall, 2004

## Original graphics, limited edition prints and portfolios

"**A Feast for the Psychiatrist**", 1966. Artist's cardboard portfolio, screen print, 12 A4 reproductions, drawings, map print. Portfolio signed and numbered in an edition of 50. 42 x 31 cm (approx. 30 copies printed). Printed by H. R. Giger/Lichtpausanstalt Zurich.

"**Biomechanoiden**", 1969. Portfolio of 8 screen prints, black on silver, all signed and numbered in an edition of 100 + XX. 100 x 80 cm (partially destroyed by fire). Published by Bischofberger, Zurich. Printed by Steiner, Zurich.

"**Trip-Tychon**", 1970. Portfolio of four 3-coloured screen prints, all signed and numbered in an edition of 100. 100 x 70 cm (partially destroyed by fire). Published by Bischofberger, Zurich. Printed by Silkprint, Zurich.

"**Passagen**", 1971. Portfolio of 4 multicoloured serigraphs, all signed and numbered in an edition of 70 + XX. 90 x 70 cm (partially destroyed by fire). Published by Bischofberger, Zurich. Printed by Silkprint, Zurich.

"**H. R. GIGER, Li I**", 1974, Photogravure, hand coloured, 70 x 100 cm. Signed, edition of 170.

"**Second Celebration of the Four**", 1977. Clothbound presentation box with embossed title and 8 fold-out sheets, all issues signed and numbered in an edition of 150, of which nos. 1–10 contain a hand-finished photo (original). 42 x 40 cm. Printed by A. Uldry, Hinterkappelen.

"**Alien**", 1978. Portfolio of 6 screen prints in four colours, all signed and numbered in an edition of 350. 70 x 100 cm, 100 portfolios released for sale. Published by H.R. Giger and 20th Century Fox. Printed by A. Uldry, Hinterkappelen.

"**Erotomechanics**", 1980. Portfolio of 6 screen prints in eight colours, all signed and numbered in an edition of 300. 70 x 100 cm. Published by H. R. Giger. Printed by A. Uldry, Hinterkappelen.

"**N. Y. City**", 1982. Portfolio with 5 screen prints in 8 colours, all signed and numbered, edition of 350. Ugly Publishing, Richterswil. Printed by A. Uldry, Hinterkappelen.

"**Pilot in Cockpit**" and "**Alien Egg**", Version II, 1978, in an edition of 1000, signed and numbered, 19 1/2" x 27". Limited edition: Dark Horse, 1991

"**E. L.P II, Brain Salad Surgery**", record cover, 26 1/2" x 22 1/2", 1973, + Debbie Harry, "Koo Koo", triptych, 21 1/2" x 34", 1981, Record Art Collection, 1991. 10,000 prints, of which 200 are signed and numbered.

"**E. L.P IX**", 28" x 28" (picture 24" x 24") and "Biomechanoid", 28" x 40" (picture 24" x 24"), 1991. Set of 4-colour prints, signed and numbered in an edition of 495. Published by Morpheus International.

"**700 Years of Waiting for CH–91**", 1991. Accordion-folded portfolio of 50 original lithographs, all signed and numbered (nos. 1–75 on special paper; nos. 76–300 on ordinary paper), in an edition of 300. Published by H.R. Giger. Printed by Walo Steiner, Asp.

"**H. R. Giger's Baphomet Tarot**", 1992. Portfolio book of 24 zinc lithographs of drawings, in an edition of 99. Published by H.R. Giger, Printed by Walo Steiner, Asp.

"**Stier, "Fisch**" and "**Zodiac-Brunnen**", 1993. Zinc plate lithographs in five colours. Morpheus International, Printed by Walo Steiner, Asp.

"**Daemon**", 20" x 22", 1994. Offset print in 4 colour. Signed and numbered edition of 300.

"**Necronom V**", 39" x 27", 1994. Offset print in 4 colour. Signed and numbered edition of 300.

"**Sil Triptychon**", © H.R. Giger + MGM, 1995. Two-colour screen print, 90 x 120 cm, in an edition of 1/290 + EA. Published by Morpheus International, Printed by A. Uldry, Hinterkapellen.

"**Species Behind the Scenes**", © H.R. Giger + MGM, 1995. Six-colour screen print, 90 x 120 cm. Edition A: 170 x 120 cm, 1/350 + EA, c. 200 commercially available, all signed and numbered. Edition B: 100 x 70 cm, 1/400 + EA, not commercially available, all signed and numbered. Published by MGM and H.R. Giger. Printed by A. Uldry, Hinterkappelen.

"**Partial Suicide Machine**", 1997, etching, 85.5 x 64.5 cm, Printed by TASCHEN GmbH

"**Alchemic Wedding**" and "**Angel from the House of the Last Lantern**", 1997, eight-colour zinc-plate lithograph, 69 x 49 cm,

99 signed and numbered prints, printed by Walo Steiner, Densbüren.

"**Ein Fressen für den Psychiater**", 1999, expanded 1965 portfolio. Edition (No. 16 to 50 completed), 2-colour lithographs, all signed and numbered, printed by Walo Steiner.

"**Alu-Eloxale**" prints, produced from eight 1960s paintings, edition 23 each, 2000.

"**Li II**", Morpheus Fine Art, 2000. Eight colour Giclée on watercolour stock, 252 x 108 cm. Signed and numbered edition of 50.

"**The Professionals**", 2001. Six large-format posters of Biomechanoids in various professions, Berufspersonal AG, edition of 100 signed and numbered prints, Museum HR Giger.

"**Castle Train**" print for the HR Giger Museum, 2004. Digital fine art prints on acid free paper, 40 x 50 cm. Signed and numbered edition of 10,000. Museum HR Giger.

"**Cthulhu News**" portfolio, 2004. Six digital fine art prints on acid free paper of 1966 pen and ink, works No.: 44, 45, 46, 47, 48, 49. 34 x 30 cm each, limited edition of 99, signed and numbered. Museum HR Giger.

"**Xenorotica**" portfolio, 2005. Six erotic sketches reproduced as fine art Giclée prints, in portfolio case with silk-screened Museum HR Giger logo on cover. Edition of 66. Signed and numbered, ARh+ Editions.

"**Im Netz**", "**Shoe Work Landscape**", "**Rattenbild**", 2005. Three individual erotic fine art Giclée prints, 18" x 24", edition of 99. Signed and numbered, ARh+ Editions

Film Design Series: "**Alien Monster IV**" (70 x 75 cm), "**Dune 2**" (90 x 70 cm), "**Tourist IX**" (93 x 55 cm), Morpheus Fine Art, 2006. Set of 3 offset prints on acid free stock. Signed and numbered edition of 400.

## Special projects

"**Video clip**" by Odessa-Film C für Pioneer, Japan, 1985

"**Tokyo, Giger Bar**", entrance and four level interior, designed by H.R. Giger (but not fabricated by Giger). No longer in existence. 1988

"**Baphomet – Das Tarot der Unterwelt**". Tarot cards designed by H.R. Giger/Akron for Edition with book, 1993; with abridged book, 1993. with abridged book and CD, German, English and French, AG Müller, Switzerland, 1995

"**Giger Bar**", Kalchbühlcenter, Chur, 1992

"**Dark Seed**", 1992, "**Dark Seed II**", 1996, computer games, and "**Screensaver**", 1995, using images based on H.R. Giger's works. Cyberdreams, Los Angeles

"**H. R. Giger Desk Set**", containing 1996 3D calendar, blank book, address book and postcard book. TASCHEN GmbH, Cologne 1995

"**H. R. Giger 3D Calendar 1996**". Special edition as portfolio, signed and numbered, in an edition of 300 and 100 artist's copies, TASCHEN GmbH, Cologne, 1995

"**Mousepads**", Paysage XIV, Necronomicon I, by Morpheus International, Los Angeles 1996

"**The H. R. Giger Calendar of the Fantastique**", published annually since 1993 by Morpheus International, Los Angeles

"**H. R. Giger's Species Design**". Special leather-bound edition including zinc lithograph; Printed by W. Steiner, Asp 1996

"**H. R. Giger's Zodiac Fountain**", Atelier HR Giger, Zurich, 1997

"**Giger Internet Pin**", silver-plated copper pin of the HR Giger Museum International Membership Club. Diameter: 40 mm with engraved membership number. Gruyeres, 1997

"**Miniature Zodiac Signs**", white bronze, each in an edition of 23. Aquarius, Aries, Cancer, Virgo, Libra, Scorpio, Sagittarius, Capricorn, Gemini, Leo, Pisces, Taurus, each 1/5 of the original size. Atelier HR Giger, Zurich, 1997

"**H. R. Giger Watches**", Li II, Landscape XIX, by Morpheus International, Las Vegas, 1998

"**H. R. Giger Room**", Limelight nightclub. VIP Room, interior design, sculptures and prints (stolen table yet to be recovered), New York City, 1998–2002

"**Birth Machine Baby/9 mm Giger**", sculpture in bronze and aluminum, 20" x 8" x 8", based on the Bullet-Babies in Work No. 25, Birth Machine, 1967. Edition of 2 x 23 in bronze and aluminum, HR Giger/ARh+ Editions, New York, 1998

"**Microphone stands**" for rock group Korn, Atelier HR Giger, Zurich, 2000

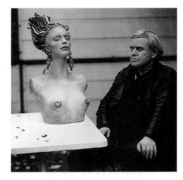

*H.R.G. with Sil model on the terrace. Photo: Panja Jürgens*

"**Computer virus sculpture**" for "Open Systems", Orbit-Messe, Basle, 2000

**Design of the awards** for Festival International du Film Fantastique, Neuchâtel, 2000

**Stage design** for French rock singer Mylene Farmer, 2000

"**H. R. Giger Diary**" 1996, 1998, 2001, 2004, 2006, TASCHEN GmbH

"**H. R. Giger Museum Jewelry**", rings, pendants, belt-buckle, on-going project since 2002

"**Opening of the H. R. Giger Museum Bar**" at Château St. Germain, Gruyères, 2003

"**Tattoo Biomechanoid**", brass and black resin, 5" x 6.5", miniature silver tattoo machine, numbered editions of 500, signature etched into the sculpture. ARh+ Editions, NYC, 2004

"**Li II collectible**" from McFarlane Toys, USA, 2004

"**Smart Skin**", Giger cell phone, Wildseed, USA, 2004

**"MacSkinz"**, artist series Ipod covers, USA, 2005

**"Ibanez Giger guitars"**, Hoshino, Japan, 2005 and 2006 series

**"Museum H.R. Giger Posters"**. Continuing poster publishing relationship with long time friend, Hans H. Kunz, of Wizard & Genius-Idealdecor AG, Oetwil Am See, Switzerland

**"Satan I T-shirt"**. The artwork used on the album "To Mega Therion" is produced as a T-shirt in partnership with Celtic Frost, worldwide, 2006

**"Absinthe Brevans"**. *ELP II* painting used as bottle label design by Absinthvertrieb Lion, Teningen, Germany, 2007

**"*Life-Support* T-shirt"**. Artwork used on the Carcass album "Heartwork" is produced as a T-shirt by Carcass and Just Say Rock! Inc. 2007

## Books and catalogues by and about H.R. Giger

**"ARh+"**, by H.R. Giger, Walter Zürcher Verlag, Gutendorf, 1971 (out of print)

**"Passagen"**, by H.R. Giger, Bündner Kunsthaus, Chur, 1974 (out of print)

**"Catalogue for H.R. Giger exhibition"**, Galerie Sydow-Zirkwitz. Text by Horst A. Glaser, Frankfurt, 1976 (out of print)

**"H.R. Giger's Necronomicon"**, Sphinx Verlag, Basle, 1977 and 1978; new editions as "H.R. Giger's Necronomicon I", Edition C, Zurich 1984, and Edition C, Zug 1988 (all softcover) and 1991 (first hardcover edition). Licensed editions: Humanoid Assoc., Paris, 1977 (out of print), Big O, London, 1980 (out of print), Treville, Tokyo, 1987, and Morpheus International, L.A., 1991 and 1992

**"Giger's Alien"**, Sphinx Verlag, Basle; Edition Baal, Paris; Big 0, London, 1980 (softcover, all out of print); Treville, Tokyo, 1987. New editions: Edition C, Zug, 1989, 1992, 1995 (hardcover); Titan Books, London and Morpheus International, L.A., 1990

**"H.R. Giger/New York City"**, Sphinx Verlag, Basle, 1981; Ugly Publishing, Richterswil, 1981 and Edition Baal, Paris, 1981 (all out of print), Treville, Tokyo, 1987

**"H.R. Giger, Retrospektive 1964–1984"**, ABC Verlag, Zurich, 1984 (out of print)

**"H.R. Giger's Necronomicon 2"**, Edition C, Zurich, 1985 (in France distributed with a booklet of the text in French by Edition Baal, Paris (out of print)). New edition by Edition C, Zug, 1988 (softcover) and 1992 (first hardcover edition). Licensed editions: Treville, Tokyo, 1987; Morpheus International, Los Angeles, 1992

**"H.R. Giger's Biomechanics"**, Edition C, Zug, 1988 (softcover). Licensed editions: Treville, Tokyo, 1989; Morpheus Int., Los Angeles, 1990 and 1992

**"H.R. Giger ARh+"**, TASCHEN GmbH, Cologne, 1991. English, German, Italian, Spanish, Dutch, Swedish

**"H.R. Giger Posterbook"**. Portfolio of 6 prints in four colours. TASCHEN GmbH, Cologne, 1991

**"H.R. Giger Sketchbook"**, Museum Baviera, Zurich, 1985, 1992

**"H.R. Giger Postcardbook"**, TASCHEN GmbH, Cologne, 1993

**"H.R. Giger's Necronomicon 1 + 2"**. Collector's Edition, German, 500 copies bound in black Pecorex, embossed, signed and numbered, including original lithograph "Back to Mother" (printed by Walo Steiner), Edition C, Zurich, 1985; edition of 666 bound in black leather in a presentation box, signed and numbered with an original lithograph on the title page (printed by Walo Steiner), first 23 copies include a hologram

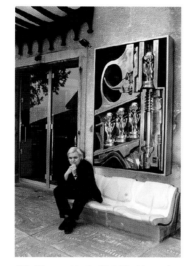

*H.R. Giger next to the Birth Machine sculpture at the entry of his museum in Gruyères. Photo: © Louis Stalder*

(produced by Kühne & Partner, Switzerland). Published by Morpheus International, Los Angeles, 1990

**"Giger's Watch Abart '93"**. Exhibition catalogue, H.R. Giger and ARh+ Publications N.Y.C., Foreword by Leslie Barany

**"H.R. Giger's Species Design"**, Morpheus International, Los Angeles, 1995; Edition C, Zug, 1995; Titan Books, London, 1995; Treville, Tokyo, 1995; Special leather hardcover edition with cloth slipcase. Signed and numbered lithograph with silver ink (printed by A. Uldry, Hinterkappelen) bound in each book. Edition of 350, Morpheus International, Los Angeles, 1995

**"H.R. Giger's Film Design"**, Edition C, Zug, 1996. Licensed editions: Morpheus Int., Los Angeles, 1996; Titan Books, London, 1996; Treville, Tokyo, 1996; "Special Limited Edition" – signed and numbered edition of 200. Leather-bound, silver foil-stamped with cloth slipcase, with folded "Alien III" lithograph, signed and numbered, "Ultimate-Limited Edition" – signed and numbered edition of 150. Leather-bound, foil-stamped in cloth slipcase, with folded, signed and numbered "Alien III" lithograph, plus unfolded, signed and numbered "Alien III" lithograph on vellum, Morpheus International, Beverly Hills, 1996.

**"HR Giger Visioni di fine millennio"**, catalogue of the exhibition in Milan at the Palazzo Bagatti Valsecchi, hardcover deluxe edition A: 1–70 signed and numbered with a CD by Shine; B: 71–170, signed and numbered, 1996

**"www HR Giger com"**, TASCHEN GmbH, Cologne 1996 (German). English, French, Spanish, Italian, Dutch and Portuguese edition 1997; Deluxe edition with zinc plate lithograph in 3 colours, signed and numbered. Printed by Walo Steiner, Asp 84 x 60 cm, folded and bound. Edition A: 1–23/

300 lithograph and "Hoppla 1" hologram, 60 x 20 cm. signed by Urs Fries; Edition B: 24–300/300, lithograph signed and numbered.

**"HR Giger Retrospective 1964–1984"**, Morpheus International, Los Angeles, new English and German edition, 1998

**"The Mystery of San Gottardo"**, TASCHEN GmbH, Cologne, 1998

**"H.R. Giger Bestiary: Monsters from the Id"**, Morpheus International, LA, 1998

**"HR GIGER"**, Icons, TASCHEN GmbH, Cologne, Texts by Stanislav Grof and Les Barany, 2002

**HR Giger Work Catalogue**, catalogue raisonné, Matthias Belz and Marco Witzig, continuing work in progress. www.Giger-WorkCatalog.com.

**"The World According to H.R. Giger"**, Halle Saint Pierre & Passage Pietons, Paris, retrospective catalogue, 2004

**"El mundo de HR Giger"**, published thesis by Dr. Carlos Arenas, University of Valencia, Spain, 2005

**"HR Giger in Prague"**, PP Production, Prague, Czech Republic, retrospective catalogue, 2005

**HR Giger**, Publisher "Um die Ecke", Museum Baviera, Zurich, edition of 500, signed and numbered, with five enclosed signed and numbered Prague inspired prints, 2005

**"Giger in Wien"**, KunstHausWien, Vienna, Austria, retrospective catalogue, 2006

**"Magician with the Airbrush"**, Frank Festa Verlag, Taucha. Biography by Herbert M. Hurka. In preparation.

**"HR Giger's Biomechanics"**, Morpheus International, Las Vegas, edition of 300. Included with each book is one of three different signed and numbered Giclée prints, 2006

**"HR Giger: Through Their Eyes"**, never before published behind the scenes photos by 30 photographers, in development, ARh+ Editions & Scapegoat Publishing, USA, 2007

**"HR Giger in 3D"**, translation of Giger's paintings for 3D viewing by Michael Verhoef. In development, ARh+ Editions & Scapegoat Publishing, USA, 2007

## Broadcast interviews and documentaries

ZDF, Heute und Morgen, "Zwei Künstler sehen unsere Welt: Pfeiffer und Giger", 1978/79
DRS, TAF, 1979
ORF, Kintop, 1979
DRS, Rendez-vous, 1979
ZDF, A propos Film, 16.10.79
TF1, Temp X "Giger's Alien", 1980
ORF, Café Zentral, 1980
DRS, Film-Szene Schweiz, 29.9.80
SSR, Zone Bleue "Bruno Weber", 10.1980
DRS, Karussell, 1981
"Giger's Dream Quest", 40', 1981
DRS, Tagesschau "ART 12'81", 1981
ORF, Musik-Szene "Debbie Harry" 10.1981
BBC 1, "Debbie Harry", 28.7.81
ORF, Magazin Okay "H.R. Giger-Porträt", 23.5.82
DRS, Kassensturz, 1984
Sidney, The Occult Experience, 1985, by Nevill Drury
SSR, L'aventure surréele, 27', 1984/85, by Gilber Bovay

3SAT, "Das phantastische Universum des H.R. Giger", 44' 47", 1986
ZDF, "Das phantastische Universum des H.R. Giger", 44' 47", 1986
ZAK, 1987
ZDF, Engel, Teufel und Dämonen, 19.7.87
DRS, Sonntags-Magazin "Gastro Styling U. Steinle", 8.11.87
DRS, Engel, Teufel und Dämonen, 1989
TF1, Créateurs Studio Hollywood, 10.5.89
TSR, Viva "Gens de la Lune", 100', 1990
DRS, Kultur Aktuell "Migros-Tragtaschen", 22.4.90, 19.50
France, "Les livres d'esquisses de H.R. Giger", 1991
DRS, Dynamix, 1992
3SAT, "Giger-Bar", 1992
BBC, Omnibus, H.R. Giger-Interview über R. Scott, 1992
BBC, Wall to Wall "Documentary an Cyberpunk", 1992
Finnish TV, "Giger's Passage to the Id", 30', 1992
Teleclub, Close Up "Alien III", 1/3.9.92
RTV, 36', 11.6.92
RTL Plus, Explosiv Magazin, 12.11.92
RTL+, Ungelöste Geheimnisse "Satanskopf", 20', 13.12.1992
Press Kit, "Alien III", 1993
BBC, Man Machine, 1993
DRS, Fragment "Magie und Tarot", 14.1.93
DRS, TAF "Necronomicon", 15.2.93
DRS, TAF "Horoskop", 1993
DRS, Zehn vor Zehn "Satanismus", 2.3.94
DRS, Tagesschau "Pin-Festival Flims", 2,5', 9.4.1994
DRS, TAF-Bazar "Mondaine N.Y.C.-Watch", 13.4.94
S Plus, City Arte, 26.5.94
RTV, Alien-Swatch "Ausstellung Mangisch Zürich", 30.5.–5.6.94
DRS, Zehn vor Zehn, "Haus zur letzten Laterne", 1.7.94
DRS, Aktuell "Haus zur letzten Laterne", 1994
ZDF, Aspekte "Fetisch und Kult", 1994
SCI-FI-Channel, Trader, 12.12.94, 23.54
R.T.B.F., Téléjournal "Festival du Film Fantastique Bruxelles", 3.1995
B.R.T.N., Ziggurat "Festival du Film Fantastique Bruxelles", 3.1995
Télébruxelles, Travelling "Festival du Film Fantastique Bruxelles", 3.1995
VT4, émission cinéma "Festival du Film Fantastique Bruxelles", 3.1995
Vox, Wahre Liebe, 1995
Züri 1, Akasha, 30.6.95
Züri 1, Telebazar "Bits & Grips", 0.2', 11.7.95, 19.00
DRS 4, CH–Magazin, 13.0', 5.10.95
Tele Züri, Zip, 12.10.95
Tele Züri, Steinfels Live, 29.10.95
DRS 4, Gesundheit "Schlaf", 15.11.95
DRS, Zebra, 1995
Tele M1, Magazin, 23.2.96

## English bibliography

Gert Schiff: "Images of Horror and Fantasy", catalogue, Bronx Museum
Harry Harrison: "Mechanismo", London, 1978
Robin Stringer: "The Man Who Paints Monsters in the Night", Sunday Telegraph Magazine, No. 151, 1979
Katrin Ames: "Hollywood's Scary Summer", Newsweek, 1979
Frederic A. Levy: "H.R. Giger, Alien Design", Cinefantastique, No.1, 1979
Mike Bygrave, Joan Goodman: "How Art Triumphed Over Science", Observer, 1979
Albert Foster: "How a Monster Called "Thingy" is Taking Over the World", Daily Mirror, 1979
Jeff Walker: "The Alien – A Secret too Good to Give Away", Rolling Stone, No. 292, 1979
Helen MacKintosh: "The Thing that Laid a Golden Egg", Time-out, No. 490, 1979
Dawn Maria Clayton: "Giger Rhymes with 'Meager'", People Weekly, 1979

David Houston: "H.R. Giger: Behind the Alien Forms", Starlog No. 26, Sept. 1979
Palmer Poroner: "H.R. Giger Comes to New York", Artspeak, December, 1981
Debbie Harry and Chris Stein: "Interview with H.R.G.", Andy Warhol's Interview, December, 1981
Debbie Harry and Chris Stein: "Strange Encounter of the Swiss Kind", Heavy Metal, December, 1981
Richard S. Meyers: "Giger, the Great Alienist of Artists", Famous Monsters, Oct., 1981
E. F. Watkins: "Tales from the Dark Side", Airbrush Action, January, 1987
Rober Masello: "Deathscapes", Omni, September, 1987
Clifford Steiglitz: "On Giger's Turf", Airbrush Action, January, 1988
James Cowan: "Giger", Twilight Zone Magazine, April, 1988
Les Paul Robley and Jan Doense: Interview in Cinefantastique, Vol 18 No. 4, May, 1988
Lou Stathis: "H.R. Giger/High Art", High Times, March, 1990
Lou Stathis: (Dark Horse Comics), "Monster from the Id: Giger's Alien", Alien 3, Volume 2, March, 1990
"Gallery", Heavy Metal, Volume 14, No. 3, July, 1990
Lou Stathis: (Dark Horse Comics), "H.R. Giger", Cheval Noir 10, August, 1990
Justine Herbert: "Surreal Royalty", Fad Magazine, No. 21, December, 1990
Juhani Nurmi and Peter Briggs: "Eye of the Giger", Fear 24, December, 1990
Vincent Di Fate: "The Roots of Imagination", Cinefantastique, May, 1992
Jan Doenes: "Design Genius H.R. Giger", Cinefantastique, June, 1992
Justine Herbert: "Fantastique Giger Bar", Fad Magazine, Spring, 1992
Maya Browne: "Creature Comfort", Details, November, 1993
Jessica Willis: "Swiss + Myth", New York Press, November, 1993
Jana Eisenberg: "Probing Darkly, Watching Out for the Future", New York Newsday, December 1, 1993
Javier Martinez de Pison: "An Artist from the Future", La Prensa, December 12, 1993
Ray Johnson: "Riding H.R. Giger's Nightmare Train", Manhattan Mirror, Vol. 1, No. 8 1995
Steve Johnson: "Those That Devour Children: A Visit with H.R. Giger", Gauntlet, Vol. 1, 1993
Valery Oisteanu: "Blood, Swatch and Fears", Cover Magazine, January, 1994
Genevieve T. Movie and Lou Stathis: "H.R. Giger Under Your Skin", International Tattoo Art, February, 1995
Les Paul Robley: "Alienated", Image-Movies, March, 1994
Fred Szebin: "H.R. Giger's The Tourist", Cinefantastique, August, 1994
Justine Herbert, Leslie Barany, H.R. Giger: "Digressions in Time", Fad Magazine, No. 31, 1994
Steve Cerio: "H.R. Giger/Alienated", Seconds, No. 25, 1994
Shade Rupe: "Gigerwerks, 1990–95", Funeral Party/The Horror Society/NYC, 1995
Joseph B. Mauceri-Macabre: "Species, MGM, Sil, The Ghost Train, and the Frustrations of H.R. Giger", Part 1, World of Fandom, Vol. 2, No. 25, Winter, 1995
Joe Mauceri: "H.R. Giger and the Beautiful Monster", Shivers, No. 21, September, 1995
Joe Mauceri: "All Aboard the Ghost Train!", Shivers, No. 22, October, 1995
Louis Stalder: "Species Behind the Scenes", 3-D sculpture by H.R. Giger, Cover photo, World of Fandom, Vol. 2, No. 24, Summer, 1995
Dave Hughes: "H.R. Giger Surreal Visionary", Starlog movie series 3, 1995
Les Paul Robley: "H.R. Giger, Origin of Species", "Ghost Train Nightmare", "Sil's Design Prototype" and "Building Giger's Alien", Cinefantastique, Vol. 27, No. 7, March, 1996
H.R. Giger: "The Designer's Movie Post-

mortem", "Giger Speaks (letter column)", Cinefantastique, Vol. 27, No. 7, March, 1996
Robin Perine: "Harkonnen Capo Chair and Natasha Henstridge", Cover photo, Femme Fatale, Vol. 4, No. 8, June, 1996
Joseph B. Mauceri-Macabre: "Species, MGM, Sil, The Ghost Train, and the Frustrations of H.R. Giger", Part 2, World of Fandom, Vol. 2, No. 26, Spring, 1996
Edward Gross: "Death and the Maiden", Cinescape Insider, Vol. 3, No. 9, 1997
"Winner/Loser of the Week", Entertainment Weekly, December 12, 1997
"Alien Father Attacks", Dreamwatch magazine, Issue 41, January 1998
"Loving the Alien", Uncut, January 1998
Starburst magazine, Science Fiction Entertainment, February 1998
"Alien Insurrection", Total Film, Issue 14, 1998
Sci-Fi Channel Entertainment, Vol. 4, No. 7, April 1998
Dan Scapperotti: "Alienated Again", Cinefantastique, April 1998
Dan Scapperotti: "Species 2: Designer H.R. Giger. The World's Premier Monster-maker on his Art" (Editorial by Frederick S. Clarke), Cinefantastique, Vol. 30, No. 1, May 1998
Stewart Jamieson: "Origin of the Species", SFX, No. 38, May 1998
Neil Johnson: "Alien Insurrection: Giger vs. 20th Century Fox", Airbrush Action, May/June 1998
Patrick Sauriol: "Father of the Beast", Sci-fi Invasion, Summer 1998
Afarin Majidi: "H.R.Giger: Night Visionary", Shout, Vol. 1, No. 7, September 1998
James Cowan: "We Have Met the Alien and He Is Us", Art Visionary, No. 1, October 1998
George Blooston: "The Pod Squad", Entertainment Weekly, No. 454, October 1998
Shade Rupe: "Giger in NYC", Scream, No. 10, January 1999
Paul Taglianetti: "The Mother of Them All", Sci-fi & Fantasy Models International, No. 45, 2000
"Cthulhu Rising", Edge Magazine, September 2000
R.F. Paul: "Baphomet's Lament", Esoterra, No. 9, Fall/Winter 2000
Ron Magid: "Timeless Sci-Fi", Total Movie & Entertainment, No. 3, February/March 2001
Dan Epstein: "Sex Machine", Revolver, No. 4, March/April 2001
George Petros: "The Biomechanical Surrealism of HR Giger", Juxtapoz, No. 35, November/December 2001
Doktor John: "Safe And Surreal – Fuse Gallery Opening", The Aquarian, No. 2–132, April 2002
George Petros: "H.R. Giger Into the Heart of Darkness", Propaganda, No. 27, October 2002
George Petros: "H.R. Giger – On Tattoos and Tattooing", Needles, Ink., 2002
Javier Martínez de Pisón: "In the Belly of the Beast", WestEast, No. 7, Summer 2003
George Petros: "H.R. Giger on Tattoos and Tattooing", Woodstock Tattoo and Body Arts Festival Program Guide, September 2003
Zak Shaw: "Woodstock Tattoo Festival", Alm@nac Weekly, No. 36, September 2003
"Bones Brigade", Juxtapoz, No. 46, September/October 2003
"H.R. Giger's Woodstock 2003", YRB, No. 35, November 2003
Javier de Pison: "In the Belly of the Beast", Secret No. 23, 2003
Mark Ramshaw: "Create Creatures", 3D World, No. 45, December 2003
Gothic Beauty, No. 11, Winter 2003
Mark Ramshaw: "Levi's Train Ad Spot", 3D World, No. 47, January 2004
"Biomechanic, The Art of H.R. Giger", Fiend, No. 2, March 2004
Liisa Ladouceur: "Warning: Travelogue of Terror – H.R Giger Museum and Bar in Gruyere, Switzerland", Rue Morgue, No. 38, March/April 2004
"Panic Room", Airbrush Art + Action, No. 54, April 2004

*The complex of buildings of Château St. Germain: The Museum HR Giger on the left and the Museum Bar on the right. Photo: © Louis Stalder*

Christine Ehren: "H.R. Giger's Baphomet", Cthulhu Sex, No. 19, Fall 2004
Gary Butler: "The Forsaken Art of H.R. Giger", Rue Morgue Collectors Ed., No. 42, January/February 2005
Samantha Warwick: "Out of This World", The Guardian, April 29th 2006

**Editor's Note: An archive, with PDF file downloads, of most articles published about H.R. Giger can be found at www.littlegiger.com.**

## Missing H.R. Giger artworks

View From My Room in the Alpine Middle School Davos, 1958, opaque colour on paper, 24.8 x 34.7 cm
Work No. 025, Shaft Nr. 1, 1964, ink on paper, 21 x 15 cm
Work No. 026, Shaft Nr. 2, 1964, ink on paper, 21 x 15 cm
Work No. 075b, Armor for a Dog, 1967–68, polyester
Work No. 217 and 218, ELP I and ELP II (Brain Salad Surgery album cover paintings), 1973, acrylic on paper, 34 x 34 cm each. Stolen in Prague in 2005.
Work No. 372, Alien III, side-view 3, 1978, acrylic on paper, 140 x 100 cm
Work No. 396, Wreck (detail), 1978, acrylic on paper on wood, 100 x 140 cm
Work No. 476b, 477b, 478b, 479b, series of 5 self-portraits for the documentary film "Giger's Dream Quest", 1981, acrylic on photograph, 45 x 35 cm each. Stolen in The Netherlands.
Work No. 491, The Tourist III, Hanging Crab Alien, 1982, acrylic on paper, 100 x 70 cm
Work No. 492, The Tourist IV, Bathtub Creature with Tentacle, 1982, acrylic on paper, 100 x 150 cm
Work No. 509, Biomechanoid with Alien Head, 1983, acrylic on paper, 100 x 70 cm
Work No. 701b, Biomechanical Matrix Small Table, 1990–91, aluminum, 46 x 100 x 110 cm. Stolen from the Limelight Giger Room, New York City, in January 2002.
Galerie Carré Blanc (700 years of Waiting), 1991, ink on transcop, 30 x 21cm

## Museum HR Giger

Château St. Germain, CH–1663 Gruyères, Switzerland
Tel: +41 26 921 2200 Fax: +41 26 921 2211
E-Mail: info@hrgigermuseum.com

**1997**
September 11: Château St. Germain, a medieval castle, purchased by H.R. Giger at auction

**1998**
June 20 (Fête de la Sainte Jeanne): Inauguration of the Museum HR Giger.
Director: Prof. Dr. Barbara Gawryziak, Architect: Roger Cottier
December 29: Dedication of the exhibition

area for the permanent exhibition of H.R. Giger's private collection of Fantastic Art

**1999**
December 11: Exhibition "Fred Engelbert Knecht" in the expanded museum space

**2000**
August 4: Opening of the Museum HR Giger Gallery, exhibition of linoprints by François Burland

**2001**
April 6, Museum HR Giger Gallery: Exhibition "Günter Brus", works from the private collection of H.R. Giger

**2002**
Carmen Scheifele and Ingrid Lehner become the co-directors of the museum replacing the retiring Barbara Gawryziak.
March 9, Museum HR Giger Gallery: Exhibition "Claude Sandoz", works of the late 1960s

**2003**
April 12, Inauguration of the Museum HR Giger Bar, and opening of the Martin Schwarz exhibition "Amongst The Living" in the Museum HR Giger Gallery, book objects, digital montages, over-painted collages, and collaborative paintings with H.R. Giger

**2004**
February 28, Museum HR Giger Gallery: Exhibition "Prof. Ernst Fuchs", paintings, prints, and sculptures

**2005**
June 25, Museum HR Giger Gallery: Exhibition "Imagine Yourself", art of Rudolf Stüssi

**2006**
June 17, Museum HR Giger Gallery: Exhibition "Flights of Imagination", selected works from the Society for Art of Imagination
November 18, Museum HR Giger Gallery: Exhibition "Hans Bellmer – Drawings and Graphics"

**2007**
The launch of the homepage www.HRGiger-Museum.com

**Official HR Giger Websites:**

**www.HRGiger.com**
**www.HRGiger-Museum.com**
**www.HRGigerAgent.com**
**www.LittleGiger.com**
**www.Giger.com**

*Page 236 and 237: No. 471, New York City XXI (Subway), 1981.*
*Acrylic and ink on paper, 140 x 200 cm*

# MUSEUM HR GIGER

Known throughout the world as the creator of the terrifying creatures and their otherworldly environment in the sci-fi film classic "ALIEN" (for which he received the Oscar for Best Achievement in Special Effects), H.R. Giger is, at once, one of our great visionaries and an artist whose imagination co-exists with the reality of his time.

Often compared with Bosch and Dali, H.R. Giger's aesthetic universe far transcends cinematic dreams and science fiction. Painter, sculptor, designer, interior architect, the pandemonium of Giger's vision into all domains.

The HR Giger Museum in the medieval walled city of Gruyères, Switzerland, is the permanent home to many of the artist's most prominent works, including the largest collection of the artist's paintings, sculptures, furniture and film

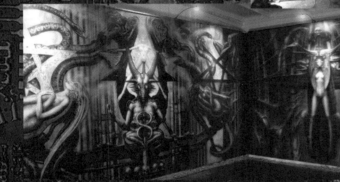

designs, dating from the early 1960's until the present day.

Displayed on the museum's top floor is Giger's own private art collection, including the works of Armand, Burland, Brus, Coleman, Dado, Fuchs, Helwein, Lassen, Sandoz, Schwartz, Venosa and many others, as well as the HR Giger Museum Gallery where, on a rotating basis, Giger curates one-man shows for other artists.

The new HR Giger Museum Bar, a permanent part of the museum complex, is open for business. Giger's designs for the bar emphasizes the pre-existing Gothic architecture of the 400 year old space. The giant skeletal arches covering the vaulted ceiling, together with the bar's fantastic stony furniture, evoke the building's original medieval character and give the space a church-like feeling.

Opening hours
april – october 10 a.m. to 6 p.m.
november – march 11 a.m. to 5 p.m.

## MUSEUM HR GIGER
Château St. Germain, CH - 1663 Gruyères, Switzerland,
Tel. +41(0)26 921 22 00, www.HRGigerMuseum.com